THE ENCYCLOPEDIA OF VISUAL ART

GENERAL EDITOR

SIR LAWRENCE GOWING

17 68

ENCYCLOPAEDIA BRITANNICA INTERNATIONAL, LTD

LONDON

This edition first published 1983 by
ENCYCLOPAEDIA BRITANNICA INTERNATIONAL, LTD
London

ISBN 0 85229 187 6

Parts of this publication have also been
published separately under the titles
A History of Art and
A Biographical Dictionary of Artists

AN EQUINOX ENCYCLOPEDIA
Planned and produced by
Equinox (Oxford) Limited,
Littlegate House, St Ebbe's Street,
Oxford, OX1 1SQ
Copyright © 1983 Equinox (Oxford) Limited
Reprinted 1984, 1986

Project Editor Valerie Mendes
Picture Research Anne-Marie Ehrlich,
Christine Forth, Diana Morris
Additional Research Mel Cooper
Production Clive Sparling
Design Sarah Tyzack, Trevor Vincent
Art Editor Jerry Burman
Text Editors Janet Graham, Robert Peberdy
Index Sandra Raphael

Text set in Sabon by
Tradespools Limited, Frome, England
Monochrome Origination by
York House Graphics, Hanwell, England
Color Origination by
M.B.A. Ltd, Chalfont St Peter, England,
E. Moffat & Co., High Wycombe, England,
and Siviter Smith Group Ltd, Birmingham, England
Printed and bound in Spain by
Heraclio Fournier, S.A. Vitoria

*Equinox wishes to thank the following institutions and individuals for their
help in the preparation of this work:*

INSTITUTIONS: Ashmolean Museum, Oxford; Bibliothèque Nationale, Paris;
Bodleian Library, Oxford; British Library, London; British Museum, London;
Courtauld Institute of Art, London; Gulbenkian Foundation, Lisbon; Louvre,
Paris; Merseyside County Museums, Liverpool; Metropolitan Museum, New
York; Museum of Modern Art, New York; Museum of Modern Art, Oxford;
Oriental Institute, Oxford; Oxford City Library; Petit Palais, Geneva; Phaidon
Press, Oxford; Pitt Rivers Museum, Oxford; Sainsbury Centre for the Visual
Arts, Norwich; Sotheby Parke Bernet & Co., London; Tate Gallery, London;
Victoria and Albert Museum, London; Warburg Intitute, London.

INDIVIDUALS: Margaret Amosu Professor Manolis Andronikos, Janet
Backhouse, Claudia Bismarck, John Boardman, His Grace the Duke of
Buccleugh, Richard Calvocoressi, Lord Clark, Curt and Maria Clay, James
Collins, Bryan Cranstone, Mrs E.A. Cubitt, Mary Doherty, Judith Dronkhurst,
Rosemary Eakins, Mark Evans, Claude Fessaguet, Joel Fisher, Jean-Jacques
Gabas, Dr Oscar Ghez, Paul Goldman, G. St G.M. Gompertz, Zoë Goodwin,
Toni Greatrex, A.V. Griffiths, Victor Harris, Barbara Harvey, Maurice
Howard, A.D. Hyder, Jane Jakeman, Peg Katritzky, Moira Klingman, Andrew
Lawson, Betty Yao Lin, Christopher Lloyd, Jean Lodge, Richard Long, Lorna
McEchern, Eunice Martin, Shameem Melluish, Jennifer Montagu, Sir Henry
Moore, Richard Morphet, Elspeth O'Neill, Alan Peebles, Professor Dr Chr.
Pescheck, Pam Porter, Professor P.H. Pott, Alison Renney, Steve Richard,
Andrew Sherratt, Richard Shone, Lawrence Smith, Don Sparling, Graham and
Jennifer Speake, Annamaria Petrioli Tofani, Mary Tregear, the late Jim Tudge,
Betty Tyers, Ivan Vomáčka, Tom Wesselmann.

Equinox wishes to thank the numerous individuals, agencies, museums,
galleries, and other institutions who kindly supplied the illustrations for this
book.

Equinox also wishes to acknowledge the important contributions of Judith
Brundin, Ann Currah, Bernard Dod, Herman and Polly Friedhoff, the late
Juliet Grindle, Jonathan Lamède, Giles Lewis, Andrew McNeillie, Penelope
Marcus, and Louise Pengelley.

Note

The Encyclopedia of Visual Art subsumes six approaches to visual art: a History of Art, a Biographical Dictionary of Artists, a Glossary of Terms, three sets of illustrated studies (Special Studies, Comparative Studies, Media Studies), a summary guide to Museums and Galleries of the World, and an encyclopedic Index. The locations of these elements are given in the Contents list on page viii. The aims of the *Encyclopedia* and the nature of its construction are discussed by Norbert Lynton in his Introduction (pages xi–xiii).

Detailed Contents lists of the chapters and special features in the History of Art can be found on page ix of this volume and at the beginnings of volumes II–V. Special features are of two kinds: Gallery Studies, which take the broader view, compare and contrast works of art; Close Studies bring readers face to face with individual works.

The Bibliographies and lists of suggestions for Further Reading usually specify latest editions. Where possible, details of publication in both the United Kingdom and the United States of America are given.

With regard to the list of Museums and Galleries (vol. X, pp. 163–76), it should be noted that many works of art are housed in churches, monasteries, temples, etc, throughout the world. The list makes no attempt to include such locations.

The Index (vol. X, p. 177) contains brief biographical details of many artists not included in the Biographical Dictionary.

Technical matter in the contributions and captions has been edited according to the following conventions. Titles of works are given in English, except where a title in another language is more familiar. Wherever possible the locations of works are provided, by reference to the full name of an institution and to the town or city in which it stands. Names of institutions in English, French, German, and Italian are normally given in their original forms. Others have been translated except where an original name is familiar or because an idiomatic translation is not possible. The names of some major institutions have been abbreviated. A statement of location does not necessarily imply a statement about ownership.

In the captions dimensions are given in the order: height × width (× depth in the case of sculpture). Measurements for most works are given to the nearest centimeter with, in parentheses, an imperial equivalent to the nearest inch. Where possible, the media of works are also given, but for many works, especially those from the period of European painting when tempera and oils were both in common use, media have not been specified in full because the binders and pigments of such works have not been analyzed.

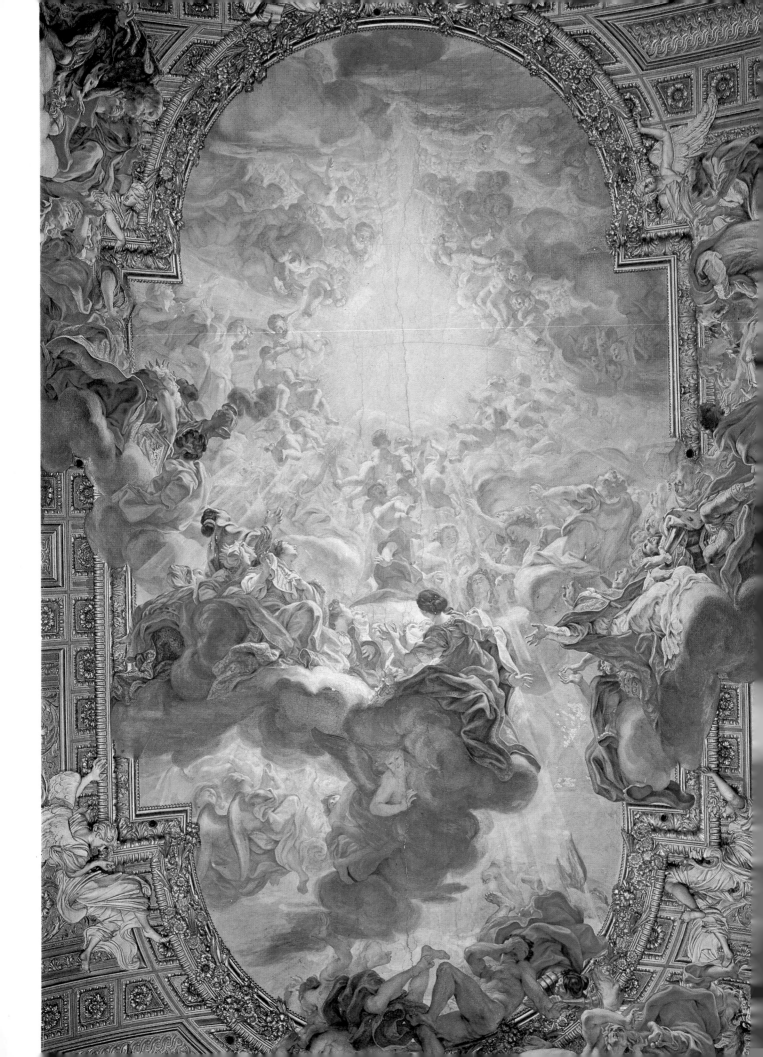

PREFACE

A team of authorities as distinguished as those whom I am privileged to introduce does not often come together to work on a project like this. The publishers and I felt proud to have them with us and now that the *Encyclopedia* is finished our feeling seems justified. The major elements of the work are a History of Art and a Biographical Dictionary of Artists. In the History, as one specialist after another takes up the more or less continuous story, even readers who already know something about a culture or period are likely to join the rest of us in discovering a little more. We find ourselves closer to actual objects than most histories bring us. The Biographical Dictionary deals with more than three times the number of artists who figure in the only previous dictionaries of equal readability and convenience.

In reading the *Encyclopedia* none of us will doubt that what is of most value in its subject is precisely that which is in some sense unknowable, something beyond the reach of words, however well-informed and perceptive. The essence of art, which gives purpose to a survey like this, is notoriously variable. The altering character and changing focus which make art as elusive as it is entrancing also make it harder to read about than sometimes need be: we hope and believe that no more thoroughly approachable and more delightful *Encyclopedia of Visual Art* than this exists. Yet if the going is not uniformly easy I counsel persistence, in the confidence that rewards are certain. In one respect both writers and readers are fortunate that the mental climate in which we write has peculiar advantages. We all mistrust generalization; the most significant thing we know about the faculty of art is that even in the most distant periods and places, nothing human was foreign to it.

If we are discouraged to learn, what history teaches, that the essence we extract from art is perennially the creation of the culture that extracts it — is in fact itself a part of history — we can take courage. Knowledge of art is without doubt not only a luxury, a self-indulgence, and an unfailing joy — though it is all these things — it is knowledge, and very likely our deepest, most unguarded knowledge, of humankind.

LAWRENCE GOWING

◀ Triumph at the Name of Jesus by Gaulli, a fresco on the ceiling of the Gesù, Rome; 1674–9 (see vol. IV, page 705)

THE ENCYCLOPEDIA OF VISUAL ART

CONTENTS

HISTORY OF ART

BIOGRAPHICAL DICTIONARY OF ARTISTS

VOLUME ONE

CONTENTS

INTRODUCTION

Our view of art is global, all-embracing across time and space. The process begun two centuries ago is now complete. What we call art and value as art has broadened from a particular tradition or stream, dominated by particular sorts of objects and purposes, to a broad flood in which many traditions mingle and many kinds of activity coexist. In the museum of the mind — and in some actual museums on the ground — we can switch our attention from primitive artifacts from many parts of the world to the most sophisticated achievements of successive civilizations, from the weightiest of programmatic works dealing with the great themes that have occupied mankind to elegant frivolities. What we mean by "art" necessarily becomes wider and less definite when the word is used to cover such variety; at the same time, our understanding of it has referred more and more to the personal and the cultural processes that generate the art product. If "art" disconcerts us as a term under which such a host of diverse objects shelter, it also comforts us with the implication that these things represent a drive and a capacity in all mankind to invest skill and intelligence and deep feeling, communal as well as individual, in the inventing and fashioning of objects especially charged with visual power and spiritual significance. The diversity before us is that of humanity itself; the undying drive and capacity confirm our membership of one vast family.

Awareness of art is pressed on us from all sides. Newspapers and magazines, radio and television bring us news and comment. They speak to us of art as a leisure occupation, an encounter on offer beside others, competing with cinema, film, and other presentations for our spare time interest, our evenings out. Lecture courses, books, and also more recent forms of instruction such as slide sets with notes on tape or art films and video tapes, offer what is often more weighty information, visual and verbal, responding to a desire for more knowledge about art and clearer guidance to its multifarious and often contradictory ways. On the one hand we are treated to news of record prices, marvelous discoveries and outrageous novelties; on the other we are asked to follow some of the complex interactions of cultural and economic factors, convention and innovation, stylistic and technical conditions that affect the creation of any work. While the news treatment of art becomes more and more sensational, explanations of art — which are mostly attempts to trace the development of a particular stream in order to discover its constant and its temporary components and thus highlight the contributions made by a particular people, period or individual — become more complex. In between the two fall attempts to popularize, and these are legion.

One hesitates to say how successful they are. What is clear is that they are dominated by concepts and attitudes that work against a proper understanding of the whole of art because they represent only one phase of it. The same two centuries that witnessed "art's" growth from a specific term to a compendious one, saw the establishment of ideas of genius, originality, spontaneity and self-expression that do not serve the art of these centuries very well and can work against any proper understanding of the art of other periods. The ideas we associate with Romanticism have tended to dramatize art's role in society from one of selective support and celebration to that of conflict. The artist has been relocated outside the community. We may see him as a prophet or a madman, as a guru or a jester; we do not see him as a worker alongside other workers. We look at art for signs of revolution and for that insistent uniqueness which demonstrates conflict within the world of art itself; we value these in the art of the past even as they trouble us in the art of our own day. The writer wanting to hold our attention will need to stress the isolation of a Rembrandt or a van Gogh and the misunderstanding such men met even within the supposedly informed inner world of art ... and thus add weight to an aspect of their aspirations that is quite marginal and actually makes it more difficult to see both the point and the true originality of what they did. It has become habitual to write only in terms of change and shock. Meanwhile the art historian is becoming more and more painstaking in tracing the origin and gradual emergence of new ideas and methods, finding originality not in leaps and wholesale demolitions and reconstructions but in inflections and combinations often of very subtle kinds. The result is that the art historian and the general reader are increasingly at odds, the one seeming to remove from his subject just those excitements that attract the other.

There is another difficulty, a peculiarly delicate one to the art historian. Historical explanations are not the only means of discussing art and are not always apt. Yet they are the ones most frequently on offer, for example in the documentation that accompanies exhibitions where we usually find biographical data compounded with accounts of what is called artistic development. An individual work is rarely examined as such. In other words, relationships are stated without sufficient attention being given to what these resulted in. The general public, with some justice, is made to feel that the historian thinks of the work under discussion as a sort of receptacle into which the artist has dropped, and unconsciously allowed to fall, this and that item of art and emotion and circumstance. An equivalent would be to describe a fine meal only in terms of the recipes used and the personality and age of the cook. Other sorts of approach are easily dismissed by saying the word "appreciation" (which should not deserve it) in a contemptuous tone. There is justice in this when the study of a work of art turns into a parading of untested personal responses. However, literary and musical analysis have proved their value.

In short, there is a wealth of information about art, and it grows daily. There is a wealth of art, also growing through discoveries, new affiliations, and the current production of art. Historical accounts on a variety of scales provide essential maps and guides, but need to be matched by the patient experiencing and examining of individual works as a complementary means of access to art. Many an art historian would benefit from it. Many perform it for themselves but do

◄ A fragment of a red quartzite head of Sesostris III (reigned 1878–1843 BC). Metropolitan Museum, New York (see vol. I, page 46)

not see it as part of their professional role to guide others in it. Yet it is done best by those who know the historical situation. To do both would be to bring together again processes of explication and of construing that used to be one. To arm the public with both is, in effect, to arm it with a tool other than that of what is usually called personal judgment. "Does this please me?" is not the best question to ask of a work of art and should never be the only one.

The Encyclopedia of Visual Art is a new kind of publication, conceived and published to meet present needs. Art history, museums, and encyclopedias as we know them are children of the Enlightenment, of the 18th century's final (as it seemed) establishment of natural reason over authority and dogma. Commonsense, reflecting verifiable and shared experience, would henceforth regulate human affairs to the benefit of all. Compendious institutions and volumes, holding objective information in an orderly system, would make knowledge — and in consequence good judgment — available to all.

We can see how what was taken to be a culmination of human organizing turned out to be an opening of floodgates. Knowledge results in questions, not final answers. Systematic ordering itself constricts and falsifies. Objectivity is impossible; were it possible to attain, it would presumably be of no use to us. History itself turns out to be an approximation that an age adopts as answering to its needs, its silent or spoken questions. It is rewritten as much to adjust itself to changes in the writer's context as to adapt it to additional or better information.

These volumes bring a variety of methods and approaches together to complement each other. The first volumes (I–V) are dominated by a history of art written by experts. Its chapters can be read consecutively — and form as nearly as is possible a chronological sequence; they can also be used singly as up-to-date introductions to the art of a culture or period. Each ends with a list of suggested further reading. Strategically placed within these chapters are shorter features dealing with one work of art or with one particular kind of art product characteristic of a culture or period: attention is focused on the particular instance or type. Read in conjunction with the related historical survey, these articles add a dimension of depth to what has otherwise to be a broad account. The features can also be taken in conjunction with each other to yield a succession of investigations that illuminate art historically and a-historically.

The second half of the project is in part a dictionary of artists (volumes VI–IX), providing biographical information and also commentary on each individual's achievement and thus complementing the first half's offering. It also provides material not found hitherto in publications of this sort. Again, the historical data is accompanied by other sorts of information. There are the Media Studies (Volume X, pp.109–162) which together form an expert introduction to the materials and processes associated with various art forms. They are detailed enough to be of value to the specialist. For the general reader they provide guidance of a sort for which there is little room in the historical essays, yet which is essential if the historical information is to be understood fully.

The relationship of style to process is an intricate one, best seen as operating in both directions with style making demands that methods and materials are developed to meet, while methods and materials encourage stylistic development in some directions and constrict it in others. The Comparative Studies (volume X, pp.59–108) involve a broad historical conspectus. They could almost be said to deal with mental materials and methods in that they set out some of the ideals and concepts that have guided art, more particularly those that have been fundamental to Western art. An understanding of what is called the "genres" of painting is essential to anyone wishing to understand the classical tradition and its development and enrichment in the Renaissance and after. What is discussed here is the structure of conventional functions and forms against which modern artists are often said to have rebelled, but which reflected and also supported some of mankind's greatest artistic achievements and yet accommodated art of dazzling variety and rapid development — and it is suggested that in many respects the same structure, far from being an outdated rule-book of no relevance to our own century, survives today and continues to prove its validity. We believe that this is the first Encyclopedia to make this essential information available to the nonspecialist reader, and we hope it will encourage specialist and nonspecialists alike to be more aware, and to encourage awareness, of the positive role of conventional systems in providing a framework of agreed expectations within which the creative artist can operate persuasively and with a large measure of freedom. Similarly the matters raised in the Special Studies (volume X, pp.1–58): unusual in encyclopedias of art and outside the reach of art histories, they touch on the place of art in society, on the relationships artists have tended to establish with the world outside their studios, and on the use society makes of art.

Thus *The Encyclopedia of Visual Art* recognizes the complexity of its subject and the multiple and mutually enriching ways in which it needs to be approached. This is reinforced by the multitude of illustrations brought into the volumes. We all must guard against the habit of accepting illustrations as representatives of what they show: they are not, and the better they are the greater is the danger that we shall think we know an actual work from its stand-in. One need hardly stress the difference in size, physical character, precise color and tone, and luminosity in several senses, that come between even good illustrations and actual works of art, but we are all inclined to forget that most works of art in the history of mankind have been made for particular places and often to serve particular purposes in those places: only book illustrations are done to exist on the pages of books and await our approach by means of "edge access" (as the communication experts call it today). Museums too have led us to dissociate art from any role other than that of hanging on walls and standing around in large, impersonal halls for us to file past. This said, it must be recognized that a large gathering of illustrative material from the whole history of art permits cross-referential study of a sort we would scarcely make in a lifetime without this resource, and here the illustrations are selected and organized so as to encourage full

use of the ten volumes. The comprehensive index plays a cardinal role in this, not only showing where additional illustrations may be found: it is itself encyclopedic, directing us towards words and images via the names of artists and of works of art, via the main techniques, technical terms, and materials.

The multiplicity of approaches and of data found in this work mirrors the multiplicity of demands likely to be made of it. Never have more calls been made on art. We go to art — often, as was said, in the guise of entertainment and in the spirit of relaxation — for many sorts of stimulus and pleasure, but also for information and ideas. There are some historical and a-historical kinds of knowledge we can get only or mainly from works of art, and here art serves as evidence of human life and concerns that cannot be found elsewhere. Moreover it is a very direct guide. We cannot, obviously, stand before, say, Egyptian tomb paintings or royal statues like ancient Egyptians, yet we can and do identify easily and warmly with these images; we must guard against interpreting them the way we would if they had been done by different people for different purposes, yet when all the warnings have been given we still feel the vigor of the art; its basic meanings break through the barriers of time and situation to confront us with extraordinary directness. Similarly the host of primitive artifacts conquered for art, so to speak, by modern artists from the confines of ethnography and travel curiosities. With effort we can come to understand some part of the function and thus the meaning of these objects to the tribal and other societies that created and used them. More than most art objects, they lose their significance and most of their force when gathered into the chill order of the museums and galleries; they were no more made for keeping still and being looked at than butterflies. Nonetheless, the loss of reality is compensated for by the close and repeated contact we can make with these objects, and with the peoples and the aspirations and fears they represent. Such contact, incomplete but peculiarly direct and personal, is available to us through art alone, and it breeds an awareness of the underlying unity of mankind as well as its diversity of expression and organization.

Art history is taught in schools, colleges, and universities. Art history and art appreciation are sought after as courses in institutions open to the general public. Art exhibitions are increasingly on offer, at all levels of complexity and glamor; all of them have an educational value and function, now increasingly stressed via guided tours, informative leaflets and catalogs, and a variety of other aids. Public museums and galleries grow and develop their services. The information and the propositions offered serve not merely the art historian or the art-taster: art is studied as an aspect of social, cultural, economic, and political history, as data for anthropology and psychology, as an illustrational companion to literature in its many forms. More particularly art serves art: for all the anti-traditionalism and isolationism associated with modern artists, the art of others, past and contemporary, is their prime source. Indeed, the most illuminating and penetrating comments made about art often come from artists. While art

lasts — and technology is coming ever more to the aid of the conservationist — the more we and succeeding generations are able to go again and again to the same objects and question them in different ways and for different immediate purposes: the work of art lives on through our continuing use of it.

The medium of art history and art appreciation is words; here (as in other areas of communication) lies the great problem. They are not, let me add quickly, the only medium. Artists know art without exchanging it for words: they make copies in order to know the originals and, by other means too, not excluding plain observation, they can enter into the processes as well as the completed product before them with a clarity that few others can attain. This does not mean that we cannot imitate them. We too can get to know a work of art intimately by, say, drawing it or parts of it; but there is a more essential way in which we can share the artist's close engagement with art. Wide knowledge and frequent contact is part of it, but not the essential thing: that essential thing is time and attention. Only with time and effort (the most important part of the effort being not to let external and internal distractions intervene) can we get beyond the stage of that superficial contact that consists only of checking the credentials: name, van Gogh; known for flowers and landscapes and portraits: OK, this is a landscape; known for strong feelings and colors: OK; went mad and shot himself: well, still alive here but you can tell . . . And so on to the next work of art, checking off the names and labels and expectations stored in our heads, all derived from reading and not from looking.

From words; that is where the misunderstandings start. Few of us use words with sufficient care; few of us use them with sufficient freedom when there is something very special we want to say that the usual phrases will not carry. Worse, coming to art more through words than through art, we tend to recognize the art we meet in terms of the words we are armed with. To be specific: if we see the work of a Cubist painter we see it in terms of Cubism; if by some lucky accident or extra-cunning exhibition of a sort that never seems to happen we see the same work under a different stylistic banner, say Expressionism, we actually see it differently, i.e. see, in effect, a different kind of art to which we attribute different priorities. Try it on Delaunay! The world being as it is, words inevitably lead the way and often they lead us by the nose.

These volumes, for all their rich illustrative offering, are word constructions. Expert and up-to-date information has been gathered together, and commentary from people experienced in their special subjects and in reporting on them to a variety of readerships and audiences. Our hope has been to provide better guidance and more stimulating ideas than it has been possible to expect on such a wide front and to meet a variety of needs by the variety of our approaches. But our work will have failed in its main purposes if it stands between our readers and the direct experiencing of art. It is a bridge we have attempted to build, not a self-referring monument.

NORBERT LYNTON

T. A. HESLOP
Lecturer, School of Fine Arts and Music,
University of East Anglia, Norwich

JAMES HOLLOWAY
Assistant Keeper of Art, National Museum of Wales,
Cardiff

CHARLES HOPE
Lecturer in Renaissance Studies, Warburg Institute,
London

JOHN HOUSE
Lecturer in the History of Art, Courtauld Institute of Art,
London

MAURICE HOWARD
Lecturer in the History of Art, University of Sussex

PETER HUMFREY
Lecturer in the History of Art, University of St Andrews

SAM HUNTER
Department of Art and Archaeology, Princeton University

OLIVER IMPEY
Assistant Keeper of Eastern Art, Ashmolean Museum,
Oxford

CHRISTOPHER JOHNSTONE
Curator of Education and Information, National Gallery of
Scotland, Edinburgh

MARTIN KEMP
Professor and Chairman of the Department of Fine Art,
University of St Andrews

PETER KIDSON
Reader in the History of Art, Courtauld Institute of Art,
London

HELEN LANGDON
Author of *Everyday Life Painting, Holbein, The Mitchell
Beazley Pocket Art Gallery Guide*, etc

ERIKA LANGMUIR
Reader in the History of Art, University of Sussex

PETER LASKO
Director, Courtauld Institute of Art, London; author of *Ars
Sacra*, etc

NIGEL LLEWELLYN
Lecturer in the History of Art, University of Sussex

CHRISTINA LODDER
Lecturer in the Department of Fine Arts, University of St
Andrews

NORBERT LYNTON
Professor of the History of Art, University of Sussex;
author of *The Story of Modern Art*, etc

ELLEN MACNAMARA
Author of *Everyday Life of the Etruscans*

SHEILA MADDISON
Tutor, Open University, West Yorkshire region

ANDREW MARTINDALE
Professor of Visual Arts, School of Fine Arts and Music,
University of East Anglia

JODY MAXMIN
Associate Professor, Department of Art, Stanford
University

HUGH MELLER
Historic Buildings Representative, The National Trust,
Devon

HAMISH MILES
Director, Barber Institute of Fine Arts, Birmingham

JOHN MILNER
Senior Lecturer, Department of Fine Art, University of
Newcastle-upon-Tyne

LYNNE MITCHELL
Research Student, Courtauld Institute of Art, London

PARTHA MITTER
Lecturer in South Asian History, University of Sussex;
author of *Much Maligned Monsters: History of European
Reactions to Indian Art*

JENNIFER MONTAGU
Curator of the Photographic Collection, Warburg Institute,
London

KATHLEEN MORAND
Professor and Head of Department of Art, Queen's
University, Kingston, Ont.

JOHN M. NASH
Senior Lecturer, Department of Art, University of Essex

TERESA NEWMAN
Lecturer, Open University, London Region; formerly on
the curatorial staff, Tate Gallery, London

PATRICK NOON
Assistant Curator, Yale Center for British Art, New Haven,
Conn.

PAUL OVERY
Author of *Kandinsky, the Language of the Eye, Pop Art*, etc

OLGA PALAGIA
Lecturer in Archaeology, University of Athens

RONALD PARKINSON
Head of the Department of Education, Victoria and Albert
Museum, London

E.J. PELTENBURG
Lecturer in Archaeology, Department of Extra Mural and
Adult Education, University of Glasgow

†E.D. PHILLIPS
Formerly Professor of Greek, The Queen's University of
Belfast

RONALD PICKVANCE
Richmond Professor of History of Fine Arts, Department of
Fine Arts, University of Glasgow

GRISELDA POLLOCK
Lecturer in the History of Art, University of Leeds

A.J.N.W. PRAG
Keeper of Archaeology, The Manchester Museum,
University of Manchester

ANTHONY RADCLIFFE
Keeper of Sculpture, Victoria and Albert Museum

PHILIP RAWSON
Dean, School of Art and Design, University of London,
Goldsmith's College

BENEDICT READ
Deputy Witt Librarian, Courtauld Institute of Art, London

HON. JANE ROBERTS
Curator of the Print Room, Royal Library, Windsor Castle

†KEITH ROBERTS
Formerly Associate Editor, *Burlington Magazine*,
and sometime Commissioning Editor for Phaidon Press

GILES ROBERTSON
Professor Emeritus, Department of Fine Art,
University of Edinburgh

RUTH RUBINSTEIN
Warburg Institute, London

N.K. SANDARS
Author of *Prehistoric Art in Europe, The Sea Peoples*, etc

ANDREW SHERRATT
Assistant Keeper, Department of Antiquities, Ashmolean
Museum, Oxford

ANNE SIEVEKING
Author of *The Cave Artists*, etc

ROBIN SIMON
Director, Institute of European Studies, London

LAWRENCE SMITH
Keeper of Oriental Antiquities, British Museum, London

ROBIN SPENCER
Lecturer, Department of Fine Arts, University of St
Andrews

PAUL SPENCER-LONGHURST
Assistant to the Director, Barber Institute of Fine Arts,
Birmingham

GERETH SPRIGGS
Freelance writer and authority on English medieval
manuscript illumination

SARAH STANIFORTH
Scientific Department, National Gallery, London

JOHN STEER
Head of Department of History of Art, Birkbeck College,
London

MARY-ANNE STEVENS
Lecturer and Chairman of the Board of Studies, History
and Theory of Art, University of Kent at Canterbury

NEIL STRATFORD
Keeper of Medieval and Later Antiquities, British Museum,
London

SARAH SYMMONS
Lecturer, Department of Art, University of Essex

ALAN TAIT
Reader in the History of Art, University of Glasgow

DANIEL THOMAS
Senior Curator of Australian Art, Australian National
Gallery, Canberra

KATHRYN B. THOMPKINS
Lecturer in the School of Classical Studies, University of
Manchester

MARY TREGEAR
Keeper of Eastern Art, Ashmolean Museum, Oxford;
author of *Chinese Art*, etc

NICHOLAS TURNER
Assistant Keeper, Department of Prints and Drawings,
British Museum, London

WILLIAM VAUGHAN
Reader in the History of Art, University College, London;
author of *Romantic Art*, etc

PETER VERGO
Lecturer, Department of Art, University of Essex; author of
Art in Vienna, etc

NICHOLAS WADLEY
Head of Department of Art History and Complementary
Studies, Chelsea School of Art, London; author of *Cubism*,
etc

CHRISTOPHER WAKELING
Lecturer in Fine Art, University of Keele

ERNST WANGERMANN
Reader in Modern History, University of Leeds

MALCOLM WARNER
Freelance writer; coauthor of *The Phaidon Companion to
Art and Artists in the British Isles*

ANTHONY WHITE
Managing Director, Frederick Muller Ltd, London

FRANK WHITFORD
Author of *Kandinsky, Egon Schiele*, etc

ALAN G. WILKINSON
Curator of the Henry Moore Sculpture Centre, Art Gallery
of Ontario, Toronto

D.J.R. WILLIAMS
Research Assistant, Department of Greek and Roman
Antiquities, British Museum, London

CHRISTOPHER WRIGHT
Freelance writer; publications include *Rembrandt and his
Art, Paintings in Dutch Museums, French Painting*, and
Rembrandt: Self-portraits

ERIC YOUNG
Distinguished authority on Spanish painting; publications
include *Francisco Goya*

GEORGE ZARNECKI
Professor of the History of Art, Courtauld Institute of Art,
London

PALEOLITHIC ART

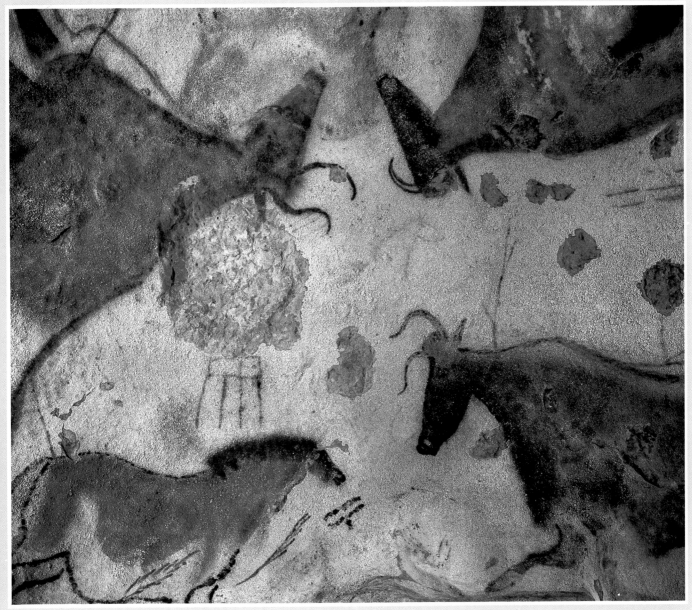

A horse and three cows painted on a gallery ceiling at Lascaux; the total length
of the figure at bottom right is 200cm (79in) (see page 8)

PALEOLITHIC is the name given to that period of man's history before he invented agriculture, domesticated animals, or discovered the use of metals. For his subsistence he depended on hunting and gathering, a way of life that sufficed for more than two million years. Art, however, had not so long a development, and is known only from the latest, or Upper, stage of the Paleolithic, a period we recognize by technological changes in bone- and flint-tool production that took place *c*40,000 years ago.

Such art as remains from this period is of two forms: either small objects found among the debris left by Paleolithic hunters in their camps, or murals in rock-shelters and deep caves. The first group is described in French as *Art Mobilier* and both the terms "mobiliary" and "portable" are used in English, but "miniature art" is a preferable description. The size of these pieces is a clear reflection of the nomadic economy of their makers, for to a nomad all sizable possessions are a burden.

Miniature art consists of three-dimensional figurines of animals and women, of pieces of bone, ivory, or stone with naturalistic or schematic engravings cut upon them, and a number of carefully ornamented tools. Obviously only objects made of the most durable materials have lasted: originally

there were perhaps many decorated objects made of wood or leather, but they have not survived.

Mural art is represented in daylit rock-shelters by low-relief carving and, in some cases, engraving, and in more sheltered deep caves by engraving and painting. The pigments used are manganese, carbon, and ochers with a color range of black, red, brown, yellow, and, very rarely, purple. Both naturalistic and schematic motifs are used in mural art, the naturalistic consisting almost exclusively of animals, principally the large herbivores such as horses, bison, and mammoths, and the schematic element of signs. Much of the painting is beautiful and highly accomplished; in its context doubly surprising both by its quality and character, for very few primitive people exploit the naturalistic element in art.

Paleolithic art has a time span of more than 20,000 years, lasting from approximately 30,000 to 9,500 years ago. The first datable art objects that we have are ascribed to the Aurignacian Culture (an early geographical variant within the Upper Paleolithic) and were found at Vogelherd, in West Germany, in a level dated to more than 30,000 years BC. One of the characteristics of Paleolithic art is its homogeneity and its adherence to formulas. The drawings in caves, for example,

Distribution map of main Paleolithic art sites in Western and Central Europe

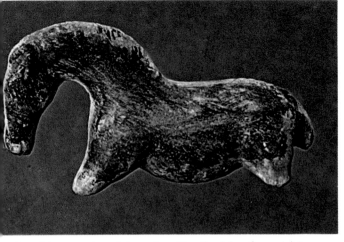

A small ivory carving of a horse from Vogelherd; length 5cm (2in)

subscribe to a particular inventory and this persisted with little change throughout the period in which caves were decorated. Such continuity over so great a period of time is unique in the history of art and the only explanation for it is that it reflects the social stability we postulate for its creators.

Beyond the fact that they were all members of the genus *Homo sapiens* (that is, modern man) we do not know who these men were and so in the absence of almost any skeletal material are forced to group them by their tool types. Equally, it is virtually impossible to identify the artists, although we could speak of "the Painter of the Altamira ceiling" and we can recognize certain objects as made by the same hand (two spear-throwers, for example, from Bruniquel in the Tarn-et-Garonne and Laugerie Basse in the Dordogne, France). It is quite probable, however, that each, or many, Upper Paleolithic tribes supported a specialist. Australian Aborigines living in a much poorer environment than prevailed in the Upper Paleolithic are known to have had enough surplus to support one man whose only occupation was making and repairing their tools. On this analogy an Upper Paleolithic group could have supported a tool-maker and decorator, whose work perhaps included painting a nearby cave or carving the rock-shelter wall.

Paleolithic art is in itself the beginning of art, although the earliest surviving pieces are not necessarily man's first artistic efforts. The Vogelherd figures, for example, are already so accomplished that we should perhaps regard them as the earliest surviving objects made of durable material, in this case mammoth ivory, which were originally preceded by an experimental series in wood. Within the span of 20,000 years all techniques are found at all periods, that is, sculpture does not precede two-dimensional work, nor engraving painting. In western Europe the latest periods are the richest, however, principally those that are associated with the middle and late stages of the Magdalenian (another industrial variant of the Upper Paleolithic, taking its name, as do the majority of these designations, from a type site in France). As it has no precursors, so Paleolithic art has no direct descendants—the Mesolithic cultures that followed the Paleolithic in Europe produced little art and that of a simple and rudimentary type. With the exception of the narrative rock-shelter painting of the Spanish Levant, which has only tentative links with

Paleolithic art, the naturalistic tradition died out completely at the end of the last Ice Age.

As the content of Paleolithic art is constant, so its distribution is limited. It is confined to the northern hemisphere of the Old World and to certain regions within this area, although the products of Upper Paleolithic industries with which it is associated have a much wider distribution. Miniature art is found in Spain, principally in the Cantabric region; in France, principally in Aquitaine and the Pyrenees; in Italy; in central and eastern Europe in the Ukraine and the Don Valley; and in Siberia, near Lake Baikal. Culturally this distribution forms two major groups: the western group including Spain, France, and Switzerland; the eastern, Italy, central Europe, European Russia, and Siberia. The arts of these two groups show great similarity, their principal difference being that in the East art is only known in its miniature form and is mainly three dimensional, while in the West the existence of mural art strengthens the two-dimensional factor, and enriches the total.

Mural art, by its nature, demands a location in caves or rock-shelters, but in fact the occurrence of karst formation limestone does not determine the distribution of this art form, which is concentrated in the Dordogne, the French Pyrenees, and the Basque provinces of Spain. Suitable caves exist elsewhere, in Moravia for example, but with the exception of Krapova in the Urals no painting is known outside France and Spain and very little engraving. There is a group of engraved caves in South Italy and Sicily, the most famous being the Grotta Romanelli near Otranto and Addaura near Palermo, but in style they are closer to the eastern cultural group than to the western. That the earliest examples of art, either miniature or mural, are widely scattered gives further support to the idea, put forward above, that the earliest pieces of art we have do not represent the first made.

The first pieces of Paleolithic art to be recognized as such were excavated in France in the middle years of the 19th century. After Darwin had established the antiquity of man, the search for human remains moved from the gravel pits of the Somme to the rock-shelters of the Perigord, rich in Upper Paleolithic deposits. By 1878 enough miniature art pieces had been retrieved to fill a case at the Exposition Universelle in Paris: they attracted great interest. In the 1890s Piette and others extended the search to the Pyrenees. We have a large corpus of art objects from these 19th-century excavations, although due to poor early methods of excavation we possess little scientific data about them.

Miniature art in the East is a much more recent discovery: with the exception of Predmosti in Moravia; which was first dug in 1880, the major sites have all been explored in this century and, in comparison to the West, are still few in number.

In France miniature art was accepted without question as the work of "early cave man" but mural art, interestingly, was at first firmly rejected. It is true that its date can seldom be established except by comparative means, that is, miniature art is found in the accumulated layers of domestic rubbish

A bison on the ceiling of the Altamira cave; length of figure 195cm (77in)

while mural art stands clear on the wall of a cave or shelter, except in a few instances where rubbish has accumulated against a wall, giving a terminal date. However, such proofs exist and, since the drawings on miniature-art pieces are similar to those in caves, it is hard to see why 19th-century scholars, having accepted the first, repudiated the second.

The story of the discovery of Altamira, in northern Spain, is well known. A famous ceiling there shows bison and other animals, painted with a marvelous utilization of the natural bosses on the stone roof. The accidental shapes suggested to the Paleolithic artist that he should depict a number of bison lying down and use the stone projections to add to the illusion of relief in each painting. They are painted in polychrome and are perhaps some of the most sophisticated and elegant work known from the Paleolithic. Their modern discoverer, the Marquis de Sautuola, believed in their authenticity and Paleolithic origin but could convince no one else of these. Indeed, he died without vindicating his opinions, although further discoveries made after his death have forced archaeologists to accept that Altamira and other similar caves are both genuine and of great antiquity. Perhaps it was the actual

quality of Altamira that made it unacceptable as the work of primitive man, or perhaps it was that this form of painting, which is almost idiomatic and is easily understood in the 20th century, after the impact of Matisse, for example, was quite alien to 19th-century eyes. Whatever the reason Altamira, one of the most beautiful of Paleolithic caves, was not unanimously accepted as such until 1902, 23 years after its discovery.

Having briefly considered the modern history of Paleolithic art, let us look at the present state of knowledge. In eastern, central, and western Europe there are respectively 14, 18, and 71 sites that contain miniature art pieces in significant quantities, while in western Europe there are more than 80 decorated caves of major importance and as many again of minor. From this evidence, although it is still extremely inadequate, we may attempt some analysis of styles and chronology.

Miniature art is found in both eastern and western cultural provinces. The sites in central Europe and European Russia, though few, are often very rich and the Venuses are probably the most famous series of objects known from them. They are naked female figurines, usually less than 3 in (8 cm) in height, made of stone or ivory, in which certain features are much

exaggerated at the expense of others. Breasts, buttocks, and stomach are usually voluminous, while hands, feet, and facial features are not represented at all. Their appearance is of age, rather than youth, and although so fat, few can be described as pregnant. The Venus of Willendorf in Austria is typical of them, and there are notable series from Kostienki on the Don (USSR) and two sites nearby (Avdeevo and Gagarino), as well as from Dolni Vestonice in Czechoslovakia. Not all Venuses are fat, nor are all figurines feminine; for example, an ivory male figure was found in the grave of an adult man at Brno, Czechoslovakia. All figures are associated with settlements, however, and because of their placing in the houses, very often near the hearths, or grouped at one side, it is considered that they are perhaps house guardians whose importance is domestic rather than erotic.

Most Venuses are very naturalistic, even if exaggerated in form, but with time very schematic and stylized syntheses of these figures were developed. At Mezin in the Ukraine such stylized figures were covered with decorative patterns of chevrons and "Greek key" designs. These geometric patterns were used in the East for the decoration of ornaments, such as the ivory bracelets from Mezin, and even for tools. The designs are often elaborate and beautifully executed, being cut with a sharp flint point on ivory or bone. A few engravings of animals on such material are also known and a number of animal statuettes, usually of marl. Often only fragments survive, as at Kostienki (USSR), but at Dolni Vestonice (Czechoslovakia), where they are very numerous, some complete figures have been found. Here they were made of a mud compound, and baked in a kiln.

Venuses are both more numerous and of greater variety in the East, suggesting that this was the cult's area of origin, but they occur in western Europe and appear at a similar date, that is early in the Upper Paleolithic, between approximately 26,000 and 24,000 years BC. As in the East it is common to find a group of Venuses at one location, and such groups have been found at Grimaldi, on the Côte d'Azur, and at Brassempouy in the Landes (France) but there are a number of single finds also: the very stylized Venus from Lespugue (Haute Garonne, France) is one example. The western Venuses are similar to the eastern and follow the same later pattern of stylization, finally making a transition to mural art, as at

Angles sur-l'Anglin in Vienne (France) where, on the frieze, three half-figures are carved in low relief among the animals.

Schematic decoration is used on tools and ornaments in western Europe, but it is here that the naturalistic tradition has its greatest development and this is reflected in both miniature and mural art. Engravings of animals occur on non-manufactured pieces and on bone and antler tools, and low- and full-relief carving are used. Decorated pieces are known from all Upper Paleolithic stages in France and Spain but more than 80 percent of such work, as well as that of greatest quality, belongs to the middle and late stages of the Magdalenian, that is from c13,000 to 8,000 years BC. Much of the most beautiful work is found on antler tools, tools that a man would retain, such as spear-throwers, or thong-softeners, rather than on expendable objects such as javelin points. For example, spear-throwers are weighted with three-dimensionally carved animals, thong-softeners are decorated with engraved head and forequarters, and rib bones are made into spatulas, decorated with animal heads or fish.

Magdalenian IV is a particularly rich period, not only are a number of objects and techniques peculiar to this stage, but the way in which animals are drawn is both elaborate and stylized, with much shading and infilling. After this stage, although its inventory is much reduced, miniature art develops a freer and more lifelike style, with occasional narrative scenes, unrealistic combinations, and some essays in perspective. Many of the richest miniature-art sites are in the foothills of the French Pyrenees, for example La Vache, Mas-d'Azil, Lorthet, and Labastide, while Isturitz is farther west in the Pays Basque. Two sites farther north, Laugerie Basse and Bruniquel, are closely allied to the Pyrenean group, and there are two rich sites in northern Spain, El Valle and El Pendo near Santander.

Miniature art is found only in daylit habitation sites, mural art, however, although sometimes also found there, was mainly used to create sanctuaries in deep caves. Some of these painted or engraved panels are in extinct subterranean rivers that are difficult to reach and in positions that are awkward to see. At no time were such caves inhabited and they were probably little frequented. Nevertheless, many of the most beautiful decorated caves, such as Lascaux (Dordogne, France), and Niaux (Ariège, France), belong to this group.

Two reindeer carved on a reindeer antler; from Bruniquel, France; length 21cm (8in). British Museum, London

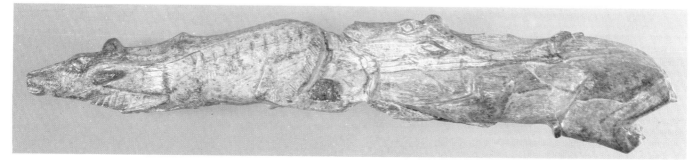

Paleolithic Venuses

The greatest achievements in naturalistic representation in the Upper Paleolithic period (whether in two dimensions or three), with one very important exception, were made at a late stage. This exception is the group of miniature sculptured female figures, described as "Venuses", that are found between Europe's Atlantic coast and Siberia at an early stage of the Upper Paleolithic, a period described variously as the Upper Perigordian or Gravettian, which dates from c27,000 to 23,000 years ago.

If, at first sight, it seems inappropriate to describe figures that are usually neither young nor slender as Venuses, it may be justified by their beauty of form, for the balance of mass and the symmetrical positioning of shapes achieved in these figures is remarkable. While hands, feet, and facial features are almost always omitted, and certain sexual characteristics, such as the pubic triangle, are on occasion represented, or on occasion also omitted, it is the essentially feminine forms of buttock, breast, and stomach that are emphasized. Viewed objectively, the Venus of Lespugue has pendant breasts, a protruding stomach, and fat buttocks, all developed to the point of distortion; but viewed aesthetically, the incline of her breasts and the curve of her buttocks are beautiful and each shape complements the other.

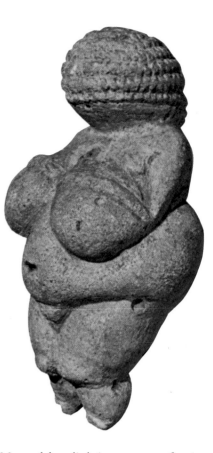

▼ The Venus of Lespugue, front view; height 15cm (6in). Musée de l'Homme, Paris

▼ The Venus of Lespugue, back view. Musée de l'Homme, Paris

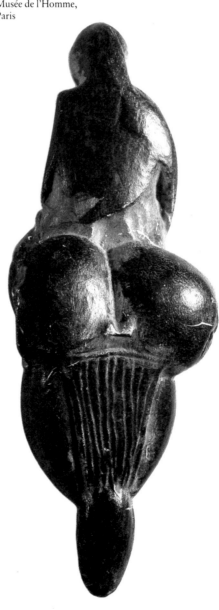

Many of these little ivory or stone figurines have a high polish, which suggests they were much handled and carried about; they are often found in groups and are habitually associated with living sites, whether these were constructed huts, as were made in eastern Europe, or rock shelters, as were used in the west. The individual appearance of the Venuses suggests they are figures of fecundity, made to endow or ensure plenty in some form, rather than to be erotic symbols, and the context in which they are found endorses a domestic importance: beyond this one can offer little explanation of their purpose. As a group (a group which to date numbers nearly 150 examples) they show great uniformity and with time the basic figure is adapted and simplified into schematized forms of considerable sophistication. The Venuses of Vestonice, Balzi Rossi, and Lespugue are typical examples of the basic naturalistic shape; the Venuses from Kostienki in the USSR, from Gagarino, or the remainder of the group from Balzi Rossi all fall into this type, as does the Venus of Willendorf and the figure from Brassempouy in France, though this statuette has an atypical, more natural beauty, as though a portrayal from life had interfered with the formalized concept. The Venus of Laussel, unusual in that it is carved in low relief on a freestanding stone block, is also atypical; in this case, although the detail is executed carefully, the general ungainly shape suggests a lack of conceptual ability.

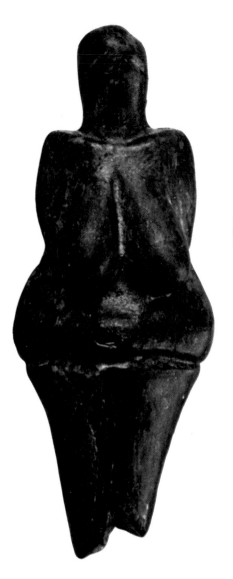

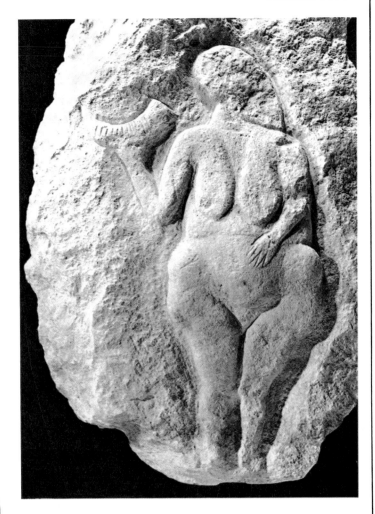

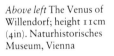

Above left The Venus of Willendorf; height 11cm (4in). Naturhistorisches Museum, Vienna

▲ A Venus from Dolni Vestonice, Czechoslovakia (a cast of the original); height 11cm (4in). Moravian Museum, Brno

▲ The Venus of Laussel, France, holding a bison horn; height 42cm (16½in). Musée d'Aquitaine, Bordeaux

◄ Schematic figures from Vestonice: *above* fork-shaped, emphasizing the hips; height 8cm (3in); *below* straight, emphasizing the breasts; height 8.5cm (3½in). Both Moravian Museum, Brno

► The ivory head of a young girl, from Brassempouy, France; height 3.8cm (1½in). A cast. The original is in the Musée des Antiquités Nationales, St-Germain-en-Laye

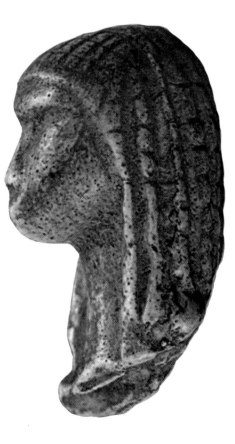

With time the Venus figures become diversified, some hermaphroditic forms occur, and the naturalistic female figures are superseded by more schematic forms; in eastern Europe two such variants appear, one based upon the hips, the other upon the breasts of the basic female figure, while in western Europe it is the raised seat profile, a form of the second variant, that is predominant. The profile shape finds its ultimate reduction in the claviform signs that are drawn in caves in the Magdalenian era; and it is interesting that this final simplification of the Venus figure is not only the last expression of the cult, but here has found a change in location: claviforms are generally part of the decoration of deep, uninhabited caves.

ANN SIEVEKING

Further reading. Abramova, Z.A. "Palaeolithic Art in the U.S.S.R.", *Arctic Anthropology* IV no. 2, (1967) pp1–179. Delporte, H. *L'Image de la Femme dans l'Art Préhistorique*, Paris (1979). Hancar, F. *Problem der Venusstatuetten im Eurasiatischen Jungpaläolithikum*, Berlin (1940). Leroi-Gourhan, A. *The Art of Prehistoric Man in Western Europe*, London (1968). Passemard, L. *Les Statuettes Féminines Paléolithiques dites Venus Stéatopyges*, Nimes (1938). Saccasyn della Santa, E. *Les Figures Humaines du Paléolithique Supérieur*, Anvers (1947).

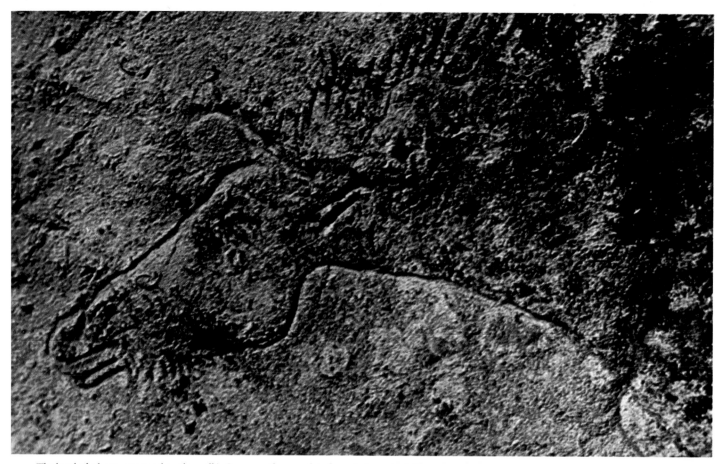

The head of a horse engraved on the wall in Lascaux; the complete figure is 60cm (24in) long

It is probable that, originally, every Paleolithic shelter habitation had a painted or engraved overhang, but apart from a few fragments that have been preserved by falling on to the ground below, no painting now remains, with the exception of the newly found cave of Tito Bustillo at Ribadasella (Spain) where a rockfall sealed off the habitation area and its painted overhang. There are a number of rock-cut, low-relief friezes, the most beautiful perhaps being that at Angles-sur-l'Anglin in Vienne (France) or the horses at Cap Blanc in the Dordogne. The work required to create these, cutting limestone with flint picks, must have been tremendous. It could not have been attempted in deep caves, but from these sculpture is not entirely absent. In the Tuc d'Audoubert (central Pyrenees, France) there are two beautiful bison modeled in mud that was collected from the cave floor nearby.

When people speak of Paleolithic art they are usually referring to the painted caves, and most probably they consider Lascaux, in the Dordogne, as typical: but the most striking aspect of Lascaux, the fact that the cave is decorated as a single unit, is an almost unique feature. In most caves the paintings are not displayed in this way; only certain, often inconspicuous parts of the cave are decorated; the drawing of one animal is not placed in relation to another with any regard for size or availability of space so that they are often superimposed, even jumbled together; some are unfinished and some may be upside down.

Of the animal species drawn, horses are much the most numerous, followed by bison, oxen, mammoth, deer, ibex, anthropomorphic figures, and carnivores; fish are rare, birds almost unknown. A few caves have a series of hand prints. Gargas, in the Pyrenees, is famous for these, and in certain areas, or at certain periods, signs are abundant. These signs are schematic: they may be quadrangular, brace-shaped, or composed of groups of dots or lines, and they give some indication of local grouping in cave art. Certain quadrangular signs, for example, are restricted to the Dordogne area while club-shaped signs are found at a later date in the Pyrenees and Spain.

Schematic signs in Castillo; the sign second from right is 63cm (25in) high

It is not easy to establish a chronology for cave art; style is probably the safest guide. The large-bodied, small-headed animals of Pech Merle (Lot, France) and Lascaux, for example, are early and have affinities to the low-relief friezes, while the very tautly drawn black outline figures of Niaux and Portel (Ariège, France) or Santimamine (Spain) are of characteristic Middle Magdalenian style. Fifty years ago the Abbé Breuil attempted a detailed classification of cave art based upon style and superpositions and concluded that there were two cycles in its development, but this is no longer accepted: as in miniature art one cycle seems adequate here.

There are decorated caves of an early date but present evidence suggests that the use of deep caves was short lived. The decorated rock-shelters and shallow daylit caves are mainly of early or late date, such as, respectively, Pair-non-Pair (Gironde, France) or La Mairie at Teyjat (Dordogne, France), while in the Middle Magdalenian period (from approximately 15,000 to 14,000 BC) there was a fashion for decorating caves progressively deeper and where access was more difficult. Lascaux, which has a date of 15,000 years ago, Pech Merle or

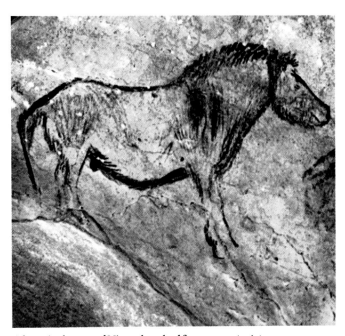

A horse in the cave of Niaux; length of figure 30cm (12in)

An ox and a mammoth from Pech Merle; the mammoth is 140cm (55in) long

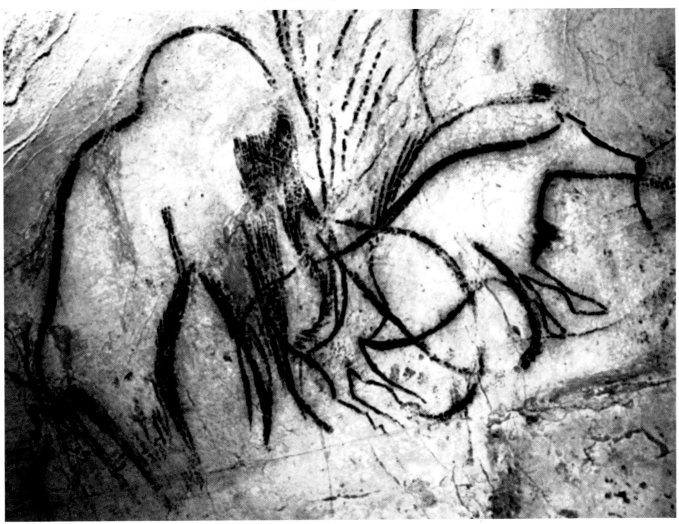

Cougnac (Lot, France) are among the earliest of these deep sanctuaries while Niaux, Le Portel, and the Volp caverns (Les Trois Frères, Le Tuc d'Audoubert), in the French Pyrenees and the Spanish group in Monte Castillo near Santander (Castillo, Monedas, Pasiega, Chimeneas) are among the later, as is Altamira. Some caves are clearly one period in style, such as Niaux; others, such as Castillo, had a long use and show a succession of styles. The majority are difficult to reach and cannot have had an everyday use and, although miniature art may have filled that requirement, the deep caves were apparently abandoned in the Late Magdalenian in favor of open-air sanctuaries once more, formed by groups of engraved plaquettes or wall engravings.

Breuil and his contemporaries were interested in the content and style of mural art but could see no meaningful design in its layout. They concluded that it was the creation of each individual drawing that was important and the animal species shown, mostly edible animals, suggested that this art was a form of sympathetic magic for hunting; a view endorsed by the occurrence of arrows drawn on the flanks of some animals. For a time such an explanation seemed adequate but the recent work of Leroi-Gourhan and others has called it into question. Leroi-Gourhan has studied specifically the layout of cave paintings and concludes that this is far from haphazard: in fact he considers that it follows a formula. Certain animals, horses and bovines, are of primary importance and are given central positions. Others, such as ibex and mammoth, are peripheral and of secondary importance; superpositions, unfinished outlines, signs of various forms all have their place and the formula may be repeated, at intervals, a number of times in one cave. The virtue of his interpretation is that it takes account of elements such as superpositioning, human figures, and signs for which sympathetic magic could offer no explanation. Certain signs may indeed be interpreted as traps, clubs, or even houses, but such an explanation does not invalidate Leroi-Gourhan's conclusions. There are further objections to the theory of sympathetic magic. Firstly, archaeological evidence shows that reindeer was the principal game of Upper Paleolithic hunters, but it is little represented in the art. Secondly, although climate and the available animal species varied greatly throughout the Upper Paleolithic, the inventory of animals in the art is remarkably constant. And finally, current ethnographic research suggests, by analogy, that the Upper Paleolithic was a period of considerable plenty.

We know that, although the climate was periodically severe, vegetation and large animals were very abundant and we should realize that, far from being threatened by starvation, Paleolithic man had no need to supplicate for food to be provided. The creation of cave sanctuaries suggests Paleolithic art had a magical or religious importance, while its quality, its homogeneity, and its duration demand a social sanction of great strength. We may conclude that it was not simply decorative, but had a great and continuing social importance. It may be assumed that miniature art is an expression in different media and locations of the same beliefs as mural art; tools, for example, may be invested with some added power by decoration.

Ethnographic parallels are of little value in explaining Paleolithic art, beyond the fact that Australian aboriginal art, for example, suggests that its meaning may be very complex. Leroi-Gourhan thinks that the limited and repeated number of animals in mural art constitutes a mythogram and that what one sees may only represent a vehicle for a meaning that one can only guess at; in his opinion, a synthesis of the universe, perhaps.

The Paleolithic is a period for which we have no social history; rather we look to the art to give us some insight into the mentality of its creators. In so doing we see the work of artists who could perfectly conceptualize and execute a formula, who had mastered all the problems of rendering three dimensions in two, and who could instantly create an image by an ideogram. Further, from the development and duration of the art we can deduce a considerable degree of social harmony. Paleolithic art represents an unbroken religious and artistic tradition lasting for 20,000 years, a phenomenon that has not been repeated.

ANN SIEVEKING

Bibliography. Abramova, Z.A. "Palaeolithic Art in the U.S.S.R.", *Arctic Anthropology* IV no. 2, (1967) pp1–179. Breuil, H. *Four Hundred Centuries of Cave Art*, Montignac (1952). Giedion, S. *The Eternal Present: the Beginning of Art*, New York and London (1962). Graziosi, P. *Palaeolithic Art*, London (1960). Leroi-Gourhan, A. *The Art of Prehistoric Man in Western Europe*, London (1968). Marshack, A. *The Roots of Civilization*, London (1972). Naber, F., Berenger, D.J., and Zalles-Flossbach, C. *L'Art Parietal Paléolithique en Europe Romane* Parts 1 and 2 (3 vols), Bonner Hefte zur Vorgeschichte nos. 14–16, Bonn (1976). Sieveking, A. *The Cave Artists*, London (1979). Ucko, P. and Rosenfeld, A. *Palaeolithic Cave Art*, London (1967).

NEOLITHIC ART

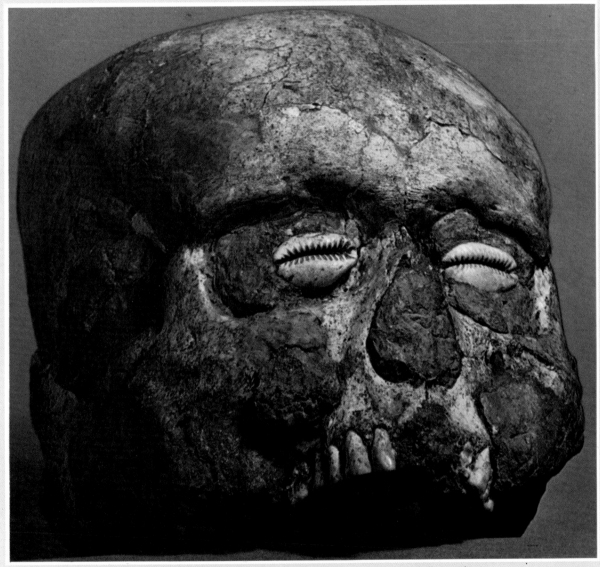

A human skull from Jericho, its features molded in plaster and cowrie shells inset for eyes;
7th millennium BC. Ashmolean Museum, Oxford (see page 12)

THE Neolithic period is the earliest phase of agricultural society, before cities and before the widespread use of metal for tools and weapons. After the end of the last Ice Age some 10,000 years ago, new climatic conditions brought woodland once again into Europe and the tribes o reindeer-hunters who had created the remarkable cave art of France and Spain (*see* Paleolithic Art) were no longer able to exist in their accustomed way. Small groups of hunters remained in the woodlands or on the coasts, but after 5000 BC these were increasingly absorbed or displaced by the colonizing activity of farmers, spreading with their flocks and cultivated grains from a homeland in the Near East, and settling in villages on the more fertile soils. Cutting down the forests for fields and pastures, these peoples used the new and effective polished-stone ax—hence the archaeologists' term "Neolithic", or New Stone Age. This period began *c*8000 BC in Iran, but only *c*4000 BC in the British Isles. It lasted down to 3500 BC in the Near East, and nearer 2000 BC in Europe.

The way of life of these peoples, and hence the character of their art, was in great contrast to that of the hunting groups they replaced. They lived, for example, in solid-built houses rather than the caves or makeshift shelters of their often nomadic predecessors. They developed, and brought with them to Europe, the technique of making pottery. They lived in larger communities and therefore developed more organized forms of religion and public ritual. And they probably had to work harder to make a living than their predecessors, for, contrary to popular belief, the development of agriculture was not "emancipation from the food quest"; it probably created less spare time than hunting. The achievements of Neolithic artists were not, therefore, simply the result of sufficient leisure to devote to creative pursuits, but arose from the nature of their society, their technology, and their mythological beliefs, and from the increasing number of their material possessions, mostly still produced on a domestic or village scale. The achievements of Neolithic art are thus mainly in the areas of domestic design and decoration.

Distribution of main Neolithic sites

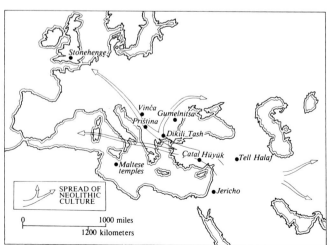

In discussing the various media used by Neolithic man, it must be remembered that we know practically nothing of his output in organic materials—textiles, woodcarving, featherwork, leather objects, or painted decoration on perishable materials. Enough survives in fragments to hint at the importance of all these, but it is impossible to recapture the vividness and color of the originals. Nor is the significance that these objects once had to their makers clear or easy to reconstruct. There are, of course, no written texts from this period, and there is very little realistic representational art before the coming of cities. What representations there are show single figures: there are very few groups, or figures that are part of a wider scene. Portrayal is often schematic and detail ambiguous. While it is likely that figures and motifs had a mythical or religious significance, attempts to reconstruct beliefs are pure speculation.

The mudbrick villages of the earliest farmers spread gradually across Iran and Turkey and into Europe through Greece and the Balkans. Most of these were small communities, though in the richer lowlands some larger sites not only grew to the size of small towns but also served as craft and religious centers.

Two examples of these (dating from *c*7000 and 6000 BC) are the original settlement at Jericho, and the site of Çatal Hüyük in southern Turkey. At the latter, an impressive shrine has been excavated, with the skulls of long-horned wild cattle (aurochs) covered in mud plaster and set into the wall of the sanctuary. The smoothed wall surfaces of nearby buildings were painted in red ocher with representations of hunting scenes, showing men surrounding the bull. Other scenes in the sanctuary depict large birds pecking at what are probably human corpses—strongly suggesting that bodies were exposed before burial. At Jericho, a similar concern with the body after death is shown by skulls with plastered faces and cowrie shells set in the eye sockets.

More widespread than these practices associated with central cult areas was the manufacture of small figurines for domestic ritual. The slightly later site of Hacilar (in western Turkey) has provided a great diversity of these objects, many of which have been copied by forgers and ultimately sold to museums. They are usually female, and in some cases show birth scenes or groups of a mother and child. The corpulent mothers are unclothed, but the rounded bodies are schematically treated and often covered in painted decoration. Anthropomorphic vessels were also made, with obsidian inlay used for eyes.

In addition to the production of small sculpture, a variety of utilitarian and decorative crafts were widely practiced in these earliest villages in Turkey. The pottery was fired at low temperatures, but effectively decorated by slips and painted areas of white, iron-free clay on red iron-bearing clay oxidized to a fine red color. These were evenly burnished before firing in the same manner as the figurines. Woodworking and basketry are sparsely preserved—the former as carbonized fragments and the latter as mat-impressions—but the designs of woven fab-

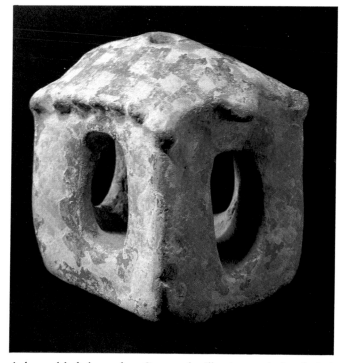

A clay model of a house, from Greece; 5th millennium BC. Archaeological Museum, Volos

rics with their strong geometric emphasis are reflected in the repetitive zigzag and rectilinear ornament of the painted pottery.

Personal ornaments made use of a variety of decorative stones obtained through long-distance trade. Beads were bored from steatite, turquoise, carnelian, onyx, and malachite, which later became an extensively used ore of copper. Indeed, even at this time some small ornaments may have been made by hammering small nuggets of naturally occurring pure copper. Shells were another commodity widely in demand for use as ornaments. These were carved into simple shapes as beads or bangles.

In southeast Europe, including Greece, no sites of the size and importance of Çatal Hüyük have yet been discovered, but from the 6th millennium BC onwards the same crafts were practiced, and the pottery shows a similar kind of design with "step" and "flame" motifs clearly relating to woven textiles. Figurines are similarly common, and again show local styles.

Thessaly, in particular, produced a wide range of forms, but further north the types are more standardized. Especially characteristic of Macedonia are the so-called "rod-head" statuettes with an exaggerated head and neck, the lines of which are broken only by applied pellets of clay forming "coffee-bean" eyes. This style is important in demonstrating the links between communities on the north Aegean coast and those further north in Yugoslavia. The religious area of Çatal Hüyük has its counterparts, on a smaller scale, in cult-houses, differing from ordinary dwellings in their size and painted-plaster ornamentation. The designs (as at the Bulgarian site of Karanovo) are purely geometric—often spirals and meander motifs—and the only representational designs besides anthropomorphic figurines are a few schematic "stick-figures" made of applied strips of clay on coarse pottery. When they have any specific identity, they are most often of animals such as deer.

As Neolithic groups moved further north into Europe in the 5th millennium BC, fine-painted pottery became increasingly rare and the surviving assemblage appears artistically impoverished in comparison with contemporary products in the eastern Mediterranean. We lack objects made of organic materials, however, and in consequence our impression of artistic poverty may be wholly false: a vast artistic and cultural legacy may have perished with the materials in which it was fashioned. Certainly, wood was a much more important raw material than clay or stone for many purposes in northern Europe. Large areas of heavy woodland had to be cleared for settlement, and for building houses timber was more appropriate than mudbrick in northern climates. Drinking vessels and tableware were probably increasingly the products of woodcarvers rather than potters, though pottery remained important for storage and cooking vessels. Until the later part of the 3rd millennium BC, fine pottery was a regional speciality rather than a universal commodity in northern Europe. Cult-houses were still built in each village, but the earliest farmers of central Europe did not produce figurines like those so characteristic of southeast Europe. Fine craftsmanship continues to appear in the stonework, however. Axes were naturally essential working tools, but finely polished examples in attractive and widely traded hard stone were also significant as indicators of status and power. Along with imported shell ornaments, they were placed in the graves of the older male members of the community.

In the far west and north of Europe, along the Atlantic seaboard and in the north European plain, the introduction of agriculture in the 4th and 3rd millennia BC involved the clearance of huge stones from fields. Now not only timber dwelling-houses but also large monumental tombs of undressed blocks were built, serving as cult-centers, and also as territorial markers among the more scattered hamlets of these areas. The earliest monumental architecture in stone used two techniques: in one, vast unhewn blocks were lined up or piled up one on top of another to provide burial chambers, and in the other, drystone construction techniques were used either to fill in the gaps between these blocks or to roof over a chamber by corbeling. Some of the most impressive of these tribal mortuary shrines occur in Brittany, Ireland, and the Orkney islands. Maes Howe in Orkney, for instance, has three side-chambers under a covering cairn.

A particularly well-preserved group of prehistoric monuments of this type was built in the Maltese islands, where the soft and easily worked limestone hardens on exposure to give an enduring record of the kinds of carving that may well have been made in wood further north. The temples were modified and enlarged over the centuries, as the cathedrals of the Middle Ages were to be, over four millennia later. Besides spiral and scroll ornament on lintels and altars, gigantic statues—somewhat reminiscent of the east Mediterranean terracotta figurines—were erected in the temples. Laboriously pecked ornament of spirals and concentric circles was also used on a smaller scale, for instance to adorn megalithic struc-

Gumelnitsa and Vinča Ceramics

The style of pottery making and modeling that characterized the Neolithic and Copper Age communities of southeast Europe in the 4th millennium BC is one of the high-water marks of prehistoric European art. The culture of this period represents the culmination of 2,000 years of indigenous development in this area, when the traditions established by the earliest farmers reached their peak.

The artistic achievements of this period are most notably expressed in pottery and terracotta figurines, painted or incised in a characteristic decorative style which ultimately reflects designs used on textiles and basketry. The sites that have produced examples of this style of art are the mounds (formed by the remains of successive prehistoric villages) that occur in lowland areas of northern Greece, Yugoslavia, Bulgaria, Rumania, and Hungary. Excavations at Gumelnitsa near Bucharest and Vinča near Belgrade have given their names to local groups within this cultural province. These well-preserved settlements of mud-and-timber huts, grouped in small village communities, contain plentiful remains of decorated ceramic objects; while their nearby cemeteries may yield examples of rarer metal (copper or gold) ornaments, which were placed as offerings in graves.

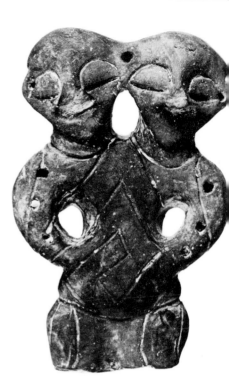

► A double-headed figurine with geometrical ornament. Vojvodjanski Muzeum, Novi Sad

◄ A Vinča figurine from Selevac, central Yugoslavia

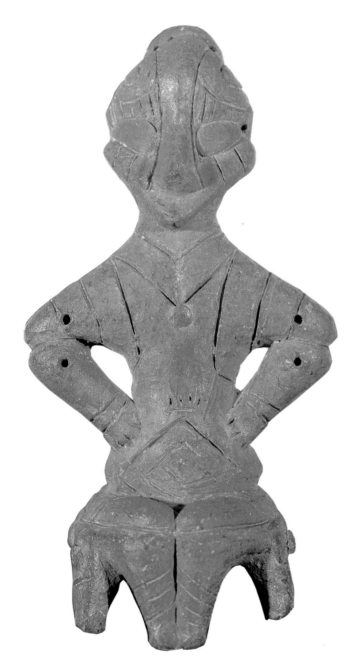

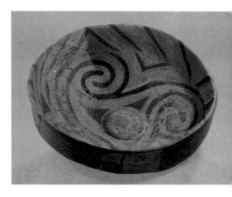

► A Gumelnitsa style pottery bowl with a spiral pattern. Museum of History, Turgovishte, Bulgaria

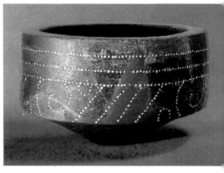

► A Gumelnitsa style painted pottery bowl, its incised decoration filled with white paste. Museum of History, Turgovishte, Bulgaria

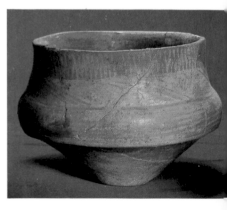

► A Gumelnitsa style painted pottery bowl of more complex shape. Museum of History, Turgovishte, Bulgaria

The decorative art of this period was closely related to domestic ritual and cult. Similar types of decorative patterns and representational elements appear on fine pottery, models, and on certain parts of the houses themselves. These categories thus overlap one another: "cult-vessels" such as triangular pottery lamps were decorated with modeled animal heads, while domestic fittings used for cult purposes, like ceramic pillars and offering-tables, were painted in the same way as fine pottery. The concentration of these elaborately decorated features in specific houses and rooms suggests they were cult objects used by particular members of certain families.

The style of decoration contains both abstract and representational elements, though the latter are always strongly schematized and often themselves bear geometrical ornament. This ornamentation takes two basic forms: a flowing meander or spiral pattern, and a more rigid, rectilinear version resembling woven matting. These were not mutually exclusive, and were sometimes combined on the same object. In the west (Yugoslavia) the figurines are more elaborate, though the pottery bears less decoration: in the east (Bulgaria) the figurines are often fairly schematic, while the pottery has a profusion of painted ornament.

▲ Human figures and furniture: the cult scene from Ovcharevo. Museum of History, Turgovishte, Bulgaria

The fully developed Gumelnitsa style of painted pottery emerged in the later 5th millennium BC from earlier traditions based on repetitive geometrical motifs executed as incisions filled with white paste. The vessel shapes became more complex, while the ornament—now usually painted—often took the form of freely swinging curves and spirals. At about the same time, more developed forms of terracotta models came into use. These included not only human figures but also items of furniture, as in a famous "cult scene" from Ovcharevo in northeast Bulgaria.

The most elaborate examples of such figurines come from the Vinča group in Yugoslavia. These are characterized by three-dimensional "mask" faces with protruding, almond-shaped eyes and sharp noses, sometimes depicted as seated on chairs or stools. Some show suggestions of dress and *coiffure*, and ornaments such as bracelets or pendants. Occasionally a more naturalistic rendering of the head was attempted, as in the attractive example from Dikili Tash in Greek Thrace, ornamented with graphite paint.

The production of these types of object came to an end in the 3rd millennium BC, when economic and social changes cut across established traditions in religion and art, and the beginnings of bronzeworking introduced a new medium for ornament and display.

ANDREW SHERRATT

Further reading. Gimbutas, M. *The Gods and Goddesses of Old Europe*, London (1974). Sandars, N.K. *Prehistoric Art in Europe*, Harmondsworth (1968). Todorova, H. *The Eneolithic Period in Bulgaria in the Fifth Millennium BC*, Oxford (1978).

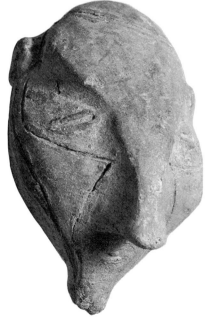

◀ A head of a man from Dikili Tash in Greek Thrace. Ashmolean Museum, Oxford

▼ A head from Predionica, southern Yugoslavia; height 18cm (7in). Kosova Museum, Pristina

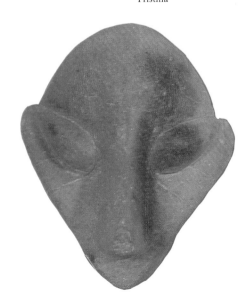

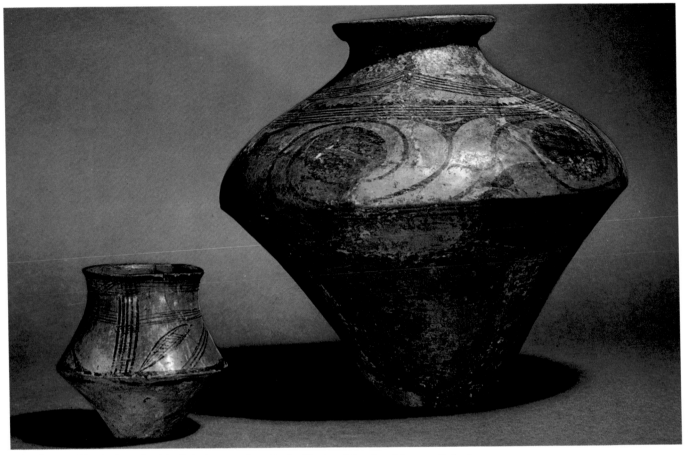

4th millennium biconical vessels of the Tripole group, found in the Ukraine. Ashmolean Museum, Oxford

tures in Ireland and Scotland. It has often been suggested that these are the results of contact with the west Mediterranean, or even ultimately from the Aegean—perhaps involving some kind of missionary activity. Modern methods of dating, however, have shown such influence to have been unlikely; similarities in social structure and local raw materials seem to be a more probable explanation for these resemblances.

While the megalithic style of architecture was developing in the north and west, the prosperous communities of southeast Europe began a period of economic expansion that ensured the continuation of their way of life and allowed them to develop new techniques.

The growth of trade meant that desirable materials traveled over long distances. Experimentation with new substances for use as paints, and more complex firing procedures, resulted in more elaborate multicolored pottery in a variety of blacks, reds, and browns and also a silvery color obtained from graphite. This was especially effective because of the deep black color that could now be produced in the pottery fabric by controlled firing in a reducing atmosphere. It could also be enhanced by the addition of powdered manganese minerals such as pyrolusite, lumps of which have been found in graves. Interestingly, there were mines for cinnabarite, which produces a bright vermilion tint not found on the pottery; we may take this as an indication that striking colors were also used on organic materials.

Some of the most attractive surviving artistic products of the 4th millennium BC are the ceramics of the Gumelnitsa and Salcutsa groups in Bulgaria, and the related Cucuteni and Tripole groups of Rumania and the Ukraine. Their pottery shapes make use of elegantly opposed curves, especially carinated forms with a convex profile above and a concave one beneath. The elegance of shape was complemented by painted ornament of geometric intricacy. In the early phases of the style the paint was mainly applied in narrow multiple lines, making a repetitive succession of motifs. With time, the linear style gave way to a block-painted style in which larger areas were covered with paint, and the motifs themselves became bolder and simpler. Individual panels of ornament gained an organic relationship with one another, with bold curves balanced on opposite sides of the vessel. Finally, the continuity of decorative elements was broken and individual motifs occurred in isolation—circles or squares rather than spirals—sparsely distributed around the surface of the vessel. This cycle of development—emergence, florescence, and decline into incoherence—is a characteristic feature of the evolution of particular styles in decorative systems over long periods of time.

The figurines of the Gumelnitsa and related groups were in general flat and highly schematized, but in other contemporary contexts, and especially that named after the site of Vinča near Belgrade in Yugoslavia, more three-dimensional work was attempted. The Vinča figurines are characterized by their exaggerated triangular faces with staring almond-shaped eyes. As these statuettes are quite detailed (showing, for example, hands and feet with fingers and toes) and as there are contemporary examples with naturalistic faces, their schematized faces may represent masks. Rows of perforations around the rim of the mask may have held feathers or tufts of straw. Some sites in the Pristina area of southern Yugoslavia have produced larger, life-sized versions of these figurines. More naturalistic modeling of the facial features is a characteristic of southern Thrace, and the site of Dikili Tash in northern Greece has yielded attractive "portrait" faces as well as the more schematic types.

Evidence about these figurines is relatively substantial because they derive from a large number of excavated sites belonging to the same period. They are commonly found in houses, often in very large numbers. It has been claimed that one such house (at the site of Sabatinovka in southern Russia) with 32 figurines, was a special shrine, but the presence of ordinary domestic fittings makes this unlikely; this discovery

An anthropomorphic jug from northwest Bulgaria, c6000 BC; height 25cm (10in). Vratsa Regional Museum

Vinča pottery representation of a seated figure. Ashmolean Museum, Oxford

A Halaf polychrome bowl from northern Iraq. Iraq Museum, Baghdad

seems rather to indicate that these terracottas were extremely common objects.

A significant technical development of the period was the discovery of copper smelting. (Because of this the mature Neolithic period is also termed the Eneolithic or Copper Age; but metal had little economic significance.) Copper was cast in open molds; it was used mainly for heavy, flat axes, but also for small personal ornaments such as pins with double spiral heads, or flat, hammered disks pierced to be sewn on to clothing. Gold was also used, on a smaller scale, especially in the regions in contact with Transylvania. It was beaten into small pendants and larger pectoral ornaments (up to 12 in, 30 cm, in diameter), sometimes decorated with rows of repoussé dots.

Whereas in Europe urban life only began in the 2nd millenium BC and only became widespread in the 1st, in the Near East there were large cities as early as the 3rd millennium BC, which followed a long period of proto-urban development. Copperworking, too, had a long history, and the term "Neolithic" has a somewhat different meaning than in the European context. Nevertheless, there are many points of similarity between the southeast European Neolithic groups and corresponding early village communities further east; and it is the ceramics that dominate the surviving art objects.

Before the colonization of the Mesopotamian plain and the growth of irrigation-based towns and temple centers in the lowlands, the cultural focus of the Near East in the 5th millennium BC lay in the villages of the arc formed by the flanks of the Taurus mountains to the north, connecting northern Syria with northern Iraq along the upper reaches of the Tigris, the Euphrates, and their tributaries. The relatively open character of the country promoted wider contact than was possible in the forested regions of Europe, and not only raw materials such as fine stone but also finished pottery was traded over long distances. This resulted in a uniform culture which allows us to speak of the whole area from the Mediterranean to the Tigris as a single cultural entity. It has been called the Halaf culture after the German-excavated site of Tell Halaf in Syria.

The pottery of the Halaf culture was produced by similar techniques to those used in the Copper Age of southeast Europe (though fired at higher temperatures) but stylistically there is little in common between the two. The flowing curves of the Balkan products have no equivalent in Halaf. Instead, rectilinear panels packed with lines, dots, crosses, and rosettes are the basis of ornament, sometimes mixed with naturalistic motifs of animal, bird, or human figures. Bulls' heads and deer are common images, but always as small, repetitive elements in a closely packed design. Early pieces were executed in single-colored paint on a slipped background, but in the later phases of the style several colors of paint were combined, as in the magnificent polychrome plate from Arpachiyah in north Iraq.

It would be hard to claim that these decorative styles or the representational techniques of the terracottas made any lasting contribution to the art of succeeding cultures. New cultural needs and technical possiblities altered both the style of art and the materials that were employed. Only in our own day, with a wide familiarity with primitive and tribal art, can Neolithic art be appreciated for what it is.

ANDREW SHERRATT

Bibliography. Gimbutas, M. *The Gods and Goddesses of Old Europe*, London (1974). Mellaart, J. *The Earliest Civilizations of the Near East*, London (1965). Sandars, N.K. *Prehistoric Art in Europe*, Harmondsworth (1968). Sherratt, A.G. *Animals in Early Art*, Oxford (1978). Torbrügge, W. *Prehistoric European Art*, London and New York (1968).

EGYPTIAN ART

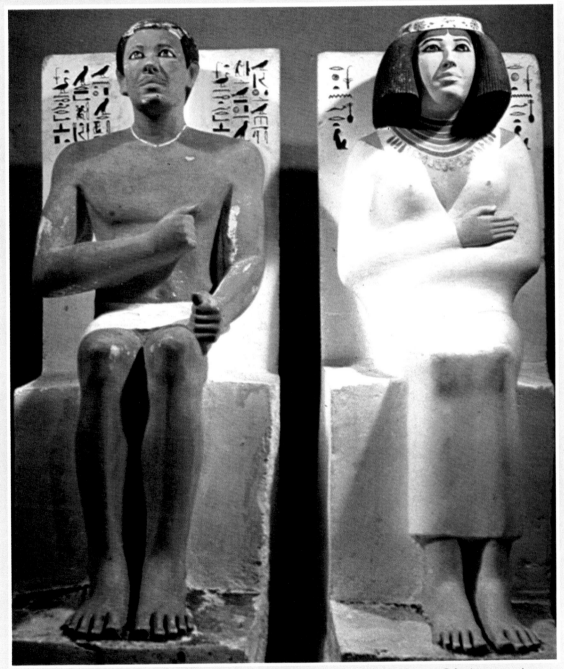

Old Kingdom sculpture: Prince Rehotep and his wife Nefert; c2620 BC. Egyptian Museum, Cairo (see page 25)

ART to the people of ancient Egypt was not an abstract concept. The works of Egyptian artists and sculptors served a practical purpose; they were not simply the tangible expressions of inspiration and imagination. If an object, a person, or even an occasion was represented in art—in sculpture, relief, painting, or as a model—and the right religious formula was inscribed on it, or even just recited, it would continue to exist forever. Therefore objects or scenes in tombs could be made "real" to equip the dead person for his existence in the afterlife. Every aspect of public and private life was involved with the pattern of religious belief and practice. The statues and reliefs that decorated the temples were not intended to be admired from a distance, to be awe-inspiring and remote. They linked the people with their gods through the person of the living god, and the king of Upper and Lower Egypt.

Distribution map of the main centers of Egyptian civilization

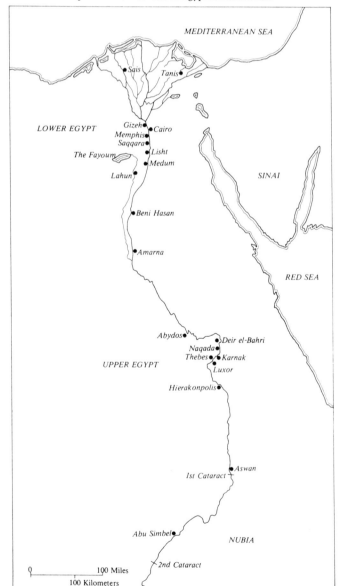

The traditions followed by the artists and craftsmen of ancient Egypt were established at an early date. The result was a sense of unity in art that persisted until Egypt became a province of the Roman Empire. In fact about 3,000 years elapsed between the establishment of the kingdoms of Upper and Lower Egypt and the death of Cleopatra, the last of the Ptolemies. During this time techniques developed, fashions changed, and variations did occur, but in general the basic patterns were faithfully reproduced by generations of Egyptian craftsmen. It is possible to look at a statue or a piece of jewelry and to be certain it was made in ancient Egypt, even though its exact date may not be at once apparent.

Geographical background. In Egyptian art nearly everything had a specific or indirect religious significance, and illustrated the special response of the people of the Nile Valley to their environment. They called their country *kemt*, the Black Land. The fertile valley running almost exactly north and south is an anomaly in the desert latitudes of North Africa. The civilization of ancient Egypt could not have occurred without the river, which created cultivable land in the middle of a desert to produce enough wealth to support not only farmers but craftsmen. The cultivable area, only a mile wide in some places, broadens out into the flat lands of the Delta in the north. The dark, rich color of the soil is in sharp contrast to the parched country to east and west, the Arabian and Libyan deserts.

The White Nile rises south of the Equator and flows north towards the Mediterranean Sea. Its chief tributary is the Blue Nile, which in spring is swollen by the melting snows from the mountains of Ethiopia. The floodwaters carry rich silt which is eventually deposited in a fertile layer over the alluvial plain to the north of Egypt.

To the people of ancient Egypt rising waters signaled the beginning of another agricultural year. A "good Nile" promised a successful harvest and a year of plenty. The floods moved steadily northwards; by the end of July the season of Inundation had begun at Memphis, the ancient capital of Egypt south of the Delta, and by early September the waters were at their height. After they had subsided, sowing could begin, the growing crops almost taking care of themselves in the fertile soil. With irrigation channels the floodwaters could be carried further, and otherwise-barren land could be brought under cultivation.

The Nile not only gave life to Egypt but united it in a very practical way. The Delta coast was 600 miles (965 km) north of the first cataract at Aswan and the southern boundary, but river traffic kept the capital in close touch with the provinces. Agricultural produce of all kinds was carried by water, and raw materials could be taken swiftly to the places where they were needed. Gold and ivory from Nubia, granite and sandstone from the quarries near Aswan, and fine limestone from Tura, near Memphis, were easily transported on the river. Indeed, much labor could be avoided in the construction of great royal monuments such as the pyramids at Gizeh. During the Inundation huge blocks of stone could be floated right to

the edge of the floodplain, close to the sites where they were to be used, so they only needed to be dragged on rollers for comparatively short distances.

For sculptors and other craftsmen, Egypt was rich in stone of all kinds. Fine sandstone, granite, dolerite, and serpentine were quarried in the south, and limestone of all qualities was readily available. The finest, from Tura, was used to carve reliefs of exquisite detail, although rougher stone was, of course, cheaper. Calcite, commonly called Egyptian alabaster, the stone most often used from earliest times to make vessels, was utilized for its lovely banded markings. In the deserts to east and west semiprecious stones were found, the most common of which were pebbles of garnet, carnelian, and amethyst. For metal, the ancient Egyptians exploited the copper mines of Sinai, and imported gold from Nubia. Fine wood, such as cedar, also had to be imported. The knotted native woods, such as acacia, had to be jointed to produce pieces of useful size; the joins in coffins and furniture were disguised by surface decoration.

Historical background. In prehistoric times the alluvial plain was marshy and teeming with wildlife, while the edges of the Nile Valley were still covered with enough vegetation to support large numbers of wild animals. Both areas provided rich hunting-grounds for a basically nomadic population. However, until it became possible to begin to coordinate efforts to cultivate the land, the valley itself was almost uninhabitable. Drainage and irrigation systems were essential for productive agriculture, and they had to be organized and constructed by people working together. The first settlements were situated on spurs of land above flood-level, and have been found round the lake in the Fayoum Depression west of the Nile, and on the edges of the valley itself further south. By c3600 BC the hunting-and-collecting economy of the earliest inhabitants had developed into a settled agricultural system. At settlement sites, evidence has been found of progress in social organization, with communal granaries for storing wheat and barley, and shrines for the local gods.

Succeeding prehistoric cultures not only developed and improved techniques of cultivation, but also of pottery making, which in this early period constituted a major element of their creative art. Even as early as 4000 BC, the people of Badari in Upper Egypt had been making black-rimmed pottery vessels with thin walls and a highly polished surface. Slightly later, other groups began to produce jars and bowls with combed or white-slip decoration, while from c3600 BC the characteristic painted pottery of the later prehistoric period is found in large numbers in the great cemeteries of Naqada and other sites in Upper Egypt.

This was the time when the potter's art flourished, more than at any other period in ancient Egypt. Vessels were made in a great variety of forms, decorated mostly in red on a buff ground with a wealth of patterns. These range from spirals and dots imitating contemporary stone vessels to stylized landscapes with water, hills, birds, and animals covering the

A painted pottery box from the late prehistoric period, height 8cm (3in). British Museum, London

surfaces. Most elaborate of all were the scenes showing ships with many oars, carrying the standards of local deities.

Fine stone vessels were also produced, the earliest examples of one of the most characteristic products of ancient-Egyptian craftsmen and later to claim more attention than the pottery. Tools and weapons of stone and flint were also skilfully made; and objects of luxury and personal adornment included beads, ivory combs, and stone cosmetic palettes often carved in the form of fish, antelopes, hippopotamuses, and other animals. The earliest inhabitants of the Nile Valley were already showing their delight in the natural forms that were such a familiar part of their daily life. In prehistoric times, too, the first stylized figurines in human form were made of clay, ivory, or bone, and are sometimes found with offerings in graves.

Gradually the districts of the Valley in the south and of the Delta in the North were banded together under the strongest of the local chieftains until two separate kingdoms were formed: Upper Egypt with its capital near Naqada in the south, and Lower Egypt with its capital at Buto in the Delta. About 3200 BC the king of Upper Egypt, known to us as Narmer-Menes, completed the unification of the Two Lands, and established some kind of centralized government.

Little is known about the so-called Archaic period that followed, but the tombs of kings and courtiers found at Saqqara, Abydos, and elsewhere, and the desert graves of poorer people, have yielded objects of all kinds demonstrating that the craftsmen of Egypt were able to flourish and to improve their skills under a stable government.

Written records soon began to be kept, and from surviving fragments the history of Egypt can be pieced together. The names of kings are known, and often the numbers of years they reigned. The main periods of Egyptian history can be divided into Dynasties of rulers, each Dynasty usually spanning the period of time in which one family was in power.

During the Old Kingdom, the period when Egypt was ruled by the kings of the 3rd to 6th Dynasties, strong central government meant that artists and craftsmen were drawn to the court to work under the patronage of the king and his great nobles. Techniques of working in stone, wood, and metal made tremendous progress, demonstrated by surviving large-scale monuments, such as the pyramids of the 4th Dynasty and the sun temples built by 5th-Dynasty kings. These monuments celebrated the divinity of the kings of Egypt, linking the people with the great gods of earth and sky who controlled the welfare of the land.

This was a time when trade and the economy flourished. Craftsmen worked in the finest materials which were often brought great distances, and were able to experiment with recalcitrant stones as well as new techniques of metalworking. This enabled them by the 6th Dynasty to produce large metal figures. The earliest that survive are the copper statues of Pepi I and his son, found at Hierakonpolis. Made c2330 BC they are badly corroded but still impressive in their stiffly formal poses. The eyes are inlaid, and the crown and kilt of the king, now missing, were probably originally made of gilded plaster.

The Old Kingdom ended with the reigns of weak kings and the disintegration of the centralized government that Egypt needed to enable the economy to flourish. The so-called First Intermediate Period, c2160–2000 BC, was a time of relative chaos, of petty kingdoms and the breakdown of the bureaucratic system. Artists and craftsmen who depended on national prosperity for their livelihood were the first to suffer, and few monuments of any consequence survive.

The prosperous period known as the Middle Kingdom really began with the reunification of the country started by Mentuhotep of Thebes c2050 BC. His successors, the strong kings of the 12th Dynasty, moved their capital from Thebes in the south to Lisht near Memphis, a more convenient administrative center. Under their rule Egypt flourished and looked once more beyond the boundaries of the Nile Valley. Lower Nubia was annexed to Egypt, and the copper mines of Sinai were exploited. Egyptian influence was strong in the states of Syria and Palestine, and was also felt in Cyprus. Fortresses were built to defend the southern and eastern borders, and within Egypt itself the administration was reorganized and new areas of land brought under cultivation. For two centuries Egypt enjoyed the benefits of peace under a capable government, and craftsmen achieved new levels of excellence. Very little architecture remains—many royal monuments were robbed for their stone in later periods—but what has survived shows great simplicity and refinement. The quality of royal statues was never surpassed, nor was the jewelry found in the tombs of royal ladies of the 12th Dynasty, although it may not be as famous as the treasures of Tutankhamun made over 400 years later.

The stability of the Middle Kingdom, like that of the Old Kingdom, disintegrated into a period of chaos called the Second Intermediate Period. Once again Egypt became a prey to civil strife, and the way was opened for foreign invaders.

Nomads from Asia infiltrated the Delta, and finally ruled Lower and Middle Egypt until they were driven out by Ahmose of Thebes who founded the 18th Dynasty c1550 BC. Egyptian propaganda later represented the Hyksos, as these nomads were known, as cruel persecutors. In fact, although surviving works of art are comparatively rare, these rulers seem to have adopted Egyptian traditions and to have encouraged native artists and craftsmen.

The establishment of the 18th Dynasty marked the beginning of the New Kingdom and a new blossoming of the arts and crafts of ancient Egypt. Under warlike kings such as Tuthmosis III and Ramesses II the boundaries of Egypt were extended far to the north and east, and trade flourished as never before. Craftsmen benefited from wider contact with other civilizations, such as those of Crete and Mesopotamia, and were also able to work with imported raw materials.

The kings gave encouragement to artists and craftsmen of all kinds by ordering great temples and palaces to be built throughout Egypt. The temple walls were covered with reliefs celebrating the achievements of the kings and the powers of the gods, and the courtyards and inner sanctuaries were enriched with statuary. The formal traditions of earlier periods were followed, though it is possible to detect a certain softening of line and pose even in the statuary intended to decorate the temples. The so-called heretic king, Akhenaten, 1363–1346 BC, actively encouraged a break with tradition. In his city at Tell el-Amarna, a more naturalistic style was developed which became extreme in its exaggeration of the human form. After his death the earlier traditions were resumed, but works of art now lacked something of the obvious strength and vigor of those of the Old and Middle Kingdoms.

In applied art new techniques included glassmaking, which began after the conquests of Tuthmosis III had opened up contacts with the glass industry already established in Syria and Mesopotamia. As always the Egyptian craftsman showed his ability to excel in the handling of materials, and to master new skills if encouraged to do so.

The New Kingdom lasted for about 500 years, and was the last lengthy period of stability and prosperity enjoyed by the ancient Egyptians. A succession of short-lived dynasties followed, and at times Egypt was again divided into several kingdoms. During the Late Period, 715–330 BC, Egypt prospered again but some of the ruling dynasties came from outside the Nile Valley. In the Saite period, the 26th Dynasty, 664–525 BC, a conscious effort was made to recapture the artistic styles and techniques of earlier times when Egypt had been so great. This was an attempt to give the people a renewed pride in past achievements, and a sense of unity at a time when they were threatened. In 525 BC, however, Cambyses of Persia invaded Egypt and annexed it to the Achaemenid Empire. Later, for a brief period, Egypt was ruled by native kings, but a second Persian domination was followed in 332 BC by the conquest of Alexander the Great; Egypt was no longer an independent country.

After the death of Alexander, Egypt was ruled by the de-

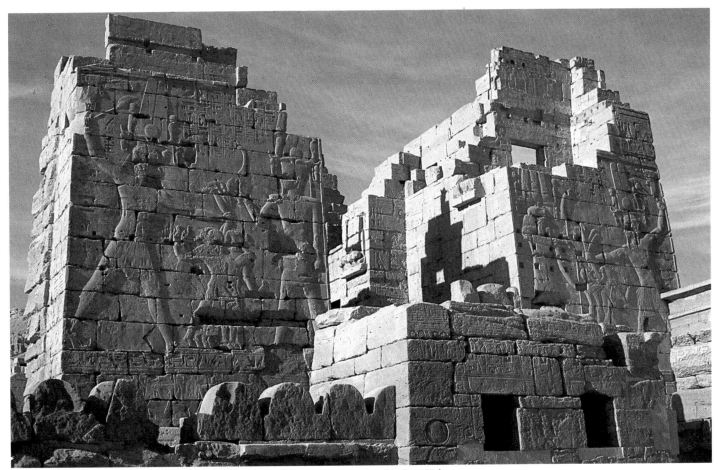

Relief sculpture showing Ramesses III striking his enemies, on his mortuary temple at Medinet Habu

scendants of his general, who became Ptolemy I. The administration of the kingdom was reorganized, and Alexandria became an intellectual center and great commercial city of the eastern Mediterranean. The Ptolemies encouraged the ancient traditions of Egypt. Many great Egyptian sanctuaries were reconstructed on a larger scale, or rebuilt, and decorated with reliefs in traditional style as if to underline the claims of the kings to rule the country and to show their awareness of its past greatness.

The gateway of the Ptolemaic temple of Horus at Edfu

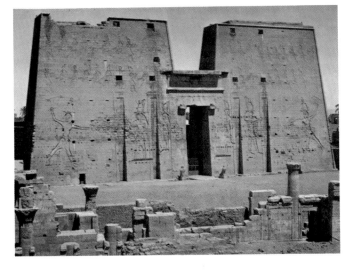

The purpose of art in Egypt. The magical reasons for the work of the Egyptian craftsmen have already been mentioned. The vital aim of a statue was to ensure the survival of the person represented for the rest of eternity. By being inscribed with his name and titles, it became magically endowed with his personality, and would provide an eternal dwelling place for his spirit after his death. The correct religious formulas would likewise make a statue fit to house the presence of a god. Such statues might have beauty, but even the roughest would fulfil its purpose if it was correctly inscribed. Many indeed were never intended to be seen by the living; once buried with their owners in tombs, they belonged to the spirit world of eternity.

Any representation, whether sculpture in the round, relief, or painting, was therefore intended to be timeless. To produce a portrait of a person was not the aim; instead the human form was idealized, so that men were shown in the prime of life and women in the gracefulness of youth. There were exceptions, however. Some men who held particularly high offices are shown as they must have appeared in later life. The seated limestone statue of the Prince and Vizier Hemon, for instance, c2550 BC (Römer- und Pelizaeus-Museum, Hildesheim), found in his tomb at Gizeh, is an imposing realistic example, showing this son of King Snefru in formal pose as a heavy, corpulent, but majestic figure.

Other rare realistic portrayals, mostly dating from the Old Kingdom, include statues of more ordinary people. There are famous limestone statues of scribes sitting cross-legged, each with a papyrus roll across his knees, as well as the famous

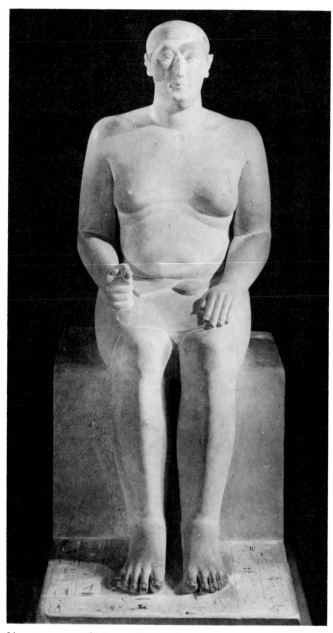

Limestone statue of Prince and Vizier Hemon, c2550 BC. Römer- und Pelizaeus Museum, Hildesheim

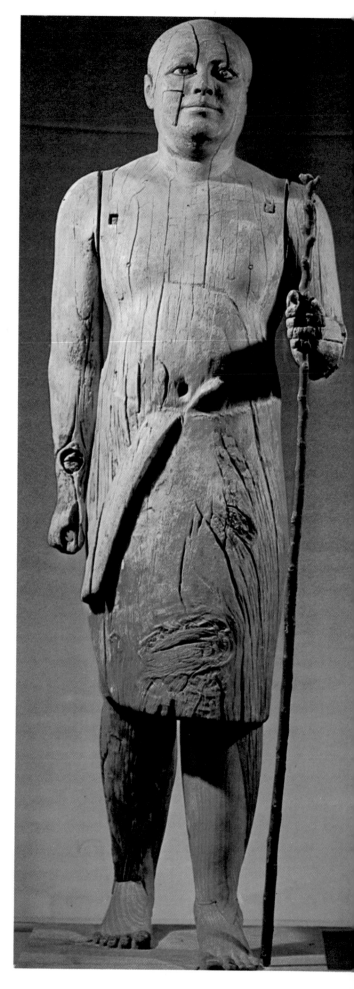

wooden figure called the Sheikh el-Beled, or village headman (Egyptian Museum, Cairo). It was made for Ka-aper, a priest and high official, c2400 BC, and shows him in prosperous middle age. A thin layer of painted stucco originally disguised the joints in the wood, and the lifelike appearance was enhanced by eyes made of quartz and crystal inserted in a copper mount. It was found in his tomb at Saqqara.

Several striking figures and groups show individuals with congenital deformities. The court dwarf Seneb, who owed his obvious success and wealth to his physique, is shown realisti-

Right: A wooden figure called the Sheikh el-Beled made for Ka-aper; height 109cm (43in); c2400 BC. Egyptian Museum, Cairo

cally in a small limestone funerary group, c2350 BC, sitting cross-legged next to his wife (Egyptian Museum, Cairo). The sculptor has treated him sympathetically. His deformity is not over-emphasized, and the group, completed by his son and daughter in the traditional pose of childhood, conveys the impression of a family closely united for the rest of eternity.

Traditional conventions. Most figures of individuals follow accepted conventions, and statues of kings and the gods in particular do achieve a timeless ideal. Treatments of the human figure in the round and in relief consistently draw on the same formal traditions. Men are usually shown striding forward on to the left foot, their hands at their sides, while women stand with their feet together or slightly apart.

Ancient traditions were also followed in coloring statues and reliefs fashioned in wood and limestone, which were usually brightly painted in their finished states. The skin of men, who spent much of their time out-of-doors, was always painted brown or reddish-brown, in sharp contrast to the creamy yellow or light pink tints used for the skin of royal and noble ladies who were expected to remain secluded from the harmful rays of the sun.

The two seated statues portraying the Prince Rehotep and his wife Nefert, c2620 BC, are remarkably well-preserved (Egyptian Museum, Cairo). Found in their 4th-Dynasty tomb at Medum they were probably carved by the same craftsman. In spite of the somewhat conventional and even sketchy treatment of the bodies, particularly the feet, the effect of the painting and the inlaid eyes is startlingly lifelike. The brown skin of Rehotep contrasts with the brilliant white of his short linen kilt and the white paint covering his chair which provides a background for the inscription. His wife is enveloped in a tightly-fitting white mantle. The hair of both is black, and fine detail such as the prince's moustache and the decoration on Nefert's headband have been left entirely to the painter.

By the mid 18th Dynasty, both men and women were often painted in the same reddish-brown, especially in tomb paintings, which often show large numbers of human figures outdoors in the marshes or indoors attending formal banquets. But with the elaboration of the dress of the late New Kingdom a different convention appears. The nobleman Menna is shown in two scenes in his tomb at Thebes, c1400 BC, in one fishing with a harpoon, in the other hunting wildfowl with a hunting stick. He wears a long sleeved garment of transparent linen over his short kilt. His face, forearms, and feet are painted the usual red-brown, but his legs and chest, outlined beneath the transparent robe, are colored creamy yellow. The effect, rather as if he was wearing dark gloves and socks, is quite common during the 18th and 19th Dynasties.

The convention of relative size was also followed from the earliest times: the most important figure in any scene was always shown larger than the rest. Thus the power and divinity of the king is at once apparent in his domination of any scene. The earliest surviving royal monuments, the ceremonial maces and palettes of c3000 BC, show that this convention

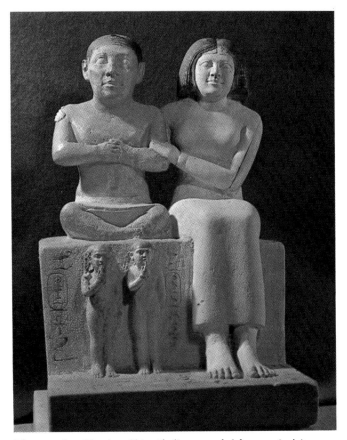

The court dwarf Seneb and his wife, limestone; height 33cm (13in); c2350. Egyptian Museum, Cairo

was already well established at the time of the union of Upper and Lower Egypt. The slate palette of Narmer, which presumably was made in celebration of his victories, depicts the king twice (Egyptian Museum, Cairo). On one side, wearing the Red Crown of Lower Egypt, he proceeds to inspect rows of corpses, perhaps of Lower Egyptian rebels. His figure is twice as large as those of his priest and sandal-bearer, who in turn are larger than the four standard-bearers who precede them. On the other side the king wears the White Crown of Upper Egypt, and is shown in the act of smiting an enemy. He appears to tower over his captive, though the contrast is achieved here by the kneeling posture of the latter who is in fact drawn to the same scale as the king. The sandal-bearer, however, is again much smaller than his lord.

The limestone Scorpion mace-head, which may have belonged to Narmer's immediate predecessor in the southern kingdom, was found at Hierakonpolis (Ashmolean Museum, Oxford). Again the king is at least twice as large as his followers and attendants, and is shown carrying out one of the most important functions of an Egyptian king: the first rite of the agricultural year, to ensure successful cultivation and a good harvest, performed as soon as the floodwaters had receded. The king's divinity enabled him to overcome his enemies, but his chief responsibility was for the welfare of the land of Egypt and its agricultural prosperity.

The Stela of Mentuhotep

Monumental stelae were first made c2850 BC and were set up to perpetuate the name of an Egyptian noble or official at the site of his tomb. The best are carved slabs of limestone or granite, and although their details vary according to the fashion of the time, they conform to a relatively standard pattern. The dead person is shown seated in front of an offering table, with inscriptions recording his name and titles. A ritual prayer formula, usually inscribed at the top of the stela, was meant to ensure that offerings would continue to be made to him throughout eternity.

The stela of Mentuhotep is a fine example of the small painted limestone stelae made during the Middle Kingdom, c2050–1750 BC. Mentuhotep, an official, sits at his offering table which is heaped with loaves, a calf's head, the foreleg of an ox, and a bundle of onions. Underneath the table are two pottery wine jars on ring stands: the seal of one is intact, but the other has been opened, ready to refill the cup on a tall stand at Mentuhotep's side. The dead man has the shaven head of a priest, and is prepared as if for an earthly feast, wearing a fine linen kilt, a broad necklace, anklets, and bracelets, and holding a lotus flower.

Stelae made during the Old Kingdom (c2680–c2180 BC) usually represent only the deceased, but here, at a later date, several members of Mentuhotep's family are also depicted on the lower part of the stela sharing his feast, although Mentuhotep himself is given due prominence. Their names and relationships are inscribed beside them, and, in fact, three generations of his family benefit from the magical power of the stela. In the register below his large figure, Mentuhotep appears again, this time on the right, facing his father of the same name. The bottom register includes three figures: on the right stands Renefseneb, a priest and probably Mentuhotep's brother, who faces a woman named in the register above as Henut, Mentuhotep's mother, seated next to her father, Kemmu, another priest.

The figures and offerings are carved in "incised" or "sunk" relief, which means that the outlines are cut deeply into the smooth prepared stone so that even modeled details with a raised and rounded form, such as the pots, never rise above the level background surface. The inscriptions consist of neat, precise hieroglyphs incised in two main lines at the top of the stela, while smaller signs are used for the individual names. The final details were painted on the carved surface so they stood out clearly against the honey color of the fine limestone background. Traces of the colors can still be seen; the red-brown used for the skin of the male figures, the pottery vessels, and the table supports has survived the best. The skin of the Lady Henut was yellow, the hieroglyphs blue, and the conventional border of rectangles between incised parallel lines was originally black, red, blue, yellow, and white. The red and yellow pigments were obtained from natural ochers, white from gypsum and black from soot, while blue was prepared from frit, a crystalline compound of silica, copper, and calcium. All the pigments were finely ground and mixed with water, and bound with either a gum or white of egg. The brushes used for small detailed work were rushes with frayed ends.

The carving of the human figures is stylized in the usual manner, with the head and legs in profile and the upper part of the body and the eye shown as from the front, which the Egyptians believed gave a perfect representation of the human form on a flat surface. The brother Renefseneb is the only standing figure, and his left leg is placed in the traditional way. They are all shown in the prime of life—how they wished to appear for the rest of eternity.

Certain features, such as the slightly elongated head and the prominent ears, help to date the stela to the early part of the Middle Kingdom, and this is supported by other details, including the personal names. The name Mentuhotep, for instance, was borne by four kings of the 11th Dynasty before 1190 BC, and it was always fashionable in Egypt to name a child in honor of the king reigning at the time of his birth. These kings had their capital at Thebes in the south, and it is possible that this stela was originally found in one of the Theban cemeteries.

The composition of the funerary formula and the way in which the hieroglyphs are carved are also characteristic of the Middle Kingdom. Beneath the two stylized eyes of the falcon sky-god Horus at the top of the stela, the formula, or prayer for offerings, is incised in two well-spaced lines. It is read from right to left, towards the animal and bird signs:

> A gift which the king gives to Osiris, lord of life of the Two Lands, that he may give invocation offerings of bread and beer, cattle and birds, linen and alabaster, incense and *merhet* oil to the *ka* [spirit] of the revered Mentuhotep, justified [before Osiris], born of Henut, justified [before Osiris].

Funerary stelae continued to be made in Egypt for nearly 2,000 years after this one. The prayers and formulae changed as time passed; later the deceased are shown praising the gods rather than sitting at their own funerary feast. But whether they are made of stone or cheaper, painted wood, the basic purpose remains the same: to preserve the identity of the dead for ever.

DOROTHY DOWNES

Further reading. James, T.G.H. *An Introduction to Ancient Egypt*, Oxford (1979).

Far right The funerary Stela of Mentuhotep; 51×38cm (20×15in). Merseyside County Museums, Liverpool

▶ A detail of the main register: Mentuhotep and a lotus flower

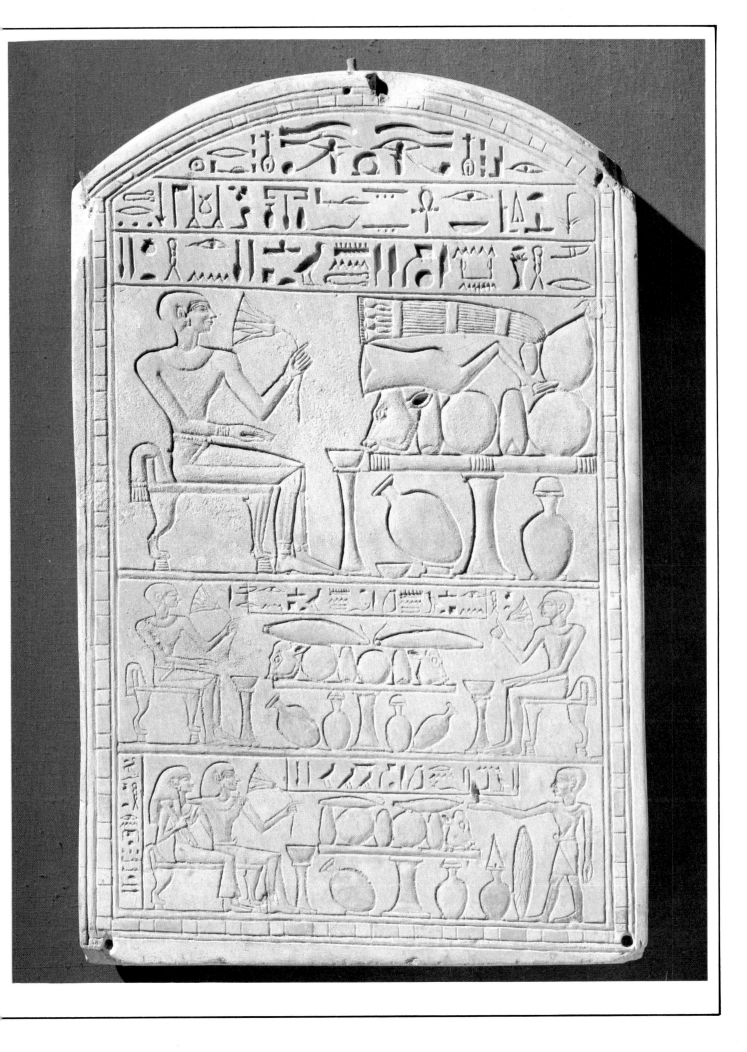

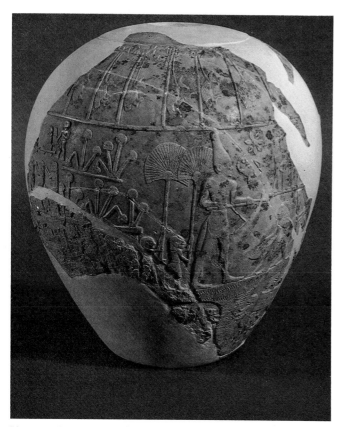

Limestone Scorpion mace-head from Hierakonpolis height 23cm (9in). Ashmolean Museum, Oxford

Ceremonial reliefs of the Old and Middle Kingdoms, though rare and fragmentary, show that the traditions of relative size were consistently followed. In the New Kingdom the emphasis was on the king as a victorious leader of armies or as a mighty hunter. Great scenes in relief on the gates and walls of temples show him in his chariot galloping across mounds of the bodies of his enemies, or leading his personal guard to hunt in the desert. Similar scenes on a smaller scale appear as decorations on the painted casket found in the tomb of Tutankhamun, c1340 BC (Egyptian Museum, Cairo).

Members of the king's family, and later other nobles and officials, gradually adopted customs and rituals that had originally been the prerogative of the king. By the end of the 5th Dynasty the walls of tombs of nobles of the Old Kingdom at Saqqara, Gizeh, and elsewhere were covered with scenes depicting life on their estates, with the magical aim of ensuring it would go on forever. The lord—hunting, fishing, or presiding at the counting of cattle and supervising work in the fields— was shown, like the king, as larger than any of his servants or the rest of his family.

This tradition of differentiation by size was often followed by sculptors portraying husbands and wives. Whether standing or seated, quite ordinary officials were shown up to three times as large as their wives. The limestone statuette of Sekhem-ka, c2400 BC (Central Museum, Northampton), shows him seated with his wife beside him, her legs tucked

gracefully beneath her. She touches his right leg in a gesture of affection, but her head only just reaches the level of his knee. The offering-bearers carved in relief on the sides of the block seat are even smaller.

Egyptian artists and craftsmen. The men who carved sculptures and reliefs and painted the walls of rock-cut tombs were not artists in the modern sense in which an artist is supposed to be a creative individual. The approach of the ancient Egyptians was essentially practical, and their art was rather the work of paid artisans who were trained and who then worked

Limestone statuette of Sekhem-ka; height 75cm (30in); c2400 BC. Central Museum, Northampton

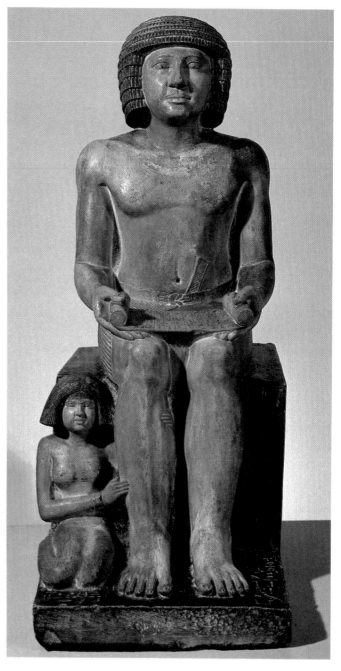

as part of a team. The master craftsman might be very versatile, and capable of working in many branches of art, but his part in the production of a statue or the decoration of a tomb was anonymous. He would certainly guide his assistants as they worked, and help to train beginners, but his personal contribution cannot be assessed.

Men at all stages of their craft worked together. The initial outline drawing would be executed by one or more, who would then be followed by others carving the intermediate and final stages. Painters would follow in the same manner. Where scenes have been left unfinished it is possible to see the corrections made to the work of less-skilled hands by more practised craftsmen.

Many master craftsmen reached positions of influence and social importance, as we know from their own funerary monuments. Imhotep, the architect who built the Step Pyramid complex for King Zoser, 2660–2590 BC, was so highly revered in later times that he was deified. The credit for any work of art, however, was believed to belong to the patron who had commissioned it.

Carving in relief and painting. Carving in relief and painting may be considered together as the conventions followed by craftsmen of one or the other were, at least in the initial stages of a work, very similar, and most reliefs were intended to be completed by the addition of color.

The earliest incised figures and scenes in relief date from prehistoric times when slate cosmetic palettes and combs of wood, bone, and ivory were buried in the graves of their owners. These were carved in the simple, effective outlines of species familiar to the people of the Nile Valley—antelopes, ibex, fish, and birds. More elaborate ivory combs and the ivory handles of flint knives which probably had some ceremonial purpose were carved in relief, the scene standing out from its background.

On the so-called Carnarvon knife handle, *c*3400 BC (Metropolitan Museum, New York), 10 species of wild animals are grouped around a boss, decorated with a rosette, in a way that suggests the representation of a naturalistic desert scene. On other fragments where animals occur they are arranged more formally in rows. Sometimes unusual themes occur, such as the hero figure shown between two lions on the Gebel el-Arak knife handle, of similar date, which seems to indicate Mesopotamian influence (Louvre, Paris).

By the end of the prehistoric period the distinctive Egyptian style is unmistakable. So far there were no great architectural monuments on which the skill of the sculptors could be displayed. From the meager evidence of a few carvings on fragments of bone and ivory we know that the gods were worshiped in shrines constructed of bundles of reeds. The chieftains of prehistoric Egypt probably lived in similar structures, very like the *mudhifs* still found in the marshes of South Arabia.

The work of sculptors was displayed in the production of ceremonial mace-heads and palettes, carved to commemorate

The relief decoration on a panel from the tomb of Hesire at Saqqara

An ivory fragment showing a prehistoric shrine. Merseyside County Museums, Liverpool

victories and other important events and dedicated to the gods. They show that the distinctive sculptural style, echoed in all later periods of Egyptian history, had already emerged, and the convention of showing the human figure partly in profile and partly in frontal view was well-established. The significance of many details cannot yet be fully explained, but representations of the king as a powerful lion or a strong bull are often repeated in Dynastic times.

Early royal reliefs, showing the king smiting his enemies or striding forward in ritual pose, are somewhat stiff and stilted, but by the 3rd Dynasty techniques were already very advanced. Most surviving examples are in stone, but the 11 wooden panels found in the tomb of Hesire at Saqqara, 2660–2590 BC, show the excellence achieved by master craftsmen (Egyptian Museum, Cairo). These figures, standing and seated, carved according to the conventions of Egyptian ideals of manhood, emphasized in different ways the different elements of the human form. The head, chest, and legs are shown in profile, but the visible eye and the shoulders are depicted as if seen from the front, and the waist and hips are in three-quarter view. However, this artificial pose does not look awkward because of the preservation of natural proportion. The excellence of the technique, shown in the fine modeling of the muscles of face and body, bestows a grace upon what might otherwise seem rigid and severe.

Hesire, carrying the staff and scepter of his rank and the palette and pen case symbolizing his office of royal scribe, gazes proudly and confidently into eternity. The care of the craftsman does not stop with the figure of his patron, for the hieroglyphs making up the inscription giving the name and titles of the deceased are also carved with delicacy and assurance, and are fine representations in miniature of the animals, birds, and objects used in ancient Egyptian writing. The ani-

mals and birds used as hieroglyphs are shown in true profile.

The great cemeteries of Gizeh and Saqqara in which the nobles and court officials were buried near their kings provide many examples of the skill of the craftsmen of the 4th, 5th, and 6th Dynasties, a skill rarely equaled in later periods. The focus of the early tombs was a slab of stone carved with a representation of the deceased sitting in front of a table of offerings. These funerary stelae were usually placed above the false door, through which the spirit of the dead person, called the *ka*, might continue to enter and leave the tomb. The idea behind this was that the magical representation of offerings on the stelae, activated by the correct religious formulas, would exist for the rest of eternity, together with the *ka* of the person to whom they were made.

The stela of the Princess Nefertiabtet, *c*2550 BC (Louvre, Paris), from her 4th-Dynasty tomb at Gizeh, is not, perhaps, technically as fine a piece of carving as the panels of Hesire. The original color, however, is excellently preserved, and shows how these stelae were intended to appear, with the carving providing a raised foundation for the brightness of the

painted detail that brings the stone to life. The king's daughter is seated on a chair with bulls' legs in front of her offering table. Her simple, closely fitting garment is of leopard skin, and she has ornamental bands at throat, wrists, and ankles. Her name is inscribed above her head, and the hieroglyphs listing the items of food, drink, oils, and linen needed for eternity are delicately outlined, spaced, and colored, while the whole scene is neatly enclosed within a painted border. As in the scenes arranged on the walls of Old Kingdom tombs, and all tomb and temple scenes of later periods, the Egyptian artist kept his characters inside the framework designed for them.

In single scenes, or in registers filling a wall from ceiling to floor, every figure had its proper place and was not permitted to overflow its allotted space. One of the most notable achievements of Egyptian craftsmen was the way they filled the space available in a natural, balanced way, so that scenes full of life never seem to be cramped or overcrowded.

The horizontal sequences or registers of scenes arranged on either side of the funerary stelae and false doors in 5th- and 6th-Dynasty tombs are full of lively and natural detail. Here

The Stela of the Princess Nefertiabtet from her 4th-Dynasty tomb at Gizeh; *c*2550 BC. Louvre, Paris

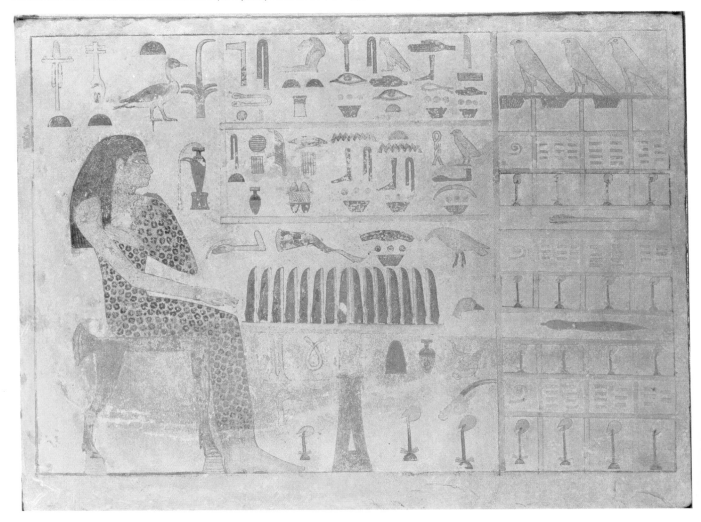

the daily life of peasant and noble was caught for eternity by the craftsman—the action of herdsman and fisherman frozen in mid-step, so that the owner of the tomb would always be surrounded by the daily bustle of his estate. The subjects were intended to be typical of normal events, familiar scenes rather than special occasions.

Egyptian craftsmen did not employ perspective to suggest depth and distance, but they did establish a convention whereby several registers, each with its own base line, could be used to depict a crowd of people. Those in the lowest register were understood to be nearest to the viewer, those in the highest furthest away. A number of these scenes occur in the Old Kingdom: many offering-bearers bring the produce of their estates to a deceased noble at his funerary table, for instance, or troops of men are shown hauling a great statue. Statues represented in reliefs, like the hieroglyphs, are shown in true profile, in contrast to the figures of the men hauling them. Perhaps the best-known scenes showing nearness and distance, however, are the painted banqueting scenes of the New Kingdom, where the numerous guests, dressed in their finest clothes, sit in serried ranks in front of their hosts.

The registers could also be used to present various stages in a developing sequence of action, rather like the frames of a strip cartoon. In the Old Kingdom, the important events of the agricultural year follow each other across the walls of many tombs: plowing, sowing, harvesting, and threshing the grain are all faithfully represented. The herdsmen are shown at work in the pastures caring for the cattle so prized by the ancient Egyptians, while other scenes depict the trapping of waterfowl in the Nile marshes and fishing in the river itself. Other domestic activities, such as baking and brewing, also vital to the eternal existence of the dead noble are represented; other scenes show carpenters, potters, and jewelers at work.

It was in these scenes of everyday life that the sculptor was able to use his initiative, and free himself to some extent from the ties of convention. The dead man and his family had to be presented in ritual poses as described—larger than life, strictly proportioned, and always calm and somewhat aloof. The workers on the estates, however, could be shown at their daily tasks in a more relaxed manner, capturing something of the liveliness and energy that must have characterized the ancient Egyptians. While the offering-bearers, symbolizing the funerary gifts from the estates to their lord, are depicted moving towards him in formal and stately procession, the peasants at work in the fields seem both sturdy and vigorous. They lean to the plough and beat the asses, tend the cattle and carry small calves on their shoulders clear of the danger of crocodiles lurking in the marshes. Boatmen fight in sport among themselves, as in the tomb of Ptah-hotep, c2400 BC. Many scenes have titles in well-carved hieroglyphs that are an integral part of the action, and the comments of the workers themselves, not always polite, are also inscribed above them.

There are some excellent scenes showing work in the fields in the tomb of Mereruka, c2350 BC, who is depicted watching the harvesting of flax and corn (in situ; copies in Oriental

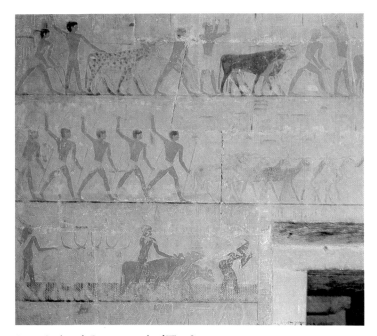

Scenes in the 5th-Dynasty tomb of Ti at Saqqara, 2470–2310 BC

Museum, Chicago). The sheaves are being loaded into panniers carried by asses, while on the threshing floor the corn is tossed by men with pitchforks, and trodden out by groups of goats, asses, and oxen. Comments such as "Hurry up" and "The barley is very fine" are included.

The decoration of many tombs survives in fragmentary condition, but some, like the tomb of Mereruka, are famous for the quality and quantity of the scenes that remain. Another fine example is the 5th-Dynasty tomb of Ti, 2470–2320 BC, also at Saqqara. The marsh scenes in this tomb are among the most vivid of all Egyptian reliefs. The herdsmen are shown urging their cattle through the water. One cow bends her neck to taste a clump of grass, while another raises her head to call to a calf, carried by a herdsman, which turns to look at her. The men themselves are not quite so successfully carved. The right shoulder of one, towards the viewer, supposed to be bent with the effort of carrying a water bottle on a staff, appears hunched and unnatural because the sculptor has not kept to the traditional frontal view of the shoulders. The man carrying the calf, however, is well done. He bends forward under the weight, and his receding hair shows he is old. Further naturalism is added by the clever combination of carved relief and painting. The carving of the legs stops at the surface of the water which is indicated by vertical zigzags, and the effect of the legs of men and animals being visible under water is achieved by painting them across the ripples.

The natural details used to fill odd corners in these tomb scenes show how much pleasure the ancient Egyptian craftsmen took in observing their environment. Birds, insects, and clumps of plants were all used to balance and complete the picture. The results of sharp-eyed observation can be seen in the details that distinguish the species of birds and fish throng-

ing the reeds and shallow water of the marshes.

Little survives of the reliefs that decorated the royal temples of the early 5th Dynasty, but from the funerary temple of the first king, Userkaf, *c*2460 BC, comes a fragment from a scene of hunting in the marshes (Egyptian Museum, Cairo). The air above the graceful heads of the papyrus reeds is alive with birds, and the delicate carving makes them easily distinguishable even without the addition of color. A hoopoe, ibis, kingfisher, and heron are unmistakable, and a large butterfly hovering above provides the final touch.

From fragments it has been possible to reconstruct the great hunting scene carved on the wall of the sun temple built by Userkaf's successor Sahure at Abusir. This scene is particularly interesting because for once the sculptors did not keep to the convention of parallel registers. The base lines are there, but they undulate and give an impression of desert landscape. Hunting dogs pursue many different species of antelope and gazelle, or wait to seize newly born antelope. The larger animals are beautifully outlined, but the smaller animals again provide the finishing touches: hedgehogs, jerboas, and desert hares crouch among the tussocks of grass, or scuttle across the open areas of sand.

The tradition of finely detailed decoration in low relief, the figures standing out slightly above the background, continued through the 6th Dynasty and into the Middle Kingdom, when it was particularly used for royal monuments. Few fragments of these remain, but the hieroglyphs carved on the little chapel of Sesostris I, now reconstructed at Karnak, show the sure and delicate touch of master craftsmen.

During the late Old Kingdom, low relief was combined with other techniques such as incision, in which lines were

Limestone funerary Stela of Ne-ankhteti; 84×66cm (33×26in); c2250 BC. Merseyside County Museums, Liverpool

Stela of Hotep; height 95cm (37in); 2000–1800 BC. Merseyside County Museums, Liverpool

simply cut into the stone, especially in non-royal monuments, and the result is often artistically very pleasing. The limestone funerary stela of Ne-ankhteti, *c*2250 BC, is a fine example (Merseyside County Museums, Liverpool). The major part of the stela, the figure and the horizontal inscription above it, is in low relief, but an incised vertical panel of hieroglyphs repeats his name with another title, and the symbol for scribe, the palette and pen, needed for the beginning of both lines, is used only once, at the point at which the lines intersect. The result is a perfectly balanced design, and a welcome variation in the types of stelae carved during the Old Kingdom.

A further development is shown in the stela of Hotep, carved during the Middle Kingdom, 2000–1800 BC (Merseyside County Museums, Liverpool). The figures of three standing officials and the hieroglyphic signs have been crisply incised into the hard red granite. Originally the signs and figures would have been filled with blue pigment, to contrast sharply with the polished red surface of the stone. (Incidentally, the inscription is an excellent example of the standard prayer for funerary offerings, the *hotep-di-nsw* formula, in its classic Middle Kingdom form. Hieroglyphs are read towards

the front of the animal and bird signs, here from right to left, and this inscription begins: "A gift which the King gives to Osiris, Lord of Busiris, the good god, Lord of Abydos, that he may give invocation offerings of bread and beer, oxen and fowl, alabaster and clothing, and every good and pure thing on which a god lives, to the revered superintendant of the palace, Hotep, born of the Lady Khnumhotep", and more genealogy follows. In this inscription the hieroglyphs are in outline, and are not shown in the exact detail of some of the inscriptions already mentioned, but here again the sense of space and balance that seems to have been so natural to the ancient Egyptians is very much in evidence.)

During the Middle Kingdom the use of sunk relief came into fashion, and in the 18th and early 19th Dynasties it was employed to great effect. The background was not cut away as in low relief to leave the figures standing above the level of the rest of the surface. Instead the relief design was cut down into the smoothed surface of the stone. In the strong Egyptian sunlight the carved detail would stand out well, but the sunk relief was better protected from the weather and was therefore more durable.

Some of the finest 18th-Dynasty scenes in low relief decorate the mortuary temple of Queen Hatshepsut, 1490–1470 BC, at Deir el-Bahri, where the delicate carving is complemented by the colors that give light and beauty to the elaborate scenes. Hatshepsut, needing to underline her claim to the Egyptian throne, had the traditional scenes of daily life supplemented for the first time in Egyptian history by scenes depicting actual events. On the north side of the central terrace is the divine conception and birth of the queen, while the south side is devoted to the story of the expedition that she

Queen Hatshepsut drinks from the udder of the cow goddess Hathor in her mortuary temple at Deir el-Bahri

sent to fetch incense trees from the land of Punt. The ships commissioned by the queen are carved with loving care, while the artists surpassed themselves in the details of Punt itself. Native huts, various species of plants and animals, and the people themselves, are all represented with great accuracy, particularly the Princess of Punt with her lined face and bulky body.

Similar delight in natural detail is shown in the scenes carved in a room of the temple of Tuthmosis III at Karnak, c1470–1450 BC. Here the animals and plants brought back to Egypt after the king's campaign are depicted, and the result is gay and joyful. In the more public halls of this and other great temples scenes showing the successful campaigns of victorious New Kingdom rulers were designed as propaganda, with the aim of emphasizing the all-powerful nature of the kings of Egypt. Delicacy frequently gives way to the need for bold, eye-catching detail, especially during the 19th Dynasty. Later, however, many Ptolemaic reliefs are characterized by the subtle modeling of the rather fleshy features of royalty and gods alike.

Painting in ancient Egypt followed a similar pattern to the development of scenes in carved relief, and the two techniques were often combined. The first examples of painting occur in the prehistoric period, in the patterns and scenes on pottery already mentioned. We depend very much for our evidence on what has survived, and fragments are necessarily few because of the fragile nature of the medium. Parts of two scenes depicting figures and boats are known, one on linen and one on a tomb wall. Panels of brightly colored patterns survive on the walls of royal tombs of the 1st Dynasty, the patterns representing the mats and woven hangings that decorated the walls of large houses. These patterns occur again and again throughout Egyptian history in many different ways. Some of the finest may be seen on the sides of the rectangular wooden coffins found in the tombs of Middle Kingdom nobles at Beni Hasan and elsewhere, c2000–1800 BC.

The earliest representational paintings in the unmistakable traditional Egyptian style date from the 3rd and 4th Dynasties. The most famous are probably the fragments from the tomb of Itet at Medum, c2725 BC, showing groups of geese which formed part of a large scene of fowling in the marshes (Egyptian Museum, Cairo). The geese, of several different species, stand rather stiffly among clumps of stylized vegetation, but the markings are carefully picked out, and the colors are natural and subtle.

Throughout the Old Kingdom, paint was used to decorate and finish limestone reliefs, but during the 6th Dynasty painted scenes began to supersede relief in private tombs for economic reasons. It was less expensive to commission scenes painted directly on walls of tombs, although their magic was just as effective.

During the First Intermediate Period and the Middle Kingdom, the rectangular wooden coffins of nobles were often painted with elaborate care, turning them into real houses for the spirits of the dead. Their exteriors bore inscriptions giving

Wooden Models from the Tombs

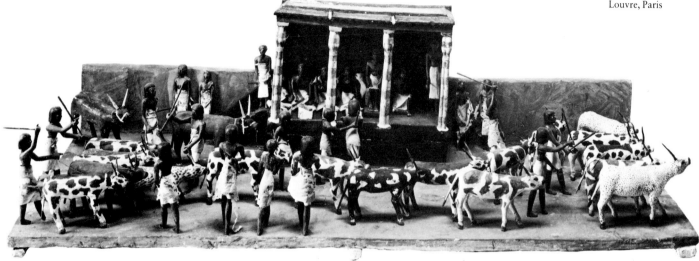

The cattle census from the tomb of Meket-Re. Louvre, Paris

The tombs of Egyptian nobles and officials have yielded a rich variety of objects, but none more valuable to the archaeologist than the small, wooden models showing scenes of daily life which were packed into the tomb chamber around the coffin. Most of these were made between 2000 and 1750 BC for the magical purpose of ensuring that life after death would incorporate all earthly necessities and comforts. So the models depict every aspect of life on the great man's estates.

In general they do not exhibit a high degree of skill in carving and construction, the average model consisting of painted peg-doll figures (parts of which are often missing) crudely mounted on a wooden base about 16 in (40 cm) square. However, this very roughness contributes to an impression of vitality, and many people find them charming and attractive. Traditional artistic conventions are respected as far as possible, the men-servants painted reddish-brown, the women yellow or cream, all with exaggeratedly large eyes. A tendency towards realism is shown in such details as the wisps of actual linen tied over the painted garments, and it is this quality of verisimilitude that makes them so fascinating. Through them we can build up a detailed picture of daily life in Egypt 4,000 years ago.

A particularly fine example is a model from the Theban tomb of the Chancellor Meket-Re showing the annual cattle census. The noble sits under a shady canopy with his sons, while scribes record the count as herdsmen drive the beasts past. Scribes also feature in the granaries, which are a favorite subject of the model-makers, and are shown recording the number of sacks carried up by laborers to be emptied into the grain bins. Other models represent the work done in the fields, with men hoeing and teams of oxen plowing.

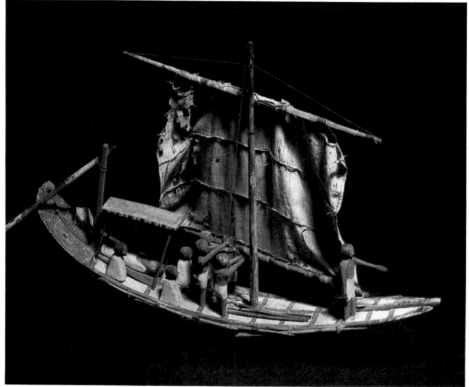

▲ A sailing boat from Beni Hasan. Ashmolean Museum, Oxford

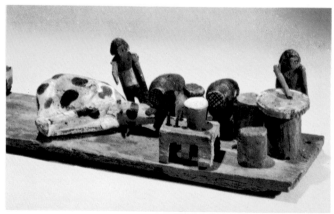

◀ A baker and a butcher. Merseyside County Museums, Liverpool

But the whole range of jobs involved in the running of a busy estate is depicted in three-dimensional fullness. Kitchen models show women engaged in all stages of bread-making, grinding, kneading, and baking, side by side with men making beer, straining the mash from fermented barley bread into beer vats, while trussed oxen lie ready at the butchers' feet. Great quantities of linen were required by a large household, and we can watch some women spinning and winding the thread, while others weave cloth on horizontal looms. Sometimes these are merely painted on the base of the scene, but sometimes the looms and all their fittings have been carefully modeled. Other sources may tell us that the estate carpenters were highly skilled men who furnished the noble's house on earth and provided much of his funerary equipment, including the all-important coffin to house him for eternity, but the models give us an insight into how they worked: sawing planks from logs lashed to vertical posts, and wielding their mallets and chisels and adzes.

Boat models emphasize, by the frequency of their occurrence, the importance of the Nile in Egyptian life, and illustrate the different types of craft: large cargo boats with oars for rowing downstream, and detachable masts which were erected for sailing upstream; passenger boats with hide-covered cabins for important passengers and kitchen boats following to supply creature comforts; lighter vessels made of bundles of papyrus reeds lashed together. These included the craft the nobles used for pleasure—pleasure which was continued after death by the inclusion of the models in the tombs.

For all these models were made for the benefit of great men who dominated their fellows during earthly life, and who dominate our view of their civilization because of the attention paid to their afterlives in the form of funerary furnishings. Not the least value of the wooden models is the glimpses they give of the everyday existence of ordinary laborers and artisans in ancient Egypt.

DOROTHY DOWNES

Further reading. James, T.G.H. *The Archaeology of Ancient Egypt*, London (1972). Jordan, P. *Egypt, the Black Land*, Oxford (1976). Winlock, H.E. *Models of Daily Life in Ancient Egypt*, Cambridge, Mass. (1955).

▶ A private boat showing rowers and the owner from Deir el-Bahri. Egyptian Museum, Cairo

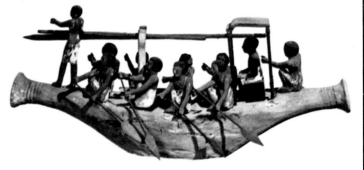

▼ Estate Carpenters from the tomb of Meket-Re. Egyptian Museum, Cairo

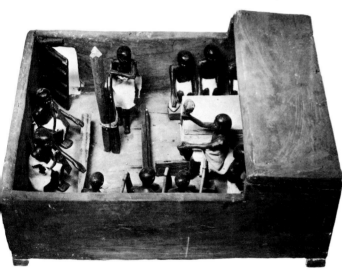

Below left A granary. Ashmolean Museum, Oxford

▼ Nubian soldiers march to war. Egyptian Museum, Cairo

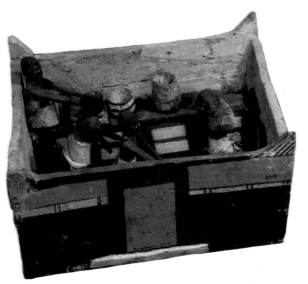

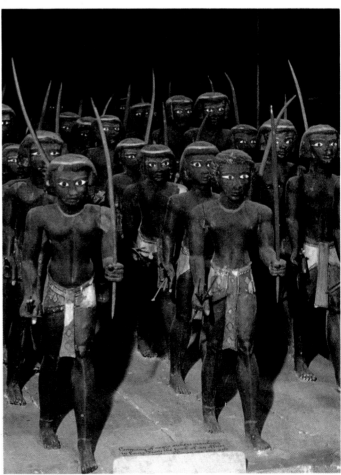

the names and titles of their owners, and invoking the protection of various gods. The remaining surface areas were covered with brightly painted panels imitating the walls of houses hung with woven mats, and incorporating windows and doors in complicated geometric patterns. Great attention was paid to the "false door" situated at the head end of the coffin through which the *ka* would be able to enter and leave as it pleased. This panel always included the two sacred eyes of the falcon sky-god Horus, which would enable the dead to look out into the living world.

The interior surfaces of the coffins were sometimes painted with the offerings made to the dead, ensuring that these would continue in the afterlife. An offering table piled with bread, meat, and vegetables was the central feature. A list of ritual offerings was also important, and personal possessions such as weapons, staffs of office, pottery and stone vessels, and items of clothing were all shown in detail. Headcloths were painted at the head end, and spare pairs of sandals at the feet.

These coffins were placed in the small rock-cut chambers of Upper Egyptian tombs, where the stone is often too rough or crumbly to provide a good surface for painting. Fragments of painted murals do survive, however, and some tombs have lively scenes of hunting in the desert or of agricultural work. Acute observation also produced unusual subjects such as men wrestling or boys playing games, shown in sequence like a series of stills from a moving film. Others are painted with outstanding skill. Part of a marsh scene in a tomb at Beni Hasan, *c*1800 BC, shows a group of birds in an acacia tree. The frond-like leaves of the tree are delicately painted, and the birds, three shrikes, a hoopoe, and a redstart, are easily identifiable.

Tomb painting really came into its own, however, during the New Kingdom, particularly in the tombs of the great necropolis at Thebes. Here the limestone was generally too poor and flaky for relief carving, but the surface could be plastered to provide a ground for the painter. As always, the traditional

The "false door" at the head end of the coffin of Keki. Merseyside County Museums, Liverpool

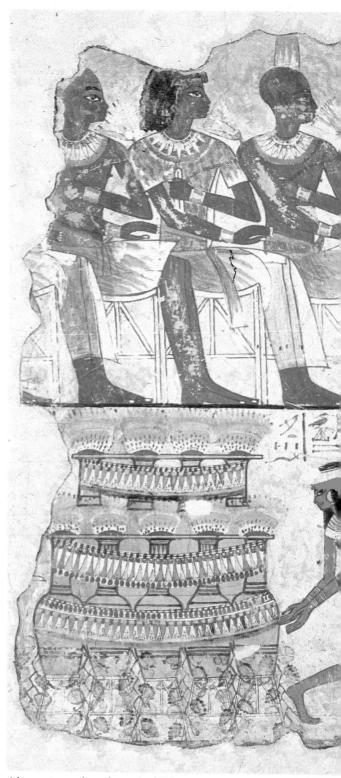

A banquet scene from the tomb of Nebamun; *c*1400 BC. British Museum, London

conventions were observed, particularly in the formal scenes depicting the dead man where he appears larger than his family and companions. Like the men who carved the Old Kingdom reliefs, however, the painters could use their imaginations for the minor details that filled in the larger scenes. Birds and animals in the marshes, usually depicted in profile, have their markings carefully hatched in, giving an impression of real fur and feathers; and their actions are sometimes very realistic. In the tomb of Nebamun, *c*1400 BC, a hunting cat,

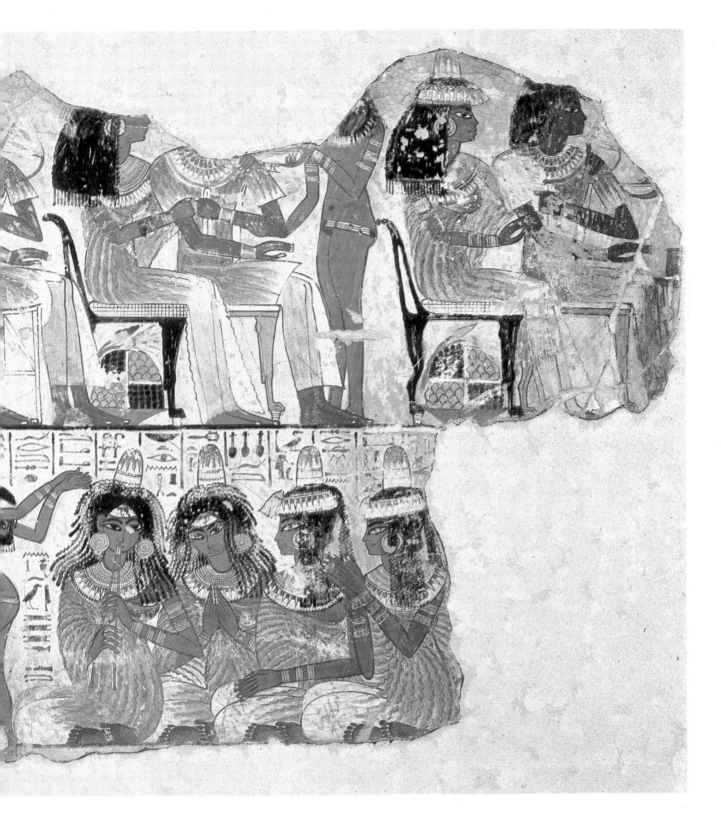

already grasping birds in its claws, leaps to seize a duck in its mouth.

Fragments illustrating a banquet from the same tomb give the impression that the painter not only had outstanding skill but a particular delight in experimenting with unusual detail. The noble guests sit in formal rows, but the servants and entertainers were not so important and did not have to conform in the same way. Groups of female musicians kneel gracefully on the floor, the soles of their feet turned towards the viewer, while two in one group are shown almost full-face, which is very rare. The lightness and gaiety of the music is conveyed by their inclined heads and the apparent movement of the tiny braids of their elaborately plaited hair. Lively movement continues with the pair of young dancers, shown in profile, whose clapping hands and flying feet are depicted with great sensitivity. A further unusual feature is the shading of the soles of the musicians' feet and pleated robes.

Painting not only decorated the walls of New Kingdom

tombs, but gave great beauty to the houses and palaces of the living. Frescoes of reeds, water, birds, and animals enhanced the walls, ceilings, and floors of the palaces of Amarna and elsewhere; but after the 19th Dynasty there was a steady decline in the quality of such painting. On a smaller scale, painting on papyrus, furniture, and wooden coffins continued to be skillful until the latest periods of Egyptian history, though there was also much poor-quality mass-produced work.

Techniques of relief and painting. Before any carving in relief or painting could be done the ground, whether stone or wood, had to be prepared. If the surface was good, smoothing was often enough, but any flaws had to be masked with plaster. During the New Kingdom, whole walls were plastered, and sometimes reliefs of exquisite detail were carved in the plaster itself. Usually mud plaster was used, coated with a thin layer of fine gypsum.

The next stage was the drafting, and the scenes were sketched in, often in red, using a brush or a scribe's reed pen. This phase was important, particularly when a complicated scene with many figures was planned, or when a whole wall was to be covered with scenes arranged in horizontal registers. Some craftsmen were confident enough to be able to use freehand, but more often intersecting horizontal and vertical lines were used as a guide. These could be ruled, or made by tightly holding the ends of a string dipped in pigment, and twanging it across the surface. Quite early in Egyptian history the proportions of the grid were fixed to ensure that human figures were drawn according to the fixed canon. Since the decoration in some tombs was never finished, the grid lines

A limestone fragment with a figure of Tuthmosis I; height 36cm (14in); 1530–1520 BC. Merseyside County Museums, Liverpool

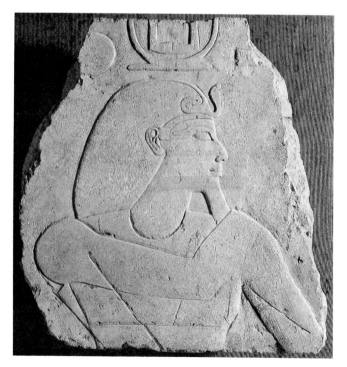

and sketches can be clearly seen, together with corrections made by master craftsmen.

The next stage in producing a relief was to chisel round the correct outlines and reduce the surrounding level, until the scene consisted of a series of flat shapes standing against the background in low relief. Then the final details could be carved and the surface smoothed ready for painting. Any corrections and alterations made to the carving could be hidden beneath a coat of plaster before the paint was applied. A limestone fragment with a figure of Tuthmosis I, 1530–1520 BC, now bare of plaster and paint, shows a change in the position of the arms which would not have been visible when the relief was finished (Merseyside County Museums, Liverpool).

A number of finely decorated tombs were left with the carving finished but unpainted on the death of the owner. Scenes in the tomb of Ramose at Thebes, c1400 BC, show the guests at his banquet, seated in pairs in front of their host. The painting of the scene never progressed beyond the eyes, and the skilful modeling of the elaborately plaited wigs and finely pleated linen robes can be examined in detail. The carving is sophisticated and beautifully finished, although the warmth and vigor evident in Old Kingdom reliefs seem to be missing.

The painter working directly to a draft on a flat surface, or coloring a relief, began with the background. This was filled in with one color, gray, white, or yellow, using a brush made of a straight twig or reed with the fibers teased out. The larger areas of human figures were painted next, the skin color applied, and the linen garments painted. Precise details, such as the markings of animals and birds or the petalled tiers of an ornamental collar, were finished with a finer brush or a pen.

The pigments were prepared from natural substances such as red and yellow ocher, powdered malachite, carbon black, and gypsum. From about six basic colors it was possible to mix many intermediate shades. The medium was water to which gum was sometimes added, and the paint was applied in areas of flat color. During the New Kingdom delicate effects were achieved by using tiny strokes of the brush or pen to pick out animal fur or the fluffy heads of papyrus reeds. Shading was rarely used until the mid 18th Dynasty, when it was employed, particularly in crowd scenes, to suggest the fine pleating of linen garments. The figure of Nefertari, Queen of Ramesses II, 1301–1235 BC, in her tomb at Thebes, is carved in plaster. The relief is most delicately painted, the face in an unusual shade of light pink. The subtlety of the painting is enhanced by shading, particularly on the face and neck.

The comparative freedom felt by painters when dealing with subsidiary figures has already been mentioned. Close examination of groups of figures, particularly in tomb scenes, is often rewarding because tiny details are not always easy to see. Figures in a group may at first appear to be exactly alike, but slight variations in the positions of arms and head give individuality to each, while the faces of female mourners, for instance, are finished with the marks of tears.

Sketches made by painters on flakes of limestone, mostly dating from the New Kingdom, show that when they drew for

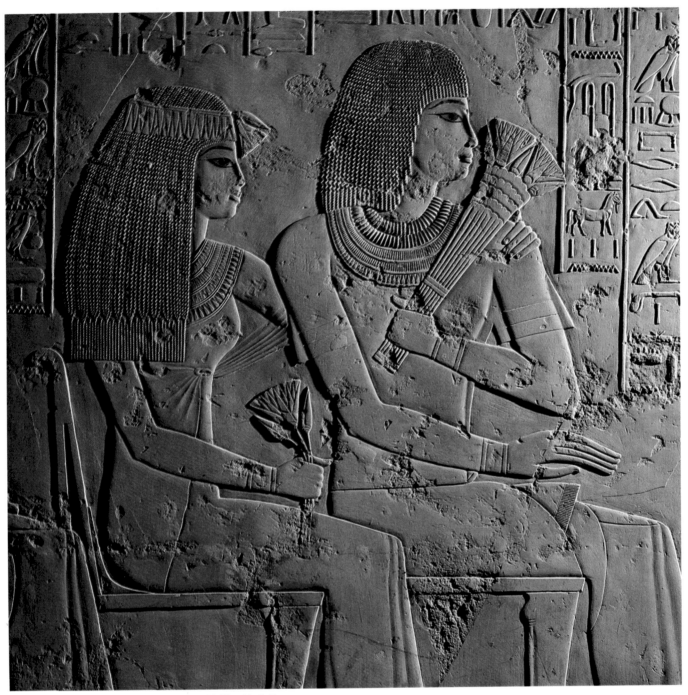

In the tomb of Ramose at Thebes: Ramose with his wife (left); c 1400 BC

their own pleasure they were unfettered by convention. Some are painted and finely finished, such as the figure of an acrobatic dancing girl bending backwards with her hair trailing on the floor (Museo Egizio, Turin). Others are simply quick sketches catching their subjects in the middle of an action; a girl painting her lips or a man riding.

Sculpture in the round. Egyptian craftsmen were producing a wide variety of small figures in clay, bone, and ivory, well before the emergence of a formal style of sculpture at the time of the unification of the Two Lands of Egypt. A few, fragile figurines have been found in prehistoric graves. The tradition

Right: A New Kingdom sketch of an acrobatic dancing girl.
Museo Egizio, Turin

of making such objects survived right down to the New Kingdom. Bone and ivory were used to make stylized female figures of elaborate workmanship between 4000 and 3000 BC. Clay, which was easier to shape, was molded into representations of many species of animals, easy to identify because their characteristics have been captured by acute observation.

By c3000 BC ivory statuettes were being carved in a more naturalistic style, and many fragments have survived. One of the finest and most complete was found at Abydos, representing an unknown king, depicted in ceremonial costume (British Museum, London). He is wearing the tall White Crown of Upper Egypt and the short cloak associated with the *heb sed* or Jubilee ceremonies, here patterned with lozenges. He strides confidently forward in the pose used for all male standing statues in Dynastic times, left foot in front of right. The quality of the carving is shown in the way in which the robe is wrapped tightly across the rounded shoulders, and the head is thrust forward with determination and strength of purpose.

From this period, just preceding the 1st Dynasty, there is evidence that sculptors were making great advances, and were using wood, and stone of various kinds. This development continued through the Archaic Period, when the first larger royal statues were made. Work in metal also made progress; miniature copper statuettes and gold amulets have been found in tombs, while an inscription of the 2nd Dynasty records the

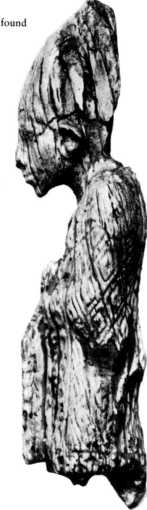

An ivory statuette of an unknown king, found at Abydos; ivory; height 9cm (3½in). British Museum, London

making of a royal statue in copper.

Much more evidence, of course, survives to show the development of sculpture in stone. It was in the late 2nd and early 3rd Dynasties, from about 2700 BC, that what could be termed the characteristic ancient-Egyptian style of sculpture in stone was established, a style transmitted through some 2,500 years to the Ptolemaic period with only minor exceptions and modifications. The predominant features of this style are the regularity and symmetry of the figures, solid and four-square whether standing or seated. Michelangelo is reputed to have believed that a block of stone contained a sculpture, as it were in embryo, which it was the artist's task to reveal. The typical ancient-Egyptian completed figure gives a strong impression of the block of stone from which it was carved. The artists removed an absolute minimum of raw stone, commonly leaving the legs fused in a solid mass to a back pillar, the arms attached to the sides of the body, while seated figures were welded to their chairs. Not that these sculptures seem clumsy or crude; they convey an impression of severe elegance, a purity of line that suggests by its tautness a restrained energy.

The first stages in the making of a statue, as with relief and painting, involved the drafting of a preliminary sketch. A block of stone was roughly shaped, and the figure to be carved was drawn on at least two sides to give the front and side views. Guidelines, and, later, a squared grid ensured that the proportions of the statue would be made exactly according to the rules fixed early in Dynastic times. Master-drawings, some of which have survived, were available for reference. A wooden drawing board with a coat of gesso, now in the British Museum, London, is a good example. A seated figure of Tuthmosis III, 1504–1450 BC, first sketched in red and then outlined in black, has been drawn across a grid of finely ruled small squares. Master craftsmen after years of practice would be able to work instinctively, but inexperienced sculptors would keep such drawings at hand for easy reference.

The actual carving of a statue involved the sheer hard work of pounding and chipping the block on all sides until the rough outline of the figure was complete. New guidelines were drawn in, when it became necessary to keep the implements cutting squarely into the block from all sides. The harder stones, such as granite and diorite, were worked by bruising and pounding with hard hammer-stones, thus gradually abrading the parent block. Cutting by means of metal saws and drills, helped by the addition of an abrasive such as quartz sand, was used to work the awkward angles between the arms and the body, or between the lower legs. Each stage was long and tedious, and the copper and, later, bronze tools had to be resharpened constantly. Polishing removed most of the toolmarks, but on some statues, particularly the really large ones such as the huge figures of Ramesses II at the temple of Abu Simbel, traces of the marks made by tubular drills can still be seen. For a colossal statue, scaffolding was erected round a figure, enabling many men to work on it at once. Limestone, of course, was softer, and therefore easier to work with chisels and drills.

Unfinished statues provide useful evidence of the processes involved. Most of them showed that work proceeded evenly from all sides, thus maintaining the balance of the figure. A quartzite head, possibly of Queen Nefertiti, found in a workshop at Amarna, c1360 BC, is obviously near to completion (Egyptian Museum, Cairo). It was probably intended to be part of a composite statue, and the top of the head has been shaped and left rough to take a crown or wig of another material. The surface of the face appears to be ready for the final smoothing and painting, but the guidelines are still there to indicate the line of the hair and the median plane of the face. Rather thicker lines marking the outline of the eyes and the eyebrows make it look as if further work was planned, to cut these out to enable them to be inlaid with other stones so that the head would be really lifelike when it was finished.

Egyptian statuary was made to be placed in tombs or temples and was usually intended to be seen from the front. It was important that the face should look straight ahead, into eternity, and that the body viewed from the front should be vertical and rigid, with all the planes intersecting at right angles. Sometimes variations do occur; large statues for instance were made to look slightly downwards towards the spectator, but examples where the body is made to bend or the head to turn are very rare in formal sculpture. The four little goddesses who protect the canopic chest of Tutankhamun with outstretched arms, their heads slightly turned to the left, are among the most delightful of such exceptions.

It is usually accepted that the finest craftsmen worked for the king, and set the patterns followed by others who produced sculpture in stone, wood, and metal for his subjects throughout Egypt. The Old and Middle Kingdoms in particular saw the production of many statues and small figures that were placed in the tombs of quite ordinary people to act as substitutes for the body if it should be destroyed, to provide an eternal abode for the *ka*. Quality was desirable, but was not particularly important, for as long as the statue was inscribed with the name of the dead person it was identified with him. In fact it was possible to take over a statue by simply altering the inscription and substituting another name. This was done even at the highest level, and kings often usurped statues commissioned by earlier rulers. It was also believed to be possible to destroy the memory of a hated or feared predecessor by hacking the names and titles from his monuments. This happened to many of the statues of Akhenaten, and the names of Hatshepsut were erased by Tuthmosis III.

Most of the *ka* statues found in the tombs of nobles of the Old Kingdom follow royal precedent. Royal tombs at Gizeh and Saqqara were surrounded by cities of the dead, as the officials sought to be buried near their king and to pass into eternity with him. Gradually the beliefs once associated with the king or his immediate family were adopted by his nobles, and then by less important people, until everybody at their death hoped to become identified with Osiris, the dead king; but the quality, size, and material of the *ka* statue buried in a tomb depended upon the prosperity and means of its owner.

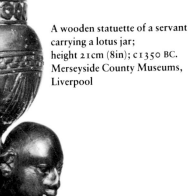

A wooden statuette of a servant carrying a lotus jar; height 21cm (8in); c1350 BC. Merseyside County Museums, Liverpool

The earlier private sculptures, like the royal ones they imitated, were very much in the ritual tradition. In later periods craftsmen, particularly those working in wood, often produced small figures of great charm when they did not feel themselves bound by magico-religious convention. Such small statuettes were often made to serve a practical purpose and carried containers which held cosmetic substances; later they were buried among the personal possessions of their owners. A fine example in dark wood is the figure of a servant carrying a lotus jar, c1350 BC, which he supports with one hand while his back bends beneath its weight (Merseyside County Museums, Liverpool). Another of about the same period, now at Durham (Gulbenkian Museum) depicts a young maidservant with her body curved sideways to counterbalance the heavy cosmetic jar which she carries on her left hip.

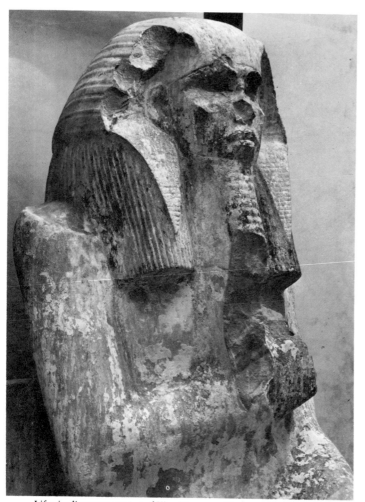

Life-size limestone statue of King Zoser; c2660–2590 BC.
Egyptian Museum, Cairo

It is the sequence of formal royal sculpture, however, that most clearly shows the changes in detail and attitude that occurred during the many centuries of Egyptian history. Unfortunately very little royal sculpture has survived from the earliest periods, but one of the oldest examples is also one of the most impressive. This is the life-size limestone statue of King Zoser, c2660–2590 BC, found in a small chamber in the temple complex of the Step Pyramid, which was planned by the Vizier Imhotep (Egyptian Museum, Cairo). Once in place, the statue would never again be seen by the eyes of the living. It was made to provide a dwelling place for the *ka* of the king after his death, and was walled up in a niche. Two holes were left opposite the eyes so that it could look out into the adjacent chapel where daily offerings were to be made. The king, seated on a square throne, is wrapped in a mantle. The face, framed by a full wig, is impassive and full of brooding majesty, conveyed in spite of the damage caused by thieves who gouged out the inlaid eyes. Smaller statues of nobles from the first three Dynasties, seated in the same position with the right hand across the breast, convey a strong impression of the density of the stone from which they were carved.

The magnificent diorite statue of Khephren, c2500 BC (Egyptian Museum, Cairo), builder of the second pyramid of Gizeh, once stood with 22 others in the long hall of the Valley Temple there. The posture of the king has changed a little from that of the statue of Zoser, and both hands now rest on the knees. The detail of the body, no longer enveloped in a mantle, is superbly executed. Protected by the falcon of the god Horus, the king sits alone with the calm assurance of his divinity. This statue was intended to be seen in the temple, and the power of the king is underlined by the design carved on the sides of the throne which symbolized the union of the Kingdoms of Upper and Lower Egypt with a knot of papyrus and lotus plants.

The sculptures preserved from the funerary temple of another 4th-Dynasty king, Mycerinus, at Gizeh, dating from c2480 BC, are still full of the concept of divine majesty, but depict the king with more humanity than his predecessors. The statue groups are cut from schist, showing traces of painting; one portrays the king with his queen; the others are triads where he is shown with gods of the provinces of Egypt. The double statue, nearly 5 ft (1.5 m) high, was never quite completed. The legs and base were not given their final polishing, and the statue is uninscribed. The powerful figure of the king is supported with affection and dignity by the figure of the queen who stands slightly behind his left shoulder, gazing directly ahead, with her right arm round his waist and her left hand touching his left arm. There is similar contact between the figures in the triads, also of schist, which are slightly smaller. The hands of goddesses, placed delicately on the arms of the king, promise divine support to the ruler. As is usual in ancient Egypt the goddesses are represented with the features of the queen.

Few fragments of royal sculpture in stone survive from the remaining period of the Old Kingdom. A granite head of Userkaf, c2470 BC, three times lifesize, provides the first evidence for colossal statuary in Egypt and is clearly by the hand of a master craftsman. A diorite dyad showing King Sahure with the god of the Coptos district, however, although carved in the tradition of the magnificent sculpture of the 4th Dynasty from Gizeh, does not show the same mastery in its proportions or the same skill of workmanship and finish, although the feeling of majesty remains.

The sculptors represented the rulers of the Old Kingdom as gods on earth. During the Middle Kingdom the surviving fragments of royal statues show a line of rulers who had achieved their divinity by their own power and strength of personality. The aloof and solitary nature of kingship appears in their portraits, but it is combined with an awareness of a human personality beneath the trappings of royalty. The heads and statues of these Middle Kingdom rulers give the impression of being real portraits, carved by craftsmen of consummate skill.

In some ways the sculpture recalls earlier royal statuary. A portrayal of Amenemhat III, c1840 BC, as a sphinx shows a face strongly reminiscent of the statue of Zoser, carved nearly 1,000 years earlier, in the cast of its eyes and mouth, the large

ears, and jutting chin. Large ears are indeed a characteristic of Middle Kingdom sculpture, particularly the smaller, more roughly carved statuettes of private individuals.

It is possible to make out a family likeness especially about the eyes and mouth, in a number of surviving heads of 12th-Dynasty kings. The most remarkable are those that represent Sesostris III, 1878–1843 BC. A sphinx now in the Metropolitan Museum, New York, represents him as a relatively young man, presumably near the beginning of his reign. Portraits in brown quartzite, obsidian, and red granite, among others, depicting him in later years, show the development of deep grooves at the corners of his mouth and between his eyes, and his expression, although kingly, shows the cares and burden of state. In contrast, a greenstone head of a queen, portrayed with a broad brow and high cheekbones, has a serene and gracious expression. Very few portraits of royal ladies survive from the Middle Kingdom, although the high regard in which they were held is shown by the richness of the objects found in their tombs.

During the New Kingdom the lines disappear from the faces of kings, who gaze into eternity with unclouded expressions. Many more statues survive than from earlier periods, and some kings, such as Tuthmosis III and Ramesses II, had hundreds carved to decorate the temples they raised for the gods. Many statues show features taken from life, such as the large hooked nose of Tuthmosis III, but the faces were idealized. From the reign of Queen Hatshepsut onwards there is a certain softness about the expression, and a refinement in the treatment of the body. Sculpture during the New Kingdom is technically splendid, but it lacks something of the latent power of the royal sculpture of the Old and Middle Kingdoms.

A hard limestone statue of Hatshepsut from Thebes, c1480 BC (Metropolitan Museum, New York), larger than lifesize, shows the queen seated on a block throne with her hands on her knees, wearing the headdress and kilt of a king

Diorite statue of Khephren; height 168cm (66in); c2500 BC. Egyptian Museum, Cairo

The Sphinx in Ancient Egypt

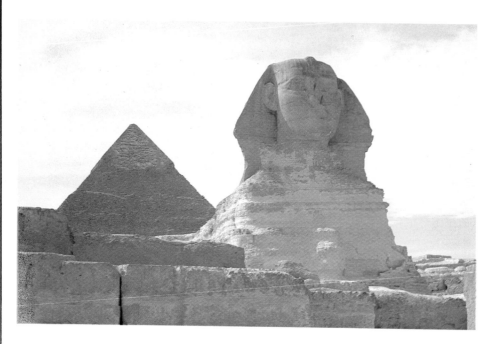

From the 15th century AD European travelers carried home tales of the mysterious and amazing remains of the civilization of Egypt. One of its most remarkable monuments, which still evokes this sense of awe and might, is the Great Sphinx of Gizeh, the oldest surviving sphinx, dating from *c*2550 BC, carved from a natural outcrop of rock. The body is 240 ft (73 m) long and the face is over 13 ft (4 m) wide.

Sphinx is a Greek word, but is probably derived from *shesep ankh*, "living image", and the true Egyptian sphinx, unlike the Greek version in the story of Oedipus, was a male creature, depicted with the crouching body of a lion and a human face. It portrays the king, usually wearing the striped *nemes* headdress with the royal uraeus above the forehead, and a ceremonial beard. The head-dress actually helps to disguise the join between the animal body and the human head and neck.

The concept of the king as a powerful lion goes back into prehistoric times, and several

▲ The Great Sphinx of Gizeh

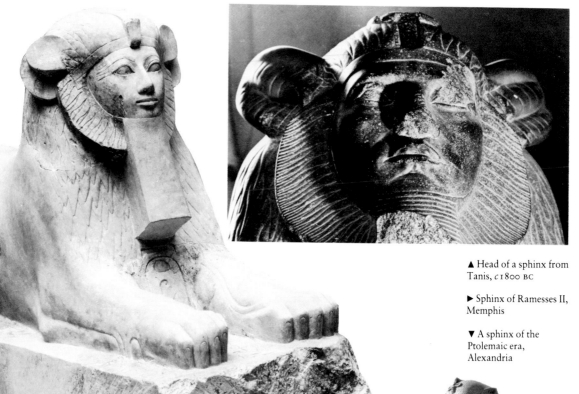

▲ Head of a sphinx from Tanis, *c*1800 BC

► Sphinx of Ramesses II, Memphis

▼ A sphinx of the Ptolemaic era, Alexandria

▲ Limestone sphinx from Queen Hatshepsut's temple, Deir el-Bahri. Metropolitan Museum, New York

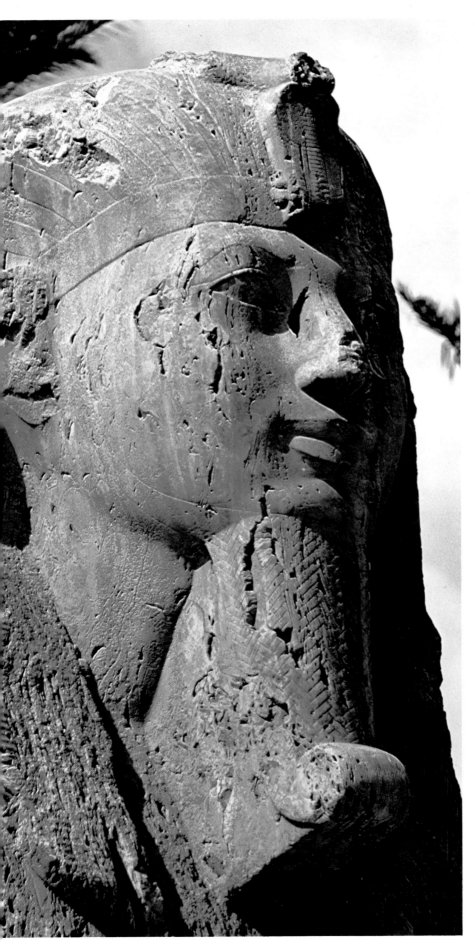

ceremonial objects have survived which depict him in this guise, overthrowing his enemies. The sphinx was, therefore, a natural development, personifying the divine power of the king as a force protecting his land and repelling the power of evil. The human head was the means of individualizing the sculpture, so that the Great Sphinx probably bears the idealized features of Khephren whose pyramid is nearby. A colossal red granite head of King Userkaf, *c*2400 BC, may have been part of a sphinx, but there is little other evidence of sphinxes in the Old Kingdom (*c*2680–2180 BC), although there surely was a tradition: relatively little royal sculpture of any kind has survived from this early period.

The Middle Kingdom (*c*2050–1750 BC) yields an interesting variation on the established convention in the shape of four gray granite sphinxes dated to the reign of Amenemhat III, *c*1800 BC, which were found at Tanis in the Delta. In these the king's face is framed not by the *nemes* headdress but by a stylized form of lion's ruff, mane, and ears. The effect is rather to emphasize the majesty and realism of the human features, contributing to the brooding power of the statues. This type of "lionized" head reappears in two small, painted limestone sphinxes from Queen Hatshepsut's temple at Deir el-Bahri, these dated some 300 years later in the New Kingdom. However, the temple also contained six larger, red granite sphinxes which wear the *nemes* headdress, and are notable for the sensitive portrayal of the face and the skillful modeling of the heavy muscles of the lion's body.

The alabaster sphinx of Ramesses II, which still stands among the ruins of Memphis, was carved *c*1250 BC, and seems initially more impressive than Hatshepsut's sphinxes through sheer size, being more than twice as large at 26 ft (8 m) long, 14 ft (4.2 m) high and weighing about 80 tons (81 tonnes). Although the carving is skillful enough, however, it does not convey such an impression of vitality and character as the earlier ones. As time passed, sphinxes continued to be made as royal monuments, but technique had so taken over that the latest sphinxes, of the Ptolemaic era, 332–30 BC, are bland imitations of their powerful precursors.

The Great Sphinx is one of the most distinctive and dominant of all the images of ancient Egypt, which is perhaps the source of the misconception that sphinxes are of central importance in Egyptian culture and proliferate throughout its history. However, those that have survived are among the most impressive as well as intriguing examples of Egyptian sculpture.

DOROTHY DOWNES

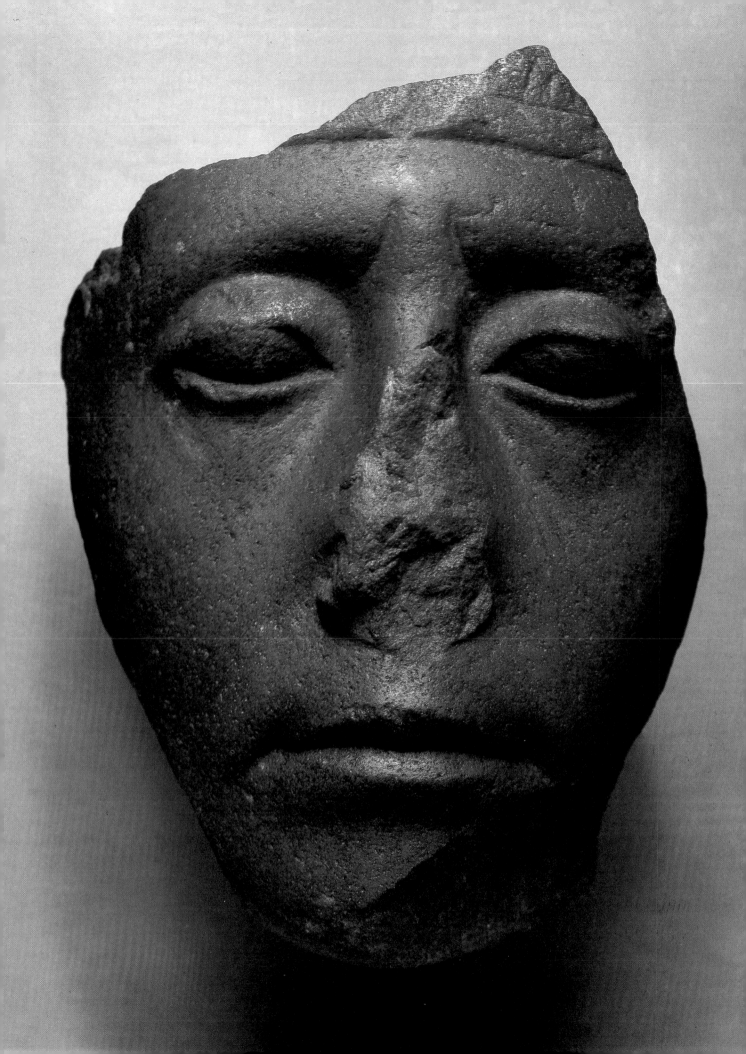

of Egypt in support of her claim to rule. The body is set squarely in the ancient tradition and the eyes are steadfast, but the chin is pointed and delicate and the effect is feminine. When Tuthmosis III succeeded in replacing her on the throne of Egypt, the sculptors knew what was expected of them and produced statuary that celebrated the power of a capable, warlike king, a confident link between his people and the gods.

Royal sculpture from Tell el-Amarna. When Amenophis IV broke with the old traditions he moved his capital to the city he built in the desert at Tell el-Amarna, which he called the Horizon of Aten. He changed his name to Akhenaten and worshipped the Aten, the lifegiving force of the sun, in light and airy temples decorated with statues and reliefs. Encouraged by the king, craftsmen between 1363 and 1346 BC produced scenes and sculptures characterized by a new informality that had begun to appear during the reign of Amenophis III. Members of the royal family were shown taking part in ceremonies, as before, but the artists also went behind the palace facade, as it were, to depict more domestic scenes. The king, his queen Nefertiti, and their daughters are portrayed relaxing in their private apartments, and although ritual is observed in the way that the hands of the Aten rays reach down to protect the family, the princesses scramble upon their parents' knees or play beside their chairs. Hands touch not merely in the ancient gesture of protection but in genuine affection, and the princesses may be said to smile.

During the early part of Akhenaten's reign, and probably at his own instigation as a rebellion against the idealism and decorum of earlier times, many royal statues appear to show the human form exaggerated to the point of caricature. Some are even repellent. All the physical peculiarities of the king, his long head and pointed chin, sunken chest, protruding stomach and large thighs, are shown in detail, and some of the colossal statues are quite overpowering in their effect. This distortion, particularly in official statues, must be the result of the king's own wish to display, rather than conceal, what was probably a pathological condition. In spite of this, the sculptors still manage to communicate a god-like quality to the larger statues of the ruler.

Later in the reign, the trend to naturalism asserted itself. Surviving fragments show that the ideal female form was young and lithe with gently swelling belly and thighs. The body was shown naked or covered with light garments of clinging linen. Studies of the heads of the princesses have been found, and these, together with the quartzite head of Nefertiti already mentioned, and the beautiful painted limestone bust of the queen now in Berlin (Staatliche Museen), are outstanding in their delicacy and charm. The painted head, found at Amarna in a sculptor's workshop, was a master-portrait used as a model for other studies, some of which have been found. The face and neck are finely modeled, and are painted in most natural colors. The left eye was never inserted, but the right is effectively inlaid in rock crystal with a black pupil.

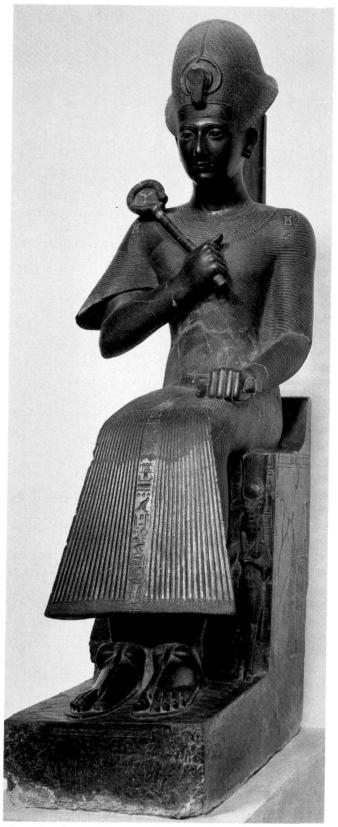

Above: Seated statue of Ramesses II; c 1290 BC. Museo Egizio, Turin

Left: Fragment of a red quartzite head of Sesostris III. Metropolitan Museum, New York

After the death of Akhenaten his successors returned to Thebes, and government and religion resumed their traditional courses. The influence of the Amarna style lingered, however, in a soft delicacy of touch which is shown in the best of later New Kingdom art. In formal sculpture the rulers of the 19th Dynasty were represented in statues which in style recall those of the early 18th Dynasty. Sometimes, however, they were represented in contemporary dress and not always in the simple traditional garment of the king. A beautifully finished, black granite, seated statue of Ramesses II, c1290 BC, in the Turin Museum, portrays the king wearing the helmet-shaped Blue Crown, and long, finely pleated linen robes. Traditional detail is supplied by a figure of the queen, standing by his left leg but not even as tall as his knee. His reign became the great period of colossal sculpture, and among many huge figures of Ramesses II that survive, the seated statues at the temple of Abu Simbel and those showing the king as Osiris in his mortuary temple at Thebes are among the most famous.

Smaller statues from his mortuary temple, the Ramesseum, include figures of royal ladies in painted limestone. The carving is very fine, particularly the details of the wigs, collars, and ornaments, and the faces are idealized and serene. These statues have their parallels in the funerary figures placed in the tombs of nobles and officials. Many of these are carved with meticulous care by sculptors trained in the royal traditions.

Statues of private individuals were also dedicated in the temples, and here, with the development of the block statue, there is a trend towards compactness and simplicity. The figure, squatting with its knees drawn up towards the chin and enveloped in a mantle, is reduced almost to a block from which only the head protrudes. The heads of many block statues are well-carved, but the stylized body was intended to be as simple as possible in order to provide the ground for the inscription, often covering the entire surface and including the name and titles of the votary. This type first appeared during the Middle Kingdom, and gradually became more common during the New Kingdom. The climax of its popularity occurred during the 19th Dynasty.

In later periods, royal sculptors, although very competent, produced statues very much in the traditions of earlier Dynasties, and mostly of a smaller size. In c660 BC, however, Montuemhat, who was High Steward of the Divine Consort of Amun at Thebes, gave great patronage and encouragement to a new movement in art. This drew its inspiration from past glories, setting out to reestablish national pride at a time when foreign powers were threatening Egypt. For a time there was a new flowering of technical brilliance, particularly in the treatment of hard stones; and several outstanding pieces of sculpture survive. A remarkable dark granite statue of Montuemhat himself, found at Karnak, is an exciting amalgam of the traditions of 2,000 years of art. The pose and dress conform to the traditions established early in the Old Kingdom, and the wig is in the fashion of the New Kingdom; but the face is a portrait of real character, carved with a sensitivity worthy of the great craftsmen of the Middle Kingdom.

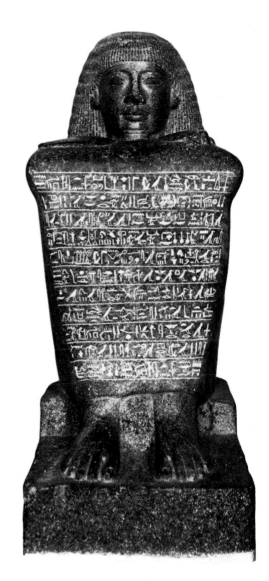

Block statue of Amenophis, steward of Memphis; height 74cm (29in). British Museum, London

Sculpture in wood and metal. Although the very nature of stone imparts a certain stiffness to statuary, this same rigidity tends to be repeated in other materials such as wood or metal where greater freedom is in fact possible. The innate conservatism of the Egyptians meant that craftsmen kept to the established artistic conventions, mainly for magical or religious reasons, though certain differences do appear in lighter materials. Plinths and back pillars can be abandoned when their support is no longer needed, and legs and arms can be separated from the body, giving a lighter effect. These figures, however, seldom survive in perfect condition. Metal corrodes, and wood rots if damp, and is susceptible to the ravages of ants and other pests. Copper was precious so many statues were probably melted down and the metal reused.

From inscriptions we know that royal statues of copper had been made as early as the 2nd Dynasty, but the 6th-Dynasty statues of Pepi I and his son are the earliest that survive. From that time onwards metal figures occur in a wide range of sizes. One of the most notable is the tiny gold figure of Amenophis III, 2 in (5 cm) high, found in a miniature coffin in the tomb of Tutankhamun, c1340 BC. This was probably cast in a mold by the cire perdue method.

The bronze statuette of Queen Karomama of the 22nd Dynasty, *c*825 BC, is one of the most sophisticated surviving examples of sculpture in metal (Louvre, Paris). Nearly 2 ft (61 cm) in height, it was made for her chapel at Karnak, and shows the queen with her arms extended before her. The hands originally held scepters or an offering, but, like the crown and plumes that must have adorned her head, these were probably of gold and have long since disappeared. The details of her elaborately patterned dress and collar were originally inlaid with gold, silver, and electrum, and the face, arms, and feet were gilded. Much of this is now lost, but the queenly and womanly beauty of the figure and the open expression of her face are very striking. Other fine bronze statuettes of about this period show the skill of workers in metal. They include figures of other royal ladies, and one of the god Amun.

Royal statues made of wood survive in relatively large numbers. The most impressive are those placed in the tombs of kings after playing an important part in the funerary ritual, representing them as they would have appeared during their coronation ceremonies and on other important ritual occasions. A figure of Sesostris I, 1971–1930 BC (Egyptian Museum, Cairo), found at Lisht, is one of the earliest and best preserved. Finely carved in cedar wood and wearing the high White Crown of Upper Egypt, the king strides forward on his left foot, holding a long crook in his left hand. The right hand would have held the other royal symbol, the so-called flail. The crown and kilt are white with a layer of gesso, and the body and eyes are painted with natural colors.

A series of statuettes (Egyptian Museum, Cairo), each under 3 ft (1 m) high, found in the tomb of Tutankhamun, *c*1340 BC, a young and relatively unimportant ruler, shows that such figures were an essential part of royal funerary equipment. It was believed that after death the king would continue to perform ritual acts on behalf of his people. Similar figures must have been placed in other royal tombs, but most were looted by tomb robbers. One statuette represents Tutankhamun, wearing the Red Crown of Lower Egypt. He is in the same pose as Sesostris I 600 years earlier, and paces forward holding crook and flail, solemn and intent. The effect of the realism of the Amarna period is shown in the relaxed, slightly drooping shoulders, which contrast with the straight and powerful shoulders of Sesostris. The most graceful statuette of the group shows Tutankhamun like the god Horus, poised effortlessly on a small papyrus skiff, about to cast the harpoon that would kill Seth, the enemy of his father Osiris, transformed into a hippopotamus.

Besides a number of beautifully carved wooden *ushabtis*, or figurines of funerary servants, also found in his tomb, the splendor of the burial of Tutankhamun is underlined by the two life-size statues found guarding the walled-up entrance to the funerary chamber itself (Egyptian Museum, Cairo). They represent the king as Osiris, not mummiform but with the face, body, and legs coated with shining black resin. Against this the gilding of the garments, and the gold eyes and eyebrows stand out with startling effect.

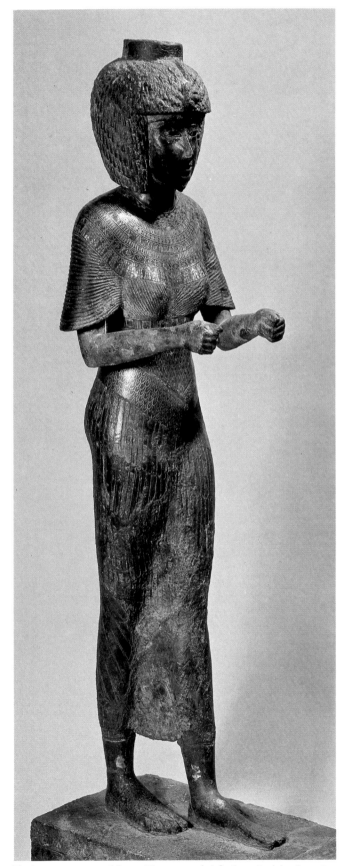

The bronze statuette of Queen Karomama; height 61cm (24in); c825 BC. Louvre, Paris

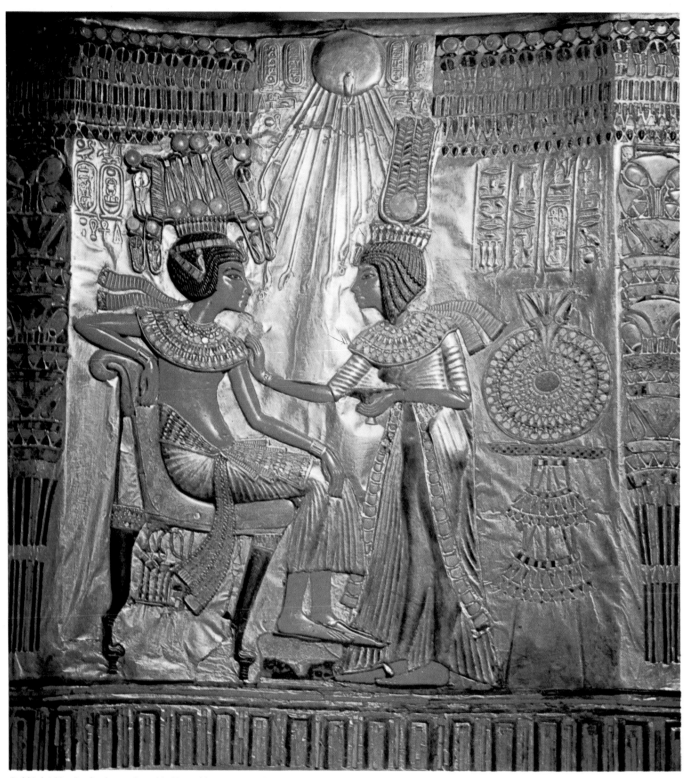

Gold inlaid back of a throne found in Tutankhamun's tomb. Egyptian Museum, Cairo

One of the most striking of royal portraits carved in wood is a small ebony head of Queen Tiye, wife of Amenophis III, *c*1360 BC (Staatliche Museen, Berlin). It was intended, presumably, to form part of a composite statue. The wig is covered with painted plaster, and the earrings and eyes are inlaid. The sculptor, working with great skill in the hard wood, has managed to convey the impression of an acute and perhaps ruthless personality in portraying a commoner who became the Great Royal Wife of a king of Egypt.

Applied art. The craftsmen who produced the fine furniture, beautiful jewelry and small personal possessions which were obviously so beloved by the people of ancient Egypt, were not limited in the same way as sculptors who were normally expected to conform with religous tradition. It is quite clear that they appreciated the beauty of natural things, and delighted in their ability to reproduce them in stone, fine wood, ivory, and precious metal. Few of these objects had the magical purpose of the statues and reliefs, but were buried with their owners as

cherished, familiar things. Craftsmen could let their imaginations run freely in the decoration of utilitarian objects, many of which are ingenious as well as beautiful.

From the earliest times jewelry was made of gold and semiprecious stones. Prehistoric beads of garnet, amethyst, haematite, and carnelian, laboriously ground and polished by hand, are found in the most ordinary of graves. Later, four bracelets (now in the Egyptian Museum, Cairo) found on a linen-wrapped arm cast aside by tomb robbers in a royal tomb at Abydos, *c*3000 BC, show that the Egyptian love of brightly colored beads, strung together in elaborate patterns, was already well established, and during the Old Kingdom some exquisite pieces of jewelry were made. Outstanding among these are the bracelets found in the tomb of Queen Hetepheres, *c*2600 BC, some produced specifically for funerary use (Egyptian Museum, Cairo). Made of beaten sheet silver, they are decorated with delicate butterfly patterns inlaid with turquoise, jasper, lapis lazuli, and carnelian.

The jewelry buried with the princesses Khnumet, Sithathor-yunet, and Mererit at Lahun, *c*1900 BC, shows that the craftsmen of the Middle Kingdom were never surpassed as designers. Inlaid diadems, ceremonial pendants, bracelets, and filigree wreaths of gold and semiprecious stones are richly decorated, elegant, and beautiful. Technically the craftsmanship of the New Kingdom was more polished, but although many pieces are more splendid, the effect can sometimes be gaudy and unrestrained. The best known are the sumptuous pendants, diadems, earrings, and finger rings found in the tomb of Tutankhamun, *c*1340 BC (Egyptian Museum, Cairo).

The techniques used to produce vessels and other objects of precious and base metal apart from personal jewelry were very accomplished. A gold falcon's head from Hierakonpolis, *c*2330 BC, is one of the finest examples of goldsmiths' work of the Old Kingdom (Egyptian Museum, Cairo). Eyes of polished obsidian give a lifelike appearance to the head, crowned with a gold uraeus and tall plumes, that must have formed part of a composite statue. The copper nails that fixed it to a body, probably made of wood sheathed in copper, are still in place.

Extensive use was made of precious metal in the furnishing of royal burials, and the few that have escaped the attention of plunderers show how splendid and magnificent the others must have been. Within a series of wooden coffins sheathed in gold, and inlaid with glass and semiprecious stones, the funerary mask of Tutankhamun (Egyptian Museum, Cairo) was of solid gold, and the rich equipment found in the tomb of Psusennes at Tanis, *c*1050 BC, included fine silver coffins and gold funerary masks.

Gold inlay was used to pick out the details on wooden statuary, and to decorate the bronze statuettes made in increasing numbers from *c*1000 BC. Many of these figures represented various gods shown in characteristic attitudes, and were probably for household shrines. The great gods of earth and sky are among them, but there are also many figures, often roughly made and finished, of the familiar, domestic gods worshiped by ordinary people.

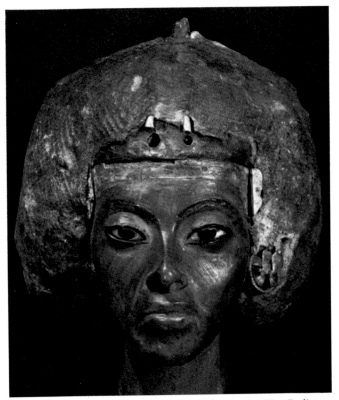

Ebony head of Queen Tiye; c1360 BC. Staatliche Museen, West Berlin

Head of a priest from the Ptolemaic era. Staatliche Museen, West Berlin

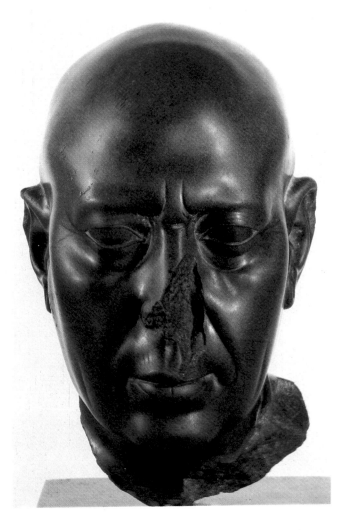

Precious metal was also widely used by the makers of fine furniture, and in cases where the wood has rotted away it has been possible to reconstitute items of furniture from the gold mountings that have survived. Supplies of good timber were always scarce and usually had to be imported, but Egyptian carpenters were adept at disguising joins and flaws in the poor native wood with layers of plaster and paint. Chairs, beds, and chests of the highest quality were covered with thin sheet gold, and this could be enhanced by inlaid decoration of ivory, ebony, and semiprecious stones. The work of the cabinetmakers had already reached a high degree of excellence early in the Old Kingdom, when the magnificent pieces of furniture found in the tomb of Queen Hetepheres, c2600 BC, were made (Egyptian Museum, Cairo). These have been reconstructed using the gold mountings, and the sheets of gold that covered the poles of the canopy, and the chairs, chests, and bed reveal an austere beauty of design and a wonderful quality of workmanship, delicately underlined here and there by inlaid panels of ebony set with tiny gold hieroglyphs.

Some of the chairs of state of New Kingdom date, those found in the tomb of Tutankhamun for instance (Egyptian Museum, Cairo), are wonderfully decorated with colored inlay. On the gilded back of one, an elaborate scene in silver, glass, and faience inlay represents the young king seated, with his wife standing in front of him anointing his ceremonial collar. Sometimes the effect of such craftsmanship is almost too exuberant, but small chests, jewel boxes, and gaming boards of cedar wood and ebony, minutely inlaid and painted, are often more tasteful and elegantly made.

Egyptian faience or glazed composition was often used for inlay. It consists of a core of ground quartz coated with an alkaline glaze, and was made from prehistoric times onwards. The colors vary, but the most characteristic are blues and greens produced by adding copper compounds in the required proportions to a glaze made by heating sand and natron. A brilliant clear blue glaze, mainly typical of the New Kingdom, was the most admired. Faience was used as a substitute for semiprecious stones, as well as in its own right in the making of beads, scarabs, and inlay. In the New Kingdom finely decorated bowls and chalices of faience were made, together with thousands of funerary figures or *ushabtis* which are to be found in many Egyptian graves.

Real glass was not made regularly in Egypt until the conquests of Tuthmosis III in the 18th Dynasty opened up contacts with the glass industries already established in Syria and Mesopotamia. The finest Egyptian glass, in the form of small vessels and colored inlay, was made during, and just after, the Amarna period, c1350 BC.

Although the majority of the ordinary people of Egypt could not afford objects of the artistic quality that characterized the funerary furnishings of the tombs of their nobles and kings, a great deal of evidence can be gathered from the modest equipment found in humble graves. Copies in wood and poorer stone reflect the work and style of more skillful craftsmen, and nearly every burial includes a treasure of some kind, such as a tiny cosmetic holder made of polished stone. Every object helps to fill in a detailed picture of the civilization of ancient Egypt, which owed so much to the resources of the Nile Valley and its people, and so little to external influences.

Foreign emissaries brought tribute to Egyptian rulers, and the trade in fine wood, metal, and other commodities scarce in Egypt meant that officials were in regular contact with the peoples of Africa to the south, and of the East Mediterranean and Mesopotamia to the north and east. But very little outside influence is to be detected in the work of Egyptian craftsmen. Imported objects were regarded more as valuable curiosities than as sources of inspiration to Egyptian artists, who were required to work by method and ritual.

Even dynasties of foreign rulers adopted the ancient traditions, rather than trying to impose new ideas, because they realized that they were then more likely to be accepted by the majority of the people. Artists flourished under the rule of the Ptolemies, but they were employed to rebuild and decorate temples in the ancient Egyptian manner. Even the influence of Greek sculpture made very little immediate impact, and a tendency towards more rounded, realistic forms becomes apparent only gradually. The faces of statues were quite often lively and expressive, but the bodies remained unbending and traditional until Roman times.

It is only relatively recently that the work of ancient Egyptian craftsmen and artists has begun to be appreciated in its own right. The forms and traditions they followed are foreign to the artistic heritage of the west, rooted as it is in the Classical tradition. Napoleon's expedition to Egypt in 1798, and the discovery of the Rosetta stone, led to a great vogue for Egyptian antiquities, but they were regarded more as curiosities than as works of art. Many great collections were founded in the early 19th century, but it was not until towards the end of the 19th century when the decipherment of hieroglyphic writing and the development of systematic archaeology had begun to reveal the complexities of the civilization of the Nile Valley, that the work of ancient-Egyptian craftsmen really began to be appreciated. It could then be seen that forms of art, which had seemed primitive in design and limited in achievement, were rather the products of an alien and highly sophisticated culture, embodying the response of the people of the Nile valley to their environment.

DOROTHY DOWNES

Bibliography. Aldred, C. *Egypt to the End of the Old Kingdom*, London (1965). Aldred, C. *The Egyptians*, London (1961). David, A.R. *The Egyptian Kingdoms*, London (1975). Hayes, W.C. *The Scepter of Egypt*, New York, Part One (1959) Part Two (1960). Posener, G. (ed.) *A Dictionary of Egyptian Civilization*, London (1962). Woldering, I. *Egypt, the Art of the Pharaohs*, London (1963). Wood, R. and Drower, M.S. *Egypt in Colour*, London (1964).

4

ANCIENT NEAR EASTERN ART

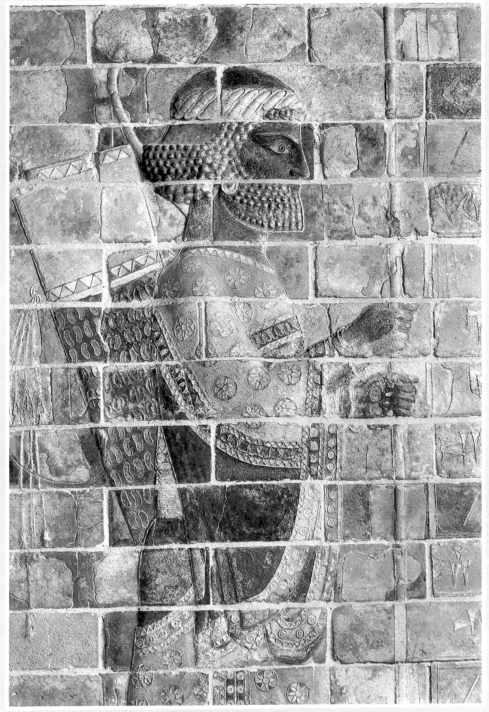

A mural relief figure of a royal guardsman at Susa, the capital of Achaemenid Persia
c404–358 BC. Louvre, Paris (see page 78)

EARLY Mesopotamia. The setting for the development of one of the first literate civilizations, that of the Sumerians (*c*3500–2000 BC), was the land enclosed by the two rivers, the Tigris and the Euphrates. In the lower reaches of these silt-depositing rivers (in modern Iraq), in the dangerous and inhospitable oval of marsh and desert between Baghdad and the Shatt al-Arab waterway, primitive society overcame formidable challenges and succeeded in wresting economic surpluses from well-tended alluvial soils and in establishing urban communities. Partly as a consequence of such achievements monumental art made its first appearance, as an element in buildings used for religious observance. Its abiding themes were man's relationship with the deities and with the forces of nature that surrounded him, which were usually considered malevolent.

Modern knowledge of the Sumerians was slow to materialize because their monuments, built of poor stone since good-quality material was unavailable in Sumer, disappeared long ago, and because of the scarcity of historical records.

In 1850 Edward Hincks suggested that there were older, non-Semitic elements in the known Akkadian language that had been used by the Assyrians and the Babylonians. They were identified as Sumerian a few years later. In 1877 Ernest de Sarzec, a French Consul, began at Tello the first major series of archaeological investigations at a Sumerian site. Others followed, Americans at the larger mound of Nippur, Germans at Uruk (biblical Erech, the city of the hero of *The Epic of Gilgamesh*), the British at the sites of Kish and Ur. But these are only a few of the many Sumerian cities and villages that remain to be investigated in this 10,000 sq mile (25,900 sq km) area, so our understanding of these people and their art remains extremely patchy.

The influence of the Sumerians extended well beyond the frontiers of their homeland. In order to obtain minerals and timber for building, for example, they traded over enormous distances, with Syria, Anatolia, and beyond the Persian Gulf, thereby spreading artistic influence through exported works. In return the Sumerians were influenced by materials they imported. At times there were also foreign craftsmen employed in Sumer.

Although we speak of "Sumerian civilization" we in fact refer to an amalgam of several peoples. The cuneiform or wedge-shaped writings demonstrate the coexistence of at least two languages (the non-Semitic Sumerian and the Semitic Akkadian) whilst a third group of inhabitants, probably indigenous, is indicated by the names of the main rivers, principal

The Ancient Near East showing main sites

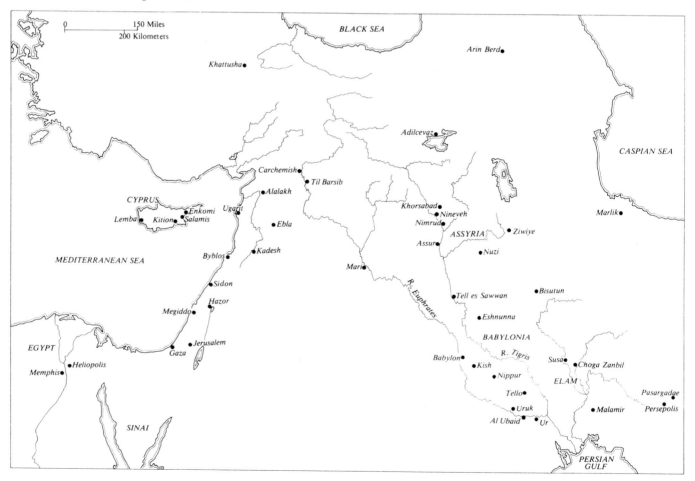

cities, and native crafts which are in a third language. So we must imagine Sumerian society to consist of a basic Sumerian element which was ineluctably overwhelmed by the constant renewal of Semitic stock from the deserts to the west.

The elements of this society cannot be distinguished in its works of art until certain trends within its development are transformed by an interlude of Semitic political control. But before this, in the most ancient protohistorical periods, the distinctive Sumerian contribution can be most readily identified.

The prehistoric periods (*c*6000–3500 BC). Sedentary communities are found first in northern Mesopotamia where rainfall was sufficient for many types of edible crops to be grown without the irrigation necessary in the south. At Umm Dabaghiyah, a settlement in marginal terrain, there are wall-paintings that probably depict onager hunts. But they mark the end of a great Paleolithic tradition rather than the beginning of a new form. In fact for centuries afterwards painting was only employed in the decoration of pottery and some of the first attempts in this novel genre, mere blobs and squiggles, were made at this site.

The pottery of two northern cultures subsequently reached great heights of excellence; firstly Samarra pottery, which incorporated swirling figures on the bases of dishes, and secondly Halaf pottery which, while including abbreviated motifs such as *bucrania* is perhaps most noteworthy for the intricacy of its polychrome floral decoration. Although both styles were ultimately replaced, the symbolism inherent in the stylization of some Halaf designs was a forerunner of the earliest Sumerian writing, which was based on pictograms, and the bitumen hairdresses and inlaid eyes, features of alabaster statuettes from Tell es Sawwan near Samarra (Iraq Museum, Baghdad), recur in Sumerian statuary.

By the late 5th millennium BC the inhabitants of southern Mesopotamia had made such advances that the initiative in artistic development had passed to them. So little is known about this change that we can only guess that the fertile soils of the area were being better exploited. The decoration of pots changed, from all-over textured patterns to carelessly applied dabs of paint. And this in turn was abandoned in favor of monochrome washes. The making of statuettes continued, usually of female figures, the normal shape evolving into a slender, columnar figure with broad shoulders and a pinched face resembling that of a lizard.

Even towards the end of the prehistoric period we can discern the beginnings of Sumerian civilization. The beginning of wealth accumulation, and external contacts, is suggested by a strip of gold from Ur. And also dating from this period are large temples at Eridu, the first cult-center to receive kingship according to the Sumerian king-list. They are built in a form that heralds the classic early Sumerian tripartite shape. Similar and better preserved examples have been found in the north, their walls tinted in red, black, ocher, and vermilion. At this same site, Tepe Gawra near Khorsabad, a series of stamp seals has been found (now in the University Museum,

Philadelphia). Believed to possess amuletic properties, they were used to mark individual property and offer us an important insight into the development of figurative art during this period. In the earliest examples men and animals appear randomly deployed in free-field compositions. But towards the end of the period the figures become more corporeal and the scenes more orderly, often arranged in rotation form or around a vertical axis. Such scenes were probably derived from ritual.

The Early Sumerian Period (*c*3500–3000 BC). It is fair to conclude that the culture of this period revealed by finds from the site of Uruk is Sumerian on account of its continuity into later times, and also from Sumerian language texts of slightly later date whose signs are directly evolved from those on tablets found at Uruk.

Some scholars have suggested that Sumerian newcomers were responsible for the many innovations that now took place in southern Mesopotamia. But, as we have seen, there were indigenous antecedents for some of the developments and furthermore a similar pattern of development occurred in neighboring Elam. Perhaps a change in the nature of trading patterns and a collateral increase in wealth may be the causes we are seeking. This is certainly suggested by the recent discovery of early Sumerian sites along the bend of the Euphrates, 500 miles (800 km) upstream in northern Syria, at a crucial junction on the route to timber and mineral resources in the northwest. It may be that archaeological finds will demonstrate that the suddenness of these changes in Mesopotamia is more apparent than real, but we should not underestimate the importance and extent of this sudden burst of artistic and other activities.

In the city of Uruk the most outstanding features of the period were two sacred complexes. The first, Eanna, the House of Heaven, was probably dedicated to the goddess Inanna, the other to Anu. Both were rebuilt during the Early Sumerian Period apparently without any change of character, but the Sumerians' practice of reconstructing their temples on the bases of their predecessors' (as also happened at Eridu) eventually led to the appearance of ziggurats.

The ground plan of the monumental temples of Eanna was rectangular though the walls were deeply recessed to provide niches. Within, the predominant feature was a long, narrow, axial court, sometimes opening out into transept-like rooms in front of a rear chamber. We have not been able to discover their purpose from contemporary documents (the pictograph inscriptions of the period have not yet been deciphered) but later buildings of similar form were undoubtedly temples, though they often featured a niche for a cult-statue in the *cella* or rear chamber. No example of this has been found at Uruk, nor have the ancillary rooms and courts that usually indicate a cult bureaucracy.

Within one of these buildings there was a decorated hall or court, capable of holding a large number of people. At one end stood two rows of six massive mud-brick columns. They

occupy a raised area which was reached by a central staircase leading up from the court. The walls, staircase parapet, and columns were all inlaid with baked clay cones—thousands of them, set contiguously so that their protruding painted heads formed colorful linear patterns. Similar cones were also driven into the exterior walls of other buildings in Eanna to provide both decoration and protection (as suggested by copper-sheathed cones found at Eridu).

The impulse to embellish by such laborious means must have lain deep in the Sumerian psyche. Its expression is unmistakable—a true myriad of parts creating a unified entity. Evidence of its influence can be found in a temple in North Syria where the altar bears a frieze of gold and bicolored limestone and the walls are decorated with mosaics of colored cones and rosettes of black, white, and red stone petals. Only occasionally were the walls of buildings painted, one of the few examples being the terraced temple at Uqair, just north of Kish, where there are representations of animals and humans, the latter perhaps offering-bearers, similar to those depicted on a ritual vase from Uruk.

Three-dimensional and relief sculpture flourished in this period, presumably for religious purposes since most surviving examples come from the sacred precincts at Uruk. In its substantial forms and figurative quality Sumerian sculpture surpassed earlier work and indeed the work of this period

The near-life-size female head from Uruk; height 20cm (8in); c3200 BC. Iraq Museum, Baghdad

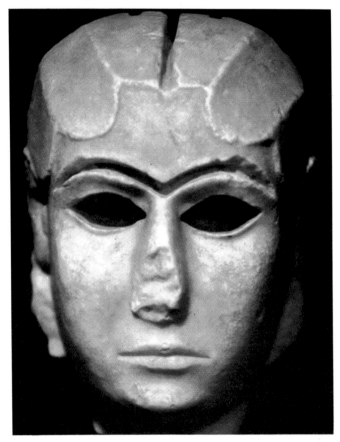

manifests a solid confidence that later Sumerian society rarely achieved.

The statuettes of the period were executed in stone, replacing the earlier medium of clay. They display a fresh massiveness, emphasized by the sculptors' reluctance to free figures from their matrices. Legs appear almost as thick as hips—only a shallow incised line separates them. On one exceptional example the muscles of the chest and forearms are cursorily rendered (Iraq Museum, Baghdad). Attention was normally directed to the face which, in the case of male figures, features a prominent nose framed by a large beard, and a cap with a thick rolled edge. One example of particularly sensitive facial modeling is a near-life-size female appliqué head found in the precinct of Eanna. Faint depressions around the thin-lipped mouth heighten the individuality of the work whose eyes are naturalistically oval rather than stylized as in later products. The pupils themselves are lost, but like the brows and hair were probably made of bitumen, shell, and precious blue lapis lazuli from Afghanistan. Originally such composite works were gaudy in appearance; otherwise harmonious surface planes were broken up by the insertion of alien materials—a practice similar to the method of architectural decoration just described. Bull figurines treated in this manner display an unearthly might.

The artistic endeavor directed into reliefs sought to represent the experience of religious observation. This purpose is implicit even in apparently secular reliefs, in which, for example, a man slays lions with a spear and arrows. There can be no doubt, however, about the contents of the three relief bands on a tall alabaster vase from Uruk (Iraq Museum, Baghdad). Below the lowest frieze are two incised wavy lines representing water. Moving upwards, there are then cereal crops and caprids—a progression from basic water through the plant and animal kingdoms which are represented by the species most important to the Sumerian economy and therefore most beneficial to man. In the next frieze upwards men are shown bearing gifts. Whilst above, in the top frieze, a procession of animals and men faces a woman, wearing a long robe, who stands before two tied bundles of reeds, symbols of the goddess Inanna. It is not certain whether the figure is the goddess herself or a priestess. This scene includes cult paraphernalia and should probably be interpreted as showing the property of the goddess stored in her temple treasury. The formal planning in the order of friezes suggests that the artist is seeking to do more than just depict Sumerian ritual. For here he has surely transcended the dictates of mere representation to represent as ritual a total view of Sumerian society. Such preoccupying depth of thought implies that Sumerian society was now served by specialist, full-time artists.

The flat relief carving, used on the alabaster vase just described, was later abandoned in favor of high relief in which, for example, rows of animals become almost detached from vases. Many cult vessels decorated in this heavier, later style feature lions attacking domestic bulls: an epitome of the perpetual conflict in nature. The marauding lions that infested the

dense marshscapes of Sumeria in the 4th millennium caused immense human fear—vividly evoked in the writings of Austin Henry Layard and other 19th-century investigators. A bearded protector figure, with arms draped over the bulls, was sometimes introduced into high-relief works. He is the "tamer of animals", a significant theme in the religious thought of many ancient societies. It was taken up by Egyptian iconography *c*3000 BC, demonstrating the existence of contacts between Sumeria and Egypt and, indeed, the preeminence of the former.

The cylinder seal was another invention of this period. It was usually made of stone and carved with intaglio designs so that it left impressions when rolled along a plastic surface. The effect it created—the endless repetition of stock motifs—influenced other forms of art, for example vase decoration. On the other hand, engravers borrowed subjects from larger works of art, adapting scenes showing ritual boating, architecture, construction, and antithetic compositions, many ill-suited to the new miniature form.

Both seals and impressions were sufficiently varied and numerous to provide us with an unmatched source of infor-

A cylinder seal from Uruk; *c*3000–2750 BC. Ashmolean Museum, Oxford

An alabaster vase from Uruk; height 92cm (36in); *c*3200 BC. Iraq Museum, Baghdad

mation about life at that time. A familiar figure in them is the distinctive Uruk Man who, with his cap roll, beard, and kilt, is often much taller than other humans. In one scene of surpassing mastery he is shown feeding leaping goats, heraldically arranged.

The period of the early city-states (c3000–2371 BC). The causes and indeed the events of the breakdown of the old Sumerian order are not known. Perhaps one important contributory factor was the increased flooding of settlements, accounts of which were later condensed into the Sumerian and biblical flood stories. The period's change of character, the replacement of confidence by tension and timidity, is well demonstrated, however, by its surviving works of art.

Seals provide a particularly good thread of evidence across the void linking the two periods. Human forms became less frequent, their place taken by exploded, stylized animals arranged in brocade-like patterns. They in turn were replaced by attenuated semihuman and animal figures locked in mortal

Brocade-like patterns (left) produced from early cylinder seals

combat. Similar development is seen in statuary where roundly modeled bodies gave way to geometric, abstract conceptions whose production sprang from utterly different motives.

The period of the early city-states saw a growth in population and a proliferation of urban centers. Towards its conclusion there was armed conflict between cities and the beginning of historical writing. Each city was held to be the property of a deity, and the leader of each cult-center to be the divine steward or bailiff. But as strife (often caused by disputes over water rights) became endemic, religious leaders became military leaders and the period developed into an age of heroes. Gilgamesh, hero of *The Epic of Gilgamesh*, lived in this age. But as the claims of rulers escalated little room was left for independent cities.

Such developments are well represented in temple architecture and objects. The worshiper was increasingly distanced from his deity and stores, priestly living quarters, and courtyards were interposed before the *cella*. At the holy city of Nippur a dual shrine lay beyond no less than three courtyards, one of which had columns. To overcome the resulting separation of the deity statues of worshipers were made to stand before him in continual prayer.

With the emergence of secular power during this period there appeared secular architecture. At Mari and Kish where, according to the Sumerian king-list, kingship first descended from heaven after the flood, complex structures that were probably palaces have been discovered. Further remains of this phase are the objects found in the mass burials at Ur, excavated by Sir Leonard Woolley. Their variety is bewildering; they show a delight in gold, silver, lapis lazuli, and carnelian—all deservedly worked to the highest standards of native craftsmanship.

As an introduction to the stiff and severe plastic statuary of the period we can consider the group of statues from the Abu Temple at Eshnunna (Iraq Museum, Baghdad). The largest wears a typical plain skirt with tufted hem on a stylized torso. The hair is corrugated and the beard stained with bitumen. Its impression of geometric immobility, however, is belied by the folded hands around the cup and the enlarged eyes which express the internal tension between the man, peering after the unattainable, and his god. Compositions too reflect a similar state. Indeed the consciousness of a breach is made salient by the rarity of representations of men and gods together.

Local schools of sculptors were well established in this period. At Mari, for example, fine work was produced for the temples in a style in which appeared complacent, smiling figures wearing richly flounced skirts, standing one foot in front of the other, with delineated strands of hair and their names inscribed on their torsos (National Museum of Aleppo). It is not know whether the style began here or elsewhere but it certainly became universally popular and used for metalwork as well as stone sculpture, as shown by a metal figure of a scribe who dedicates himself to the goddess Ningal, the Great Lady.

At the same time as statuary reappeared so also did relief

works. The most popular form was a square tablet with a central hole to secure it, perhaps to the wall of a building. The pattern of division into registers, seen on the Uruk vase of the Early Sumerian Period, was maintained but new subjects including boating, wrestling, and, above all, feasting to the accompaniment of music were introduced.

This important new theme, the "banquet scene" (which occurred throughout southern Mesopotamia) was also executed in mosaic-like inlaid panels composed of several precious materials. Such was the Sumerians' love of this form of decoration that, in spite of the inherent limitations of working with fragile and intractable shell, narrow friezes were inlaid high on temple walls. One such frieze, at Ninhursag's temple at Al Ubaid near Ur, shows sacred herds of cows being milked to produce cheese. The medium is white shell against a slate background.

Another prevalent motif was that of an eagle with spread wings and a leonine head resting its talons on the rumps of stags whose heads, in the round, are turned outwards in traditional manner. One of the finest renderings of this also comes from Ninhursag's temple at Al Ubaid, again a relief, but of copper sheet.

The apogee of inlaid decoration can be seen in finds from the cemetery of Ur, especially on vases and the sound boxes of harps. A harp appears in the top register of the Standard of Ur (British Museum, London) which also shows a banquet in white and red tinted shell, surrounded by irregular lapis lazuli chips inlaid in bitumen on wood. The other side of the standard shows a battle involving infantry and heavy, four-wheeled chariots: the scene presumably explains the feasting on the other side.

The same medley of materials plus gold and silver was used

A rampant goat from a tomb at Ur; c2600–2500 BC. British Museum, London

The largest statue from the Abu Temple at Eshnunna; height 72cm (28in); c2700 BC. Iraq Museum, Baghdad.

The Royal Standard of Ur

Reconstructed from numerous fragments of lapis lazuli, shell, and reddened limestone, the Ur "Standard" is still the most colorful treatment of two perennial themes of the Sumerian Heroic Age, that of the Victorious Battle and the Banquet or Symposium Scene. It lay "war" side upwards in a corner of the back room of a plundered tomb in the "Royal" Cemetery at Ur beside a man wearing a cap woven with thousands of lapis lazuli beads. Sir Leonard Woolley's masterful recovery is an assurance that the present arrangment of the mosaic is correct.

Each flat, sloped side has three registers divided by narrow bands of lapis and red limestone squares. These tesserae and the shell were fixed to a wood base by bitumen. The lapis was ultimately derived from sources in distant Afghanistan, but was obviously cut to shape locally, probably at Ur itself. The figures of contrasting white native shell were executed in silhouette form; engravers, however, were also capable of producing more sophisticated relief work.

On the "war" side are wagons and infantry in battle, while in the top register a central leader, much larger than the other figures, receives bound-and-yoked prisoners. The military engagement is stylized, for the vanquished are already without armor or clothes, but the victors are represented with attention to detail. Particularly notable are the high-fronted wagons, each with driver and, standing behind him on a projecting platform, an ax- or spearman. They are early forms of wheeled transport with fixed front axles, so they could not maneuver like chariots. Two-part solid wheels like those depicted have been found in excavations, as have the double-looped rein rings. A silver example from another Ur grave is surmounted by a bull mascot and indeed oxen rather than the onagers or wild asses of the Standard were used to draw similar wagons into adjacent tombs and death pits, probably for practical and ceremonial reasons.

The onagers link the two sides, since they recur, without wagons, on the "peace" panel in a procession of variously dressed persons leading other animals and carrying fish, a lamb, baskets, and sacks. These probably represent the spoils of the victory being celebrated by an assembly of seated figures, about to drink, to the accompaniment of a lyre and singer or dancer. Again, a larger man is shown in this top register, attired in a fleeced skirt rather than the plain ones of the six who face him beyond two attendants. The reality of detail is once more confirmed by the discovery of identical bull-fronted lyres from the same cemetery. Moreover, statues of figures holding cups, as here, are also known from Sumer, and the long hair that distinguishes the person on the far right also adorns a roughly contemporary statue of Urnanshe, who is identified as a singer.

Whatever the function of this object—perhaps the sound box of a harp—the com-

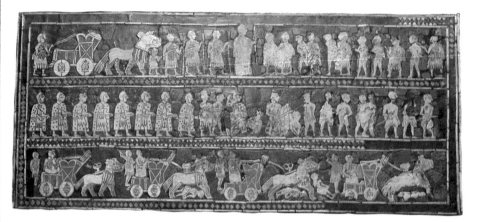

▲ The Royal Standard of Ur: the "war" panel. British Museum, London

▼ Urnanshe, the singer, from Mari. National Museum, Damascus

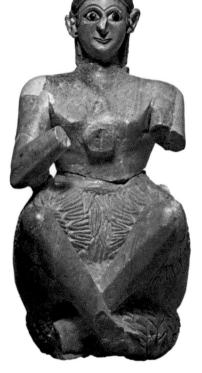

▲ The Royal Standard: an end panel. British Museum, London

► The golden lyre from the Royal Cemetery, Ur. Iraq Museum, Baghdad

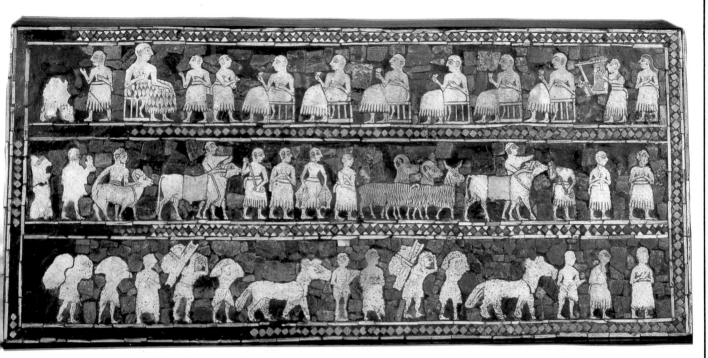

▲ The Royal Standard of
Ur; the "peace" panel.
20×48cm (8×19in); mid
3rd millennium BC.
British Museum, London

▶ An inlaid wooden
portable panel from
Mari. Louvre, Paris

position belongs to a genre well established
in Sumer. It is found on wall plaques and, in
fragmentary form, on other wooden portable
panels, almost all from temples. The latter
show variations in costume and motifs, like
some cylinder seals from the site of Mari in
Syria, but usually the Banquet Scene involves
a female dignitary. This has led to sugges-
tions that a Sacred Marriage or New Year's
Festival is represented. At the top left of the
"peace" panel is another large but destroyed
figure with what could originally have been a
flail or leaf like that held by the female on a
Nippur plaque.

It would be important to know who is
represented at the top left since the presence
of a female, as well as the existence of the
explicitly religious and mythological content
of the side-panels, would make the Standard
much more comparable with the wall-plaques.
Her position, however, would be unusual
and without her the feast in this case lacks
clear religious symbolism when compared
with other Banquet Scenes of the age, and
looks more like a general and his officers in
congratulatory poses. It is therefore an ex-
ceptional variation of an established theme
and this military aspect may have to do with
the status of the occupant of the tomb in
which Woolley found it. Unfortunately, the
tomb when found was thoroughly disturbed
and yielded only one name, that of a man,
Ezi, and, apart from odd finds and traces of a
few more bodies, five spear-bearers at its
entrance.

E.J. PELTENBURG

▼ A clay model of a
chariot from Tello.
Louvre, Paris

▶ An engraved shell
plaque from the Royal
Cemetery at Ur. British
Museum, London

Further reading. Amiet, P. *La Glyptique
Mésopotamienne Archaïque*, Paris (1961). Boese, J.
Altmesopotamische Weihplatten, Berlin (1971).
Moorey, P.R.S. "Some Aspects of Incised Drawing
and Mosaic in the Early Dynastic Period", *Iraq* vol.
XXIX (1967) pp97–116. Moorey, P.R.S. "What do
We Know about the People Buried in the Royal
Cemetery?", *Expedition* (Fall, 1977) pp24–40.

in an enigmatic object, from a tomb at Ur, showing a rampant goat peering through shrubbery (British Museum, London). Its significance is difficult to understand—it seems to be more than just a picture of a goat. At the least it reflects the Sumerians' strong belief that divine power resided in animals.

In the last century of the period of the early city-states the stela—a large decorated slab that stood in public—was introduced (c2400 BC). Its purpose was to act as a public record of an historical event and to this end combined equally both inscriptions and scenes with figures. A particularly fine example is the stela of Eannatum of Lagash, "the Stela of the Vultures" (Louvre, Paris). On one side Ningirsu, the tutelary deity of Lagash, defeats his enemies by capturing them in a net. On the other, Eannatum, riding in his chariot at the head of a phalanx of infantry, achieves his destiny. In Sumerian minds the two actions were indissolubly bound: the former realized the latter. And so we see another Sumerian pictorial affirmation of their belief that harmony between the gods and men is the basis of peace in human society.

The stela also shows how the visual arts were employed to convey the content of Sumerian epics and poetic literature, since the sequence showing Ningirsu clubbing his enemy is known from the *Epic of Creation*. This scene also demonstrates how the Sumerians have begun to represent their deities—in human form. But numinous qualities are not portrayed by facial distinctions; details of attire and divine attributes such as bulls' horns are preferred.

The Stela of Eannatum of Lagash; height 180cm (71in); c2500 BC. Louvre, Paris

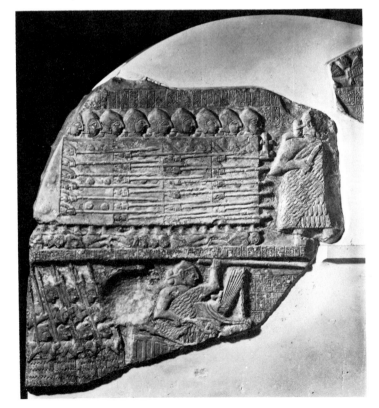

The period of the Akkadian Empire (c2371–2230 BC). This was the period of the first Semitic Empire and it takes its name from the new city of Agade, built perhaps near Kish by the first king of an upstart dynasty. The name is also used for the Semitic language which now began to supplant Sumerian.

The change involved an internal shift of power—not an invasion (our information about a major change is available from written sources for the first time). Political organization, cultural attitudes, religious outlooks, and art differed considerably from the time of the proto-imperial city-states, but many changes were crystallizations of previous trends, now with Semitic dimensions.

Two major developments were the broadening of areas of political and military interest and an intense centralization of power into the hands of one king. Into the orbit of Akkadian power came the areas covered by modern Turkey, Syria, and Iran. Boats from Dilmun (modern Bahrain) and far beyond tied up at the quaysides of Agade. The importance of Sumer was diminished and indeed it was treated as one unit in "Sumer and Akkad", the new official title for South Mesopotamia. In place of kings in this area governors were appointed—often relatives of the king of Sumer and Akkad.

The position of the king was now akin to that of a lordly sheikh—he was no longer just a humble servant of the gods. To ensure a loyal personal following it was necessary to foster charisma. In the case of the founder Sargon (his throne name, meaning "real" or "true king") this was so strong that he was celebrated in epics and omens for several centuries after his death. The inevitable outcome of developing a cult of the king was reached within a few generations: the king came to be regarded as a god.

These traumatic historical changes were reflected in the statuary of the period. Both subject matter and the spirit that pervades it are new. Statuettes of worshipers became extremely rare. Instead, imposing life-size statues of kings were carved. Their drapery ripples with a sense of life never even attempted before, and underneath there was organic musculature in place of the earlier flat planes and angles. We have reached a major turning point in Mesopotamian art. Henceforth it is often concerned with the royal personage. So unambiguous was the change that a famous, uninscribed bronze head from Nineveh (Iraq Museum, Baghdad) with portrait-like qualities can, without any hesitation, be claimed as a portrait of Sargon or one of his successors.

The movement away from Sumerian abstract and geometric forms to Akkadian animation and grandeur can be traced in several stelae, for Sargon retained both the use of such monuments for recording historical incidents and similar arrangements and styles on them. However, a harder diorite became the favored medium and there were stylistic developments: more pointed beards and, of more importance, space between individual figures where previously there had been clusters of manikins. Advantage of this change was taken later to present tense scenes of combat between individuals. Such scenes and files of warriors and naked prisoners were the main subjects of

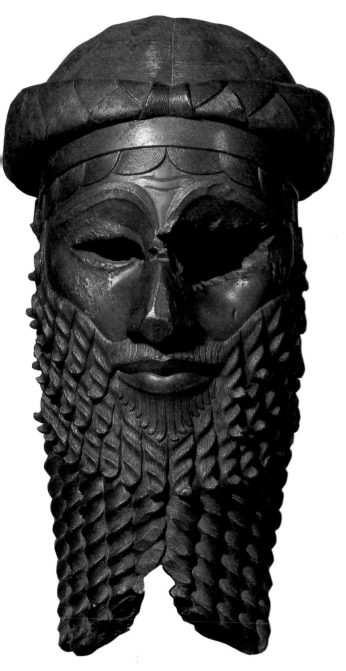

A bronze head from Nineveh; height 37cm (15in); c2371–2230 BC.
Iraq Museum, Baghdad

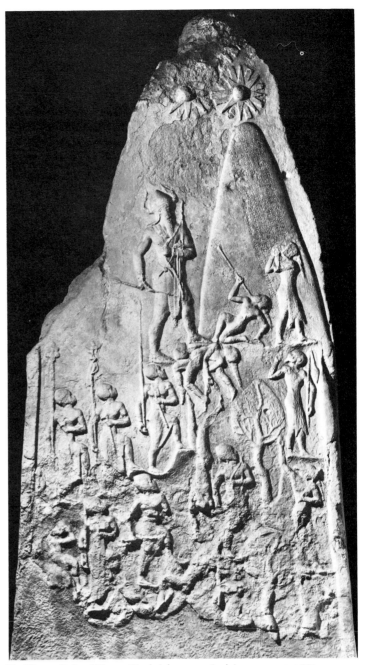

The Victory Stela of Naram-Sin; height 200cm (79in); c2291–2255 BC.
Louvre, Paris

reliefs, usually drawn from particular incidents and under-lined with inscriptions such as that of Sargon who "fought with Lugalzaggesi, the King of Erech, took him prisoner, and brought him in a neck-stock to the gate of Enlil".

The zenith of Akkadian art was reached in the Victory Stela of Naram-Sin (Louvre, Paris), the third ruler after Sargon. It is a dramatic paean to the might of the deified king who is shown wearing the symbol of divinity—a horned headdress. Gone is the rigid stela shape, the constricting register divisions, and the set battle pieces. Instead the monument is nearly conical in form, which stresses the upward movement of the soldiers it depicts climbing in wooded mountains. Their gazes lead the observer's eye upwards to the archetype of invincibility. Contorted postures heighten the drama; see the two crossed foes trampled underfoot by the King and the kneeling trumpeter (also a defeated enemy) whose back is arched.

The Stela of Naram-Sin displays a change of content that may imply a change in purpose. The battle concerned is over, victory assured; by suggestion it is futile to resist. The triumphal pose of Naram-Sin on the stela was subsequently adopted for use on rock reliefs that were cut in enemy territories during this period. They served as much to warn as to celebrate. Yet in spite of ubiquitously displayed confidence the dynasty was to last only approximately 64 more years. It then fell, at the hands of barbarians.

During the period of the city-states, seal-engravers almost exclusively carved bands of fighting figures—animals, demi-gods, and humans, usually upright, often crossed and compressed in furious biting and stabbing. Banqueting and other scenes sometimes featured as did myths during the proto-imperial period. But most figures were schematic, lifeless, staring: the products of poor workmanship.

The popularity of myths and legends during the Akkadian period opened up a new and seemingly inexhaustible fund of themes for glyptic art. The struggling figures were not forgotten—some produced during this period stand as examples of the finest glyptic art ever. For by choosing to present contests between individuals rather than crowd scenes, against an empty background (compare the development of relief composition in this period) individuals are deeply modeled, tense, and life-breathing warriors. Scenes in which a human is presented to a deity were also finely composed with realistic figures. The Sun God, fertility deities, and others frequently appear on surviving examples, but rarely can scenes be assigned to any particular legend. On some seals a man shown sitting on an eagle can be identified as Etana, who was taken to heaven on an eagle he had rescued from a pit, in order to secure the plant of birth (examples in the Pierpont Morgan Library, New York and Vorderasiatisches Museum, Berlin). The legend (of which we do not know the end) is familiar only from later sources, but was probably current at this time.

The Neo-Sumerian period (c2113–2006 BC). According to Sumerian documents, the Dynasty of Agade was doomed and Sumer laid waste because Naram-Sin wantonly destroyed the Ekur, the sanctuary of the god Enlil in Nippur. The instrument of Enlil's vengeance was the Guti, a barbarous horde perhaps from the mountains to the east, who brought chaos and anarchy to Sumer.

From the ashes of the catastrophe came a revival of former artistic traditions but in forms heavily indebted to Akkadian advances. In the Guti period the *ensis* or steward-rulers of Lagash seem to have been particularly important as patrons. They certainly had command over some of the finest artists in the land and were able to obtain materials from abroad. The results were magnificent buildings containing statues, stelae, votive tablets, and basins.

The statuary of the period radiates a chastised, pious, and yet complacent strength—perhaps the hallmark of the age. The figures possess an inner life of their own. On their lower portions are inscriptions which chronicle the construction of holy places and canals and also dedicate the work, using the first person. For example, the inscription on a statue of Gudea I (Louvre, Paris) reads, "I am the shepherd loved by my king [the god Ningirsu]: may my life be prolonged."

Statues of the Neo-Sumerian period retain the felicitous rendering of the naked human figure and the folds of garments (though the cloth now represented is heavy and tends to conceal the human form with its stiffness) which developed during the previous Akkadian period. New details appear; a wide-band headdress, shaven head, stylized conjoined eyebrows, and elongated fingers.

The many surviving fragments of relief work demonstrate clearly the conservatism of the period and its deliberate at-

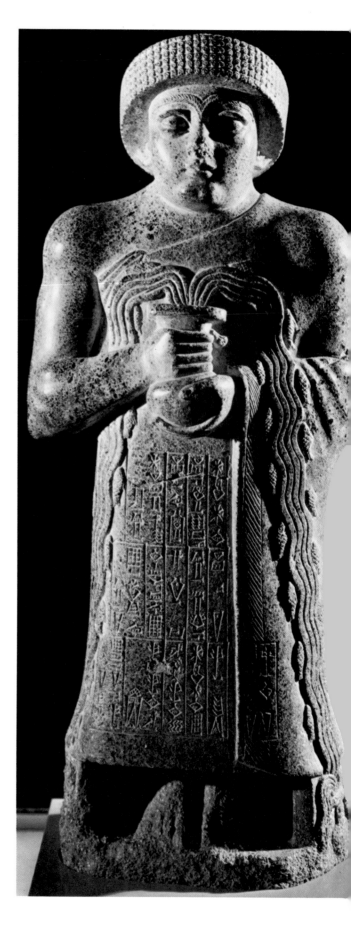

A statue of Gudea I; c2200 BC. Louvre, Paris

tempt to revive the "good old days" of the past. An imposing example of this is the 10 ft (3 m) high stela of Ur-Nammu (the founder of the last Sumerian dynasty; University Museum, Philadelphia) which reverts to the shape and register divisions of the stela of Eannatum. A memorial to the king's service to the gods, it also displays the same tranquility as the sculpture in the round of this period.

In the stela's top register Ur-Nammu, dominated by two divine symbols, makes a sacrifice to a horned deity. In the one below he stands before two seated deities, probably Nanna and Ningal, whose positions are determined by a peculiar foldout perspective. Behind Ur-Nammu is a minor interceding deity whose pose is repeated with monotonous regularity on seals of the period depicting similar scenes. For access to the great gods could seldom be direct and was usually facilitated by the intercession of a personal, guardian deity of minor status. For such deities household shrines proliferated in this period and the tedious reiteration of rituals became a stock theme of Mesopotamian art. So too did vases with flowing water, reflecting cult practice. This can also be seen in Ur-Nammu's stela, in the top right where a hovering deity pours life-giving water over the major scene.

The purpose of Ur-Nammu's stela was to embody divine justification and indeed encouragement for a building project. This is symbolized in the middle register where Ur-Nammu is seen receiving a rod and line; he is also shown realizing his project as he shoulders mason's tools. He was in fact a prodigious builder and was responsible for, among other works, the famous ziggurat or stepped tower to the moon god Nanna at Ur, ziggurats in other cities of his empire, the enormous complex for the goddess Ningal in which her statue is placed so as to be visible along an axis passing through several doorways, a palace, and his vaulted royal tomb.

Building activity on such a widespread scale has resulted in the preservation of many of the copper figures that were sealed under the walls and thresholds of buildings to provide magical protection. They were mass produced, and the figure of the king, carrying a basket, perfunctorily rendered. The last specimens of a type that began as part man, part nail in the period of the early city-states, they disappeared along with many other Sumerian conventions in the cultural disintegration following the arrival of more waves of Semites in southern Mesopotamia.

The Old Babylonian period (c1890–1600 BC). The demise of Sumerian civilization at the beginning of this period took place at the same time as a complete rearrangement of the props and actors on the ancient Near Eastern stage. The Amorites established themselves in the south. Assyrian power grew in the north. Hurrians moved from east to west across the northern Mesopotamian marches. The Hittites assumed political control in Anatolia.

In Sumer and Akkad there was strife, until Hammurabi, the sixth king of the First Dynasty of Babylon (1792–1750 BC) welded together a precarious empire. Its formation required

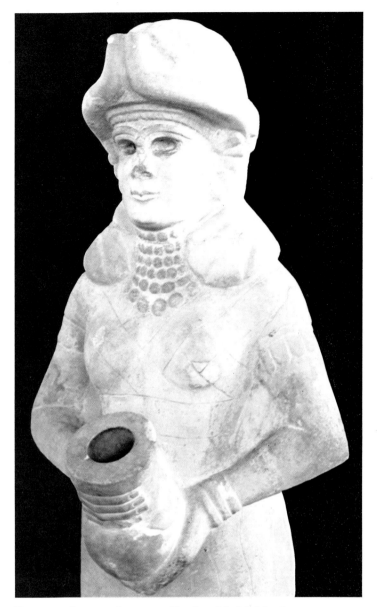

Upper part of a statue of a water goddess from Mari; height of statue 140cm (55in); c1900–1760 BC. National Museum of Aleppo

the destruction of several cities, including Mari. It is this city, rather than the later rebuilt Babylon, that has yielded the most information about this phase of Mesopotamian history.

Mari was both renowned and rich. Kings from places as far away as Ugarit on the Mediterranean coast requested permission to visit the city's 200-room palace. From its control of trade Mari derived its wealth, even from abroad. Texts of the period mention a dagger from Kaptara or Minoan Crete. The products of its artists, however, were infused with Amorite spirit.

In one of the courts of the palace stood a near life-size statue of a water goddess holding a jar similar to the one on the stela of Ur-Nammu (now in the National Museum of Aleppo). This one actually dispensed water since the vase was connected by a pipe through the body to a hidden basin. Through its stream onlookers were able to discern fish. These were lightly incised on the goddess's robe, which was flounced—a Sumerian practice. New interpretations are to be seen, however, in the rendering of the shoulder straps, the tabbed hems, and the massive yet crisply modeled head.

Similar water goddesses appear in the lower panel of the central structure of the *Investiture of Zimrilim*, a wall-painting from a court of the palace of Mari (Louvre, Paris). It is difficult to interpret the whole composition because its iconographical concepts and painters' conventions are not understood. Parts are more easily comprehended. The upper panel of the middle box may show a cult scene inside a temple, surrounded by the sacred trees and guardian figures that would have stood outside the building.

The painting's "investiture" scene derives from the earlier "introduction" theme; so do the postures of the individuals. But against this religious and cultural continuity stand novel aspects in dress and perspective. The king wears a fringed garment and a tall headdress. There are composite monster-griffins. An attempt is made to render the divine horns in profile perspective. And the goddess Ishtar, holding out rod and line, adopts a new stance by placing one foot on a lion (her attribute)—a pose ultimately derived from Naram-Sin's. She also holds an eye-ax which was the forerunner of a scimitar.

The last important monument that survives from the Old Babylonian period before the destruction of Babylon by a Hittite army (c1600 BC) is the diorite stela of Hammurabi inscribed with his law code (Louvre, Paris). Shamash, the sun god (identified by the rays emanating from his shoulders) hands a rod and line to Hammurabi—perhaps the tokens of divine authority for the king's dispensation of justice. Although Hammurabi's heavy dress, beard, and headgear seem to muffle his body, the folds of the cloth and the muscles of his forearm are carved and polished with greater accuracy than ever before.

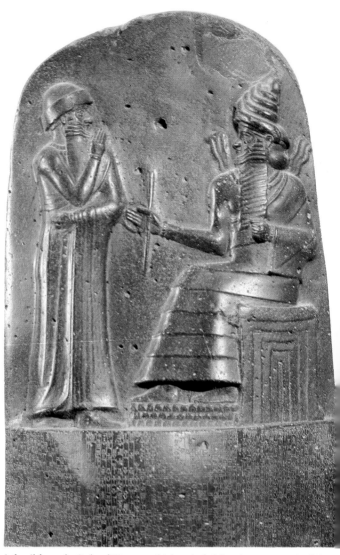

A detail from the Stela of Hammurabi; basalt; height of scene 71cm (28in); c1792–1750 BC. Louvre, Paris

Assyria and Babylonia. Our information on Mesopotamian art for several centuries effectively ceases with the destruction of Mari by Hammurabi (c1760 BC). A few cylinder seals from the time of Hammurabi's five successors are known, but they do not reveal any important artistic developments. Nor is much known about the art of the Old Assyrian Empire which flourished just before the time of Hammurabi.

The main reason for the dearth of artistic effort in Mesopotamia was the enfeeblement of the established kingdoms in the wake of newcomers. Two groups, the Kassites and the Hurri-Mitanni, became politically important in the Near East, but the extent of their independent contributions to the culture of the area has yet to be assessed.

The Kassites (c1550–1157 BC). The origins and affinities of the Kassites, who wrested control of Babylonia after the Hittite raid mentioned above, are unknown. Their language and customs were certainly alien to the lowland plains of the south. But their arrival in Babylonia is recorded by one of the few breaks in the archaeological record—a major turning point in a historical sequence of cultures generally noted for their impressive continuity.

The earliest Kassite remains date from the time just prior to

the international epoch known as the Amarna period (corresponding to the reign of the Egyptian pharaoh Akhenaten (1363–1346 BC) in whose palace at Amarna diplomatic correspondence from the whole of southwest Asia has been found). Molded clay bricks have been found at Ur, Susa, and other cities. Those found at Uruk have been reconstructed to produce the decorated, recessed facade of the temple of Inanna (Iraq Museum, Baghdad). Both the facade and the layout of the temple are in new idioms. The scheme of decoration had been first seen c2000 BC, but the Kassites must be credited with the responsibility for its inclusion in the artistic repertory. The form culminated in the Ishtar Gate of Nebuchadnezzar at Babylon.

In the recesses of the facade stand gods and goddesses, each holding a vase of flowing water above their elongated trunks. The streams of water link the deities in a manner similar to that on the painting from Mari discussed earlier, suggesting that many older traditions were preserved in spite of the new rulers. This is indeed confirmed by the archaic features and contents of writing from this period. This architectural use of sculpture was in fact similar to the Hittites' practice in Anatolia—a hint of the many international artistic similarities that were to follow. Palace walls were now painted, with rows

of heavily robed courtiers. The walls of other buildings were enriched with glass.

The most distinctive artistic form in this period and the one slightly later was the *kudurru*, a stone boundary marker erected to confirm the royal grant of land to an individual—an entirely new concept in the organization of society. The sanctity and therefore permanent nature of the grant was usually expressed by reliefs containing a plethora of divine symbols. Actual representations of divinities were now being replaced by monstrous creatures and symbols derived mainly from the Old Babylonian period. The change reflects a profound alteration in the religious outlook of Babylonia and elsewhere. Similar creatures also appeared on cylinder seals but in fact columns of inscriptions came to replace figures almost completely.

The Hurri-Mitanni (c1700–1350 BC). During this period of the 2nd millennium two disparate peoples infiltrated northern Mesopotamia (into the area between the Zagros mountains of Iran and the Mediterranean Sea). The first group, the Hurrians, of northeastern origin, were populous but completely lacking in political cohesiveness and the artistic display of higher civilizations. The second, slightly later intruders, the Indo-European Mitanni, worshiped Indra, Mitra, and Varuna. In spite of being fewer in number they formed a ruling caste vigorous enough to bring tenuous political unity to the area. It lasted until c1375 BC, managing for a time even to eclipse Assyria to become one of the strongest empires in the Near East.

It is still a matter for debate whether the Hurri-Mitanni produced any original art. No distinctive large sculptures or paintings survive from the area's central region, only a few ivories which were inspired by, if not actually imported from, the Levant. But then the Empire's capital city has yet to be found.

Two peripheral sites have been excavated. Nuzi, in the eastern sphere of the Empire, contained two temples and a building that was perhaps an administrative center. The latter contains a fragment of wall-painting, an empaneled series of stylized trees, bulls' heads, and female heads that were obviously copied from the Egyptian Hathor heads in the Levant.

Alalakh, in the west on the bend of the River Orontes, hovered between independence and vassalage to the Mitanni and other powerful states. At the time when an important statue and palace were erected its population was largely, though by no means entirely, Hurrian. The most impressive feature of the half-timbered palace was its double-columned entrance portico which formed the main part of the complex later imitated by the Assyrians. There is no proof, however, that this was a specifically Hurrian concept—indeed, an earlier palace with an internal columned entrance has been found there, suggesting a native origin for the feature.

The statue of King Idri-mi, the putative builder of the palace (British Museum, London), has a receding chin, an unbroken line from brow to nose tip, and large eyes. All these

may be recognized as traits of Hurrian art, for the statue-heads of his predecessors are differently rendered. Similar features are to be found on several bronze figurines from Ugarit, where there was also a large Hurrian element (Louvre, Paris). Idri-mi's robe has a rolled border, a North Syrian feature adopted by Mitannian kings, and is covered with his autobiographical inscription. It tells of his rejection, exile, and triumph through his acceptance by the Mitanni: "our word seemed good to the kings of the warriors of the Hurri-land".

The statue of King Idri-mi; height 104cm (41in); c1500 BC. British Museum, London

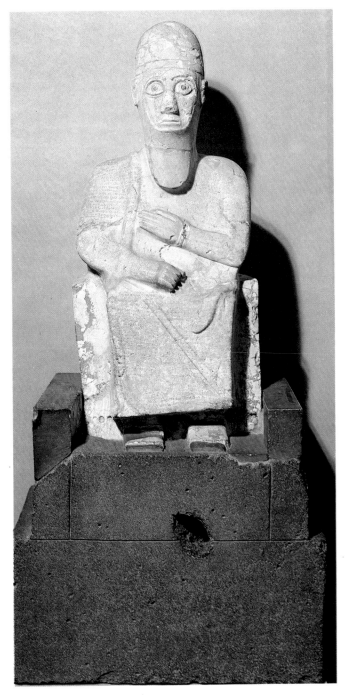

Present evidence suggests that this group rejected monumental artistic expression in favor of small works sometimes produced by new techniques in new media. This may reflect the more mobile life of this society, for now appeared the horse and chariot and the charioteer *maryannu* warriors as the society's knights. One such heroic charioteer, with reins tied round his waist to free his hands for firing arrows at fleeing animals, may be the figure on a gold bowl from Ugarit (Louvre, Paris) but such scenes and figures had now become widespread motifs. If the work shows any particularly Hurrian element it is the exclusion of landscape, which was usually included in outdoor scenes on other works, for example on another gold bowl found alongside the one mentioned above (National Museum of Aleppo).

On the seals of the period free-field composition also produces an image of timelessness. Heterogeneous yet recognizable motifs from Babylon, Syria, and Egypt are mixed, combined, and modified, but the result is an undisciplined *mélange*. Another, more restrained type shows worshipers or animals beside a sacred, artificial tree. They are mass produced in faience, a medium which, together with glass, is now of some importance.

The art of the Hurrian craftsmen-artists was essentially derivative. They showed themselves most successful in the production and decoration of small objects, such as the iron dagger that was sent to Egypt. Their independent position in northern Mesopotamia did not outlast the destruction of the kingdom, but some Hurrians continued for several centuries to live independently in the highland fastness of northwest Iran.

Middle-Assyrian art (c1500–1045 BC). An internal resurgence enabled Assyria to take advantage of declining Mitannian power and rise from servitude to independence and great statehood. The Mitanni's position in the political context of the Near East was also assumed—correspondence began with Egypt, the Hittites were threatened, and Babylonia was first checked and then conquered. In the new expanded state the principal influences came from the Hurri-Mitanni and Babylonia—the latter was especially influential in literature, learning, and religion. In the reigns of Eriba—Adad I and Ashuruballit I (1392–1330 BC)—a renaissance occurred: from this time a new burst of creativity can be traced.

Cylinder seals provide the best guide to stylistic development, for several are attested by impressions on datable tablets thereby providing a chronological framework. On the earliest ones (for example, those in the Pierpont Morgan Library, New York) are griffins and other monsters, fewer in number than before and spread across the complete width of the cylinder surface. Although the seals' motifs are often Hurrian, the style's monumentality, plasticity, and sense of orderliness is distinctly Assyrian. Landscape appeared in seal designs towards the end of the 14th century BC, passed to Assyria from Minoan Crete by way of Syria's cosmopolitan workshops, but was only used with diffidence.

During the 13th century BC a restrained mastery was achieved in glyptic art by using empty space and isocephaly to highlight intricately observed combats between a single pair of figures. New monsters, such as the centaur and "Pegasus", were unleashed into this fanciful, magico-religious iconography. One convention typical of the period was the mannered treatment of the kicking hind leg. Such work may have influenced late Kassite glyptic art. In tone and execution it is reminiscent of Akkadian verve.

Few large works of art survive from this period. One that does, from a site near Ashur (whence "Assyria"), is a paneled arrangement like the Nuzi painting showing opposed gazelles on either side of a sacred tree. The medium is painted stucco, the finishing colors red, white, black, and blue. Linked palmettes and lotus plants form a border that foreshadows later Assyrian patterns. So too did the stone pedestal reliefs of King Tukulti-Ninurta I (1244–1208 BC), which were in effect small prototypes of the great flat reliefs of the palaces.

Although the few surviving objects demonstrate that a vigorous and original Assyrian style had evolved well before the end of the 2nd millennium BC, scholars still ask themselves to what extent the foundations had been laid for the art of the later famous palaces. Tukulti-Ninurta's reliefs are the first Middle Assyrian attempt known at such a form, but they did not constitute murals. But two obelisks, which seem to belong to a transitional period, are known (British Museum, London). The pillar-like stones are stepped at the top with bands of reliefs on the sides. Their rendering is inept, but within their designs the ideas of narrative pictorial art and the appropriateness of hunting, besieging, and tribute-giving scenes are quite implicit.

Further evidence is provided by inscriptions that mention the existence in the late Middle Assyrian Period of many features that were typical of the one following. For example, in speaking of his father's palace, King Tiglath-Pileser I (1115–1077 BC) says:

> I heightened its walls and gate-towers, I surrounded it as in an enclosure with tiles of *surru* stone, lapis stone, alabaster, and marble. Pictures of date trees of *surru* stone I placed on the gate-towers, bronze nails with round heads I put round about. I attached tall doors of pinewood, with bronze sheet did I encase them and placed them in the gate.

Even if our knowledge of the styles mentioned is imprecise, the tone of the language used, the concentration on grandiose, decorated architecture, and the individual elements mentioned prefigure a Neo-Assyrian outlook.

The Assyrian palaces and their reliefs (c890–610 BC). Travelers to the Near East had often reported the existence of great mounds near Mosul. Although Claudius Rich, the British Resident at Baghdad, made a famous map and description of Nineveh in 1820, it was not until M. Emil Botta, the French Consul in Mosul, switched his attention in 1843 from Nineveh to Khorsabad, the Fort of Sargon, that the first sculp-

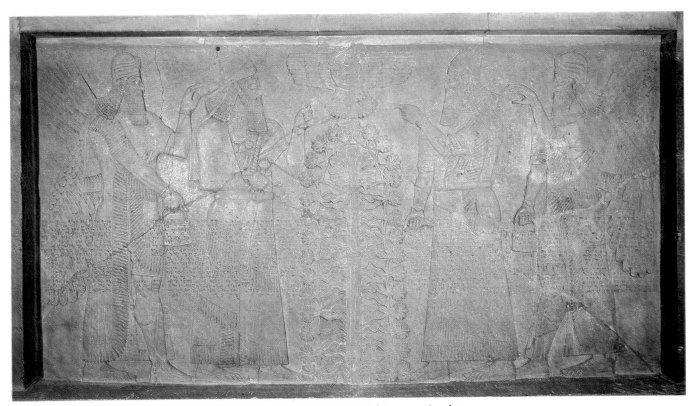

A relief from the reign of Ashurnasirpal II; height 193cm (76in); 883–859 BC. British Museum, London

tured slabs were found *in situ*—a frontage no less than half a mile (0.8 km) in length.

At this point the field of investigation was entered by Austin Henry Layard, a gifted observer and draughtsman who was to make astounding discoveries at Nimrud (biblical Kalah) and Nineveh. By 1851, as a result of fearless courage and persistence in undertaking excavations in trying conditions, Layard had discovered eight palaces and established the discipline of Assyriology. Excavations, though on a smaller scale, have intermittently continued on these mounds ever since. The most recent, by Iraqi archaeologists, have revealed traces of paint, noted also by Layard, but subject to fading.

News of the discovery of the Assyrian palaces came like a revelation to western Europe, hitherto steeped in Greco-Roman Antiquity. It stimulated an interest in corroboratory biblical research in an intellectual world that was being attuned to new perspectives following the Great Exhibition of 1851 and the publication of Darwin's *Origin of Species* in 1859. It led to the present rich collections of Assyrian murals, especially those in the Louvre, Paris and the British Museum, London.

In origin Assyria was a small state with its original capital at Ashur, beside the Tigris, about three days' ride from the top of the triangle in which most of the important cities clustered. When it expanded to form the first world empire (even taking in part of Egypt) it was forced to organize under its tutelage a mass of peoples with radically different cultures. Ultimately it failed: its capital, Nineveh, was destroyed. But the means whereby control of such an enormous area was attempted are of abiding interest, and it is in this light that painting and wall-paintings assume importance for they buttressed the crucial characters and functions of Assyrian kings. For each ruler a new style was inaugurated.

Assyria's king was the chosen warrior of the state god, Ashur. He was also the repository of the society's fortunes. Both themes were depicted in the decoration of the earliest palaces, but by the 7th century BC the secular, warlike aspect was most emphasized.

The shift probably paralleled changes in the nature of kingship and the purpose of the reliefs. In the early reliefs from the reign of Ashurnasirpal II are compositions showing rituals, in which the king achieves supernatural status, larger and in greater number than scenes of war (British Museum, London). And even the latter are imbued with spiritual significance by the presence of Ashur winging his way above the chariots' teams of horses or crouching inside a battering ram. The reliefs of the later empire make quite a contrast. Here there is no transcendence: ritual scenes are shunned, the army marches without its god. Instead of depicting the point of a battle when victory is in the balance, even if eventually assured, a narrative demonstrating the king's invincible, earthly might is shown—a tedious parade of slaughter, tribute-taking, and deportation, seen for example in the reliefs of the Elamite campaigns. In fact, gods are represented mainly by their symbols in Assyrian palace art. As the Empire grew in size the king assumed more supernatural powers though he never claimed to be divine. On the bronze door reliefs of the New Year's shrine at Ashur "the figure of Ashur going to do battle against Tiamat is that of Sinnacherib".

During the 9th century BC an unprecedented geographical expansion of Assyria took place and reliefs were carved to chronicle the king's deeds and commemorate his heroic actions. Then followed a phase of weakness succeeded by a time when new confidence is reflected in a greater number of reliefs. When illiterate kings, princes, and messengers came to Assyria, and beheld the miles of pictures in the Babylonian,

Arab, and Susiana rooms at Nineveh, they must surely have been inpressed by the might of Assyria, the hopelessness of resistance, and the futility of rebellion.

Slab after slab, room after room, the message recurred. Reliefs provided intense propaganda immediately relevant to the political context of palace life. They proved that once the Assyrian army was mobilized the result of battle was a foregone conclusion, so foreign kings under diplomatic pressure (for example Hezekiah at Jerusalem, mentioned in 2 Kings 18: 17f.) were wise to submit before the ultimate resort of war.

Such reliefs were only one element of palace decoration, the lowest on walls that had aesthetically unrelated, colorful, painted and glazed adornment higher up. The palaces themselves were composed of several courtyards, which were divided into public and private sectors by the long, narrow throne room with its great buttressed elevation and sumptuous relief decoration. In the citadel of a city founded by Sargon, Khorsabad, several temples and a ziggurat were closely linked with the palace, a conjunction reflecting and stressing the dual political and religious importance of the king.

The Assyrians produced artistic work in forms other than

A mural relief from Sargon's Khorsabad: shooting fowl in a grove; height 127cm (50in); 721–705 BC. Louvre, Paris

reliefs, and did not necessarily hold the latter in higher esteem than the former. This is borne out by Sinnacherib's description of his rebuilding of Nineveh. The earlier palace there was "not artistic" so he had a new one constructed with cypress doors "bound with a band of shining copper", cedar and copper pillars on bases in the forms of two lions or two mountain sheep, the "protecting deities", and limestone reliefs that were "dragged" in by the conquered. Elsewhere Sinnacherib introduced portals "patterned after a Hittite palace"; "female colossi of marble and ivory ... pegs of silver and copper"; pillars with capitals of lead; beams sheathed in silver; lion, bull, and cow colossi over posts and crossbars. He was particularly pleased to find new veins of raw materials and to have metals carted down from the mountains so that sculptors could pour the molten material into clay casts for bronze images in Assyria itself. Such was Sinnacherib's close interest in artistic work that he called himself "wise in all craftsmanship".

Layard excavated a small part of Sinnacherib's palace and reports that "seventy-one halls, chambers and passages whose walls ... had been panelled with slabs of sculptured alabaster ... nearly two miles of bas-reliefs, with twenty-seven portals formed by colossal winged bulls and lion-sphinxes were uncovered".

Assyrian art: the early phase (883–824 BC). The minimal standards for the art and architecture of the Assyrian Empire were set by Ashurnasirpal II (883–859 BC) in his new eight-winged palace at Nimrud, opened in the presence of 69,000 inhabitants from his newly conquered territories. Although certain sculptured and architectural prototypes existed in Assyria and Syria, and there were already walls with attached relief orthostats in northern Syria, an area that helped to populate the rising metropolis of Nimrud, Ashurnasirpal II was no mere copyist. He did not simply draw together preexisting traditions and employ them for work of larger proportions, but contributed something original and enduring in the form of narrative, pictorial art.

The annalistic depiction of Ashurnasirpal II's deeds—besieging cities, taking tribute, hunting lions and bulls—displays the systematic planning of several slabs to create a consecutive unified world of action. The earlier individual slabs of northern Syria accommodated only a handful of figures. Another development was the introduction of a horizontal division to produce two bands of equal height which were then carved separately. The division took the form of inscriptions although they did not yet serve as captions. Each slab was tentatively linked to its neighbor by the structure of the events and sometimes by the original and important feature of an overlapping minor detail. The reason for the division is not known; perhaps simply to provide more space for the portrayal of more deeds at greater length, or to avoid problems of

Right: A winged bull-god from Sargon's palace at Khorsabad; height 396cm (156in); 721–705 BC. Louvre, Paris

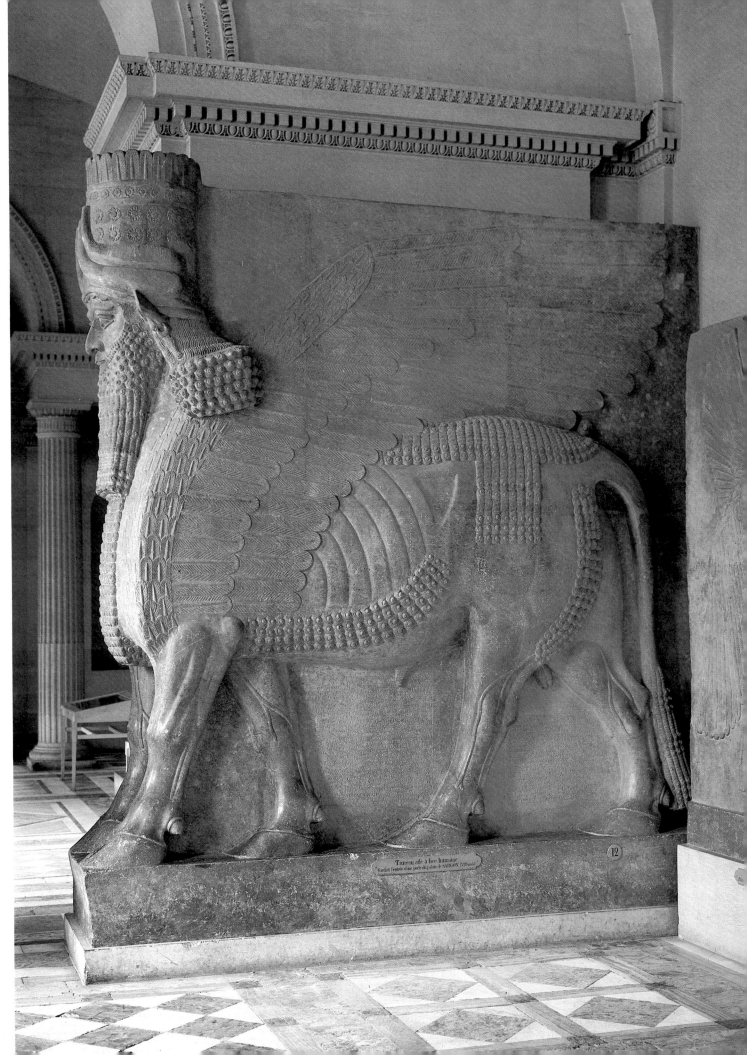

Taureau ailé à face humaine
Gardait l'entrée d'une porte du palais de SARGON (VIII siècle)

⑫

perspective presented by the idea of carving the previous large surface.

The problems of composition seemed to have loomed larger in the minds of artists than the problems of modeling. In fact, for the rest of the Neo-Assyrian period figures remained flat, drawn, and incised, rather than sculpted. This suggests the influence of paintings or tapestries, either direct or indirect by way of the glazed orthostats of Ashurnasirpal II's predecessor.

In contrast to the alabaster murals, giant winged bull-gods were integrated into the walls in an architectonic manner. Within them dwells a timeless quality that is absent from the historical episodes. Their enduring character derives from myth and ritual and stands in opposition to the time-bound deeds of the king. A similar character is found, however, in murals that deal with traditional Mesopotamian rituals centered on the tree of life.

Various features of the reliefs indicate the work of apprentices following the limited repertoire of a master's copybook, for example heads awkwardly placed on bodies, bodies fixed at different angles, and repeated scenes. But in spite of these observations the workmen created "a strongly accented sequence by means of a rising and falling flow of figures into an organized rhythm related to the picture's meaning", to quote a modern commentator, Moortgat, who compares these relief compositions to music and poetry.

The reliefs are, of course, packed with historical information, often so accurate that we can only assume that "war artists" attended campaigns. On the Black Obelisk of the reign of Shalmaneser III (858–824 BC) appears the only representation of an Israelite monarch, Jehu. Also from Shalmaneser's reign comes the most complete example of bronze sheeting, originally part of the gates at Balawat near Nimrud. Showing 24 strips of battles and rituals from Urartu to Tyre, the bisected band system of Shalmaneser's predecessor is retained, but the whole reveals a real decline into mediocre, conventional narrative.

Assyrian Art: the late phase (744–627 BC). The work prompted by Sargon (721–705 BC) at Khorsabad is distinguished by attempts to attain a new monumentality. The complete heights of the slabs were employed for figures that were modeled in higher relief than before. But figures were still not freed from two dimensions, as shown by the provision of five legs for a *lamassu* (winged lion) which was intended to be recognized as complete whether viewed from the front or the side. It highlights a new concern, however: the striving to render impressions of spatial depth which was to concern Assyrian designers for the rest of this period.

Two other notable developments occurred in this period. The first was the growth of concern to introduce sufficient

On the Black Obelisk of Shalmaneser III: Jehu of Israel pays tribute to the King; 858–824 BC. British Museum, London

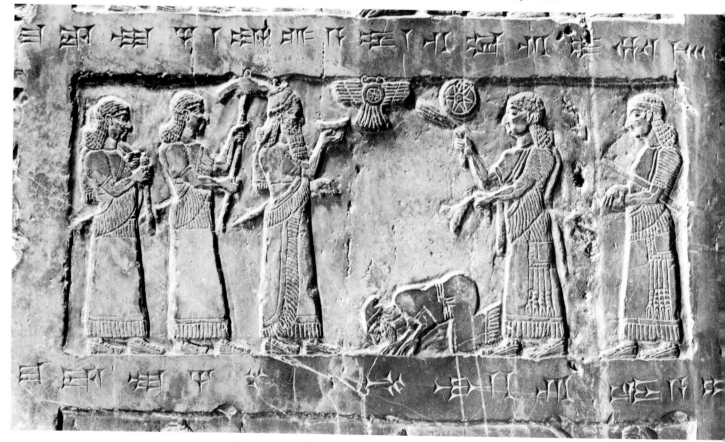

detail to heighten a picture's historical reality—hence captions appear and also landscape to give an action geographical context. The second was the introduction of courtly leisure in the parks as an acceptable subject for representation—both reflecting the mood of secularization and a landmark in the subject matter of the art of western Asia.

Unfortunately we know many of Sargon's reliefs only from drawings—the originals sank on a raft in the River Tigris. But of approximately the same period are some of the wall-paintings from Til Barsib, once a provincial Assyrian center in northern Syria (now in the Louvre, Paris and the National Museum of Aleppo). They are in fact of greater interest than subsidiary paintings from Assyria itself since they duplicate the subject matter of reliefs and provide us with evidence of painting's separate existence as a major art form. They are also evidence of the original polychrome appearance of the reliefs.

In the reliefs carved in the reign of Sinnacherib (704–681 BC) and in the early years of the reign of Ashurbanipal (668–627 BC) the love of detail of location reaches its most intense expression (British Museum, London). Multitudes of people are packed in to create confusing tumults which are shown to be representations of specific scenes by the accompanying legends. Just above the beheading episode on one relief the inscription reads:

> Te-umman, the King of Elam, who was wounded in a violent battle, and Tamaritu, his eldest son, grasping his hand, fled to save their lives and hid themselves in a thicket. With the help of Ashur and Ishtar, I killed and beheaded them.

On the same slab the section showing the battle of the River Ulai discloses the uneasy compromise reached by designers trying to retain their traditional sense of perspective in settings that have broadened beyond the rigid narrow friezes of earlier times. Above, files of prisoners are marched along the bands in the old fashion, though natural features such as streams are often used to separate these files. Below, on the left, register base lines remain visible, but on the right where the intention was to produce an open field, the registers were artificially continued in the guise of dead and dying bodies, and, in one case, a horse.

Similar divisions of the field can be seen in the reliefs of Sinnacherib's marsh battles and in the siege of Lachish where the drama is focused in the apex of a triangle in order to break up the picture of a single, wide siege ramp. By this arrangement movement was unintentionally introduced, but in the last phase of Assyrian relief sculpture it was deliberately employed in order to unite the narrow registers to which the art had returned, as seen for example in a relief of the Arab Wars.

Ashurbanipal's Great Lion Hunt may be considered the apogee and finale of Assyrian relief sculpture (British Museum, London). Artists show themselves now to be once again preoccupied with the problems of composition rather than landscape—the wheel has come full circle. With their accumulated skills experienced artists now had the scope to

A detail of a wall-painting from Til Barsib; height 76cm (30in); c744–705 BC. National Museum of Aleppo

Assyrian relief sculpture: Ashurbanipal's Great Lion Hunt; 668–627 BC. British Museum, London

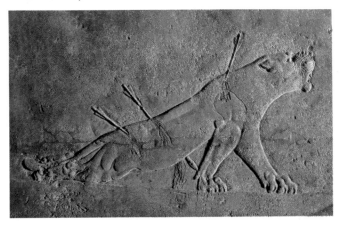

convert minor subjects into accurately observed studies, such as those of dying animals, though the contrast with stiffly carved human figures remains. The new style probably sprang from the wishes of Ashurbanipal himself.

In the garden scene he returns to the old Sumerian conventional banquet scene as originally shown on the "Royal Standard" from Ur. The war trophy in this case is Teuman's head, attached to the second tree from the left. But the style was prevented from developing by the upheavals that preceded the overthrow of Assyrian power.

The Neo-Babylonian period (625–539 BC). The state that succeeded Assyria has become more famous through the Bible and the writings of Herodotus than from surviving monuments. *Entemenaki*, the Tower of Babel, is known from its ground plan, whilst we have insufficient knowledge to be able to reconstruct the appearance of Nebuchadnezzar's Hanging Gardens.

The main reason for this scarcity of evidence of Babylonian art is simple. Although Babylon was the center of a world empire, and of paramount influence in Near Eastern art of this period, most of her buildings were constructed in the traditional southern Mesopotamian medium of perishable mudbrick—indeed, Babylon was so renowned for her work in the medium that Babylonian craftsmen were assigned the task of molding bricks for a palace built for Darius (522–486 BC). Thus no reliefs survive that are in any way comparable to those from the Assyrian palaces.

The principal influences in Babylonia were not Assyrian, however, but Sumero-Akkadian and Old Babylonian. Late-Kassite *kudurru* stones returned to favor; presentation scenes were modeled with greater plasticity; the rod and line motif reappeared; temples were laid out along earlier lines. It is unlikely that the Neo-Babylonian concept of kingship even produced reliefs to chronicle the deeds of kings.

Other features of this period's art are consistent with this independently archaic attitude. Glazed, polychrome bricks were used to coat the walls of palaces, the Processional Way, and the Ishtar Gate at Babylon. On the latter Sumerian dragons alternate with bulls, symbols respectively of the underworld and life. Such symbolism must have been a predominant feature of Babylonian monumental art.

The Hittites and Anatolia. In the centuries around the beginning of the 2nd millennium there was wholesale and repeated destruction of thriving settlements in Anatolia. Later references indicate that this was the first outburst in a prolonged struggle for dominance in the central region. Indeed, it was not until the reign of Hattusilis I in the 17th century BC (c1650–1620 BC) that Hattusas, modern Bogazkoy, was selected as the capital of the Hittite Old Kingdom, thereby indicating the establishment of stability.

The Hittites entered a country whose indigenous rulers wrote a different language from their own Indo-European one. The terrain was mountainous and literally interlaced

with a Mesopotamian presence. Assyrian mercantile colonies or *karums* were to be found at most of the large cities; they were linked to each other and to Ashur by trade routes. Mesopotamia, the native Hattians, and to a much lesser extent the Levant were to exercise a predominant influence on the artistic expression of the newcomers; indeed the originality and distinctiveness of Hittite art have been questioned.

During the period of the Old Kingdom (c1740–1460 BC) the Hittites managed to consolidate their domestic position, at least by the time of Labarnas I (1680–1650 BC), in spite of being a minority ruling class. Under his two successors spectacular foreign victories were won in Syria and Babylonia. But these proved ephemeral, causing internal dissension and instability and provoking raids that threatened the capital Hattusas itself. The paucity of archaeological remains found during excavations at its site as well as elsewhere has confirmed the documents' picture of a basically weak state.

The Hittites reached the height of their power during the succeeding Empire period (c1460–1190 BC) in the reign of Suppiluliumas (c1380–1340 BC). They managed to sweep aside their traditional foes, the Hurri-Mitanni of northern Mesopotamia, and even challenge Egypt for the supremacy of the Levant. Most Hittite monuments belong to this century and the following one, surely a reflection of the Hittites' increased wealth and power and their unerring confidence in central government.

After the destruction of the Empire a host of Neo-Hittite successor states were founded within the territory by Cilician and northern Syrian peoples. Although they wielded little power, they have bequeathed a staggering number of bas-reliefs, statues, and minor objects, out of all proportion to their importance in other cultural activities. It must be noted, however, that these works may have no connection with the true Hittites; they are known by this same name because it was used by the Assyrians, but their societies were in fact mixtures of northern Syrians, Aramaeans, and people from other stocks.

The art of the Empire period (c1460–1190 BC). The amount of surviving Hittite art is small compared with the products of the Egyptian and Mesopotamian civilizations; its variety even more limited; and its derivative elements even more obvious. Political and religious themes predominate and correspond with the outstanding caliber of Hittite ritual prayers and diplomatic acumen revealed in their texts. Their state religion was intensely nationalistic with the king having responsibility for both kingly and priestly duties, usually intimately interconnected. This is deftly pointed by the following extract from the autobiography of Hattusilis III (c1275–1250 BC):

> The goddess, my lady, always held me by the hand; and since I was a divinely favored man, and walked in the favor of the gods, I never committed the evil deeds of mankind.

On many royal stamp seals, which must figure among the most distinctive Hittite works of art, the king is shown be-

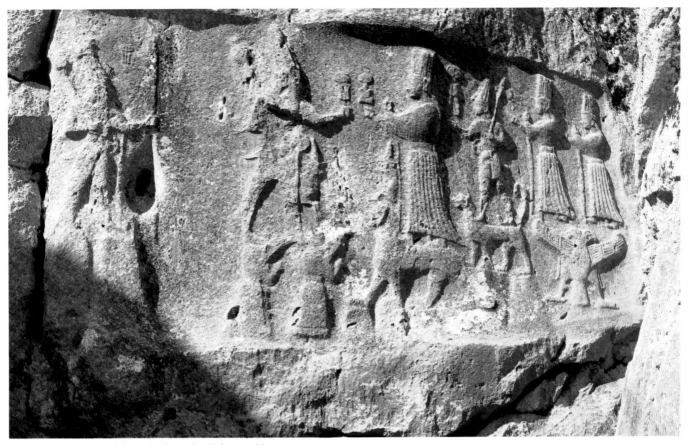

A momentous meeting of the gods: the rock relief at Yazilikaya; c1450–1200 BC.

neath the borrowed winged sun disk, guided under the protecting arm of his tutelary deity. The motif occurs elsewhere, perhaps at its most magnificent in the smaller of two natural chambers of the open-air sanctuary at Yazilikaya where Tudhaliyas IV (1250–1220 BC), dressed in characteristic trailing robe and shoes with curled toes, carrying a long crook, is embraced by the youthful god Sharruma. On the end wall of the other chamber the main scene depicts, as the culmination of a procession realized in unmatched scale, a momentous meeting of the gods. On the left is Teshub, the Hurrian weather god, supported by two mountain deities. Facing him is Hebat followed by Sharruma. The divinities are named by hieroglyphs, and the inclusion of Teshub emphasizes the Hurrian influence in Hittite religion.

The work at Yazilikaya near Khattusha (Bogazkoy) represents the mature Hittite relief style of the Metropolis, and contrasts sharply with the flat reliefs of the provinces or later work such as the libation offering of King Shulumeli at Malatya (Archaeological Museum, Ankara). Another example of the Metropolitan style is the figure of the powerful god who protectively flanks the King's Gate at Bogazkoy (Archaeological Museum, Ankara). Its apparent simplicity masks the skill of a master sculptor who has created an embodiment of massive strength (6 ft, 1.8 m high) in three-quarter relief against a starkly plain background. Its stance is purposeful, and detail in the kilt and chest hair carefully incised. An inscription claims that the local artists had been trained by Babylonian master sculptors; if so, this relief demonstrates that the Hittites were quick to develop an unfettered stylistic independence.

Little survives of the minor arts that carry perhaps their most distinctive work. We have a few examples of their red pottery libation vessels, with their exaggerated spouts and sharply defined lines. From their texts we know, however, that animal vases were particularly popular:

> cups, and *rhyta*, silver, gold and [precious] stones thou [the god Telipinus] has in the Hatti land ... reverence is paid to thy temple, thy *rhyta* [thy cups] [and] thy utensils.

The Hittite artists' most successful medium were metals, often with various inlays, shown for example in a silver stag *rhyton* (Norbert Schimmel Collection). The relief band near the rim shows three offering-bearers before a god on a stag and a seated deity, as well as a slain stag beside a stylized tree.

The Neo-Hittite period (c1150–750 BC). Wall reliefs were the outstanding form of Neo-Hittite art. Many survive, often roughly and even incompetently worked, and contain motifs and themes from various sources reflecting the active competition between petty states. It is a sterile activity to search for a predominant pure Hittite influence.

Whenever they could afford it, kings had orthostats with reliefs set up along the bases of external walls of processional ways, courts, and, especially, around gates and porticoes which were also enriched with impressive columns set on lion bases. Subject matter ranged, according to taste, from intimate family scenes, to ranks of soldiers, tribute bearers, banquets with musicians, warfare, hunting, myths, and demons. The variety of content is as wide as that of the Hittite Empire was restricted, although the Hittite rock relief genre persisted,

as shown, for example, at Ivriz near Konya.

There is substantial evidence to demonstrate that the Hittite element of this society was significant, for example the use of Hittite hieroglyphs—especially on the reliefs at Carchemish, the administrative center of the Empire in Syria whose importance continued beyond the destruction of the Empire—and the Hittite names of kings. But the history of art shows the workings of other influences. At first Hittite and Aramaean impulses combined, but they were gradually eclipsed by the power of Assyria which first caused stylistic and thematic changes before removing the political independence from which Neo-Hittite art had sprung.

The monuments of this period have an importance for the history of art by demonstrating the extraordinary wealth of Oriental imagery current in northern Syria at a time when the Greeks were both venturing into this area and at that crucial stage of their own artistic development known as Orientalizing.

Urartu. In the 8th century BC the kingdom of Urartu became the most powerful state in western Asia. It lay to the east of the center of the Hittite Empire, around the area of Lake Van, and until recently was only sketchily known from stray finds, some early work at Toprak Kale, historical references, and a relief of Sargon II of Assyria which focused on the sack of the important temple of Khaldi, one of Urartu's chief gods. But recently the excavation of several standardized temples has revealed fine drystone masonry and surrounding colonnades—the main features of flat-roofed buildings. The decorations (Archaeological Museum, Ankara) included caldrons in stands, cows with suckling calves, guardian humans at doors, large spears and spearheads, and, attached to the walls, shields with lion protomes.

The palaces of the mountain kingdom of Urartu were located in strongly fortified citadels. Like the temples they were richly adorned. At the palace of Arin-Berd, for example, the following decorations have been found: polychrome wall-paintings with protective genii, crenellation patterns, and bulls and lions placed antithetically beside concave-sided squares (State Historical Museum, Erevan). All these motifs, as well as the compositions, were borrowed from Assyria, which influenced Urartian culture in many ways.

At Nor-Aresh near Arin-Berd an example of bronze strips showing narrative scenes, worked with engraving and repoussé yet reminiscent of Assyrian murals, has come to light. It shows hunters, infantry, and cavalry. In another example, from Keyalidere, lions attack chariots, each with helmeted driver and two huntsmen. Its free-field design is reminiscent of the seals of the Hurri-Mitanni. Indeed, some scholars relate the Urartians to the Hurrians. The relief sculpture of Urartu is, however, unlike contemporary Neo-Assyrian relief by virtue of its concern with religious motifs, such as the representation of Khaldi standing on a bull at Adilcevaz.

There are indications of Urartian links with the Aramaean kingdoms and perhaps even Phoenicia, in unworked ivory from workshops. But in the case of a gilded ivory seated lion (Archaeological Museum, Ankara), the treatment is distinctively Urartian: slender body, bulbous wrinkled muscles, snarling angular mouth, small circular eyes, sharply incised mane, with projecting ruff and long tail.

The most outstanding accomplishments of Urartian artists were executed in bronzework, the copper for which was plentiful in this region. Although large-scale sculptures were made, most surviving works are small pieces such as figures, shields, caldrons, strips, candelabra, and parts of a throne. The products of this bronzeworking center were distributed over an extremely wide area and with them their Oriental iconography. So figurines from Karmir Blur in the northeast display the Mesopotamian horns of divinity. To the east many Urartian features recur in early Scythian art, as in the Kelermes kurgan for example. To the west, in Greece and Etruria, Urartian or Syrian caldrons with griffin and bull protomes were imported and imitated in bronze and other media.

The Persians and Iran. The best-known forms of art from the Persian Achaemenid Empire are firstly the architectural decorations of monumental buildings and secondly small, luxury objects such as vessels and jewelry chased and embossed in precious metals. The roots of the architectural decoration are to be found in the manner in which the Persians, a migratory tribal group, came to terms with their role as a world power. It developed into an original form of expression. The small luxury objects or toreutics were derived from the artisanry of peoples and places in the Zagros mountains with whom the Persians came into contact before settling at the southern end of the chain.

The influence of the Medes was especially important. The 1st-century BC Greek historian Strabo reported that:

the "Persian" stole, as it is now called and their [the Medes'] zeal for archery and horsemanship, the service they render their kings, their ornaments, ... came to the Persians from the Medes.

He continued by stating that their dress was adopted from conquered peoples, namely the Elamites. So were other features of their way of life. The arts of the Persians were undeniably eclectic in origin and development, but from the various sources they were capable of producing independent forms.

The Elamites. The Elamites dwelt in the lowland extension of the southern Mesopotamian plain through which the Kerkha and Karun rivers flow. From c3500 BC to c650 BC their civilization was distinctive. It was destroyed by the Assyrian army which created a vacuum, filled by their successors: the Persians.

Although the Elamites frequently imitated Mesopotamian art they often produced works of outstanding individuality. The Elamite ziggurat at Susa, decorated in blue-glazed bricks and crowned with brilliant copper horns, so moved Ashurbanipal, the conqueror of the Elamites, that he described and illustrated it. The Elamite tradition of monumental and highly

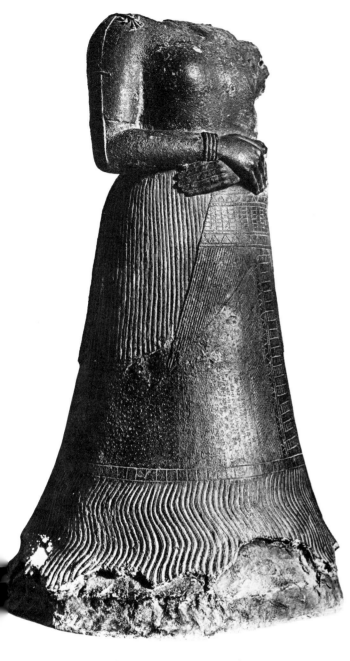

From the Elamite Golden Age, the bronze statue of Queen Napir-Asu from Susa; height 129cm (51in); c1250 BC. Louvre, Paris

and kneeling humans and polychrome-painted jars and metalwork. At an even later date dependence can still be traced as, for example, in the archaic dress and the symbols of divinity on a gold and bronze standing deity. But even this figure displays typically Elamite features, in the sharp nose and the stereotyped thick-lipped V-shaped mouth, often with a moustache.

During the so-called Elamite Golden Age (c1350–1000 BC) Elamite arts began to display increasingly independent characteristics. A burst of great building and artistic activity occurred: at least this is suggested by stone and metal statuary, relief stelae, rock reliefs, and small objects of faience.

Typical of the three-dimensional figures engaged in ritual that were produced at this time is a bronze statue of Queen Napir-Asu (c1250–1230 BC; Louvre, Paris). It is a work of studied elegance—she stands with her hands crossed over her waist, her dress splayed—and of great technical achievement. Unfortunately the head is missing.

Many graves of the period have produced bronze and faience figures. During the period they display a development towards realism which culminates in a series of female terracotta heads which, except for the eyebrows, are astonishingly free of stylization. They may well, indeed, be attempts at portraiture.

The Elamites at times in their independent history benefited from contacts with the highlands. The link is indicated by the 8th-century BC rock sculptures at Malamir. They were executed in flat relief and although they have been defaced by Sassanian reliefs and badly weathered, monotonously multiplied figures usually arranged in horizontal registers can be seen. This device in fact heightens the themes of paying homage to kings and making sacrifice; it is Elamite in origin and may well have been copied and exploited on a larger scale by the Persians.

In the later 3rd millennium BC the mountains to the north of Elam became a major center of bronzeworking in the Near East, although scholars have sometimes been too eager to attribute the works of Hurrian, Kassite, Median, and Cimmerian metalsmiths to it. Recent studies and excavations have shown that the greatest number of figurative works were produced between c1200 and 600 BC, and that the arrival of a nomadic steppe people stimulated the Elamite- and Babylonian-influenced native craftsmen into utilizing the animal style and religious iconography.

Within the smiths' repertoire two classes of objects were dominant: firstly the horsebits, harness mounts, rein rings, and axes of the hunter-warrior; secondly votive pins shaped like hand mirrors and the standards of shrines. A standard usually consisted of a long tube incorporating animal haunches and human heads below a female who grasps rearing felines along an arc. It is in fact a fantastic version of the traditional Mesopotamian "tamer of animals" motif in which adequate scope has been given for the imagination and religious beliefs of mountain dwellers.

This period saw several peoples on the move in the Zagros

ornamental building in fact stems from the earliest days of Elamite civilization. Some of the earliest constructions are depicted on contemporary cylinder seals (c3300 BC; Louvre, Paris) whilst one of its most outstanding examples was the sacred complex at Choga Zanbil (c1250–1230 BC).

The earliest seals (for example, those in the Louvre, Paris) were intimately connected with those from early Uruk, but in their representations of vases, animals, and figures engaged in hunting, fighting, and building they display a radical departure from previous conventions. The latter had demanded gracefully stylized figures which, when painted on pots, produced tectonic designs that emphasize or contrast with the shape of a vase.

Throughout the 3rd millennium Elamite art was almost completely indebted to Sumer. The Elamites' own creations consisted of representation of small, lively figures of animals

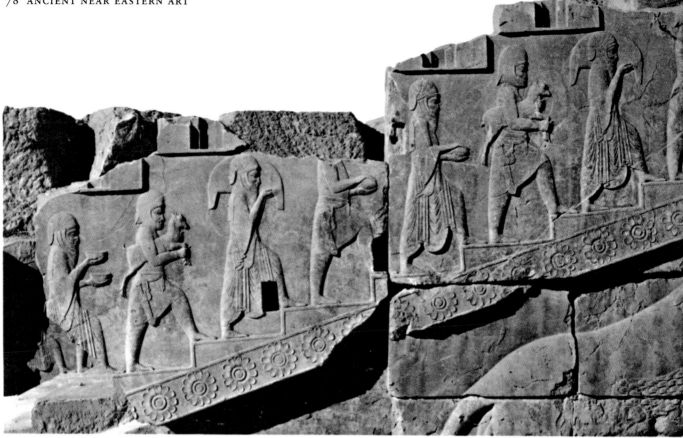

Relief carvings on a staircase of the Palace of Darius at Persepolis: servants carry dishes and young animals; 518–428 BC

mountains. The fluidity of the times is reflected in the works of ivoryworkers, metalsmiths, and glaziers contained in the so-called Treasure of Ziwiye (c750–650 BC). Hundreds of precious objects were found, many of them in a bronze tub incised with a scene showing an Assyrian dignitary receiving tribute from Iranians. Perhaps it was a hoard of Scythian loot? One piece is an Urartian type of crescentic gold pectoral or gorget which exemplifies the iconographic mixture on work of the period (Iran Bastan Museum, Teheran). In the center are Urartian palmette trees. Flanking them, arranged in two registers, are repoussé mythical animals—a winged Assyrian bull, a human-headed winged bull in Atlas pose, either Assyrian or Neo-Hittite, Syro-Phoenician griffins, and crouching bears and hares in Scythian style.

Marlik. An impressive degree of Mesopotamian influence and local originality is displayed in the works from a late-2nd-millennium cemetery at Marlik, near the Caspian Sea and once astride several migratory routes from the north and east into Iran. Local originality is mainly seen in the smooth outlines of stags, bulls, and humans on vessels and as figurines. The animal style displayed is akin to the one known in the Caucasus rather than the style of the northern steppes. Subsequently bracelets with lion-headed finials became popular in Iran. Where vases found in the cemetery display lowland motifs in their decoration these have been handled with expertise and confidence, especially the use of body stippling and the balance of composition both rendered in an eloquent native style.

Achaemenid Persia (559–330 BC). The Persian Empire was established in 539 BC as the result of Cyrus the Great's victories over the Medes, Lydians, and Babylonians. The victor built a residence for himself at Pasargadae which at once typifies and distinguishes the architecture of the Achaemenids. Its character was summed up by the Greeks' description: the "camping ground of the Persians". It contained three monumental buildings, well spaced from each other, built on large platforms. The Audience Hall is known to have contained a central rectangular colonnaded room and to have been surrounded by porches of columns half the height of the internal hall. The prolific use of columns, large blocks of stone, and contrasting black and white colors, may have come ultimately from Urartu. And the winged bulls echo Assyrian reliefs. But the diffused arrangement of the buildings is a novel principle.

Although Susa was the capital of Persia it is Persepolis that survives in best condition. It was built as a national sanctuary hard against the mountains in an area that contains several royal tombs. Its construction began in the reign of Darius I, in 518 BC, and it came to consist of several groups of buildings on an immense platform which, together with its enclosing wall reached a height of approximately 85 ft (26 m). Its main architectural features were the gates and grand staircases that led up to the square *Apadana* and Hall of a Hundred Columns. The stone columns of the latter are a peculiar mixture of foreign elements and are often surmounted by double bull capitals. It is likely that foreign craftsmen were employed in the construction of Persepolis, as we know they were at Susa, and their influence accounts for many foreign traits. But the

majestic synthesis of Persepolis is a crowning Persian achievement.

The gates, door-jambs, and staircases of Persepolis are adorned with painted and gilded reliefs which may have been the work of Ionian stone-cutters. They show the king receiving reports, or seated on a throne supported by representative members of his Empire, or processions of offering-bearers, or the king decoratively stabbing a lion—themes that proclaim the unity of the Persian Empire. Thus they lack the historical and narrative interest of Assyrian reliefs. However, the figures project from the background surface in high relief and the folds of their drapery are now accurately represented. They possess an organic life which was absent from most earlier Near Eastern representational art. It demonstrates the influence of late-6th-century Greece.

Other reliefs were carved on natural rock faces, such as the one at Bisutun where Darius is shown receiving the submission of rebels who had supported the Magian Gaumata in his bid for the throne, and the relief on the facade of Darius' tomb at Naqsh-i Rustem near Persepolis. Later reliefs at Susa, showing Babylonian-type monsters and royal guardsmen, are made of polychrome glazed bricks.

In the decorative arts the Persians achieved a greater sense of balance and mastery of materials than in the reliefs. Especially worthy of note are their drinking vessels, which terminated with animal forequarters or had two animal handles; their bracelets and pectorals with animal finials; and their circular bracteates in which animals are used to create a pattern on the inside.

Persian craftsmen favored lions, ibexes, and bulls as subjects for decorative work but treated even them in a contrived way; winged beasts, for example, were shown with their heads turned back. And from groups of animals ornamental and balanced patterns were created. Perhaps it was inevitable that in becoming sedentary the Achaemenid goldsmiths lost the sort of spontaneity that marks the animal styles of the Scythians and Marlik culture. But what they forfeited in vigor they gained in technical excellence.

The arts of Phoenicia and Israel. The modern lands of Cyprus, Syria, Lebanon, Israel, and Jordan stand on a crossroads. In ancient times they were the main area of contact between the cultures of the ancient Aegean and the Near East, between Europe and the Orient, between city-dwellers along the Mediterranean littoral and nomads of the deserts. The area produced some of mankind's most outstanding literature, and saw the birth of two of the world's major religions. But the region's visual arts, after the prehistoric Natufian and Chalcolithic periods in which individual styles flourished, as seen in a female figure from Lemba, Cyprus (Cyprus Museum, Nicosia), could hardly rise above the imitative, derivative, and syncretic to produce a distinctive expression.

Art that served royalty tended to be derived from the models of powerful neighbors. Religious art concerned itself with fertility cults. There was little freedom for artistic pro-

duction to surpass technical sophistication. These shackles were further compounded by the political and cultural fragmentation of the Levant which prevented the emergence of a major political power and a new seminal art.

The Levantine petty states lacked the cultural continuity and inclination necessary for the production of monumental works—in marked contrast to Egypt. According to sources ranging from Homer to the Assyrian annals Levantine craftsmen excelled in the production of small metalwork objects that were often inlaid with gold or silver, jewelry, dyed cloths, woodwork (especially furniture), and perhaps above all, ivorywork. The jewelry and ivorywork are, of course, epitomized in the Bible's descriptions of the caldrons, pillars, and "cherubs" and floral appliqués of Solomon's temple in Jerusalem and Ahab's House of Ivory in Samaria. But in both instances the work was that of Phoenician, not Israelite craftsmen. Israel and Jordan produced little of artistic merit. Their topography was full of divisions; they were constantly subject to nomadic incursions and invasions by neighbors such as the Egyptians. Their most notable achievements were in the fields of pottery making—their pots are amongst the most balanced and aesthetically pleasing of all produced in the Levant.

The Levant's cultural dependence on its neighbors was evident by at least the 3rd millennium BC when the production of cylinder seals began in north Syria. Not only the idea but also the designs were derived from Mesopotamia. Similarly sculpture produced in the Syrian hinterland, such as the statues found at Tell Chuera, can be considered as merely provincial renderings of Sumerian forms of the early city-state period. The custom of erecting such statues in Syrian shrines presumably implies that the inhabitants of the area were alive to Sumerian religious thought.

The strength of Mesopotamian influence increased during the Ur III-Mari age (c2113–1750 BC) when several Syrian cities became important in the new context resulting from Amorite expansion. A clear source of evidence of this is provided by a large stone basin found at the already important city of Ebla, just south of Aleppo (National Museum of Aleppo). The upper of its two registers shows figures dressed in the developed Sumerian flounced robe and the plain cloak with tabbed hem which is familiar from the Mari paintings, crowned with Ur III hairstyles. The basin also features a nude Sumerian hero with projecting hair and beard curled at the tips who enjoyed a revival in Mesopotamian iconography during the Old Babylonian period. Here he is shown grasping the tail of a winged beast which first became popular on Neo-Sumerian seals.

The decoration of the basin includes some details of local origin but it was principally in metalwork that the inklings of an independent artistic spirit began to show themselves. This is demonstrated, for example, by a group of nude bronze figures from Judeidah (Oriental Institute Museum, Chicago). Some of them have arms extended forward in a manner similar to that of a figure imported into Mari.

For most of the 2nd millennium BC the Semites of

Mesopotamia called the greater part of the Levant Canaan, a name derived from the purple dye that was obtained from the murex shell from the waters along its coast, and the period is also known by this name. It witnessed Egyptian influence in Canaan which profoundly affected the native visual arts.

From the reign of Sesostris I to Amenemhat III (1971–1797 BC) the Egyptians sent numerous objects to Byblos, a coastal city nestling under Lebanon's cedar mountains. Its kings were so impressed with all they saw and heard of Egypt that they styled themselves with Egyptian titles and instructed their artists to copy Egyptian work in stone, faience, and metal. They adapted with varying success. A gold Horus-hawk collar, for example, faithfully reproduces its model, whereas an elliptical jewel with a gold filigree hawk inlaid with semi-precious stones, bearing hieroglyphs spelling the local name Ypshemu-abi, cannot be considered more than a

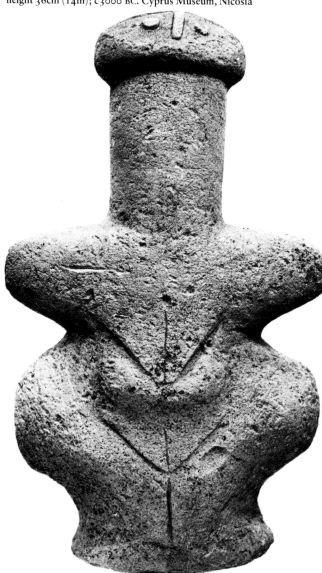

A prehistoric female figure from Cyprus known as the Lemba Lady; height 36cm (14in); c3000 BC. Cyprus Museum, Nicosia

clumsy effort (now in the National Museum, Beirut). However, the ivory handle of a dagger covered in gold foil bears a figure wearing a pharaonic kilt and "White Crown" adapted to a native design.

Egyptian influence affected other cities less strongly. Often it was Egyptian symbols that found ready acceptance. *Ankh* signs, for example, appear on Syrian-style seals found at Alalakh (British Museum, London), and a *waz* scepter and Egyptian royal crook feature on stelae at Ugarit (National Museum of Aleppo; Louvre, Paris). The way in which Egyptian trappings were incorporated into native works suggests that their meanings were known and appreciated, but they had little effect on compositions into which they were incorporated.

In the period of its history known as the New Kingdom (c1580–1200 BC) Egypt extended its kingdom into the Levant. Borrowing from Egyptian art increased and now affected style as well as subject matter. The influence of the Egyptian Amarna style is seen, for example, in the portrayal of royal figures on an ivory bed panel from Ugarit, one of the wealthiest cities in the period. An Egyptian princess is actually depicted on a marriage vase in attendance on one of the kings of Ugarit.

Egyptian scenes of feasting, chariot battles, and marshscapes, and motifs such as sphinxes, flowers, Bes and Hathor figures are all found, in fact, on other works, but they are rarely slavish copies. Syrians actually settled in Egypt at times and produced an Egyptian style that included other influences of international origin. A typical example of this is a polychrome *rhyton* from Kition in Cyprus which is Aegean in shape, Egyptian in technique, and predominantly Syrian in the style of its figures, though even in these Aegean and Egyptian elements can be noticed (Cyprus Museum, Nicosia).

A major feature of art produced during the late Canaanite era was the influence of the Aegean. In the earlier period some Minoan items had been imported into prosperous Byblos but they were considered too exotic to be serious models, unless some silver bowls with swirling patterns from Tod in Egypt are Levantine imitations rather than originals (examples in the Louvre, Paris). Contacts with the Aegean only reached a point of strength in the 14th and 13th centuries when they provoked a vogue for adapting aspects of Aegean work. Ultimately from Minoan Crete come the goat and cow shown on a gold bowl from Ugarit. Their pose is a slightly contorted flying gallop. An ivory lid from its port shows a seated goddess feeding goats: the theme is Aegean, the rendering Syrian (Louvre, Paris).

With the arrival of numerous Aegeans in Cyprus and Philistia in the 12th century BC the Aegean-influenced native style, which had hitherto remained a mixture, fused into a lively, original entity. A type of bichrome pottery was the special product of Philistia; in Cyprus remarkable ivories and metal figures whose oriental iconography is injected with vigor by the modeling were produced. A good idea of the contrast between the new style and its predecessor can be obtained by

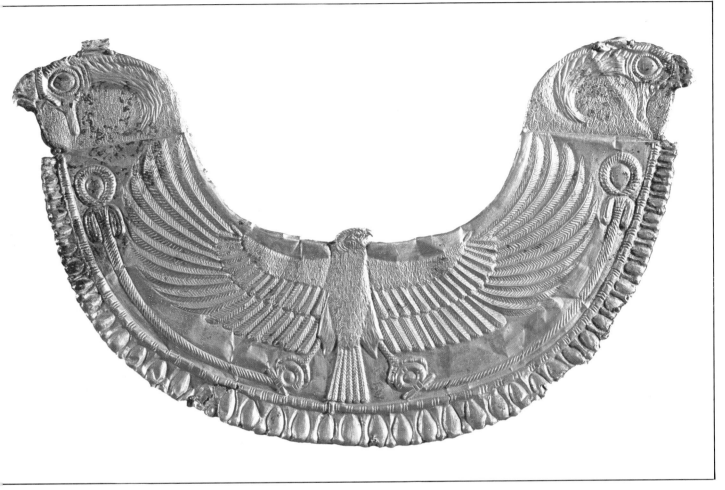

A Byblos copy of an Egyptian Horus-hawk collar; c1840–1785 BC. Louvre, Paris

Phoenician ivory work: a gilded panel found at Salamis; height 7cm (2¾in); c800–700. Cyprus Museum, Nicosia

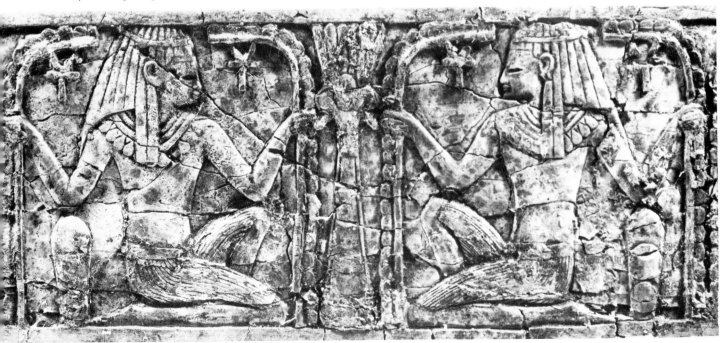

comparing the Horned God of Enkomi (Cyprus Museum, Nicosia) with earlier similar objects from the mainland (for example, those in the Louvre, Paris).

Although most artistic works of the Levant produced during the Canaanite era were hybrids of local and foreign styles, some works survive—a few masterpieces—of undoubted indigenous origin, untainted by the desire or attempt to emulate the works of foreigners. However, they are isolated works, difficult to locate in a detailed historical sequence.

In a 17th-century BC head from Alalakh, sculpture reached a poise and balance that it can surely have rarely reached in Syria (Antakya Museum). The rendering is completely natural and antedates a tendency to geometric abstraction. The development is seen in the statue of Idri-Mi (British Museum, London), in a group of pillar-shaped figures from which only limbs, face and sometimes genitalia emerge (Antakya Museum), and in the lion orthostats from Alalakh and Hazor (Israel Museum, Jerusalem).

A similar attenuated rigidity is also a common feature of various standing bronze figures. Examples from Byblos (National Museum, Beirut) are often of plaque-like slenderness. Others from elsewhere wear horns of divinity and brandish spears; many of them are also plated with gold. They probably represent Baal, the god with the most powerful and widespread cult of the western Semitic pantheon.

Occasionally items of late-Canaanite ivorywork show independent artistic attitudes, for example several items found in a hoard from Megiddo (Oriental Institute Museum, Chicago), and, from Ugarit, an ivory head in the round (National Museum, Damascus) and an ivory tusk modeled in high relief with a fertility goddess. Her head is aligned with the point and her body is flanked by sphinxes in shallow relief.

Phoenician art. This term is used to describe the artistic works made by Phoenician craftsmen anywhere in the Near East and sometimes in the western Mediterranean in the period of the late 1st and early 2nd millennia. Perhaps best described as artisans, the Phoenician craftsmen ranged beyond the frontiers of Tyre and Sidon (where later disturbances have obliterated traces of them) to the Jordan Valley in order to produce the bronzework required for Solomon's temple. They journeyed to Kara Tepe to help carve "Neo-Hittite" reliefs. They sailed to Cyprus, where many Phoenicians eventually sought refuge from the Assyrians. Their work is characterized by the blatant misuse of Egyptian motifs.

Their gaudy works could be heartily welcomed abroad—such is the suggestion of Homer's reference to a Sidonian bowl used at Patroclos' funeral games. Phoenician figured metal bowls, which have been found in places as far apart as Nimrud and Etruria, continued a tradition well known at earlier Ugarit (examples in the British Museum, London). They are usually embellished with three friezes containing an assortment of embossed Egyptian and Assyrian motifs and themes. The meaningless pastiche suggests that purchasers wanted them for their ornamental value rather than their imagery.

In Cyprus, on the other hand, there arose a vigorous, independent, and vivacious pottery style. For this the Cypriots developed a style of free-field composition for application especially to jugs. The use of figures could be either extravagant or restrained, but never without freshness and confidence attuned to produce the balance demanded by the vessel's shape.

The other medium especially worked by the Phoenicians was ivory. Numerous carved pieces have been found at Salamis in Cyprus, many with their gilding intact (Cyprus Museum, Nicosia). They are small objects, mainly from the 9th and 8th centuries BC, intricately worked in the round, ajouré, and relief. They were often intended to decorate furniture, for example a throne. The most abundant deposit of such articles, however, was found at Nimrud: Assyrian loot from the west. From examples contained in the hoard (British Museum, London) a north Syrian style can be recognized, but it is clumsy and ill-proportioned. The main motifs used by the Phoenicians in their ivories were sphinxes, griffins, "women at the window", Egyptian deities, winged goats (disposed symmetrically, often with ornate foliage), and a griffin-slayer which harks back to the Enkomi mirrors and became a Near Eastern legacy to later Europe finding renewed expression in the story of St George and the Dragon.

E.J. PELTENBURG

Bibliography. MESOPOTAMIA: Frankfort, H. *The Art and Architecture of the Ancient Orient*, London (1970). Mallowan, M.E.L. *Early Mesopotamia and Iran*, London (1965). Moortgat, A. *The Art of Ancient Mesopotamia*, London (1969). Parrot, A. *Sumer*, London (1960). Strommenger, E. and Hirmer, M. *The Art of Mesopotamia*, London (1964). ASSYRIA AND BABYLONIA: Barnett, R.D. *Assyrian Palace Reliefs*, London (1960). Frankfort, H. *The Art and Architecture of the Ancient Orient*, London (1970). Gadd, C.J. *The Stones of Assyria*, London (1936). Koldewey, R. *The Excavations at Babylon*, London (1914). Moortgat, A. *The Art of Ancient Mesopotamia*, London (1969). Parrot, A. *Nineveh and Babylon*, London (1961). Strommenger, E. and Hirmer, M. *The Art of Mesopotamia*, London (1964). THE HITTITES AND ANATOLIA: Akurgal, E. *The Art of the Hittites*, London (1962). Bittel, K. *Die Felsbilder von Yazilikaya*, Istanbul (1934). Bossert, H.T. *Altanatolien*, Berlin (1942). van Loon, M.N. *Urartian Art*, Istanbul (1966). Vieyra, M. *Hittite Art*, London (1955). THE PERSIANS AND IRAN: Amiet, P. *Elam*, Auvers-sur-Oise (1966). Ghirshman, R. *The Arts of Ancient Iran, from its Origins to the Time of Alexander the Great*, New York (1964). Godard, A. *L'Art de l'Iran*, Paris (1962). Pope, A.U. (ed.) *A Survey of Persian Art from Prehistoric Times to the Present*, vols. I and IV, London (1938). Porada, E. *Ancient Iran*, London (1965). PHOENICIA AND ISRAEL: Barnett, R.D. *A Catalogue of the Nimrud Ivories ... in the British Museum*, London (1957). Frankfort, H. *The Art and Architecture of the Ancient Orient*, London (1970). Harden, D.B. *The Phoenicians*, Harmondsworth (1971). Karageorghis, V. *Cyprus*, Geneva (1968). Mallowan, M.E.L. *Nimrud and its Remains* vol. II, London (1966). Pritchard, J.B. *The Ancient Near East in Pictures Relating to the Old Testament*, Princeton (1969).

5

BRONZE AND IRON AGE ART

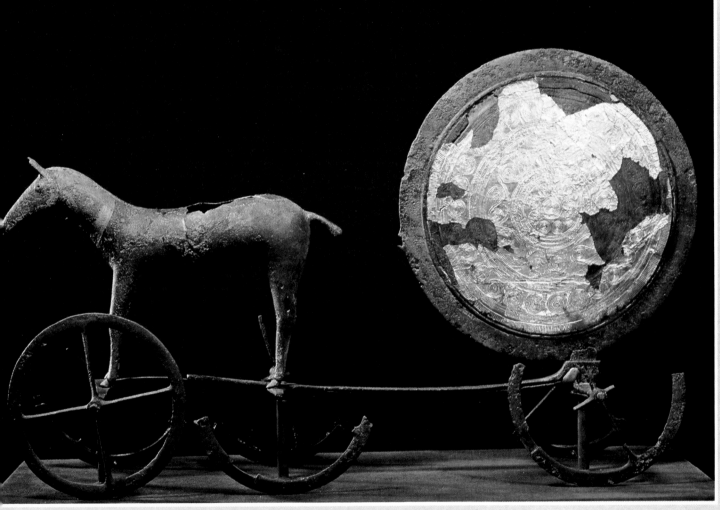

The Trundholm horse and sun-disk; bronze and laminated gold; length 60cm (24in)
14th century BC. National Museum, Copenhagen (see page 86)

THE arts of the 2nd and early 1st millennia BC in Europe are very different from the Neolithic arts that preceded them (*see* Neolithic Art). Some fine pottery was still made, but on the whole Bronze Age arts are of bronze or gold, or, more rarely, silver: the work of the smith rather than the potter and modeler. Even pots now imitate the suave lines and restrained ornament of metal tableware. Modeling in clay practically ceases, and where it does appear it is quite altered and, lacking in plastic sensuous qualities, has become a vehicle for imparting iconographic information. On the other hand, figure castings in the round appear, especially towards the end of the Bronze Age, and there are also the beginnings of narrative representation, on sheet metal in the south, and on rocks in the Scandinavian north—a return to a sort of art that had not been seen since the Mesolithic. Contact with more advanced societies outside Europe increased with the centuries, bringing new techniques and new orthodoxies. But it is still the craftsman metalworker who dominates this world.

There is no clear demarcation between Neolithic and Bronze Age Europe; all that can be said is that throughout the 3rd millennium BC the use of metals and their alloys was growing commoner and society was changing. Two opposing tendencies can be seen: one towards the seminomadic pastoral life, without fixed village settlements, whose focus appears in collections of stately burials under barrows. This was a warlike, hierarchical society whose leaders, by whatever name one calls them—tribal chief or king—enjoyed the display of weapons and ornaments, things portable and personal. On the other hand, on the plains of eastern Europe, and the European shores of the Mediterranean, there were settled societies whose villages and strongholds still survive, the former as tells, mounds of debris from fallen houses and walls, sited generally not far from some great river, and the latter as defended hills or cliff castles and townships from which the countryside was cultivated and boats put out on various ventures. By the mid 2nd millennium, within the Carpathian ring and on the Hungarian plain, we find material remains of what can reasonably be called an heroic society very much as Homer has described it, and it is here we might start with a review of some of its more durable remains.

The discovery of a large cemetery at Varna near the Black Sea coast of Bulgaria has put southeast Europe in the forefront of early metallurgical technology, especially goldsmithing. The date of the cemetery is probably 4th millennium BC. One grave alone contained 2.3 lb (1.05 kg) worth of gold objects, as rich an assemblage of gold as may be found anywhere at

Important places mentioned in the text

this early date. There are scepter-mounts, gold pectorals, animal profiles, plaques beaten out (none of the gold is cast), and in one almost royal grave features were modeled in clay with a beaten gold diadem and mouth-cover lying on them. Recent discoveries have also revealed very early mining for copper ores in Yugoslavia and Bulgaria. The mines at Aibunar in southern Bulgaria seem to have been contemporary with Varna.

In the mid 2nd millennium precious metals as well as copper and tin were readily available. A large amount of serviceable bronze weaponry was produced, but also luxury and symbolic objects such as solid gold swords, and silver and gold axes. These were a form of wealth valued not so much for the cost of the metal as for its incorruptibility.

The metallurgists must not be underestimated. As much skill and artistry are needed to carve the complex and beautiful molds that were used for casting axes and bracelets as to carve an animal in the round. Techniques of casting and chasing call for the dexterity of bone-carver, wood-carver, and engraver, as well as some knowledge of the chemistry of metals. For the rigid categories of "art", "design", "industry", "science", and "alchemy" were still closely linked, merging into each other, and the artist as smith and draftsman might be united in one individual or one family working under one roof.

The spheres of certain workshops, or groups of workshops, are recognized by the distribution of their products. One of these was active during much of the 2nd millennium BC in Transylvania, Hungary, and Slovakia. Its hallmark was a very beautiful curvilinear traced decoration applied to heavy cast axes of bronze, to swords and daggers whose blades, as well as hilts, were covered with running curvilinear patterns, and to bracelets like the gold one from Bellye (Bilje), northern Yugoslavia (Naturhistorisches Museum, Vienna), and occasionally to a gold cup or bowl. The decoration was "drawn" with a sharp tracer and hammer. It took great skill to produce the spiral and other curvilinear designs. Compasses were not used by this school, though they were used on bone objects of about the same date in Hungary, Slovakia, and Croatia, and possibly on small gold sheet ornaments with more geometric repoussé designs, concentric circles, and "pulley-patterns".

With very few exceptions the chased designs are non-representational; but within certain limits they show much freedom in adapting to the shapes of ax-butt and blade. At Hajdusamsun in northeastern Hungary and at Apa in northwestern Rumania fine axes and swords decorated in the same style were found. The Bellye bracelet shows exceptionally skillful casting, and the chased lines of the decoration have been deepened by tiny toothmarks, perhaps with a different sort of tracer. A Mycenaean Greek source has sometimes been suggested for this decoration, but in fact the styles are very different. Although spaced dots were used in setting out the designs, the spirals and sprays are neither geometric nor symmetric but seem to flow along the surfaces sprouting subsidi-

Gold bracelet from Bellye, Yugoslavia. Naturhistorisches Museum, Vienna

ary spirals in a way that foreshadows much later Celtic art. Dating is difficult, but probably some time after the middle of the 2nd millennium BC the designs begin to fall apart into isolated geometric motifs: circles, arcs, and multiple lines, while the center of gravity moves away to the north where a geometric and rectilinear phase of ornamentation suddenly changes and multiple lines, dotted fringes, and flowing tendrils reappear, though it soon relapses into compositions put together from isolated motifs.

The decoration of gold and bronze has a counterpart within the Carpathian ring, and to some extent throughout the whole of eastern Europe, in the decoration of pots, either in high relief—linked spirals surround molded bosses as on a mug from Barca in Slovakia (Archaeological Institute of the Academy of Sciences, Nitra); or else are incised, or stamped, or both as in Rumania and Bulgaria. Shapes keep the metallic profile introduced with the plain burnished pottery of the 4th millennium BC (Baden culture). A few small cult-figures were modeled and covered with symbolic patterns; some are mounted on miniature wheeled carriages, for cult purposes.

The practice of wearing personal wealth, and of being buried with it—men with their war-gear, women wearing their heavy bangles—and the rites of burial in closed single graves, have meant that much has survived in Scandinavia and the Baltic which may have been lost in regions where other rites prevailed. Also in the north, since remote Mesolithic days, treasure was dedicated to the gods and exposed beside lakes on the moors, or thrown into meres. These, becoming peat-bogs have preserved the treasure along with the men and

women who were sometimes buried or immolated in the same way, so that human flesh, hair, and the tartan thread of clothing has survived, as well as gold and bronze ornaments and weapons and wooden coffins.

The northern metalworkers like those of central and eastern Europe preferred casting to forging when making swords, axes, and bangles. They had mastered the *cire perdue* method of casting and used it with skill and sophistication. It was used to cast the famous bronze horse drawing a bronze and gold "sun-disk" found in a bog at Trundholm, Odsherred, Denmark (National Museum, Copenhagen). The two faces of the disk have different patterns of concentric circles, running spirals, loops, and zigzags; but one face also has a thin gold sheet pressed onto it so that it takes the pattern. Horse and disk were mounted on wheels for the purpose of enacting the movement of the sun across the heavens in the cosmic drama of day and night, the whirling, spiraling patterns representing the sun in splendor.

A little later than the Trundholm group a huge tomb for the burial of a chieftain was constructed of stone slabs covered by a barrow at Kivik in southern Sweden. The slabs inside the chamber of the tomb were carved with symbolic and narrative scenes in a manner unique for the north, and more at home in the Mediterranean world. On the six surviving slabs subjects are arranged in horizontal registers; horses, boats, and axes are shown, while two stones have scenes of ceremony. On one a man drives a two-wheeled chariot (the earliest depicted north of the Alps), among long-robed, hooded figures, and armed men in procession; and next to it in a more complicated scene the same hooded figures stand on either side of an altar (Historical Museum of the University of Lund). Compared to the highly professional gold and bronzeworking, the artistic level, is not very high, though neither naive nor tentative. The gestures are not the less expressive for being conventional and hieratic.

Rock-engraving in a different style, that is, nearer to the old Mesolithic tradition of Scandinavian rock-carving, had a remarkable renaissance in the early 1st millennium. Dating is uncertain and it may have started a little earlier than this. It is found on natural rocks, occasionally in Denmark and much more often in Sweden and Norway. The method is the usual shallow pecking with a hammer. Boats are a favorite subject, as are two-wheeled carts, all very schematic. In Bohuslan in southwest Sweden, near the Norwegian border, there is a different style again, of greater variety and with magical and mysterious subjects: masked men blowing horns, ithyphallic dancers, and longhaired women. In the Val Camonica in the Italian Alps, rocks are engraved with very schematic agricultural and hunting scenes.

From around the 12th century BC the northern smiths, particularly in Denmark and North Germany, were making bronze razors with long sub-triangular blades, the blade at first undecorated, ending in a naturalistic man's or animal's head cast in the round. Later, in the first centuries of the 1st millennium BC, the holding end became a snake's head coil of

Rock carvings of ithyphallic figures at Bohuslän, Sweden

metal, and the surface of the blade was chased with pictorial scenes. Often a boat was the subject, as on the rocks; or there are boats within boats like Chinese puzzles; or, more interestingly, there is a tableau staged on a boat, like a miniature picture within a frame limiting both space and time. The group on a razor from Bremen, West Germany, may copy a Phoenician jewel left in southern Spain (Zentral Museum, Mainz); but the boat is the northern war-canoe with animal prow and stern and a ram. On these small bronzes, spirals take possession of kneeling gesticulating figures. This style could have evolved out of the Apa-Hajdusámsun decoration of Hungary and Transylvania, but the spirals and sprays are no longer abstract; they have become organic, sprouting heads of horses and elk, and tumbling like waves.

In the British Isles there was an early and independent school of metallurgy which reached great heights of skill. In Ireland in the early 2nd millennium a gold rod was beaten out very thin into the crescent shape of a "lunula" neck ornament; it was then given a simple incised rectilinear ornament of great delicacy which may be derived from "beaker" pottery. The "lunula" from Killarney is a good example of this work (National Museum, Dublin). Some centuries later gold rods were twisted into handsome arm and neck ornaments, but there was no continuous tradition of metalworking, no long-lived school of decoration as in central or northern Europe, and the remarkable renaissance of gold-working in the 8th and following centuries, though still based on the supply of Irish gold, was probably due to fresh stimulus from European

workshops, especially those of Denmark and the north. The gold "gorget" of the later period from Gleninsheen has superb repoussé and chased decoration (National Museum, Dublin).

Compared to the Continent, the British Isles were undistinguished in their arts until they adopted the La Tène Celtic style in the last two to three centuries BC. But there is one important exception. Stonehenge in Wiltshire really is a unique monument, setting aside the controversy over its purpose. It was the focus for pastoral people whose burials under round barrows are scattered over the surrounding chalk downlands. The huge sarsen stones, most of which have stood till today, were brought from the Marlborough Downs and set up, probably in the early 2nd millennium.

But the site was already sanctified by earlier structures, perhaps of wood, inside an earthwork. There were a number of reconstructions, mostly affecting the smaller "blue stone" circle; but it is the tall sarsen circle with its once continuous lintels, and the setting of five pairs of uprights, each with its own lintel, in a horseshoe inside the circle, that makes the unique teasing monument we see today.

Apart from sheer size—the uprights average 13 ft 6 in (4.1 m) in height and the largest stone weighs 50 tons (50.8 tonnes)—the technical feat is the most astonishing part of Stonehenge. Huge stones were moved by Neolithic tomb builders, but here the accuracy and sophistication of the

The Killarney lunula. National Museum, Dublin

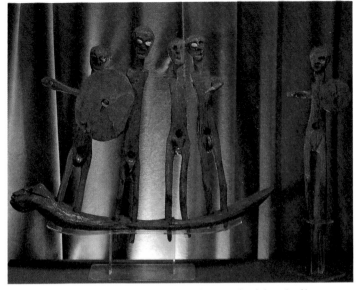

Warrior figures found at Roos Carr in Yorkshire, England; length of boat 51cm (20in). City and County Museum, Kingston-upon-Hull

work—dressing the stones, levelling the lintels, fitting tenon and mortice, and above all the cunning of entasis by which the taper of the uprights is given a convex curve so that there is an optical illusion of straightness, while the lintels are inclined inwards toward the bottom—this is something so wholly unexpected that some scholars have looked for master builders from the eastern Mediterranean.

It is impossible to say how much wood carving was done in Europe because so little has survived. An idea of its primitive quality can be had from the few carvings that have been found; these owe their survival to the acid bogs in which they lay, scattered from Ireland to the Urals. Most are rough images of male virility, like the four gaunt warriors with staring pebble eyes that stand in an animal-prowed boat found at Roos Carr in Yorkshire, England (City and County Museum, Kingston-upon-Hull). Some wooden figures are no more than slightly improved branches or trunks of saplings that may have been ritually dressed and undressed, like the goddess Nerthus of Tacitus' *Germania*.

The arts so far described have followed an indigenous European course, for the most part isolated from centers of civilization beyond the Mediterranean and the Bosphorus. But from time to time these "frontiers" became channels for closer contacts and the transmission of new skills, new needs, and new fashions; as was the case in the first half of the 1st millennium.

Some time before this a new impetus was given to the techniques of forging. Large objects of sheet metal, hammered and riveted with embossed decoration, began to appear. The method was more economical of labor and material than casting and chasing. It may have been introduced from the Aegean in the late 13th or 12th centuries and it made possible a new range of products: buckets, basins, cups, as well as shields, helmets, and corselets. Some of these found their way to the north, and gradually the old workshops were superseded there, as they had been further south.

There was also a strong school producing embossed bronzework in Italy. It required no less skill to manufacture these handsome objects than to cast in molds. Although coarser than the work of the older tradition a rich appearance could be

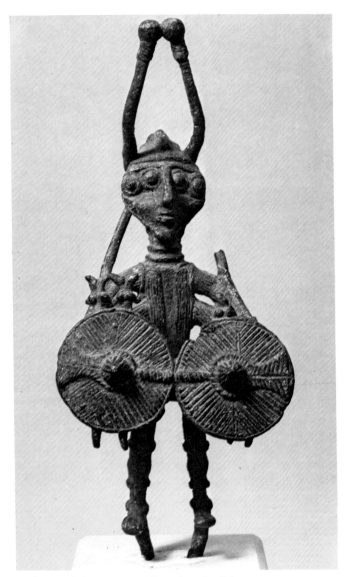

A "four-eyed" bronze warrior figure from Sardinia.
Museo Archeologico, Cagliari

these evidently kept their contacts open with their oriental homeland, for the most likely source of the Sardinian bronze sculpture of the 8th to 6th centuries is Cyprus and the Phoenician cities of the Levant.

Sardinia has a lot of drystone buildings dating back to the 2nd millennium that were still used by the people who made bronze sculptures. Buildings were sometimes clustered into compact villages with labyrinthine curvilinear walls, round towers, and encircling walls. The number of these *nuraghi* that still dominate much of the Sardinian landscape suggests a fairly dense population. More than 400 small bronze figures have been found; one or two come from 8th-century Etruscan tombs in Italy, but generally in Sardinia they are found heaped together in hoards of votive gifts in houses and sanctuaries. The *cire perdue* method of casting was used; and the style— or rather styles, for there are at least two—is quite individual and a long way removed from that of both Greek and Oriental bronzes, though closer to the latter. Some male figures, like the oriental "divine warrior", are armed with sword and shield and wear a helmet with bull's horns; but there are also archers with arrows at the ready, and a patriarchal cloaked figure with a staff. Some figures are undoubtedly gods with duplicated eyes, arms, and shields. They are solemn, hieratic, and have been called "Geometric" or "Formal". Another group is full of action and expression and has been called "Barbaric" or "Informal"; there are pipers and bowmen, a mother-and-child, wrestlers, and some people who simply appear to be talking. With rare exceptions there is no interest

A Sardinian bronze "mother-and-child". Museo Archeologico, Cagliari

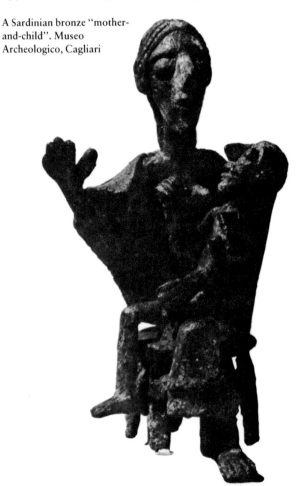

achieved exploiting light and shade, and changes in texture.

Iron technology was gradually introduced into Europe during the early part of the 1st millennium from the eastern and the Mediterranean corridors. New orientalizing arts came the same way giving rise to a school of bronze sculpture in Sardinia, of sheet bronze with narrative repoussé pictures in Italy and the east Alpine valleys, and jewelry, vase-painting, and monumental carving in Iberia, and something of all these in southeast Europe.

In the early 1st millennium BC the Mediterranean was full of pirates, and of bands of colonists and merchants hardly distinguishable from pirates. In the 9th and 8th centuries some of these found Sardinia, an island rich in copper deposits, where some of the inhabitants were probably descended from other settlers of the 12th century or earlier still. Unlike the waves of colonists in the Neolithic and Early Bronze Age,

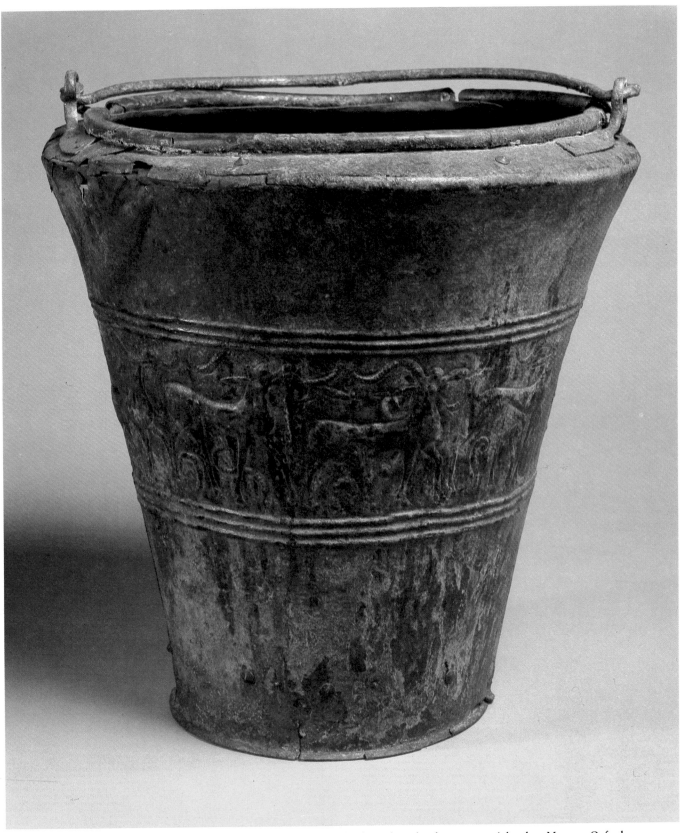

A situla found in a grave at Vače, Yugoslavia; bronze; height about 30cm (12in); late 6th–early 5th century BC. Ashmolean Museum, Oxford

in bodies, which are treated as clothes-racks and coat hangers for cloaks and weapons. It is an art of expressive silhouette, of hands and gestures caught in movement or the full flood of argument, a small-scale art, very anticlassical and far more alive than its Cypriot and Levantine forerunners.

A combination of Greek, Oriental, and Etruscan contacts south of the Alps led to a new naturalistic taste in the decoration of bronze buckets, belts, and bowls, but especially buckets. Plain versions of these "situlae" had been made in 12th-century central European workshops. Because of the number and grandeur of their decoration, this style has been called "Situla Art".

The Strettweg Cult-wagon

A unique religious scenario from the European Early Iron Age (7th century BC) has been preserved at Strettweg near Judenberg in the Austrian Alps. This is a four-wheeled bronze conveyance on which are a number of figures, human and animal. It was found in a rich cremation grave under a tumulus, along with bronze vessels, horse-harness, bronze and iron weapons, and implements, all of which, apart from the "cult-wagon" can be matched at the eponymous cemetery of the Hallstatt culture some 31 miles (50 km) to the west in the Salzkammergut, which dates from the 7th to the 5th centuries BC. Hallstatt depended on the local salt deposits for its wealth, but at Strettweg the accessibility of ores in the Styrian mountains probably accounts for the richness of the find.

The scene is a tableau arranged symmetrically around a central figure of the "goddess", who stands on an 11-spoked wheel cut in the floor of the carriage. Her divinity is shown by her size (9 in, 22.6 cm), twice the height of the other figures. She is naked except for a girdle, and both hands are lifted to support a shallow bowl resting on a cushion on her head. The bowl is also supported by four struts of twisted bronze and must have been intended to carry a certain weight. Four mounted warriors with oval shields, javelins, and conical helmets flank the goddess in front and behind. Between them stands a man brandishing an ax and a woman with hands held in a gesture of supplication, while at front and rear two sexless figures grasp the massive antlers of a stag. All the figures are naked, and the platform, where it is attached to the axles, ends in four bovine heads. Surprisingly no birds are featured.

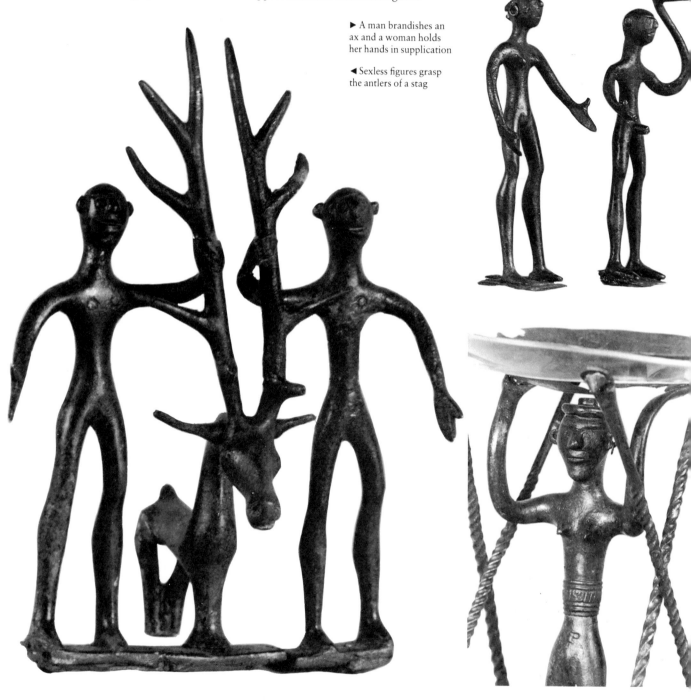

▶ A man brandishes an ax and a woman holds her hands in supplication

◀ Sexless figures grasp the antlers of a stag

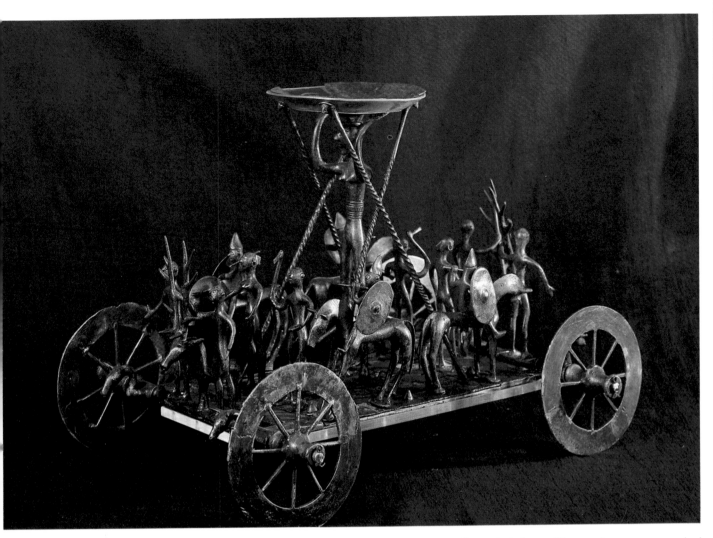

Although the Strettweg tableau is unique, bronze vessels mounted on wheels and attended by figures, usually birds, are known from earlier in the Late Bronze Age, from Denmark to Bohemia. There is a small example in a cremation grave at Acholshausen, north Bavaria. In the Hallstatt Iron Age small bovines, horses, birds, and men (not women) were occasionally attached to bronze vessels, but there is nothing to compare with the technical and iconographic complexity of Strettweg.

▲ The Strettweg Cult-Wagon; bronze; base 35×18cm (14×7in). Landesmuseum Joanneum (Abteilung für Vor- und Frühgeschichte im Schloss Eggenberg), Graz, Austria

▶ The bronze caldron wagon from Acholshausen, Bavaria

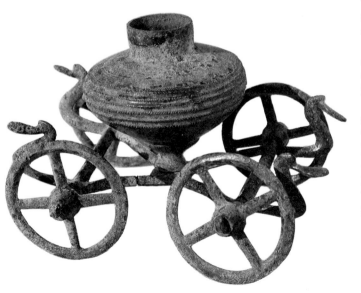

◀ The central figure of the goddess; height 23cm (9in)

In Italy small bronze figures were attached to tripods and other furniture but none were like the "goddess". This tall, slender figure must owe her proportions and style to a group of warriors, or early Zeus figures, best known at Olympia where a "Zeus" of the early 7th century BC is remarkably similar. The Strettweg horses may owe something to Greek Late Geometric workshops, for this was a time when craftsmen were very mobile.

The same *dramatis personae* appear modeled in clay attached to handsome pots in a 7th century BC chieftain's grave at Gemeinlebarn, lower Austria.

The Strettweg scene is neither a hunt nor a sacrifice, but rather an apotheosis of the "goddess with the vase" or cornucopia. The later Celts of nearby Salzbach worshiped Aeracura, a goddess who had a horn of plenty or basket of fruit and was associated with a god wielding a mallet. It is not possible to make any further interpretations but the date can be fairly confidently placed in the early 7th century.

N.K. SANDARS

It had just begun before 600 BC though most work was done in the later 6th and 5th centuries. The earliest examples came from Italy (Bologna and Este) but the liveliest work was done in east Alpine centers, with one group in Slovenia. Here situlae were sometimes used as urns holding cremated ashes and buried in groups of round barrows. The repoussé ornament, hammered on the inside, was finished with chasing on the outside, and details were added with the tracer. The area to be decorated was divided into horizontal zones, and the subjects are, for the most part, already familiar in the art of the eastern Mediterranean. There are files of animals—wild, domestic, and fantastic; carts and chariots, horse and footmen; there are banquets, musicians, boxing contests, farming and erotic scenes. All the figures are in profile and although the style of representation varies, they were the work of probably only a few artists.

The situla from a large flat grave at Vače not far from Ljubljana in Slovenia (Archaeological Museum, Ljubljana) shows both the weakness and the vitality of Situla Art. Some of the subjects may have come from copying Greek 7th- and 6th-century vase-painters and metalworkers, others from as far as Urartu in eastern Anatolia and from Assyria; but here they are transformed into genial bucolic celebrations which are technically quite accomplished, but which nevertheless betray the gaucherie of the artist working in a style that is uncongenial and outside his artistic experience. The results are neither civilized, nor strongly barbarian, but provincial. In this they are inferior to the highly professional and quite unclassical work of the northern workshops that produce "pictorial razors", or the embossed decorative bronzes of central European workshops.

In Situla Art and in a lot of the later "Hallstatt" work in Europe, we find signs of a loss of direction and an uncertainty which seems to result from an introduction to really first-class Greek and eastern Mediterranean work now occasionally imported or captured. It was evidently highly prized, for it was buried (after some lapse of time) in the graves of local potentates. There was a positive attempt to adapt and master the humanistic arts of Greece but they were too alien; and in fact the future for Europe lay in a quite different direction, as emerged in the course of the 5th century BC.

"Hallstatt" is the name given by archaeologists to the centuries immediately preceding the appearance of Celtic La Tène

Human and animal heads on a pin-head from Rovalls, Sweden. State Historical Museum, Stockholm

art in the mid 5th century BC, that is to say in the early mid 1st millennium BC north of the Alps. The name comes from a salt-mining center in the Austrian Alps. While society was evolving rapidly, with some accessions from the east—new wheelwrighting techniques, ironworking, and perhaps fighting on horseback with long swords—native chieftains were buried on fine hearses wearing gold diadems and surrounded by masterpieces from southern workshops. At Hochdorf near Stuttgart, Germany, in a very recent find, the body of a man lay on a bronze couch supported by eight bronze figures with raised arms, each standing on a single wheel. The find also included much gold work with repoussé designs. All the work appears to be local apart from three Greek lions. The well-preserved textiles with colored patterns include silk thread.

The local decorative bronzework was for the most part dull and repetitive, beating and stamping out geometric patterns on belts, or covering them with a carpet of tiny figures repeated like noughts and crosses. Geometric patterns on pots, sometimes in graphite paint on a red slip, are more successful.

In Yugoslavia and the Balkans an orientalizing influence was felt, rather different from the one that reached Italy and Sardinia. It had started, perhaps, from further east on the borders of Persia and the Caucasus, and it stimulated bronzesmiths in eastern Europe to cast small animals in a much freer style than was done in western Hallstatt centers, and indeed at Hallstatt itself. This so-called "Hallstatt Orientalizing" work traveled north to Scandinavia, as had the linear decorative style in the 2nd millennium. In Sweden and Denmark human and animal figures appear as knife-handles and heads of pins, or as scepter-ornaments, some of them having an odd likeness to the bronzes from Luristan (Persia), though no direct connection is possible.

The most ambitious Hallstatt bronze is a sacred tableau on wheels which owes most to Greek bronzes of the 7th century. This is the "cult-wagon" from Strettweg in Austria (Landesmuseum Joanneum, Graz). The central figure is a goddess who stands on an 11-spoked wheel, cut out of the floor of the "carriage", and supports on her head the bottom of some sort of bowl. This is the figure that owes most to Greek Geometric bronze warriors. Identical mounted armed men are placed before and behind the goddess, and two pairs of ambiguous figures, perhaps young girls, touch the antlers of a huge stag. The whole scene is quite static; it is not a hunting scene but rather an epiphany of the goddess and her attendants, meant, no doubt, like the Trundholm horse, to be pulled forward on its wheels in the performance of the ceremonies.

The Bosphorus and the Hellespont had never been a barrier between Europe and Asia, and this is particularly true in the first half of the 1st millennium BC. There was then a loosely linked continuity of settled communities between the Taurus and the Carpathians, whose members came to be known by such names as "Phrygians", "Thracians", "Getae", "Dacians". There was interchange and crossing and recrossing, so that the same names occur in Asia Minor and in the Balkans. From early in the 1st millennium eastern Europe was moving

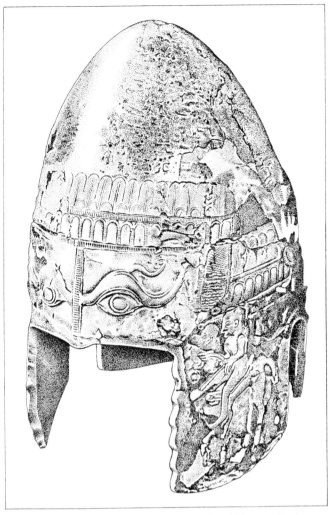

Helmet from Hagighiol, Tulcea, Rumania. National Museum, Bucharest

into an iron-based economy with iron technology learnt from western Asia. Phrygian arts have an echo in late-Hallstatt painted pottery and in bronze bowls (*phiale*), caldrons, and their handles. None of these owe anything to those Scythians who had reached northern Rumania, and who, having left the Caucasus and the Ukraine at the end of the 7th century, had reached northern Rumania, and who introduced their own style of animal art to the Hungarian plain. The fast potter's wheel made its appearance in eastern Europe, probably from Greek colonies on the Black Sea, in the 6th century BC, well before the west had it from Massilia (Marseilles) and the Rhône Valley.

In the late 6th century, still more in the 5th, a new school of decorative metalworkers in Rumania and Bulgaria began to turn out all sorts of ornamental silver and goldwork, including helmets or tiaras, with a very individual style of decoration. The partially gilt silver helmet from a tumulus burial at Hagighiol, Tulcea, in Rumania of *c*400 BC (National Museum Bucharest) shows the barbaric grandeur combined with naiveté that is characteristic of "Thraco-Getic" art. This art attempts to imitate motifs from the Greek Black Sea and Asiatic colonies, and others from oriental (Phrygian and Persian) sources. The Greco-Persian wars introduced a confusion of races and tribes to the borders of Europe, but the connection of this particular branch of decorative art is not with Achaemenian metropolitan workshops but, through that common substratum of loosely related societies, across

Detail of the above: a warrior on horseback

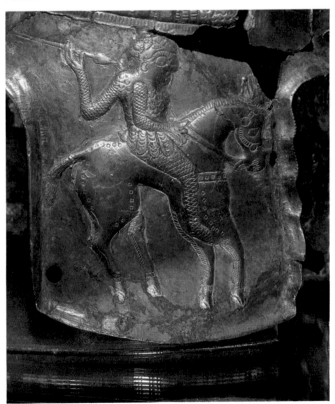

The lady of Elche; height 56cm (22in). Prado, Madrid

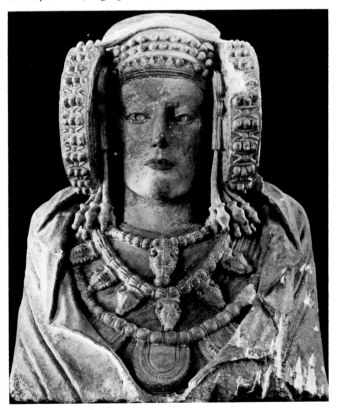

Anatolia from the Balkans to the more advanced workshops of northern Persia. This connection accounts for the strange similarity with much earlier work at Marlik in the Elburz. It is a popular art that, to a great extent, bypassed the "official art" of Susa and Persepolis; though the latter did curiously leapfrog into central Europe to be grasped at by Celtic La Tène craftsmen (*see* Celtic Art). A silver plaque from Letnica near Lovec in Bulgaria (Archaeological Musuem, Lovec), Thracian work of the early 4th century, shows a mounted hunter wearing greaves with human-faced kneecaps, full-size examples of which, in repoussé silver, have been found in Bulgaria in the Mosilanska mound at Vratsa and in Rumania at Hagighiol.

This style had great powers of survival, outlasting the impact of Greeks and Persians—it was still being produced in the 1st century AD. But probably the masterpiece of this school was found not in the Balkans at all, but in Denmark. The silver (once gilt) caldron from Gundestrup (National Museum, Copenhagen) like so much of the wealth from ancient Denmark was dug up in a bog. When found it was dismantled, its seven (originally eight) outer panels, and five inner panels piled on the base medallion. All are ornamented. Some interpretations of the iconography of the panels—the squatting antlered god of one, and the shields and animal-headed war-trumpets (the Celtic *carnyx*) of another—have claimed it as a La Tène work of art, but that it most certainly is not. Most authorities now agree it was made not far from the Black Sea, within the orbit of those Thracian and Dacian workshops that seem to have had large supplies of silver at their disposal. This would have been probably at the turn of the 2nd and 1st centuries BC, by which time Celtic tribes were well-spread throughout the Carpathian-Danubian basin (and even established in Asia Minor), an area as Professor T.G.E. Powell has written "where Thracian versions of ancient Orientalizing art were still executed by craftsmen who were perhaps not exclusively Thracian or Celtic". The repoussé work is in rather high relief and the surface is heavily chased, giving an overall effect of the texture of pelts and clothes. The work of at least three different craftsmen has been detected. The outer panels with the busts of gods flanked by attendant minor gods and creatures have severe idealized features. The narrative scenes on the interior are in a different, more agitated style, full of movement, much of it circular. The arrangement here is not in horizontal zones but continuous. There are many oriental features, from elephants to winged monsters,

while the style of these panels is closest to that of Hagighiol and Letnica.

The medallion that forms the base is the work of an altogether more sophisticated artist. A bull in high relief, its head completely in the round with sockets for horns of some other material, is a powerful adaptation of a classical subject. Its connections are with a series of bronze medallions, perhaps *phalerae* from the harness of horses, which have been found from the Black Sea to the Channel Islands, and all of which show variations of the same triad of late Greek, Oriental, and native influences.

There is an odd pendant to this eastern European Orientalizing style in the Iberian art of the far west, and for rather similar reasons. The oriental sources in this case were the Phoenician and Carthaginian colonies in southern and southeastern Spain. Before the colonies were established, perhaps in the 8th, certainly by the 6th century BC, Phoenician traders had opened up the west, Greeks joining in not much later and providing a counter attraction, less strong than in the Balkans but distinct. There is an Iberian counterpart to Hallstatt Geometric art, though with a strong Phoenician flavor, that can be seen in the sumptuous gold jewelry from El Carambolo (Archaeological Museum, Seville), with "breastplates" in the shape of ox-hides, bracelets, and plaques, all probably 6th century BC. Contact with Greek Classical and Oriental traditions also led to the rise of a native school of monumental stone-carving, in the 5th and 4th centuries, of which the so-called "Lady of Elche" (possibly as late as the 3rd century; Prado, Madrid) is exceptional for the calmness and refinement of the expression that transcends the heavy jewelry and grand but stuffy clothing. Originally the stone was painted but, fortunately, little color remains, for the effect would have been altogether too rich. The Iberians painted their pots in a crowded lively style in which hunting, fighting, and all kinds of occupations were depicted and which has odd reminiscences of the 12th-century Aegean and Levant.

N.K. SANDARS

Bibliography. Condurachi, E. and Daicovicin, C. *Romania*, London (1971). Kimmig, W. and Hell, H. *Vorzeit an Rhein und Donau*, Lindau-Constance (1958). Piggott, S. and Daniel, G.E. *A Picture Book of Early British Art*, Cambridge (1951). Poulík, J. and Forman, B. *Prehistoric Art*, Prague and London (1956). Powell, T.G.E. *Prehistoric Art*, London (1966). Sandars, N.K. *Prehistoric Art in Europe*, Harmondsworth (1968).

6

AEGEAN ART

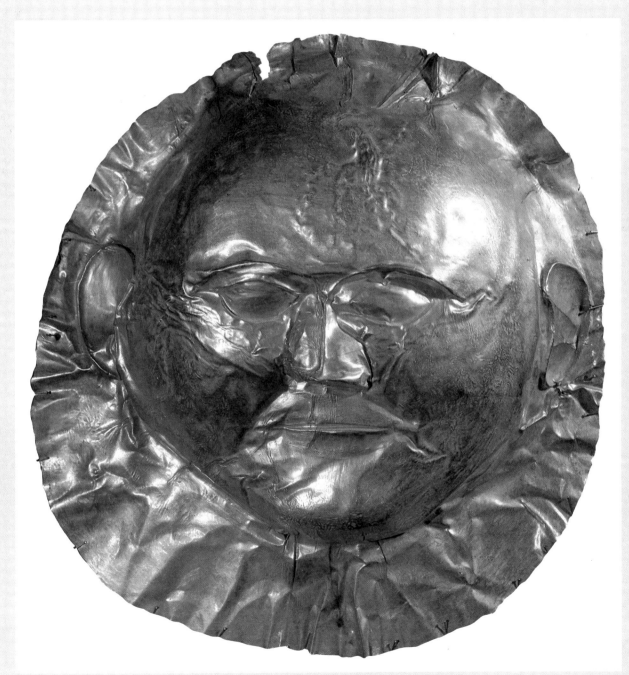

A gold mask from Mycenae; height 31cm (12in); c1550–1500 BC
National Museum, Athens (see page 112)

THE term "Aegean" is conventionally used to describe the art of the civilizations that flourished in the Aegean area in the Bronze Age (c3000–1100 BC). The Aegean Sea is that part of the Mediterranean between mainland Greece and Asia Minor (modern Turkey), limited on the south by the large island of Crete. Stretching southeast from the Greek mainland is a group of islands known as the Cyclades.

In the course of the period, the major source of creative energy, both artistic and political, seems to have shifted gradually from one part of the area to another. In the Early Bronze Age (c3000–2000 BC) the Cyclades were dominant. In the Middle Bronze Age (c2000–1600 BC) it was the turn of Crete, whose culture is called Minoan after the island's legendary king, Minos. After a transitional period at the beginning of the Late Bronze Age (c1600–1100 BC) when Crete maintained her position, her power was eclipsed by the Mycenaeans of mainland Greece. Their civilization takes its name from the mainland site of Mycenae, which seems to have been the center of power. According to a Greek legend Agamemnon, the leader of the Greek expedition against Troy, was King of Mycenae.

The Cyclades and the Early Bronze Age (c3000–2000 BC).
Village settlements of stone and mudbrick are known in the Early Bronze Age. The houses were simple and rectangular, frequently formed into blocks by the use of common walls. Modern villages, particularly in the islands, are basically similar. In the Early Bronze Age this simple form of social organization was standard over the entire area, although each region had its own distinctive variations in material culture. Communal activities probably took place on a village scale and the degree of artistic sophistication corresponded to this. Most of

Distribution of the main centers of Aegean civilization

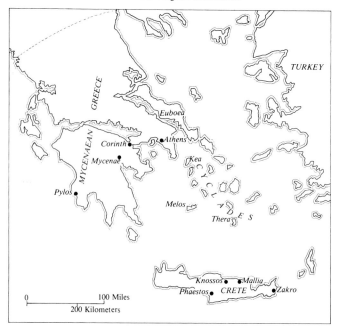

the Cyclades are small but would have been self-sufficient, and although only a limited standard of living could be achieved, the small communities on them prospered.

The islands, however, certainly had political and trading connections with each other and beyond. The islands of Melos and Yiali possessed the only sources of obsidian in the Aegean. Obsidian, a kind of volcanic glass, is used, like flint, to produce cutting edges on tools and weapons. In a period when metal was rare there was considerable demand for this material, and its exploitation was a source of profitable external contacts and experiences. Marble too was a traded commodity, largely within the islands but sometimes also beyond. Objects of Cycladic origin have been found in Early Bronze Age contexts on Crete, the Greek mainland, and the Aegean coast of Turkey.

This was the setting in which the Cyclades were prominent. But before the end of the Early Bronze Age, a series of disturbances in and around the Aegean broke up the established patterns of existence. Many sites were destroyed and migrants probably entered the area from Asia Minor and the northeast, overrunning by force settlements that lay in their paths.

Towards the end of the Early Bronze Age there was a striking reduction in the number of separate communities in the Cyclades. The entire populations of all but the largest seem to have become concentrated into individual large settlements, more easily defensible. Several are known to have been fortified.

Crete and the Middle Bronze Age (c2000–1600 BC).
From the beginning of this period Crete, whose earlier artistic achievements were by no means negligible, assumed the role of pacemaker. The Cretan palaces were constructed, of which that at Knossos is the prime example. They represent a revolution in both architectural and social terms.

A single huge complex presumably housed a supreme ruler and his retinue. It was also the religious center of the community where rites were conducted and ritual games held. But the Cretan palace was even more than this. It was the administrative center of a wide area to which the more remote farms and villages sent their produce to be accounted and redistributed. Such a center could also equip and operate workshops (for example in metals) of a sophistication that no smaller community could possibly have afforded.

Not only was Crete larger and more fertile than any single Cycladic island but also the scene of that critical economic and political transition from local (village) to regional organization. Thus living standards were raised and the central authority became strong enough to influence events beyond the shores of Crete. Prosperity stimulated rapid technical and artistic developments. As in other communities at other times, much of this increasing artistic sophistication was closely connected with religious life.

Minoan palace civilization did not, of course, develop overnight. The crucial social changes took place and the characteristic palace layout developed late in the 3rd millennium BC.

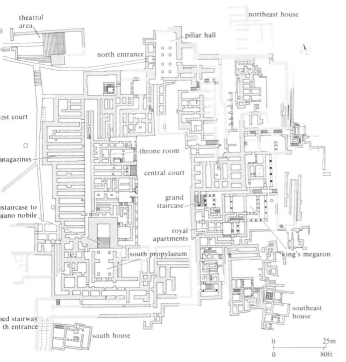

Plan of the Palace of Minos at Knossos; c1400 BC

But these centers continued paramount well into the Late Bronze Age (until c1450–1400 BC) and it is from this Later Palace Period that much of our knowledge comes.

Knossos, Phaestos, and Mallia, the three great Cretan

The throne and part of the throne room of the Palace at Knossos; c1400 BC

palaces, were built before 2000 BC. There is another palace at Zakro in the extreme east of the island on a slightly smaller scale, and almost certainly a fifth under the modern town of Chania in the west. Their creation belongs to a period of major social change in which Crete was organized into regions, each having a palace as its administrative center. There is a tendency to assume that Knossos was the ultimate capital but there is no real proof that it was more than one among equals.

The remains visible today are mainly those of the extensive rebuildings that took place after major earthquake destructions c1700 BC. But parts are later still. The basic layout seems to have remained unchanged. A large open rectangular court was surrounded by buildings of two or more stories. All the palaces share this design but differ in the details. Rooms of private, state, ritual, technical, and domestic function have all been identified. It is significant that cult-rooms regularly have direct access to the central courts. The bull-leaping sport depicted in various artistic media must have been a ritual activity and may have taken place in the latter.

Apart from their complexity of plan (Knossos contains the labyrinth of the Theseus and Ariadne legend), striking constructional features are the use of large, finely worked blocks of masonry and of columns that taper characteristically down-

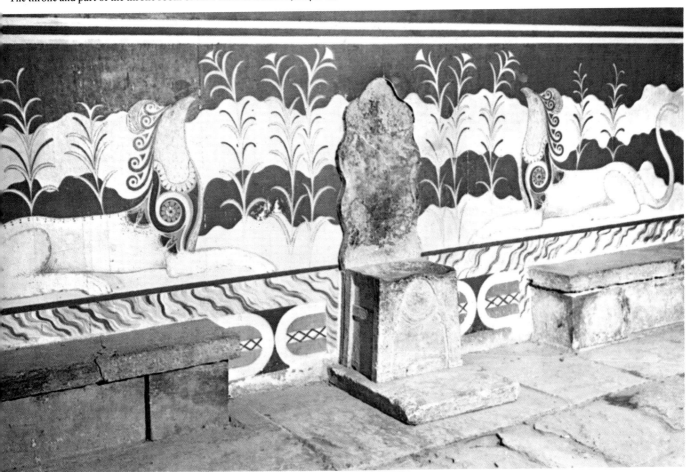

wards. The stone walls were reinforced with inset wooden beams to give some flexibility in the face of earthquakes. Light wells were used to help with illumination.

Throughout most of the life of the Cretan palaces there seems to have been nothing on the mainland or in the Cyclades to compare with them. There were indeed substantial structures outside Crete, but lacking refinements in design and construction.

In the later 16th century BC, impressive buildings, whose construction must have been influenced by Cretan models even if they were not actually built by Cretans, are found in the Akrotiri settlement on the island of Thera. Here the Cretan techniques were applied to the construction of a town rather than a palace (at least no palace has yet been discovered) and some features more appropriate to a monumental complex are not found. Slightly later, there are signs of Cretan influence on mainland construction, though the plan of the Cretan palace was never adopted there.

Late Bronze Age I (1600–1450 BC): Crete and Mycenae.
In the preceding period neither the islands nor the mainland had been able to match the authority or the artistic sophistication of Crete. Cycladic insularity, both geographical and political, was now more of a bar to advancement than an aid. The island centers continued to flourish, and developed individual art styles and traded abroad (particularly with Crete). But they were not in a position to exert unified political strength.

On the mainland, there was no sign of the social revolution that had taken place in Crete and, until late in the period, artistic products are few and have neither the sophistication of Cretan nor the spontaneous freshness of some Cycladic work. But before the end of the Middle Bronze Age, in the earlier of the two grave circles at Mycenae, there are finds that point to greater wealth and sophistication and imply some form of social change.

The later and more famous grave circle, discovered in the 19th century by Heinrich Schliemann and with burials continuing well into the Late Bronze Age, spectacularly confirms these trends. The objects found in the graves of what can only be a warrior dynasty are of an amazing profusion and wealth. The array of weaponry proves that these people were far more warlike than the Minoans. The imposition (or perhaps evolution) of this warrior caste in Mycenaean society is undocumented in detail but nevertheless a fact.

A second event, this time natural, is crucial to our understanding of this period of change. The island of Thera lies in the southern Cyclades, only about 60 miles (97 km) from the north coast of Crete. The core of the island was a volcano which, early in the 15th century BC, first erupted and finally exploded. The whole crater of the volcano collapsed and the tidal waves generated must have had a disastrous effect on coastal sites in their path, particularly those in Crete.

The settlement at Akrotiri on Thera, submerged in ash and pumice from the eruption, and thus remarkably well preserved, illustrates the extent to which the power of Crete was dominant at that time. Almost the whole local artistic produce of Akrotiri is derived from Crete and many objects actually imported. We have already noted Minoan influence on the architecture of the site. Cretan taste and authority had not only permeated the islands—on the mainland too, in this period of transition, we find Cretan objects and inspiration.

Late Bronze Age II (1450–1100 BC): The Mycenaean Empire.
The emergence of warlike Mycenaeans together with the consequences of the explosion of Thera led to the downfall of Cretan power. By the time Thera exploded, the Mycenaeans were strong enough to take advantage.

Many Cretan sites were destroyed in the 15th century. Some of the coastal settlements may have suffered from the side effects of the Theran disaster, some were probably destroyed by invading Mycenaeans. Mycenaean objects appear in Crete in the later 15th century, and shortly afterwards a palace of characteristically Mycenaean type was built at the important site of Phylakopi on the island of Melos, clearly demonstrating that Mycenaean authority was replacing Minoan.

The Cretan palaces were all destroyed about this time and the Mycenaeans concurrently developed their own palace-centered civilization. Some of the methods of organization seem to be derived from Crete, including the script in which administrative records were kept. But the Mycenaean palace itself was quite different in plan from the Cretan and reflects a different social emphasis. The similarity with the Cretan system lies in the use of the palace as an economic and political coordination center for a large area. The central unit is the so-called "megaron", long and rectangular with a main room, antechamber, and porch. The main room, lavishly decorated, had a ceremonial hearth in the center and a throne against a sidewall. Secondary rooms surrounded the megaron, though not necessarily with direct access to it: living quarters, storerooms, workshops and administrative archives. It is not easy to tell how early this form of Mycenaean palace developed. It may have originated in the 15th century or a little earlier, but only developed fully after 1400 when the Mycenaeans had gained control in the Aegean.

Massive fortifications, nonexistent in Crete, are found at many of the major Mycenaean centers. They are built with enormous unshaped blocks of stone in a style called "Cyclopean". The wall-circuit at Mycenae is entered through the monumental Lion Gate, so called from the two lions, set heraldically either side of a central pillar, carved above the lintel.

At Tiryns, where the entrance is defended by massive gateways, the Cyclopean walls contain vaulted galleries within their breadth. The Acropolis at Athens also had Mycenaean fortifications, though little now remains.

Also peculiarly Mycenaean are the "tholos" or beehive tombs which were the burial places of the mainland kings, successors to those interred in the shaft graves. Each of these tombs, cut into a hillside near the settlement with which the

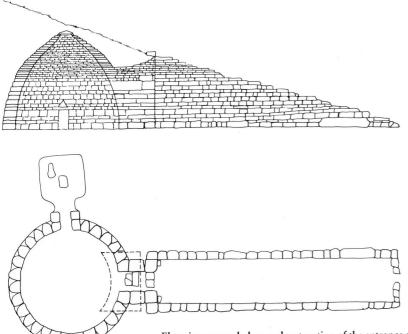

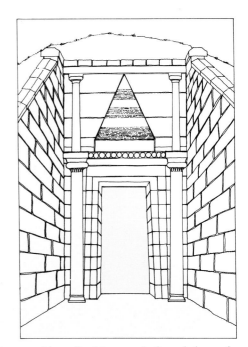

Elevation, ground plan, and restoration of the entrance of the "Treasury of Atreus" at Mycenae, the finest tholos tomb; 14th century BC

king was associated, had a long unroofed approach passage (stone-lined in the more sophisticated examples), an elaborate entrance, and a round chamber, often with side-rooms opening off it. The vault is corbeled and curves upwards to a narrow opening which was crowned with an external capstone.

These tombs may have been derived from the much cruder circular built tombs of Early and Middle Bronze Age Crete. The earliest are from southern Greece which was particularly open to Minoan influence in the transitional period.

In the generations following 1400 BC Mycenaean influence spread throughout the Aegean and beyond, and such is the degree of cultural unity that we can now speak of a Mycenaean "empire". During the 13th century, however, this empire encountered problems, either internal or external or perhaps both. Symptomatic of these are the erection of the great defence walls, and destructions at Mycenaean sites, which are widespread c1200 BC. At this point the empire broke up, the former centers of power declined, and cultural unity disintegrated. New regional centers in more remote positions developed with their own distinctive tastes. In the 12th century these in turn declined and the area entered a period of low living standards and artistic poverty.

The radical differences between Cretan and Mycenaean art will become apparent in the following pages. Mycenaean art has tendencies towards the extravagant, the formal, and, in subject matter, the violent, none of which are particularly characteristic of Minoan. The society that Mycenaean art represents was authoritarian and warlike, and probably lacked the intellectual sophistication of earlier Crete. Differences in religious tradition may have had much to do with this.

Pottery. In the earlier part of the period vases are mostly made by hand without the aid of a potter's wheel. This was introduced, in a crude form, before the end of the Early Bronze Age and its increasing use led to greater regularity and symmetry in vase shapes.

All but the most ordinary domestic pottery had some form of surface treatment. This might be simple smoothing or more elaborate burnishing (polishing) with a tool whose marks can often be seen. A slip of dilute clay was frequently painted on to the surface, especially if decoration was then to be applied. Sometimes slipping and burnishing were employed together to produce an exceptionally deep and lustrous finish.

The use of burnishing as a primary decorative technique is most common in the Early and Middle Bronze Age. Incised patterns are early and Cycladic. The incised lines are sometimes filled with a white substance. Until the Cretan palaces were well established, most painted decoration was simple linear. After this, in Crete and subsequently on the mainland, it became increasingly complex and naturalistic motifs were adopted. In the course of time these often became stylized and their origin would be quite obscure were it not possible to

An example of incised decoration: a Cycladic pyxis; height 11cm (4in); early 3rd millennium BC

Mycenaean Metalwork

Mycenaean craftsmen worked both ordinary and precious metals, producing weapons, armor, tools, utility objects, and luxury goods. Only weapons and armor (mainly in bronze) and luxury goods (often in gold or silver) concern us here. Sometimes they overlap—when weapons themselves are *objets d'art*.

The Mycenaeans seem to have learnt more sophisticated metallurgical techniques from the Minoans during the period of close contact between the two civilizations which began about the time of the Shaft Graves. The style and/or subject matter of some pieces found on the mainland is so Cretan that they must have been made by men trained in a Cretan school. Especially striking are the Vaphio cups, worked in repoussé. The subject of one is the capture of bulls, a theme particularly appropriate to Minoan ritual practices. The fluid "torsional" and very naturalistic style is thoroughly in accordance with the general principles of Minoan art and at variance with the more formal qualities of Mycenaean taste. Another gold vessel, from a tomb at Dendra, not far from Mycenae, is also distinctly Minoan, both in style and in its use of marine motifs.

In contrast to the pieces just mentioned, a gold box cover from Mycenae has mainland characteristics. The lion, stag, bull's head, and floral motifs are formally assembled without any real attention to a naturalistic relationship and the elements are all somewhat stylized.

▲ Gold panels on a hexagonal wooden box. National Museum, Athens

▼ Mycenaean jewelry: a necklace of rosette gold beads from Dendra. National Museum, Athens

▼ A battle scene, in relief, on the Siege *rhyton*, c1550 BC. National Museum, Athens

▲ A gold Vaphio cup; height 8cm (3in); 1500–1450 BC. National Museum, Athens

Fragments of a badly preserved silver vessel, the so-called Siege *Rhyton*, were found in Shaft Grave IV at Mycenae. The vase carries scenes of a sea-borne attack on a city, a "genre" subject also mentioned in discussion of the Thera Frescoes. A long time before the Thera scene was discovered, it had been suggested that the picture on the *rhyton* was probably based on a larger scale painting.

Metal vases are quite common in the early Mycenaean period. Many are of bronze, fine and elaborate, though less costly than gold. Another gold example from the Shaft Graves is the Cup of Nestor, named thus because its characteristics resemble those of a vessel, belonging to King Nestor of Pylos, described in Homer's *Iliad*.

◀ The so-called Cup of Nestor, with two birds on the lip; height 14cm (5½in). National Museum, Athens

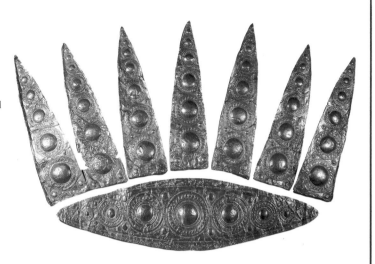

▶ A gold tiara from a woman's grave. National Museum, Athens

▼ Sword blade with inlaid scene of a lion hunt; bronze inlaid with silver; width about 6cm (2in); c1500 BC. National Museum, Athens

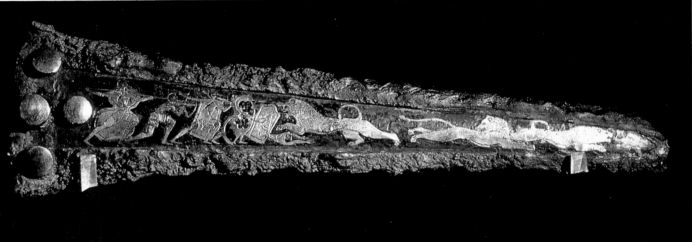

▼ A gold covered sword hilt from Skopelos; c1550-1450 BC. National Museum, Athens

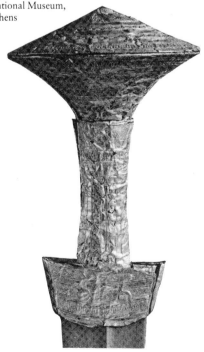

Among the gold riches from the Shaft Graves were a number of unusual masks which were laid on the faces of the dead.

Mycenaean tombs of all periods often contain pieces of personal jewelry or minor ornaments which were buried with the dead, for example necklaces, headbands, and cut-out ornaments, the latter sometimes pierced for attaching to garments. These have incised, repoussé, even granulated decoration. Finger- and earrings are also found, some of the former with very elaborate scenes in intaglio.

Weapons are prominent in the Mycenaean repertoire from the beginning. Many are entirely functional, but some swords are highly decorated, with gold-covered hilts and/or rivets and complex scenes inlaid in the blades. The technique in which these scenes were produced has been called "metal painting" and it required the use of gold, silver, and a black compound called niello. The technique is known earlier in the eastern Mediterranean and was probably learned from there by the Mycenaeans. Several examples survive, one or two with marine motifs in a seemingly Minoan style. On others the thematic and stylistic elements are mixed. The hunting scenes and heavily armored figures are Mycenaean; but some of the bird and animal subjects are almost Egyptian—an influence already noted in some fresco scenes from Thera, which may have been channeled via Crete.

Among the relatively few surviving pieces of Mycenaean body armor, pride of place goes to a fine bronze corselet from a tomb at Dendra. It consists of 15 different parts—front and back body shells, adjustable rings to guard the lower body, shoulder pieces and arm guards, a collar, and a chest piece. Otherwise, fragments of scale armor, greaves, and helmets all testify to the range and skills of Mycenaean armorers.

R.L.N. BARBER

Further reading. Hood, S. *The Arts in Prehistoric Greece*, London (1978).

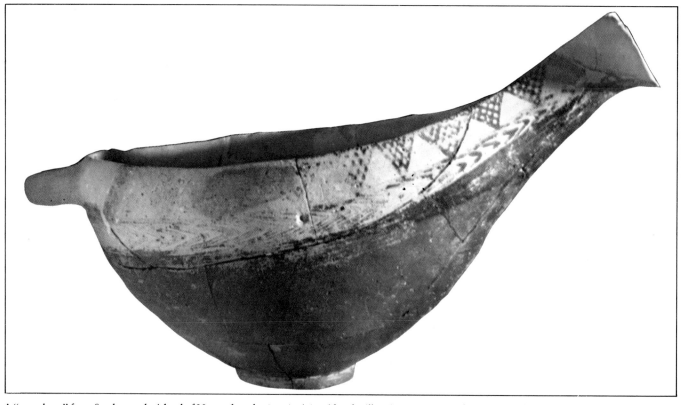

A "sauceboat" from Spedos on the island of Naxos; length 28cm (11in); mid 3rd millennium BC. National Museum, Athens

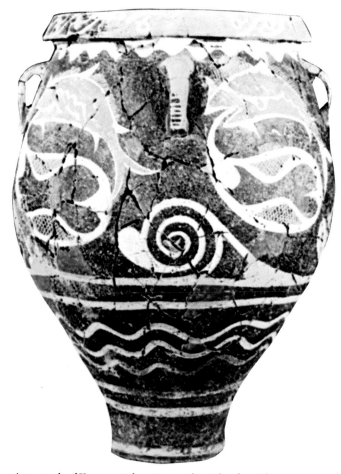

An example of Kamares style pottery: a clay pithos from Phaestos; height 51cm (20in); c1700 BC. Heraklion Museum

trace the history of the motifs from source. Such stylization is particularly characteristic of the later part of our period. Figured scenes occur but are not common.

In the Early Bronze Age the simpler forms of decoration mentioned above—burnishing, incision, linear painted patterns—predominate. In Crete a special firing technique was invented which produced a mottled red and black effect. Shapes also tend to be simple. Some are particularly characteristic of certain areas—the Cretan chalice, "teapot", and jug, the Cycladic suspension vases and *kernos* (a sort of multiple candlestick), and the mainland "sauceboat".

The pottery of the first Cretan palaces in the Middle Bronze Age is decorated in a "light-on-dark" style—lighter colors on a dark slipped vase surface. Simple white painted patterns had been used earlier. Red paint was later employed in addition to the white, and then other shades and colors. Patterns became more complex with the adoption of spiral and curvilinear elements. There were also floral motifs.

The most sophisticated Cretan pottery is the so-called eggshell ware decorated in the Kamares style. Kamares ware is polychrome on a black background, and is named after the cave in Crete in which examples were first found. There are delicate cups with very thin walls, their shapes often angular in imitation of metal vessels. The basic dark surfaces are lustrous. Larger vases too were decorated in the same style. Some vessels have plastic additions. Later vases of this kind have a smaller range of patterns executed in a cruder style and with fewer colors.

Contemporary pottery from mainland Greece and the Cyclades has little, if anything, in common with that of Early

Palatial Crete. The two most common varieties of mainland pottery at this time are called Gray Minyan (after Minyas, the legendary king of Orchomenos, at which site this type of pottery was first identified) and Mat-painted ware respectively.

Gray Minyan is always distinctive since it is a uniform dark gray color, and smooth and soapy to the touch. In its early and cruder form it belongs to the end of the Early Bronze Age but the classic shapes, which have sharp contours and seem to imitate metal prototypes, are later.

Mat-painted ware, as the name suggests, has patterns in (usually) dark mat paint on a light ground and seems to have originated in the Cyclades, but the development of the style took different courses in the two areas. Some of the shapes are similar to those of Gray Minyan ware. Polychrome designs occur at a late stage.

Barrel jars and beaked jugs are common in the Cycladic Mat-painted style, from which the mainland pottery is derived. Patterns are initially strictly rectilinear, though the rigidity is later broken up by the use of curvilinear elements.

At a developed stage of the style, the shapes are better proportioned and the vases usually made (at least on Melos from which most of our knowledge of this pottery comes) of a distinctive white fabric, often of fine quality. The decorative motifs are more ambitious and, though unsophisticated, have much freshness and spontaneity.

Popular throughout this period in the islands was dark slipped pottery with surfaces burnished to a high luster, often in red but also other shades through brown to black. Plain bowls with incurved rims and sometimes loop handles are common. Sometimes Gray Minyan shapes are imitated in these local burnished wares. True Gray Minyan is found in the Cyclades but was clearly imported. A fair proportion of the burnished wares are decorated with white patterns.

A most attractive bichrome style which combines features of Mat-painted and burnished pottery was introduced on Melos towards the end of the Middle Bronze Age. This consisted of decorative motifs whose red elements (usually circles) were burnished, the remainder being painted in the normal mat black. Birds are frequently portrayed on these vases.

We have already described the striking community of taste between Crete and the mainland in the earlier part of the Late Bronze Age. It is sometimes impossible to decide in which of the two regions a vase was made. The inspiration was clearly still from Crete whose palaces, rebuilt after the 18th-century destructions, continued to flourish. Many of the finer objects found at this time on the mainland were certainly made either in Crete or by Cretan craftsmen working abroad.

Apart from the introduction of new shapes, several of which appear before the end of the preceding period, Late Bronze Age Cretan pottery is particularly distinguished from earlier styles by the use of a radically different decorative technique. Instead of the light-on-dark system, designs are now painted in dark paint on a light-colored vase surface. Although the mainland had a light-on-dark decorative tradition (the Mat-painted style), new stylistic developments

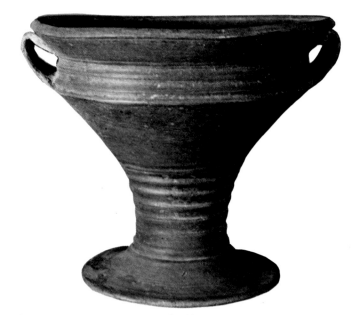

Gray Minyan ware: a ring-stemmed goblet; c 1700 BC

there are clearly more closely associated with contemporary Crete. In the Cyclades the trend was now away from local innovation and towards a copying of Cretan models.

Many of the patterns used are abstract—the spiral, sometimes elaborated with dots and/or white paint, is particularly popular. Apart from these more conventional designs, there are two trends in Cretan decoration. The first and earlier involves the use of plants, flowers, leaves, and grasses as decorative elements. The second depends on motifs from marine life—octopus, sea urchins, nautili. Such types also reached the mainland, where formal patterns were more in evidence.

Towards the end of the 15th century these motifs became more and more stylized. This tendency is particularly clear on the large "Palace style" jars from both Crete and the mainland. Since the trend coincides with the critical years of the transition of power from Minoans to Mycenaeans we may see in it evidence of the subjection of Cretan energy and naturalism to the heavier formalism of the mainland.

In the islands, Thera (destroyed before the introduction of the Marine and Palace styles) has an exceptionally large number of Cretan imports. The local pottery from the site is heavily dependent on Cretan shapes and decorative motifs, especially spiral and floral. These patterns were also much imitated on Melos. Imported Cretan pottery is found too on other islands, Paros and Kea for example.

Both the high technical quality and the dark-on-light decorative system flourished on the mainland and in Crete during the years of the Mycenaean empire. Only at the end of this period did the quality of the ware deteriorate and the decoration become careless and imprecise.

It is now Mycenaean pottery that sets the standards and Cretan products follow it in shape and ornamentation. Many Mycenaean decorative elements represent stylizations of earlier, more naturalistic motifs, often derived from Crete. They

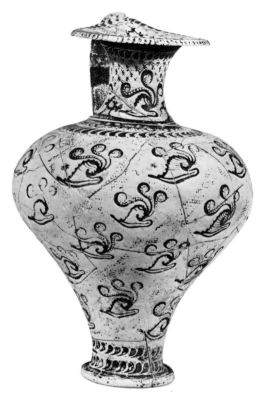

A "Marine style" jar decorated with nautili from Zakro;
height 28cm (11in); c1500–1450 BC. Heraklion Museum

A stirrup-jar from a tomb at Makresia
near Olympia; 13th-century BC

are most commonly set in zones or panels.

In the Cyclades, from the beginning of the Empire period, the local decorated pottery is entirely Mycenaean in character and most of it probably imported. Analysis may show, however, that methods of refining the usually coarse Cycladic clays had been discovered to enable local production of "Mycenaean" vases.

One of the most typical Mycenaean shapes is the *kylix* or stemmed goblet. Many examples, both plain and decorated, come from sites of this period. The stirrup-jar, although originally Cretan, becomes a standard Mycenaean shape. Such vases, which have one spout on the shoulder and a false spout incorporated in the handle on top, were easily sealed. Some have spikes projecting from the true spout to facilitate the fixing of some form of stopper. They were probably used for transporting liquids.

Vases with figure decoration are not common but there is one striking group of *kraters* (large bowls). More of these have been found in Cyprus than in Greece but clay analysis shows that they were made in Greece. Scenes connected with warfare—warriors, horses, and chariots—are particularly

prominent, revealing one of the chief preoccupations of the people for whom they were made.

The pottery of the final stages of the Mycenaean period should be considered in close conjunction with contemporary history. We have already seen how, even before 1200 BC, some Mycenaean sites had built or strengthened their defence systems. At the end of the 13th century most sites were destroyed or abandoned and only a few reoccupied. We still do not know exactly what happened, whether there was a massive invasion, a civil war, or a major climatic change which ruined the food supply, causing some to starve and others to turn against their own in a desperate fight for survival.

Whatever happened, the Empire as a centralized authority was broken, but the wealth, technical and artistic skills that had flourished within it were not entirely dissipated. Refugees from the former centers of power established themselves elsewhere—in the more remote parts of Greece and even in Cyprus. High-quality vases were produced, for example on Naxos and in the southeastern Aegean. The mainland "close" style, which has some parallel in Crete, stands firmly in the inherited tradition. However, marked regional variations appear, and there is an even greater tendency to formalism.

The more sophisticated post-Imperial styles did not survive to the end of the Bronze Age. The latest vases (appropriately called sub-Mycenaean and sub-Minoan) have a restricted range of basic shapes and ornaments. Their technical quality is poor and the contours of the vases sag and are markedly less vital. These inhabitants of the Aegean obviously lost heart and initiative in the adverse conditions which prevailed, a fact clearly reflected in the quality of their pottery.

The contrast between these gloomy products of a dying civilization and the new vitality of the subsequent Protogeometric revival is the more marked because the two styles, so totally different in feeling, share similar shapes and motifs. (*See* Archaic Greek Art.)

Frescoes. The Cretan palaces were built on a scale that left large areas of wall space free for embellishment and thus it was that the art of fresco painting developed. In the earlier palaces it was mostly limited to plain colors and simple linear patterns on the plastered walls. Later, figured and naturalistic scenes were common and many motifs can be related to those found on contemporary pottery.

Most of the advanced figured scenes belong to the later palaces. The lily fresco from Amnisos (Heraklion Museum), a villa on the north coast of Crete, is transitional. It has the characteristic red background and some of the linear patterning of the earlier style but the lilies themselves represent a more elaborate composition. The flowers also indicate the concern with plants and wildlife which were important sources of subject matter in later frescoes and vase-painting.

There are frequent ceremonial scenes, perhaps both religious and secular. An elegant lady, dubbed "La Parisienne", is from one of these. Others show figures in procession or watching events. A bull-leaping scene must have a significance

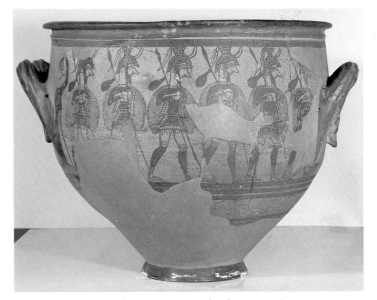

A krater from Mycenae: the "Warrior" vase; height 41cm (16in); c1200–1150 BC. National Museum, Athens

that is lost to us. This dangerous sport seems to have played an important part in Minoan religion. Analysis of the architecture of the palace at Mallia has led to the suggestion that it took place in the central court, which was closed off for the purpose with temporary barriers to protect the spectators.

Outside Crete, there are frescoes from sites in the Cyclades. A piece from Melos showing flying fish (National Museum, Athens) clearly relates to Cretan work in choice of subject matter, but is somewhat cruder and fresher in style. Extensive fresco scenes, spectacular both for their subject matter and state of preservation, have recently been discovered beneath the volcanic debris on Thera. They too in many cases have this distinctively Cycladic feeling, though there is no doubt that the technical foundation is Cretan. Again there are many scenes from nature—flowers, birds, and animals.

The most interesting fresco so far found on Thera, particularly from a historical point of view, is in miniature. It shows a landscape with towns and figures. Before one of the towns a naval battle is taking place. Features of the landscape have much in common with Cretan work but the remaining elements are most unusual. The only real parallel for the subject matter in Aegean art is the silver Siege *rhyton* from Mycenae (see page 100).

Although the style of the frescoes is vigorous and conveys a strong impression of naturalism, perspective is barely observed and gestures and features are conventionalized. Eyes are frontal and heads in profile. The Theran battle scene demonstrates the inability of the artist to show a body falling naturally.

There are no frescoes from the mainland contemporary with those on Crete and in the Cyclades, since the architectural form to accommodate them had not yet been developed. But the palaces of the Empire period were extensively decorated in this way. While the basic technique is the same as the one developed earlier on Crete, the surviving scenes create a very different impression, perhaps best illustrated by a restoration of the scene from the throne room of the Palace of Nestor at Pylos in the far southwest of mainland Greece. The naturalism typical of Crete has gone. Plant and animal life is

The Thera Frescoes

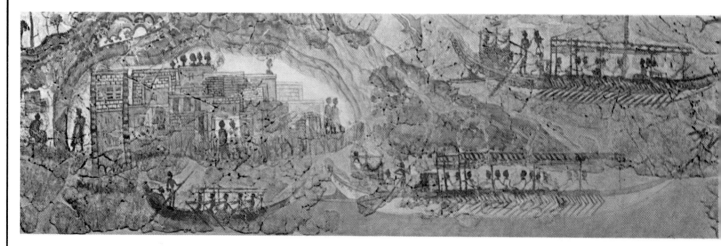

▲ The Ship Fresco; height 40cm (16in). National Museum, Athens

▶ The Ikria Fresco. National Museum, Athens

The frescoes at the Akrotiri settlement on the island of Thera belong to the late 16th century BC. They owe their remarkable state of preservation to the volcanic debris under which they were buried and have added immeasurably to our knowledge of prehistoric Aegean painting. Perhaps their most striking feature is the successful combination of high decorative quality with significant narrative or symbolic content.

The ships in the Ship Fresco are beautifully adorned with devices, flags, and bunting. The landscapes are rendered in bold colors thought to represent the variegated volcanic rocks of Thera itself. The essential theme, however, is a formal one, possibly a festival to celebrate the Annual Resumption of Navigation—clearly a key event in a maritime community.

The Ikria Fresco, so-called because its motif, repeated eight times, is the *ikria* or stern cabin seen on the flagship in the Ship Fresco, displays a similar union of the decorative and the symbolic. The *ikria* is a gay, attractive object. Placed so prominently in the decoration of a finely appointed town house in Akrotiri, as well as on the flagship, it surely indicates the status of the occupant of the house—Admiral of the Fleet.

In the same room as the Ship Fresco and also of miniature size (approx. 16 in, 40 cm high), are scenes of a sea battle set against a town and a tropical landscape. The former seems to have been a standard subject in Late Bronze Age art in the eastern Mediterranean; the latter reflects an interest in nature evident in both Cretan and Theran paintings which sometimes, as here, shows signs of Egyptian influence, probably absorbed through Crete.

◀ The Priestess. National Museum, Athens

▲ The Spring Fresco. National Museum, Athens

Before the discovery of the Thera frescoes, knowledge of Bronze Age wall-painting was fragmentary, derived from finds on Crete, Mainland Greece, and (to a lesser extent) two other Cycladic islands. The Thera pictures are most closely related to those from Crete. There are a number of similarities in subject and style (compare, for example, the Cretan "La Parisienne" with the Theran lady in the Crocus Gatherers Fresco). Technical analysis has shown that the pigments used and the methods of painting employed were virtually identical in the two places.

In spite of this, there is a strong and very attractive local Cycladic quality in the Thera painting—a quality that can also be discerned in the arts of other islands. This is manifest in a confident simplicity of line and a real, if somewhat rustic, charm. A number of the subjects and motifs are not found in Crete; there is no Minoan parallel for the Ship Fresco for example.

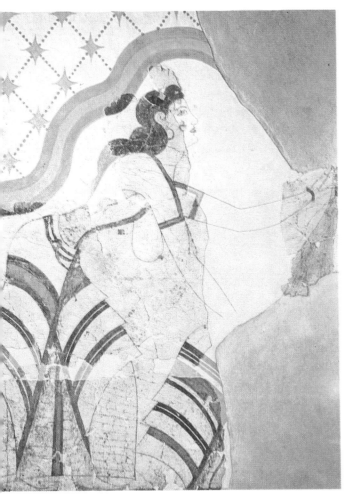

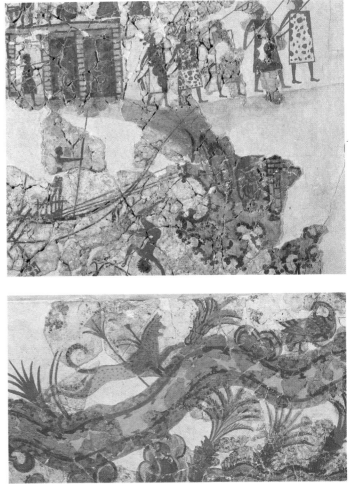

▲ The Lady of the North Wall. National Museum, Athens

▼ The Boxing Children. National Museum, Athens

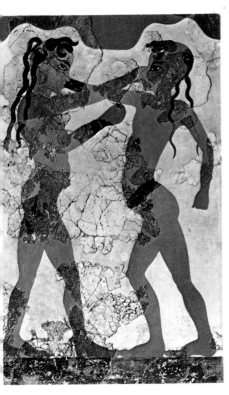

The use of natural themes at its most purely decorative is to be found in the flowers, rockwork, and swallows (a distinctively Theran subject) of the Spring Fresco. Floral motifs also form the central elements in other scenes and, in one case, were used to adorn a window recess.

An attractive treatment of the natural location can also be seen in the Crocus Gatherers Fresco, where the rocks, clumps of flowers, and grasses are charmingly rendered. The same delicacy can be seen in the figures, who wear fine dresses and jewelry. Some carry baskets; one picks a thorn from her foot. The dresses and hair styles are clearly Cretan. The theme of crocus picking is found also on Crete, but the participants there, as in another Theran fresco, are monkeys!

This scene too probably had special significance. The flowers may have been gathered for some ritual purpose, possibly the making of saffron offering-cakes which the "Priestess" of another picture may be carrying.

The "Priestess" is an impressive, interesting figure, striking for her unusual formality in the general context of these frescoes. The only comparable figures are the so-called Boxing Children, engaged in an activity we cannot readily interpret.

▲ Scenes from the Ship Fresco: *above* a sea battle; height 40cm (16in). National Museum, Athens

▲ *Below* a tropical landscape; height 40cm (16in). National Museum, Athens

Another figured scene with ladies displays something of the solemnity of the "Priestess", although the figures are more in the style of those in the Crocus Gatherers Fresco. The background is plain but the border strongly patterned—a reminder that border patterns are common, and unfigured designs consisting solely of patterns are also found.

Although technically primitive by more sophisticated standards—in anatomical naturalism, composition, the rendering of spatial relations—the Thera frescoes are remarkably effective, colorful and appealing pictures. We may assume their very existence to be proof of the success of their formal role.

R.L.N. BARBER

Further reading. Hood, S. *The Arts in Prehistoric Greece*, London (1978). Morgan Brown, L. "The Ship Procession in the Miniature Fresco" in Doumas, C. (ed.) *Thera and the Aegean World I*, London (1978). Warren, P.M. "The Miniature Fresco from the West House at Akrotiri, Thera, and its Aegean Setting", *Journal of Hellenic Studies* vol. 99, (1979) pp115–29.

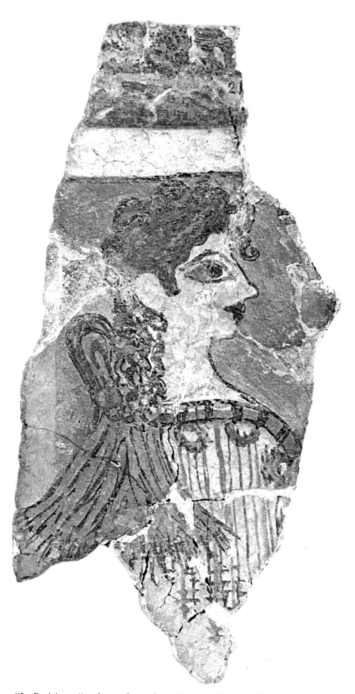

"La Parisienne", a fresco figure from Knossos; height of figure 20cm (8in); c1400 BC. Heraklion Museum

stylized; poses are formal and rigid; the composition is heavy and forbidding; and figures are vast and undynamic. There is a new emphasis on scenes of combat.

Stone objects. Early stoneworking must have been a laborious process. Objects were roughly shaped with chisels and then smoothed and polished with an abrasive. Emery is found in the Cyclades (mainly on Naxos) and is ideal for this purpose.

Before the end of the Early Bronze Age in Crete, a form of drill was invented to extract the core from a block of stone, to form a vase interior. Hollow reeds may have been used initially, again with an abrasive. Later the raw stone itself was rotated under a fixed drill. The people of the Cyclades, with their extensive marble beds, were early masters of stoneworking and achieved a remarkable degree of sophistication.

Marble figurines of schematic, though recognizably human form are regularly found in Cycladic graves of the Early Bronze Age. They vary in height from a few inches to several feet. We have no means of telling exactly what role they played in funerary practices but they must have been primarily associated with these as they are found much less often in settlements. The islands richest in marble, Paros and Naxos, probably found in these figurines and other marble products a profitable trading commodity, which may partly explain their prosperity early in the Bronze Age.

Most of the figures are standing, their arms usually crossed over their bodies. Their faces are long, oval, and backward-sloping, their noses being the only worked features. Earlier figurines are less naturalistic and reduce the human form to the shape of a violin. The "folded-arm" category includes some more complex types. Arms are set in different poses and there are some seated figures. Prominent amongst these are two musicians, one playing a harp and the other a flute. These figures have an intrinsic abstract appeal. Their firm, simple lines are certainly at home among the sharp light and fierce colors of the Aegean world.

Many vases were manufactured in stone, and most of the Cycladic stone shapes are also found in terracotta. There are simple, flattish open bowls and dishes, as well as more complex vessels. Suspension vases, with wide bodies and narrow necks and feet, had side perforations by which they could be hung.

Crete, too, was a center of stoneworking from early times and became more important than the Cyclades in this respect. The Cretans used a much greater variety of stones. Characteristic is the "Bird's Nest" Bowl, but more elaborate shapes were attempted, even at this early period.

From the later palaces come several stone vases with decoration in relief. The "Harvesters" Vase from Ayia Triadha near Phaestos shows a harvest procession, the figures carrying appropriate equipment (Heraklion Museum). It is made of black steatite and, in common with other such vases, was originally covered with gold leaf.

The palace at Zakro has been a particularly rich source of stone vases. Many of them seem to show ritual scenes and several are of the *rhyton* shape. This type of vase is especially associated with religious activity. One Zakro example shows a worshiper at a hilltop sanctuary. Other *rhyta* were made in the form of animals' heads.

There are also many undecorated vases, their appeal stemming from elegance of shape and the varying characteristics of the stone used.

Right: A marble harpist from the island of Keros (Cyclades); height 23cm (9in); mid 2nd millennium BC. National Museum, Athens

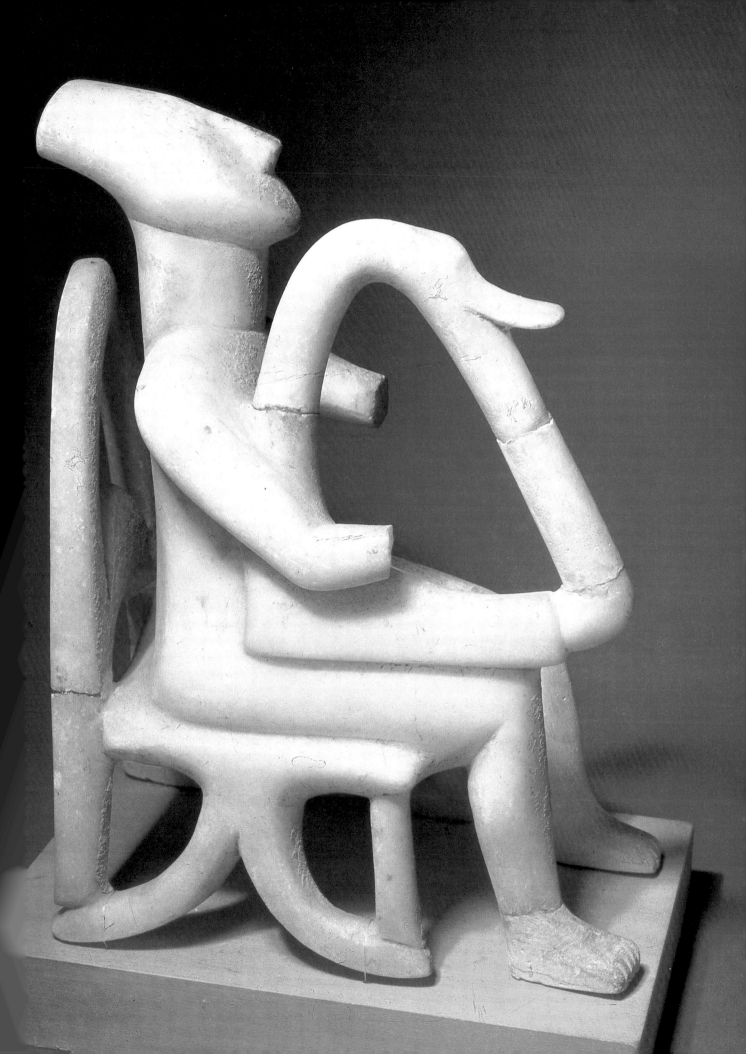

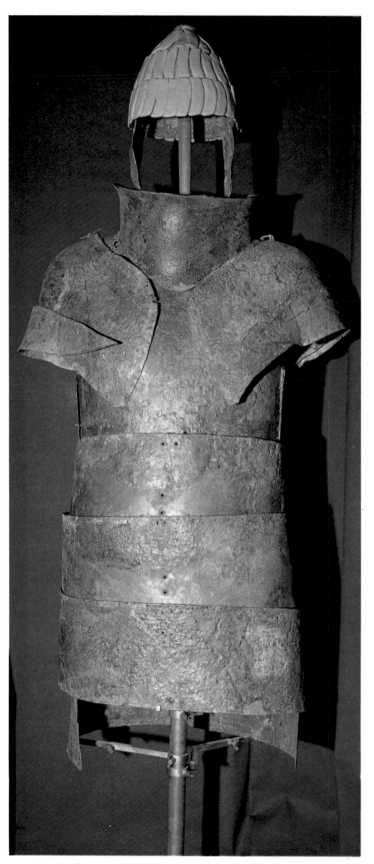

A suit of armor with boars' tusk helmet found at Dendra, near Mycenae; 1450–1400 BC. Argos Museum

Some attractive vases were also made from rock crystal. A *rhyton*, again from Zakro, is of this material (Heraklion Museum), as is a bowl with a handle in the form of a duck's head from the earlier Grave Circle at Mycenae (National Museum, Athens). This is one of the many Cretan objects from the Mycenae graves.

Relief sculpture is practically unknown in Bronze Age Greece. But crudely sculpted grave-markers are found in the Mycenae Grave Circles (National Museum, Athens). The scenes are typically Mycenaean – the battle and the hunt.

Sealstones. Large numbers of seals, and sometimes fragments of clay bearing their impressions, have been found on Aegean Bronze Age sites, particularly in Crete. They are found early in the period but at that time they were mostly made of more easily worked materials—wood or bone. Later they were made in a variety of different stones and often most delicately and skillfully engraved.

Such objects were used to impress signs of ownership, as genuine seals in the manner of signet rings, and as amulets. They were probably also treated as a form of jewelry and were highly prized as personal possessions, often being buried with the dead.

Basic stylistic developments match those already observed in other art forms. Apart from the early examples which mainly have linear decoration, seals tend to be decorated with figured scenes—animal, human, or divine. These seals were often transmitted from one generation to another. In later times (*c*700 BC) the discovery of prehistoric seals was to inspire a new school of gem-cutting.

Metal objects. Prehistoric societies have traditionally been described according to the materials on which they depended for basic tools and implements, hence the terms Stone, Bronze, and Iron Ages. Early in our period bronze was relatively rare and obsidian still widely used for tools and weapons. Bronze, however, gradually became the main material from which such objects were manufactured and, with increasing availability and more sophisticated working methods, was also used for nonessential luxury objects. Other metals, especially precious ones like gold and silver, were used exclusively for the latter.

Crucibles and molds (usually of clay or stone) for making metal objects have been found on Aegean sites. Initially the molds were mostly simple and open. Later they were more often closed. Larger objects, for example armor, were made by hammering out sheets of metal and riveting them if necessary.

The weapons of war which show a steady technical development throughout our period cannot often be classed as works of art. But some of them bore additional decoration which made them fit for princes and qualifies them for this category.

During the Middle Bronze Age the long sword came into its own. One such sword from Mallia (probably a ceremonial

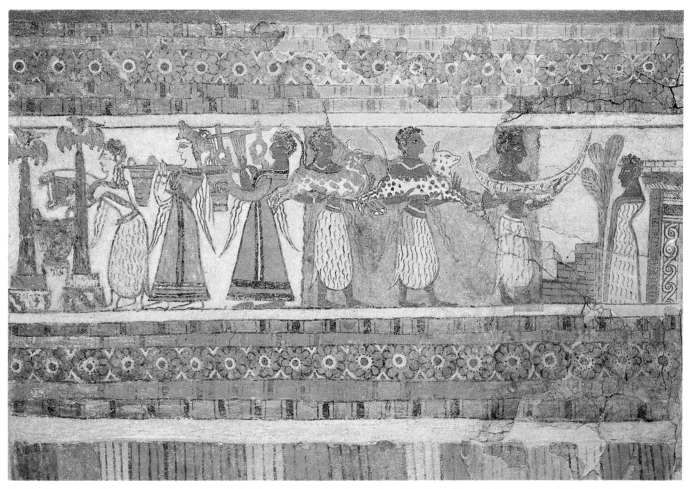

Detail of the painted limestone sarcophagus from Ayia Triadha, Crete; left, the pouring of libations, right, offerings at the tomb; length of sarcophagus 137cm (54in); c1400 BC. Heraklion Museum

object since it seems too large to have been effectively used in battle; Heraklion Museum) had a gold covering to its pommel. Round the circular field an acrobat is stretched, his head touching his feet.

The Mycenae Shaft Graves bristled with weapons. Among them were daggers whose blades were inlaid with scenes in gold, silver, electrum, and niello—a technique that came to Greece from the eastern Mediterranean. The subjects include hunting scenes, plants, and wildlife, as well as simple recurring motifs. They have a strange mixture of themes, from nature as found in Minoan frescoes, to more violent scenes perhaps closer to Mycenaean taste. The fluidity and delicacy of the execution points very definitely to Cretan workmanship. Other weapons carry incised patterns.

Body armor has rarely survived the ravages of time but from a later tomb at Dendra, not far from Mycenae, came a complete suit (Argos Museum). It consists of two separate shells, covering the chest and back, with extra attachments to guard the neck, shoulders, and lower body. This panoply included greaves or leg-guards, also known from a few other Mycenaean sites. The head was protected by a helmet of pieces of boar's tusk sewn on to a leather cap.

Such armor and, most strikingly, the helmet are described in the Homeric epic poems as worn by the legendary heroes of the Trojan war. If this war were a historical event—something that can neither be proved nor disproved—it should have taken place during the Mycenaean period. Certain objects de-scribed in the Homeric poems actually correspond with objects discovered in Mycenaean contexts.

These and other Mycenaean weapons, together with scenes of battle portrayed in various artistic media, combine to produce a picture of a distinctly warlike people. The Minoans were not lacking in weapons but the decorative attention paid to them in Mycenaean society and the prominence with which they are portrayed suggest that, whether because of circumstances or natural tendency, the Mycenaeans lived violent lives.

Gold and silver objects are found in the Early Bronze Age, though they are not common. There is a gold version of the mainland "sauceboat" shape (Louvre, Paris), and silver vessels have been found on Amorgos in the Cyclades. From Early Palatial Crete comes a gold pendant with two wasps heraldically opposed over a granulated circle. Fine techniques for gold-working, specifically filigree and granulation, must have reached the Aegean via contacts with Syria and lands further east.

Distinctively Minoan in feeling, though found on the mainland in the earlier part of the Late Bronze Age, are some gold cups. From a *tholos* tomb at Vaphio, near Sparta, are two cups decorated with scenes of the hunting and capture of bulls (National Museum, Athens). The fluidity and naturalism of the composition as well as the subject matter (bulls being caught for the ritual games?) leave their Minoan origin in no doubt. Clay vases of similar shape are commonly found and

are called *Vaphio* cups. Another Minoan gold cup, from Dendra, has a wider, flatter shape and is decorated in "marine" style with octopus, fishes, and sea life (National Museum, Athens).

Rather earlier than these cups, in the Mycenae Shaft Graves, we find an astonishing richness of gold objects. Their significance lies not only in the quantity, which is considerable, but also in the fact that there is no tradition of the possession or working of gold objects on the mainland.

Some of the objects, like the cups described above, are certainly Cretan in inspiration and, presumably, workmanship. Others, although perhaps made by Cretan craftsmen, have scenes or compositions that are more characteristic of Mycenaean taste. The gold masks are not only unique, as objects, to the mainland but are distinctly un-Cretan in feature compared with figures from Minoan art.

In addition to the masks and gems, there are a variety of gold vessels from the Mycenae graves as well as a wealth of personal ornaments (gold leaf headbands with engraved patterns) and smaller pieces which may have been sewn on to garments. A remarkable silver object—a fragment of a *rhyton* (National Museum, Athens)—has part of a scene showing the siege of a city, a similar theme to that on the miniature fresco from Thera.

Other materials. Art objects in a variety of other materials have come down to us from the Aegean Bronze Age—bone and ivory, faience (an artificial compound covered with a vitreous glaze), as well as terracotta objects distinct from pottery. Simple clay figurines were offered in religious sanctuaries from early times but the more sophisticated, and indeed most of the minor objects considered here, come from contexts not earlier than 1700 BC.

Common in Mycenaean times are small schematic figurines named after the Greek letters Φ, Ψ, and T which they roughly resemble. In recent years a small shrine has been excavated at Mycenae with fresco decoration on the walls (Nauplia Museum). It contains a variety of cult-statues 15 in (40 cm) or more in height. There are male and female types and others in the form of snakes. The dresses of some of the figures bear motifs also found on pottery. Figures of a markedly different type with hands raised in a ritual gesture, come from 13th-century Crete.

Both Crete and the mainland produced *larnakes* or coffins in the Late Bronze Age. These usually carry some form of painted decoration which can often be related to contemporary pottery or fresco painting. The most impressive example, of limestone, was found at Ayia Triadha in Crete and its four sides have detailed scenes of preparations for the sacrifice of a bull and of people bringing offerings to the tomb of the dead man. The priestess on the *larnax* resembles, at least in costume, a female faience statuette found at Knossos at the end of the Early Palace period (both in the Heraklion Museum). The snakes she holds are certain indications that she was a cult-figure.

Also in faience are some pieces of the "town mosaic", perhaps originally inlaid into another material. The surviving elements represent buildings, presumably parts of an integrated design (Heraklion Museum).

Bone was worked from the Early Bronze Age for tools and simple ornaments. Ivory figures in the round and plaques for inlay are fairly common in later times. A group of two women and a child from Mycenae is likely to be Cretan while the sphinx on a plaque from Spata in Attica is in Mycenaean style (both in the National Museum, Athens).

Conclusion. Many times in the preceding pages the essential stylistic and thematic characteristics of the art of the Cyclades, Crete, and the Greek mainland have been emphasized: the open, unsophisticated freshness of Cycladic taste, the subtler fluidity of Minoan art and its concentration on subjects from nature and religion, the formality, insensitivity, and violent preoccupations of the Mycenaeans.

These are the characteristics of the different areas at the periods of their greatest achievement. At other times the characteristics may still exist but their natural development is suppressed by other factors. The Cyclades—it is easier for islands to preserve their independence—retained much of their early individuality into the 2nd millennium BC until subordinated to Cretan and then Mycenaean power. Palatial Crete developed unhindered her free and vital art until the eruption of Thera and Mycenaean invasions curtailed liberty and stifled artistic progress. The Mycenaean Empire arose after violent clashes with Crete and her allies and faded in violence. Small wonder that its art reflects this and mirrors the preoccupations of men who valued victory and brash riches above the subtler charms of an artistic delicacy which might have developed in a different social setting.

R.L.N. BARBER

Bibliography. Higgins, R. *Minoan and Mycenaean Art*, London (1967). Hood, S. *The Arts in Prehistoric Greece*, London (1978). Hood, S. *The Minoans*, London (1971). Vermeule, E. *Greece in the Bronze Age*, Chicago (1964). Zervos, C. *L'Art des Cyclades du Début à la Fin de l'Age du Bronze*, Paris (1957).

ARCHAIC GREEK ART

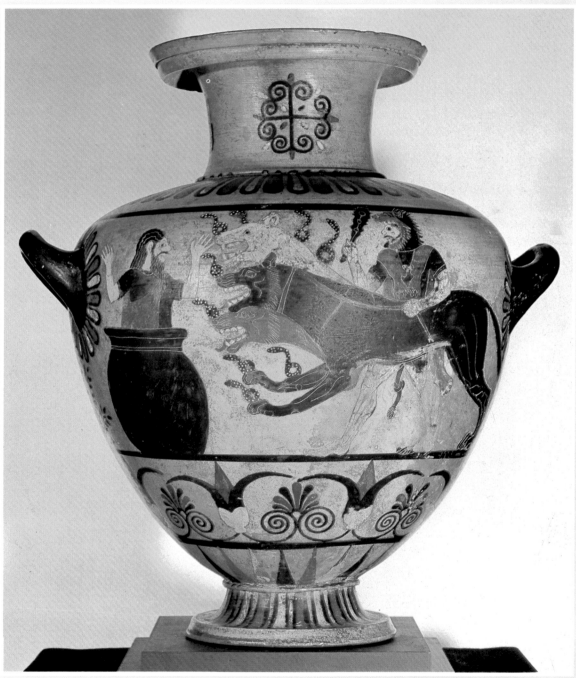

A water-jar from Caere in Etruria showing King Eurystheus, Cerberus, and Herakles
height 43cm (17in); c530–525 BC. Louvre, Paris (see page 122)

N its broadest sense the term "Archaic" can be applied to all forms of Greek art from the collapse of the Bronze Age cultures of Mycenae and Knossos at the end of the 12th century BC (*see* Aegean Art) down to the Persian invasions of 480–479 BC. During these six centuries artistic techniques and conventions developed steadily and objectives changed; a number of phases with markedly different characteristics can be distinguished. What unites them, and marks them off from the much shorter Classical period that followed (*c*480–330 BC) is a difference of attitude. Where the Archaic artists were outward-looking—striving after a complete understanding of the forms they were endeavoring to represent (in particular the human form) and also after a technical understanding of the materials they employed, assimilating new ideas and methods from outside—the art of the Classical period had absorbed all it needed and is introspective and self-sufficient.

The advance in bronzeworking is typical of technical progress during the Archaic period. From the early 8th century the first figurines appeared, generally solid-cast but sometimes still made up of beaten sections, of which the best-known examples are the group of standing male figures from Dreros in Crete (now in the Heraklion Museum). By the end of the 6th century the Greeks had learnt to cast hollow statues in life size or larger by the *cire perdue* process. In carved sculpture there was progress from the small limestone figures of the 7th century, which still readily betray their wooden forebears, to the monumental statues or *kouroi* (youths) and *korai* (maidens) carved in hard marble during the 6th century and later. The initial stimulus was provided by contact with Egypt,

but subsequent development was rapid and is easily charted by the art historian because sculptors advanced by stages, never relinquishing the knowledge they had acquired. In vase-painting the period opened with a tradition of pattern-work only; the first Geometric figures in the 8th century were schematic and stylized. By 500 BC, with the advent of the red-figure technique, even three-quarter views were understood, and the way lay open for complete solution of the draftsman's problems. For this was the period during which were developed the techniques and traditions fundamental to Classical Greek art, and thus to the arts of all later periods that draw on it.

It is probably the pervading element of exploration and progress that has made Archaic Greek art so appealing to modern eyes. For Archaic art reflects a world of enormous political and social change. At first, however, it was an illiterate world—the writing techniques of the Mycenaeans had been forgotten and the alphabet was formed only in the 8th century. The poems of Homer were composed in an oral tradition, in which images of the poet's own Archaic world were overlaid on folk-memories of the Bronze Age, producing a picture in need of careful analysis before it can be treated as historical evidence. The first proper histories to survive are those of Herodotus and Thucydides, written in the second half of the 5th century. Both provide useful information about the earlier period, and the dates given by Thucydides provide an essential chronological framework for the 7th and 6th centuries. The art objects of the Archaic period are also evidence for the archaeologist and historian. In themselves they can be

The Archaic Greek world

indicators of stylistic, social, and commercial contacts and development, while their decoration provides illustrations of the Greeks at their daily business, and of their myths and legends.

However, because knowledge of Archaic Greek art depends on the chances of archaeological survival it has some serious omissions. Wood and ivory have rarely survived, textiles hardly at all; very few bronzes remain, having been melted for scrap, while marbles have always been fodder for the limekiln. Very few free paintings survive (except insofar as vases reflect them) since most were murals painted on buildings now destroyed. Fortunately, during the Archaic period the Greeks developed vase-painting to an art in its own right, for the pottery vase, apart from being broken into pieces, is almost indestructible, and served for most of the purposes for which metal, plastic, and cardboard containers are used today.

Forerunners: Sub-Mycenaean and Protogeometric styles. In the Dark Age that followed the destruction of the wealthy palace-oriented and highly organized society of the Bronze Age, the Greek communities became divided into isolated and virtually autonomous villages, with neither place nor economic scope for the richer arts of the goldsmith, bronzeworker, or sculptor. Apparently only the potter's craft continued. Mycenaean shapes and decoration survived, for the Dorian invaders had no artistic tradition of their own, but the underlying principles of design were forgotten.

This Sub-Mycenaean ware endured for a century and a half, but *c*1050 BC there was a dramatic change. The slack and ill-organized shapes were replaced by tauter forms—developments of the old ones but conceived in a new way. There was enormous technical improvement, of which the introduction of the fast potter's wheel was a symptom rather than a cause. Shapes became more precise, and the decoration corresponded, generally being applied while the vase was turned slowly on the wheel. The repertoire consisted largely of horizontal bands and lines, often in groups of two or three, and concentric circles or semi-circles applied with compasses and a multiple brush. These simple patterns led to the more varied designs of the ensuing Geometric style, so this period is usually called Protogeometric.

The patterns themselves were found all over Iron Age Europe, but their organization on the vase was peculiar to Greek art. Perhaps for the first time the decoration complemented and articulated the shape, for the pattern-bands seem particularly placed to draw attention to the most prominent part of the vase. This feeling for harmony and form was fundamental to Greek art. Crediting its discovery to the Protogeometric potters and painters—probably at Athens, hitherto a relatively insignificant city—is to acknowledge their true position at the head of a major tradition in European art.

Geometric style. Around 900 BC another great step forward occurred, into the Geometric style proper. Some of the old motifs, concentric circles for example, were dropped, but

An Attic Protogeometric amphora; height 52cm (20in); c950 BC. Kerameikos Museum, Athens

others such as zigzags and triangles were elaborated. New elements were introduced, including meanders, swastikas, and a variety of linear and essentially Geometric designs. Two basic methods of decoration were established early: the repetition of a single motif to create a continuous frieze round the vase, organized so as to articulate its shape, and, in the 8th century BC, friezes of panels, narrow and wide, in which an elaborated design such as a swastika or rosette could serve as a vertical element to accentuate particular areas.

Around 800 BC the first figures were introduced: horses, then goats and deer, birds, dogs, lions, and finally human beings. Drawings were in silhouette, and remained schematic. The artist drew what he knew to exist, rather than what he saw, thereby illustrating the most cogent elements of each figure. Men were shown with their muscular legs in profile, their broad chests frontal, and their heads again in profile. Female breasts were drawn as short strokes; a warrior's helmet-crest became a wavy line. Figures were not necessarily shown clothed, but an awesome impression of a rank of soldiers was conveyed by allowing their bodies to be entirely obscured by their spears and shields.

At first the figures were used in exactly the same way as the linear designs. With a tradition of abstract art already three centuries old this was no more surprising than that the first

conventions of figure drawing should be rather stylized. As confidence later grew the figures became less stiff, so that by *c*700 BC their bodies were more rounded and lifelike, with a greater feeling for individual movement.

Attic Geometric art is important because it was the first consistent tradition of figured drawing since the end of the Mycenaean world, and thus stands at the head of a continuous development in western art. About 750 BC it first becomes possible to distinguish different internal trends: within the *Kerameikos*, the potters' quarter in Athens, the styles and the products of individual painters and their workshops can be distinguished. Since we cannot know their names, they are called after their outstanding pieces, favourite themes, or

An Attic Geometric grave-amphora by the Dipylon Master; height 150cm (59in). National Museum, Athens

quirks of style. Perhaps the most outstanding and influential was the Dipylon Master, named after a vase found in the cemetery by the Dipylon Gate in Athens (now in the National Museum, Athens).

The most popular shapes were large *amphorae* (storage jars), *kraters* (mixing-bowls for wine), jugs, and two-handled cups and bowls. The potting was of an extremely high standard, and often displayed an exuberance that matched the decoration: small vases were modeled in the shape of baskets or granaries; *pyxides* (toilet boxes) have lids with a whole team of horses for the handle. There was now a lively tradition of modeling terracotta figures of humans and animals, to be used as votive offerings in sanctuaries, as ornaments, and even as toys.

It was matched by the appearance throughout Greece during the 8th century BC of cast bronze figurines. Like the vases, they at first depicted animals and warriors, but scenes of daily life and mythology crept in—a hero fighting a centaur, a helmet-maker, a hunter and a lion. The bronzesmiths too represented what they knew rather than what they actually saw, and so even those compositions that appear to be groups, like the centaur-fight, are in fact made up of a series of two-dimensional views.

Other minor arts reappeared during the 8th century. The rising standard of living created a demand for bronze *fibulae* (safety pins), and in Athens and Boeotia we see their catch-plates decorated with incised patterns or figured scenes, while gold bands with similar ornamentation have been found in the graves of the rich. Engraved seals apparently reappeared in Greece as early as the 9th century BC, though they were rare before the 8th. The most common type was a square limestone block, once probably set in a wooden handle; the decoration was most commonly a linear pattern, but figured scenes had appeared by 700 BC. Although the stimulus may have come from the eastern Mediterranean civilizations, the style was pure Greek Geometric.

The new style has certain implications about 8th-century society. If the Protogeometric style was now too austere for contemporary taste it suggests a way of life that could look beyond bare necessities. This is borne out in several ways: by the reappearance of gold ornaments, and of seals (which implies the existence of property worth marking and thus of a property-owning class), and by the functions of vases (for example, mixing wine) and their decorative motifs: by the 6th century BC ownership of a horse had become an official criterion of status, and we can fairly assume that in the 8th century it gave even more distinction, and therefore the possession of a vase decorated with horses or chariots reflected the aspirations if not the actual standing of their purchasers. There was still relatively little competition from metal wares, so these vases represented the best that could be obtained. Vase-painting was still the major pictorial art of the Greeks. Despite their growing prosperity, architecture remained unpretentious: small houses, rectangular or apsidal with at best a two-columned porch, not providing contexts for mural paint-

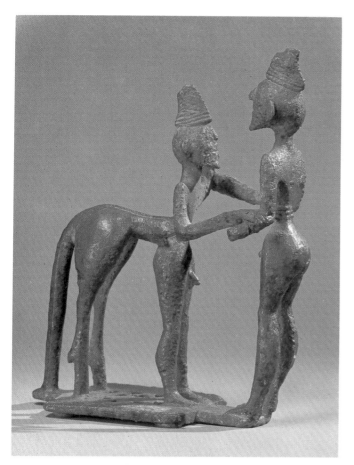

A hero fighting a centaur; cast bronze; height 11cm (4in); c750 BC.
Metropolitan Museum, New York

ing. Since there were no sculptures larger than the small bronzes and terracottas in the Geometric world either, these vases also fulfilled that role. Many of the large *kraters* and *amphorae* served as grave-markers. Because of their small-scale decoration it is not easy to convey the size of these vases, some of which stood over 5 ft (1.5 m) high. Although the painters could not yet conceive a drawing higher than a few inches, the design as a whole was conceived with a monumentality that was typically Greek. It was found on the mainland in the art of the Mycenaeans in the Bronze Age, but was totally absent from Minoan art.

The depiction of funerals, or files of warriors or chariots, on grave vases probably indicated the vases' functions or the social standing of the deceased. A number of the smaller Late Geometric vases, and the bronzes and seals, show scenes of activity that are clearly narrative. Some are probably pure fantasy, such as the figure fighting a centaur, but several seem to illustrate incidents than can already be related to Greek legends. Thus a picture of a man beset by a flock of birds may be Herakles fighting the Stymphalian birds, while the sailor who has saved himself on the upturned hull of his ship while his companions drown among the fish could be Odysseus: such epic poems as the *Odyssey* and the *Iliad* were now being composed in the form in which we know them.

Increasing stability and prosperity in Greece led to increasing trade. An important indication of this was the establishment—probably under Euboean leadership—c800 BC of a trading settlement at Al Mina at the mouth of the Orontes. It was one of the most important of such settlements in the 8th

and again in the 7th centuries. Thanks to Woolley's excavations its history can easily be reconstructed. Through such entrepôts came both raw materials and finished objects— metals such as bronze and iron, and, increasingly, gold (though Greece always had an adequate supply of silver from sites such as Laurion in eastern Attica), ivory and amber, and foodstuffs and textiles about which we can do little more than guess. The finished objects have left their mark more clearly. Ivory figures made before 700 BC have been discovered on the islands of Samos, Crete, and Rhodes, and in Athens itself, and others, made a little later, in the Peloponnese as well. Some figures of north Syrian and Phoenician origin have also been found. Bronzes occasionally came through from Cyprus to Crete and Athens as early as the 9th century, but most bronzes reaching Greece originated in Phoenicia and North Syria and, from the 7th century onwards, in Assyria, Phrygia, and Phoenicia. Finds of stands, bowls, and caldrons (especially caldron-attachments) have been made at most of the major Greek sanctuaries.

Foreign objects themselves influenced Greek artists, both in choice of subjects, such as the animal friezes with lions and hybrid monsters or floral decoration, and in their treatment of them. A grave of 750–725 BC in Athens contained five nude female ivory figures of eastern "Astarte" type, carved in an eastern technique but by an Athenian with a Geometric sense of form. The Oriental bronze caldron-attachments were soon imitated by Greek craftsmen. In many cases there are signs that they were taught by foreigners resident in Greece, and there is good evidence that a workshop was established in the 8th century in Crete by eastern bronzesmiths. There is a third possibility, that some elements may have survived from the extensive contact between Greece and the East during the Bronze Age.

Increasing prosperity resulted in increasing population. In a poor country like Greece with few natural resources the only solution was to found colonies abroad. The first such settlement was made from Euboea to the island of Ischia c750 BC, but shortly afterwards the colonists moved across to Cumae on the Italian mainland. Around 734 BC Syracuse was founded, one of the first Greek colonies on Sicily, and in 706 Taras (Taranto) on the south Italian mainland. So many other settlements followed in the 7th century that this area was called Magna Graecia, or Great Greece. The generally accepted dates of foundations are those given by Thucydides. Since the founding colonists presumably took with them the pottery fashionable in their home cities, these dates are very important for establishing the chronology of the pottery styles of the end of the Geometric and the ensuing Orientalizing period.

For the earlier period the stylistic development of the pottery itself, aided by a few chance finds of exports outside the Greek world, provides the only yardstick for measuring time in the Geometric world. Studies have tended to concentrate on Attic Geometric, largely because of its undoubted quality and its accessibility, but Coldstream, Schweitzer, and others have distinguished a number of other flourishing traditions, not-

ably those of Corinth, Argos, the Cyclades, and Boeotia, while Crete continued to maintain a vigorous tradition, though it soon became merely provincial. Contrasted with the uniformity of the Mycenaean IIIb style half a millennium earlier this proliferation of local styles is remarkable. It can no longer be explained in terms of an unsettled world where trade was impossible (as the founding of the Olympic Games in 776 BC shows); it provides a very sensitive index of influence and contact for the archaeologist, while also supplying a key to the most important political development of the early Archaic period, the rise of the independent and autonomous city-state, which was to dominate Greek history until at least the rule of Alexander.

Orientalizing style (c725–590 BC). During the 7th century BC the tendency to break down Geometric rigidity intensified. Greater population pressure and prosperity led to the opening up of new areas by the Greeks. The Sicilian colonies were enlarged and multiplied. In the East, the Ionian cities, led by Miletus, expanded into the northern Aegean and thence into the Black Sea. Commercial contact was established with peoples such as the Phrygians of Anatolia, and, by 650, with the Assyrians.

There were internal changes too, typified by events at Al Mina. The predominant type of Greek pottery passing through this port was now Corinthian, and East Greek from the Aegean Islands and the Ionian settlements in Asia Minor. This suggests that these were now the major Greek trading powers, probably with the Aeginetans and, later, Athens in close competition. Meanwhile the old kingdoms were being replaced by oligarchies of landowners, merchants, and soldiers. The first proper stamped coins appeared c650 BC (though the exact date and circumstances of their introduction are disputed). All this can hardly have failed to affect the arts.

The influence of the eastern cultures on the Greeks extended well beyond the visual arts and crafts, and was not restricted to an intellectual level, but it is through the arts that we can trace it most easily, even in mythology. To the native Greek centaur was added a whole range of monsters—Gorgons, Chimaeras, griffins, Harpies—but each of them was Hellenized, made elegant and comprehensible, and thereby less terrifying.

The Greeks' reaction to the Oriental stimulus was essentially selective, but two broad trends can be distinguished: first that of Corinth and most of the rich Dorian cities of the Peloponnese, and second that of Athens, the Ionian cities of Asia Minor, and Dorian Crete, Rhodes, and Argos. The Geometric Corinthian artists had not developed a strong figured tradition, though they excelled at fine linear decoration, particularly of smaller vases, and thus they were more receptive to the imported arts of the Near East and developed their own Protocorinthian style with remarkable rapidity and confidence.

In the period of assimilation, Early Protocorinthian (c725–700 BC), Geometric patterns still appear alongside the new

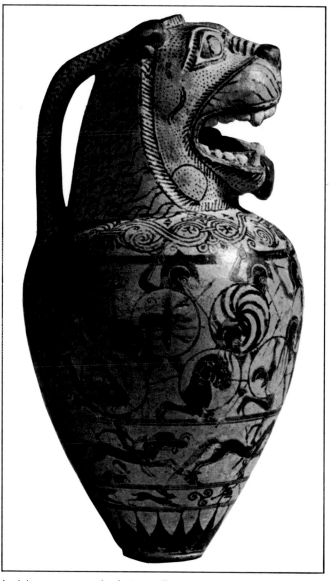

A miniature scent-vase by the Macmillan Painter, found at Thebes; Middle Protocorinthian; height 7cm (2¾in). British Museum, London

motifs: a few animals and birds, flamboyant rosettes, cable-patterns, and great curling plants that recall the Oriental Tree of Life. The preference for small vases persisted, and in the Middle Protocorinthian (c700–650 BC) the vase-painters adapted the Oriental metal-engraver's method of incision to create the black-figure technique. Details were incised with a point into figures drawn in silhouette in black "glaze" (in fact, black glossy slip), so that the pale background showed through.

In a tradition that gave no scope for shading this technique allowed the artists to show considerable detail. It was a wholly artificial, draftsman's technique, very limited in expression and subtlety, but accepted throughout the Archaic Greek world. It lent itself admirably to the miniaturist style of the Corinthians. Their favorite shape was the *aryballos* (miniature scent-vase) which developed from round (Early Protocorinthian) through ovoid (Middle Protocorinthian) to pointed (Late Protocorinthian), finally reverting to a globular shape in Ripe Corinthian. It was rarely more than 4 in (10 cm) tall, and the main figure-zone was often only 1 in (2.5 cm) high. The Macmillan Vase (British Museum, London) demon-

strates the elegant vigor and passion to which Protocorinthian could rise.

However, these narrative scenes were the exception. The staple subjects of Protocorinthian art were the friezes of animals and monsters, interspersed with floral decoration, deriving directly from Oriental sources. Corinthian vases had gained enormous popularity after 700 BC, but the standard could not be maintained. In Late Protocorinthian (c650–640 BC) the decline set in, accelerating during the Transitional and Ripe Corinthian periods (640–550 BC) as the files of animals became steadily larger, more banal, and more crowded. In contrast to the miniaturists stands the more conservative, more monumental, and ultimately more successful tradition, headed by Athens but including the Ionian cities and Dorian Crete, Rhodes, and even Argos. The initial effect of the new influences on the strongly ordered Geometric styles of this area was slow. In contrast to Corinth, it is possible to see their impact on individual Athenian artists, so that it appears more violent, and the new Protoattic style (c710–600 BC) is permeated by unexpectedness and exuberance that amaze and delight.

The father of the Early Protoattic (c710–680 BC) was the Analatos Painter. During a long career, his style grew out of his training in a progressive Late Geometric workshop into a massive confidence whose occasional crudeness is irrelevant. In his work outline drawing replaced silhouette; there was more detail and much more movement in the figures. Within a superficially traditional framework almost everything about the filling ornament was new—its nature (monstrous vegetables and rosettes), and its placing (crowding rays at the foot).

Three painters stood out in the next generation (Middle

A Protoattic krater by the Analatos Painter; height 38cm (15in); c690 BC.
Staatliche Antikensammlungen, Munich

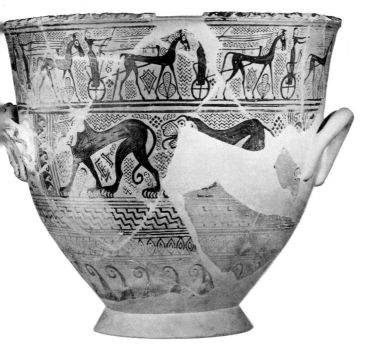

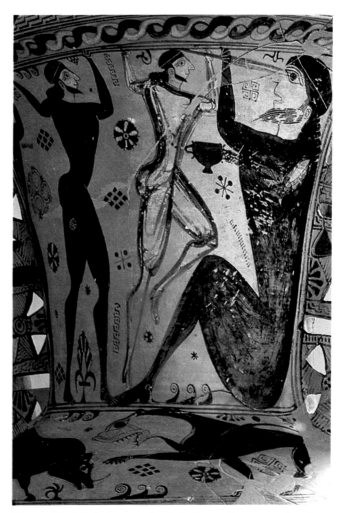

Odysseus blinds Polyphemus: a detail of a Protoattic grave-amphora by the Menelas Painter; height of panel 43cm (17in); c670–650 BC.
Eleusis Museum, Greece

Protoattic, including the Black and White style, c680–650 BC): the Painter of the New York Nessos *amphora*, the Ram Jug Painter, and the Menelas Painter. The innnovations were now accepted with restrained confidence, but the spirit of adventure persisted. The neck-panel of a grave-*amphora* by the Menelas Painter (c670–650 BC) shows this well (Eleusis Museum). The scene is the blinding of Polyphemus by Odysseus and his companions—story-telling was something that the Athenians loved above all.

During the Late Protoattic (c650–620 BC) consolidation continued, until the Athenians had fully adopted the Corinthians' black-figure technique, but without losing their own humor and spontaneity, or their feeling of monumentality (for example the name-vase of the Nessos Painter, in the National Museum, Athens, c615 BC).

Local styles still persisted all over Greece. The reason must lie in part at least not in the difficult terrain, but in the exuberant and individualist spirit of the time. Notable schools were those of Laconia with its idiosyncratic shapes recalling metalwork; the Cyclades, especially Melos, Thera, and Naxos; and the East Greek states, of which the Wild Goat style of Rhodes and Chios was the most widespread. Most lasted into the 6th century, but they were decorative rather than artistically influential styles.

Incision was also employed on other fabrics. During the 7th

century Boeotia and a number of the Cyclades developed a significant minor tradition of narrative scenes on large coarse-ware vases with details incised on relief decoration. A striking *amphora* showing the Trojan Horse was found in 1963 on Mykonos.

Painted vases like the Corinthian Macmillan *aryballos*, occasionally also had parts added in the round, in the tradition of modeling and sculpture. The Greek terracotta industry underwent a fundamental revolution soon after 700 BC with the introduction of the mold from Syria or Cyprus. This made standardization and high-quality mass-production possible. Immigrant craftsmen who had established workshops in Greek lands probably initiated the change, but imported plaques of the goddess Astarte must themselves have influenced Greek coroplasts.

These plaques were made in relief, and were frontal in conception, laying particular emphasis on the head. The Greeks soon combined this notion with their own earlier method of modeling in the round, into the "Daedalic" tradition. Its most distinctive feature was a triangular face with a pointed chin, thick wig-like hair framing the face, large eyes, and a prominent nose. Between c680 and 610 BC it evolved from an angular, geometric type into a chubbier, trapezoidal shape. It was universally applied to clay figures, jewelry, bronzes, and to sculpture.

Pausanias and other ancient writers mention wooden cult-images which were supposed to date from the 7th century and before. None survive, but they appear to have been formless planks or pillars, rather than carved figures. In the 7th century Daedalic conventions were applied to sculpture in limestone, and presumably in wood as well. Both are soft materials, and could be carved with a knife. It is probably significant that only statuettes no more than 2 ft (61 cm) high are known.

However, during the 7th century the Greeks were making contact with Egypt and soon after 650 BC 12 Greek cities, mostly East Greek, founded a trading settlement at Naucratis. Egyptian art and architecture made a deep impression on them. They found here, for instance, statues of life size and larger, carved in hard stone. Significantly, the first Greek attempts at large-scale sculpture were made in the Islands, and then Athens—both areas that had preserved the true Greek monumental spirit in their vases. Possibly the moment of intensive contact was psychologically opportune, coming when the artistic dominance of the Corinthian miniaturist style was on the wane.

The oldest surviving complete "monumental" statue is that of a woman, dedicated on Delos by Nikandre of Naxos (c625 BC). Nikandre's sculptor has used the superficial conventions of the Daedalic because for the female figure he knew no others.

For the male figure, the Egyptian standing type with one leg forward and hands clenched at the sides provided a suitable model. It was used by the Greek bronzesmiths from the early 7th century. Fragments of over-life-size marble figures of c640 BC survive on Delos, but the earliest complete *kouroi*

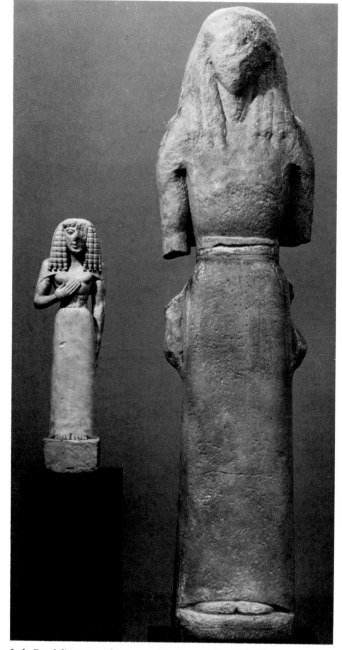

Left: Daedalic statue of a woman (the Auxerre kore); height 63cm (25in). Right: The statue of a woman dedicated on Delos by Nikandre of Naxos; height 175cm (69in). Casts in the Ashmolean Museum, Oxford

(youths) are an outstanding group from Attica (c610–590 BC). Unlike the earlier figures, and the Egyptian ones, these are nude: an important change, because it presented a greater technical challenge to the sculptor, and also because it was the form of the human body that especially interested the Greeks. The first *kouroi* followed the Egyptian canon of proportions, while the bodily features were rendered as beautiful patterns. Within a generation this canon was abandoned, and the four-square appearance caused by carving the statue out of a rectangular block gave way to a real feeling of form as the sculptors came to understand the working of the body beneath the skin. The development of the *kouros* from a type that the Egyptians had used almost unchanged for two millennia into a figure capable of movement and expression belongs to the High Archaic period. It is the story of the beginning of

the European sculptural tradition.

From the Egyptians the Greeks also derived the notion of monumental architecture, at first using wood and then limestone and marble. The first "peripteral" temple, using basically the classic plan with an external row of pillars around the *cella* or sanctuary, was constructed on Samos *c*640 BC.

The beginning of monumental architecture had important effects on painting. Greek sculptures and buildings had been embellished with paint, but substantial buildings now gave scope for "free" painting, and at this stage the metopes on Doric buildings were sometimes decorated with painted scenes. Surviving examples such as those at Thermon and Calydon in Aetolia (*c*640–625 BC) are very rare, but further evidence is provided by the Polychrome style of some Middle Protocorinthian vases (*c*680–650 BC), for example the Macmillan *aryballos* (British Museum, London) or the Chigi Vase in Rome (Villa Giulia). The free painter had a much greater range of colors than the vase-painter, and could conceive his pictures more grandly, with landscape backgrounds, but the basic principles of composition and drawing were common to both.

One further source of inspiration came from the Bronze Age. Miniature decorative work, whether gold, silver, or bronze jewelry (such as pendants, Daedalic plaques, earrings), or carvings in ivory and even amber, had received considerable impetus from demand caused by the new prosperity and from the Oriental stimulus. Series of ivory disk-seals were carved in Corinth, Argos, and Sparta with Orientalizing figures on shapes that recall Geometric stone seals. Around 670 BC begins the series of "Island Gems", carved probably on Melos in local limestone or serpentine. These copy two distinctive Bronze Age seal shapes, the lentoid and the amygdaloid (almond shape), and some Minoan motifs not found in Near Eastern art, such as griffins and twisted animals. Nevertheless, these seals, which were produced for about a century, imply neither continuity nor a throwback to Bronze Age culture. Melos had been rich and influential in the Bronze Age, and we can easily imagine that finds made by chance digging or through deliberate tomb-robbing stimulated gem-engravers at a time when they were seeking new ideas. For the art historian the Island Gems are interesting because they are the direct forerunners of later Greek and thus Roman gem-engraving.

The High Archaic period (*c*590–530 BC). The High Archaic period was the age of the Tyrants, benevolent despots, who generally rose to power as the champions of the merchant and artisan against the landowning aristocracy—Periander at Corinth (*c*625–585 BC), Pisistratus (560–527 BC) and his sons (527–510 BC) at Athens, Polycrates at Samos (*c*540–*c*522 BC) for instance. Many of these men encouraged circles of artists and poets at their courts.

Right: An Athenian kouros of the late 7th century BC; height 184cm (72in). Metropolitan Museum, New York

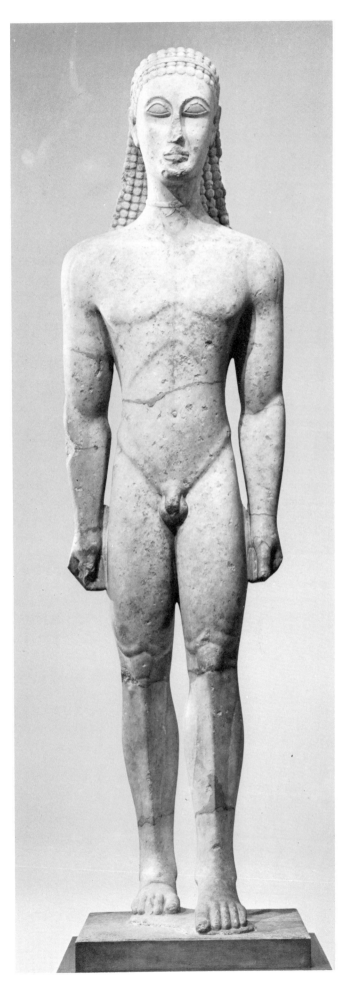

Myths became more popular as subjects in art, while the scope of figured decoration widened, running hand in hand with the growing appeal of epic and lyric poetry. This occasionally led to the political use of certain myths, sometimes in very general terms—the fight against the Centaurs as a triumph for Greek civilization, for example—but occasionally also rather more specifically. Herakles features frequently on Athenian vases made during Pisistratus' period of power, but at the end of the 6th century, when Cleisthenes' democratic reforms drove his family out, it was the truly Athenian hero Theseus who took over.

Trade expanded greatly during the 6th century BC and both artists and their products traveled throughout the Mediterranean. Trading settlements like the one at Naucratis flourished, while the arts of the Scythians on the Black Sea and the Etruscans in the west now showed strong Greek influence for the first time. In all these places the Ionians were most in evidence. After a period of high prosperity the Greek cities of Asia Minor were threatened first by Lydia under Croesus (after 561 BC), and again c547 BC by the victorious Persians. It was natural that they should seek refuge with their kinsmen, either in Attica where Ionian influence may be seen in architecture and sculpture, or in places where Ionian settlements already existed, like the Black Sea and Italy.

These movements suggest that a feeling of common race pervaded the Greek world, but local styles continued to flourish. The Spartans, renowned for their austere life-style, had a distinguished tradition of bronzeworking and during the 6th century developed a highly individual black-figure style, painted over a creamish slip and enlivened with purple. Their most characteristic shape is the cup on a high foot, but other shapes, particularly large pots, were also popular. Three workshops led from c580 to 510 BC: those of the Arkesilas Painter and his pupils, the Naucratis and Hunt Painters.

A wedding procession on a Corinthian krater; c570–560 BC. Vatican Museums, Rome

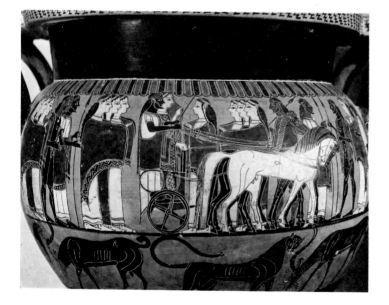

Many of the Ionian migrants carried with them the traditions of their native city. Most idiosyncratic was the Phocaean whose workshop at Caere in Etruria produced the series of Caeretan *hydriae* (water-jars) (c530–510 BC). In their polychromy and their attention to landscape these black-figure vases must recall wall-paintings. The rounded Ionian features of the figures and the zest and gaiety of the mythical scenes which the painter loves are quite unmistakable—see for example his version of King Eurystheus hiding from a lively and highly-colored Cerberus, led by Herakles in a very natty lion-skin (Louvre, Paris).

Another distinctive fabric was the "Chalcidian", probably manufactured in southern Italy by settlers from Euboea between 550 and 510 BC. It too favored large vases liberally decorated with purple and white paint, but its black-figure tradition is much closer to that of Athens.

The Corinthian Ripe style had been very popular but now declined: the Animal style was effectively dead by 550 BC, though the Human Figure style fared rather better. Padded dancers and riders were popular, but so were mythical scenes. The pale Corinthian clay favored the use of added color in the black-figure technique, but by c575 the painters were meeting Attic competition with the Red-Ground style: large areas of background were now covered with a reddish slip, to emulate Attic, but the Corinthian love of color meant that it had none of the Attic somberness. For all its brilliance and variety of subjects this final Corinthian phase did not last beyond the mid-century. It had started as a miniaturist style, and its potential was exhausted.

Attic clay, ideally suited for the new black-figure technique with its rich red and superb black glaze, coupled with Athenian skill and inventiveness, helped the Athenian vase-painters to capture completely the rising market for fine table vases by the end of the century, and to retain it for 200 years. At first they imitated the Corinthian Animal-Frieze style, but by 570 BC typically Attic scenes of myth and daily life abounded.

During the 6th century Attic vases were sometimes signed by the potter or painter (who could have been the same), or by both separately. Their personalities and influences are more easily distinguished now, and the picture of the close-knit community of the *Kerameikos* and also of its customers becomes clearer. Many vases bear the word *kalos* (beautiful) following the name of a young man, presumably the fashionable darling, and we may assume that the vase-painter was working with his circle in mind.

The Corinthianizing group was, perhaps surprisingly, led by such men as the Gorgon Painter and Sophilos (*fl.* c580–570 BC), who had been brought up in the Protoattic tradition. Their drawing was miniaturist, and scenes were arranged in friezes, particularly on large vases. Perhaps the most outstanding surviving example is the François Vase of c570 BC, a volute-*krater* signed by Ergotimos as potter and Kleitias as painter, standing 26 in (66 cm) high and decorated with six friezes showing several mythological themes but concentrating on the story of Achilles (Museo Archeologico, Florence). Its exquisite liveli-

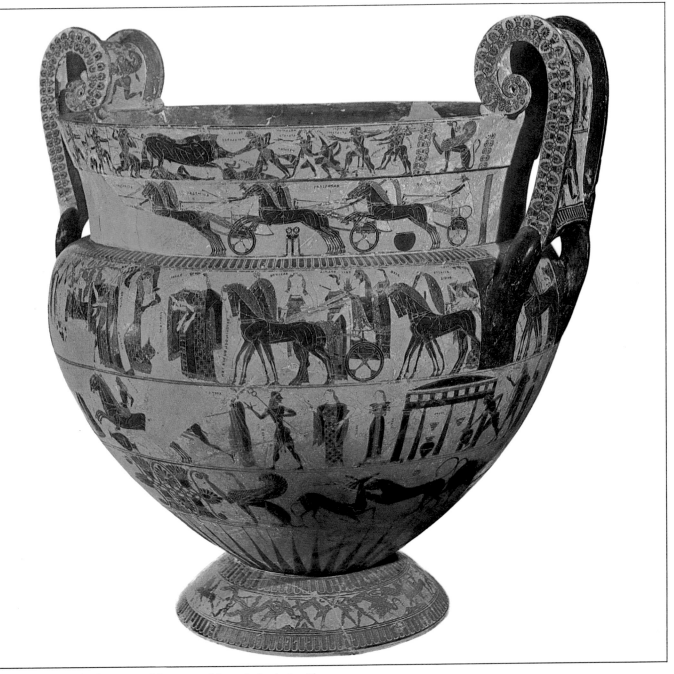

The François Vase; height 66cm (30in); c570 BC. Museo Archeologico, Florence

ness and wealth of invention, and its sheer technical dexterity, stand in pointed contrast to the rival Corinthian *kraters*.

This school really excelled as cup-painters. The development of the Attic cup progressed steadily from c580 BC: first the Comast cup, decorated with padded dancers, copying a Corinthian shape; then the sharply profiled Siana cups, and c550 "Little Master" cups, with delightful miniature figures on the lip or in a band at the handle-zone.

The alternative Athenian tradition inherited the native monumentality of Protoattic. Prominent in it were men like the Painter of Acropolis 606 and Nearchos, their figures more massive and serious, lacking the refined elegance of the Corinthianizers. Artists like Lydos (*fl. c560–540 BC*) and his contemporary the Amasis Painter could introduce a note of lively gaiety with paintings of Dionysus and his satyrs. His rival

Exekias (*fl. c545–530 BC*) combined outstanding technical skill with unequaled depth of feeling; indeed, he probably took black-figure to its limits of expression. It was essentially a highly formalized engraver's technique, though it could be used in hack workshops to provide quick lively results, for example the Tyrrhenian *amphorae*, produced for the Etruscan market in the 560s and 550s.

Shapes now covered the full repertoire, including after 550 the *kylix* (one-piece cup) which by 500 had developed into its classic shallow form. Panathenaic *amphorae* deserve special mention: these were awarded as prizes at the Panathenaic Games from 566 onwards; they were always decorated with a panel-picture of the city's goddess, Athena, and on the other side with the event in which they were won. They could be painted by leading artists and because they were at times in-

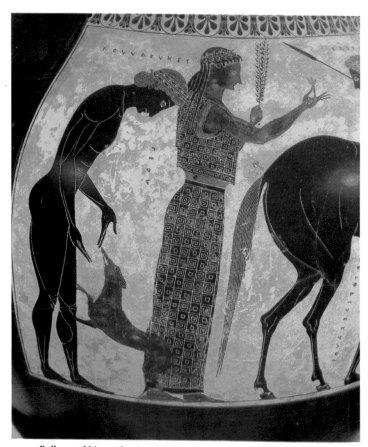

Pollux and his mother Leda: a detail of an amphora painted by Exekias; height 23cm (9in); c540–530 BC. Vatican Museums, Rome

Delos Museum). All these were dedications to the gods: the same purpose lay behind most architectural sculpture which until late Classical times was normally restricted to buildings with religious functions. During the 6th century the two chief orders of Greek architecture were developed fully: the Doric, with cushion-capitals, popular in the western colonies and at first in Old Greece; and the Ionic, whose columns had volute-capitals like ram's horns and stood on bases, and which originated in Asia Minor and the Islands but later found favor on the mainland. To break up the essential verticals and horizontals of Greek buildings decoration was added at certain places. Acroteria (ornamental statues) might be placed on the roof-peaks and gable-ends; the triangular pediment was filled with figures in very high relief or in the round; on Doric buildings the metopes (spaces between the beam-ends) were filled with relief panels; in Ionic this was replaced by a continuous frieze.

The earliest substantial survivors are the fine pediments from the Temple of Artemis at Corcyra (modern Corfu; c590 BC). The sculptor has solved the problem of filling the triangular pediment satisfactorily by varying the scale of the figures, by using animals to fill the slope, and by placing sitting and reclining bodies in the corners. These devices continued in use for at least a century, though later they were more subtly applied through groups of fighting animals, monsters, and wrestling scenes (as on the Archaic temples on the Athenian Acropolis). Because the interplay of lines they provided contrasted with the straight lines of the architecture, combat-scenes often featured on metopes too, along with other stories from myth (for example, the *Heraion* at Foce del Sele in southwest Italy, the Sicyonian treasury at Delphi, and the temples at Selinus in Sicily).

Terracotta was occasionally used for decorating buildings and for reliefs, particularly in Cyprus, Italy, and Sicily, where marble was scarce, but its chief use was for figurines. From c550 onwards, into the next century, the number of types became fewer, but style and expression improved. Their chief functions as votive offerings, toys, or ornaments are reflected in their findspots and in the commoner types—jointed dolls, animals, seated women, often holding an offering or child. Perfume vases modeled as women or youths, animals or even feet and helmeted heads became popular, just as bronze figurines of men and women, animals and monsters, were designed not only as figures but also as handles and other ornaments for mirrors and vases, like the enormous Lakonian *krater* found at Vix on the Seine (now in the Musée Archéologique, Châtillon-sur-Seine).

In general the "minor arts" followed the same trends as vase-painting and sculpture during the 6th century, developing from patterned and angular stylization to rounded naturalistic forms. The quality of work produced, especially by the engravers of gems and coin-dies, could be equally high.

Under eastern influence gems were now being cut with a

scribed with the archon's (magistrate's) names they provide important absolute dating evidence in a field that otherwise relies largely on stylistic evidence.

In free-standing sculpture the steady development of the *kouros* from a four-square to a more naturalistically treated figure is our clearest guide to the growing confidence and ability of the sculptor and now the bronzeworker too. The Tenea (c565) and Anavyssos (c530) *kouroi* demonstrate the advance most vividly (Glyptothek, Munich and National Museum, Athens respectively). Men were seen naked in the *palaestra* and gymnasium; Athenian women normally remained decently clothed, in life and in Archaic art. The sculptor treated them partly as a vehicle for drapery patterns (for instance, the curious *Standing Goddess* in Berlin, Staatliche Museen, c575 BC), although one of the earliest of the series of *korai* (maidens) from the Athenian Acropolis wears a plain woolen *peplos* (tunic) through whose subtle folds the artist has suggested the taut body beneath. Neither *kouroi* nor *korai* are portrait statues: most are dedications to a deity, some are grave-markers heralding, and from the mid-century running parallel with, the fine grave stelae carved in relief with an idealized figure of the dead. Other free-standing types were evolved, on low bases or none at all, like the riders in Athens (Acropolis Museum), or on columns, such as the sphinxes erected by the Naxians at Delphi and Delos (Delphi Museum;

Right: The Anavyssos kouros; height 194cm (76in); c530 BC. National Museum, Athens

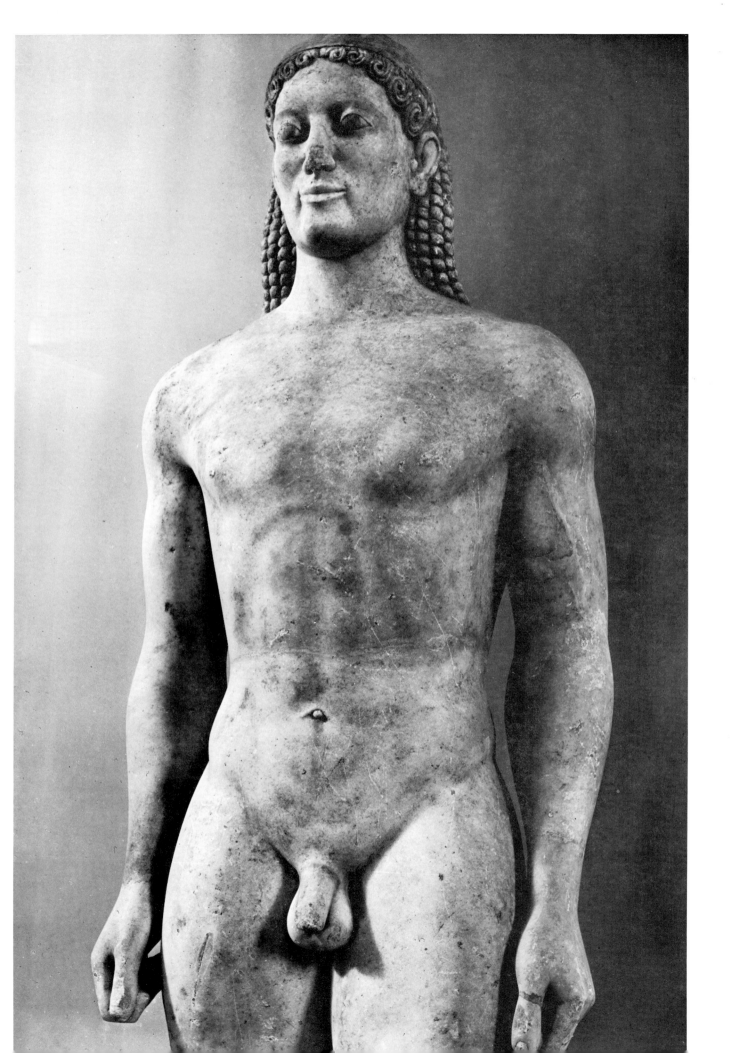

A Red-figure Vase by Euphronios

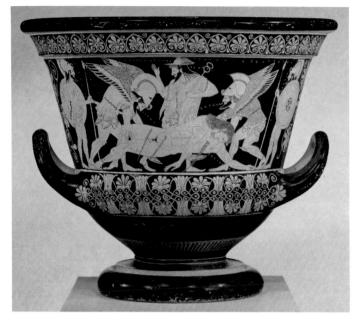

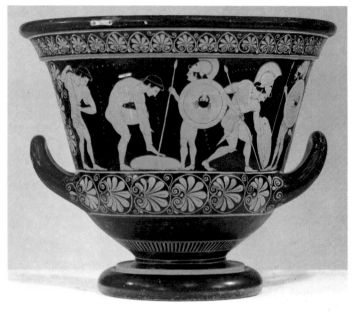

The Metropolitan Museum in New York acquired this vase in 1972, spoils from a tomb in Italy, but it is not known when it was discovered. It was painted in Athens by the artist Euphronios, who signs the work to the right of the head of the central figure, Hermes, on the front; to the left of the head another inscription praises the beauty of the Athenian youth Leagros, a topical compliment often met on vases of this period; and behind Sleep, left of Hermes, the potter Euxitheos signs too. We call the shape a *kalyx-krater*, not knowing its ancient name. It was a comparatively recent invention and its tall, straight walls appealed to the better artists since the fine drawing of their figures suffered less distortion. It was used in feasts for the mixing of wine and water, and we know this speciment was prized because it had been broken in Antiquity and mended with lead clamps, the holes for which can be seen on the reverse.

Euphronios was a leader of the so-called Pioneer Group of red-figure artists who worked *c*520–500 BC and who were the first to realize the full potential of the new, reserving, "red-figure" technique which had been invented some 25 years before this vase was made. Predecessors had experimented with mixed techniques while retaining something of the color range of the older, black-figure style, but the Pioneers preferred the more austere black-and-red and used added color sparingly. Euphronios was a masterly draftsman and his eye for pattern, in dress and wings, can be well appreciated here. But this is a period in which the pattern of anatomy was also the artist's delight, partly

▲ The red-figure *kalyx-krater* painted by Euphronios; height 46cm (18in). Side A: a scene from the *Iliad*

▲ Side B: five men arm themselves for battle

▼ Detail of a *kalyx-krater* by Euphronios: Herakles wrestles with the giant Antaios. Louvre, Paris

► A detail of side A: Sleep and Death carry dead Sarpedon from the battlefield with Hermes

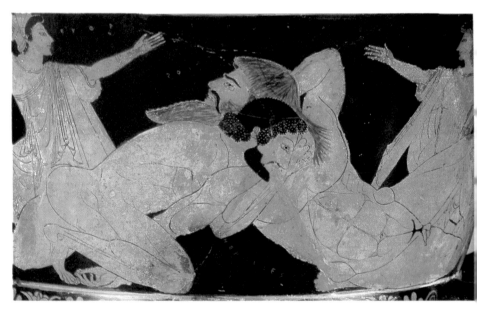

derived from observation of the body but still mainly dictated by considerations of design. Thus, eyes are still set frontal in profile heads, and details like ears and pubic hair are stylized into patterns, but the anatomical patterning of the body lifted by the two winged figures on the front of the vase shows at least a moderate understanding of superficial abdominal musculature. The rest of the poses are still strictly frontal or profile with no real three-quarter views of foreshortening,

but the contrast of profile and frontal (as in the dead man's legs—and notice the top view of a foot) is moving towards this, and the next generation achieved these breakthroughs in two-dimensional naturalism for the first time in the history of art. Compare the yet finer display of anatomical understanding and pattern displayed by Euphronios on another *kalyx-krater*, less well preserved, in the Louvre, Paris, showing Herakles wrestling with the giant Antaios. Here the

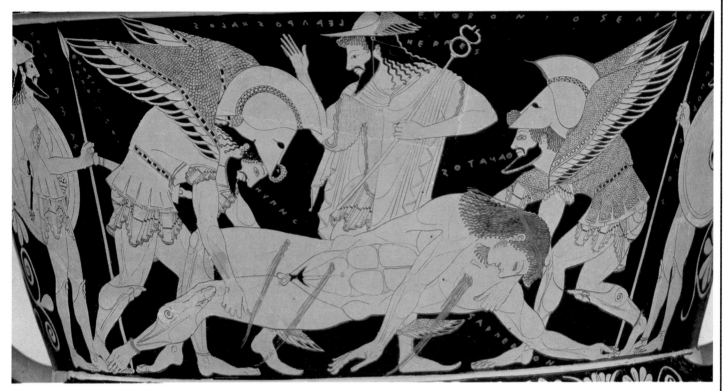

opaque gloss paint is neatly contrasted with the thinned paint used for the hair of the two struggling figures, and this contrast in intensity of line and mass is exploited well by the Pioneers in lieu of less subtle color contrasts. This is a draftsman's art rather than a painter's, at least in the sense of "painting" as understood in later Greek and European art.

Though many of the Athenian vases were exported to the west, to lie eventually in Etruscan tombs, the subject matter of the scenes on them reflect current life or episodes of Greek myth, and sometimes the myth can be used to comment upon contemporary events in the way more familiar to us from the works of Greek poets and playwrights. On the front of our vase is an episode from Homer's *Iliad*. Dead Sarpedon is carried from the battlefield by Sleep and Death, winged warriors, with Hermes, escort of souls, beyond them. Two comrades watch. Sarpedon was a Lycian prince, fighting on the Trojan side, but it is not uncommon for

Greek artists and poets to treat sympathetically the distress of their adversaries of myth—indeed, they seem to make a point of it. Notice the attention to detail—the pads at the bottom of the greaves to stop them chafing ankles, minutiae of armor and weapons, on the reverse the strange shield blazons: a scorpion and a crab playing pipes! These may be heroes but their dress is that of 6th-century Athenians, and we learn much of contemporary life and manners from scenes of myth. On side B of the vase five men arm themselves. Inscriptions praise Leagros again, and name the men. Two bear the names of the two earliest archons (leading magistrates) of Athens and it has been suggested that these arming Athenians of the "good old days" are an allusion to recent restrictions on citizens carrying arms made by the tyrant rulers of Athens. This is attractive, but the other three names are not Athenian, and three of the five names are also carried by heroes fighting at Troy, for the Trojans, so any contemporary allusion there may be is perhaps more subtle than we can readily understand.

JOHN BOARDMAN

Further Reading. von Bothmer, D. "Greek Vase Painting: an Introduction", *The Metropolitan Museum of Art Bulletin* vol. 31 Part 1, (1972) p2, pp34–9. von Bothmer, D. "Der Euphronioskrater in New York", *Archäologischer Anzeiger*, Berlin (1976) pp484–512.

▼ A detail of side B

A youth restrains a horse: a chalcedony scaraboid by Epimenes; length 1.7cm ($\frac{6}{10}$in); c500 BC. Museum of Fine Arts, Boston

wheel from harder stones, such as carnelian, agate, and chalcedony, into new shapes like the Egyptian scarab and then the scaraboid with plain back, showing new themes. The result is seen well on the groups of Greco-Phoenician gems (from 550 BC onwards), where Greek engravers transformed and Hellenized eastern themes. Soon local schools can be distinguished all over Greece, and individual engravers like Epimenes stand out.

The same is true of the coins, in scope, tradition, and quality. By 500 the major cities except Sparta were issuing their own silver coins, stamped on both sides and marked with their own devices. While three main artistic divisions can be distinguished—Ionia, Old Greece, and Magna Graecia—coin types, especially those of the commerically more influential cities, changed more slowly than other art forms because of natural conservatism. In this way alone do they stand slightly aside from the steady development of the Archaic tradition.

The sack of Troy on a red-figure cup by the Brygos Painter; diameter 33cm (13in); c490 BC. Louvre, Paris

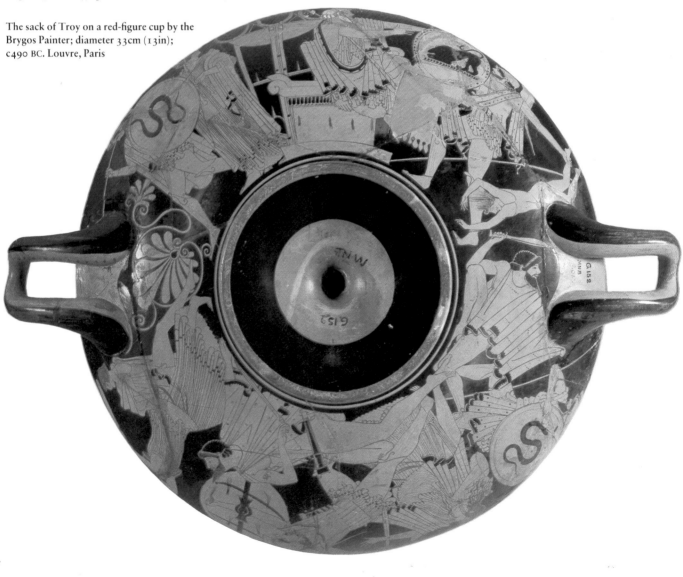

The Late Archaic period (c530–480 BC). The years 530–480 BC saw considerable changes in Greece as the tyrants were replaced by democracies and Persian expansion was only checked at the battles of Marathon (490) and Salamis and Plataea (480–479 BC), but in the world of art this Late Archaic period merely showed a continuation of the trends of the previous half century, in style, technique, and subject matter, though because of particular advances sculpture and vase-painting merit special examination.

By the end of the 6th century most provincial schools had succumbed to the overwhelming popularity of Athenian vase-painting. After Exekias at least one further generation of artists worked in black-figure, improving drawing and making composition fuller and better related. The Leagros Group (named after their favorite *kalos*-name) produced the last flowering of the stronger tradition with a series of heroic and domestic scenes (c510–500 BC). Black-figure continued to be used for hackwork in the 5th century, and for the Panathenaic *amphorae* into the 2nd, but after c530 BC the more adventurous painters worked in red-figure.

This was the earlier technique in reverse: the body of the vase was covered with black "glaze" and the decorated parts left reserved in the natural color of the clay, details being added in a distinctive relief line, and sometimes in white and purple paint. Although more difficult, it presented much greater scope for expression and emotion even if still typically mannered. This is clearly reflected in the composition, drawing, and gestures of early red-figure painters as they groped after the full potential of the new technique.

In the next half century the painters made great strides in mastering technical problems such as foreshortening and the three-quarter view. Many potters were also painters, and in-

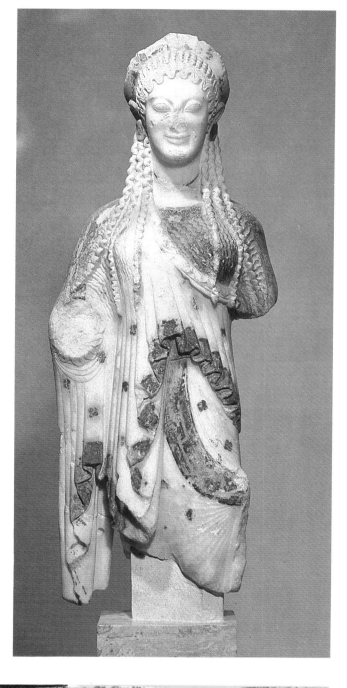

Right: A kore wearing a chiton and a himation; c525 BC.
Acropolis Museum, Athens

The battle of the Gods and Giants on the Treasury of the Siphnians at Delphi; height of frieze 66cm (26in)

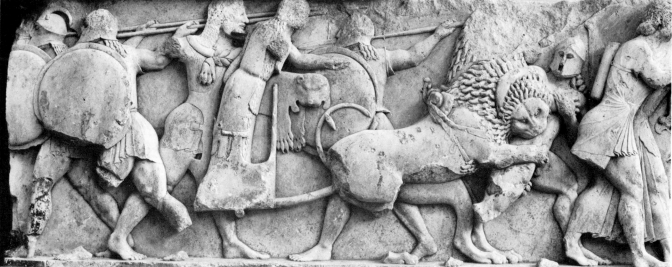

stances of cooperation and of changing partnerships were common. Influential artists stand out—Euthymides (*fl. c520–500 BC*), Euphronios (*fl. c520–465 BC*), and Phintias among the late-6th-century "Pioneers". Their often massive figures look best on large vases such as *amphorae, kraters,* and *hydriae.* There were also excellent cup-painters, like the neater, prolific Epiktetos (*fl. c490–420 BC or later*) and Oltos (*fl. c525–500 BC*).

These men exemplify the tendency towards specialization, and shapes like the elegant, high-stemmed *kylix*, created *c500 BC*, required special skills in potting and painting. Among the outstanding cup-painters of the early 5th century were the Panaitios Painter, the Brygos Painter, and Makron and Douris, who combined powerful, lively composition with delicate draftsmanship and considerable feeling. Their vase-pictures can have a surprisingly monumental quality (perhaps recalling wall-paintings) which is even more striking in works of such men as the Kleophrades Painter (*fl. c500–470 and later*) who specialized in large vases showing complex mythological scenes. On the other hand the Berlin Painter (*fl. c505–460 BC*) achieved an equally compelling effect through simple, spacious groupings that foreshadow the Classical period.

A similar trend ran through Late Archaic sculpture. *Kouroi* and especially *korai* of the last quarter of the 6th century have a mannered, confident grace about them, perhaps—because it undoubtedly reflects a trend in dress fashions—best illustrated in the *korai,* who now wear a fine linen *chiton* (sleeved tunic or dress) under a woolen *himata* (cloak). The sculptor makes much of the contrast; the latest figures in the series, *c480*, are also endowed with expression, and with the first intimations of movement. This is clearer on the nude *kouroi.* The anatomy was now fully understood, and the body given a twist and a tilt that corresponded to the distribution of weight, clearly

seen on the *Critian Boy* (Acropolis Museum, Athens). Free-standing sculpture was about to move into the Classical period.

The new dress fashions of the *korai* show growing Ionian influence, and in architecture the elaborate Ionic order appeared in mainland Greece. A fine example is the Treasury of the Siphnians at Delphi (*c525 BC*), with a frieze depicting the battle of the Gods and Giants and scenes from the story of Troy. Pedimental sculptures were now produced to a single scale, the gable-ends filled with crouching or falling figures. Fights were popular themes, as on the temple of Athena Aphaia on Aegina, *c500 BC*.

One can rarely pinpoint the precise moment when a style changes, but from our standpoint the defeats of the Persians in 480–479 BC seem to have coincided with the moment when the Greek artists had reached a full understanding of the human body, of their own techniques, and when their mood became more introverted. The change cannot have been a sudden one, but it must have been accelerated by the upheavals of the war years.

<div align="right">A.J.N.W. PRAG</div>

Bibliography. Arias, P.E., Hirmer, M., and Shefton, B.B. *A History of Greek Vase-Painting*, London (1968). Boardman, J. *Athenian Black-Figure Vases: a Handbook*, London (1974). Boardman, J. *Athenian Red-Figure Vases: the Archaic Period*, London (1974). Boardman, J. *Greek Art*, London (1973). Boardman, J. *Greek Sculpture: the Archaic Period*, London (1978). Boardman, J. *Pre-Classical: from Crete to Archaic Greece*, Harmondsworth (1967). Cook, R.M. *Greek Painted Pottery*, London (1972). Homann-Wedeking, A. *Archaic Greece*, London (1968). Richter, G.M.A. *A Handbook of Greek Art*, Oxford (1974). Richter, G.M.A. *The Sculpture and Sculptors of the Greeks*, New Haven (1970). Robertson, C.M. *A History of Greek Art* (chapters 1–4), Cambridge (1975).

8

CLASSICAL GREEK ART

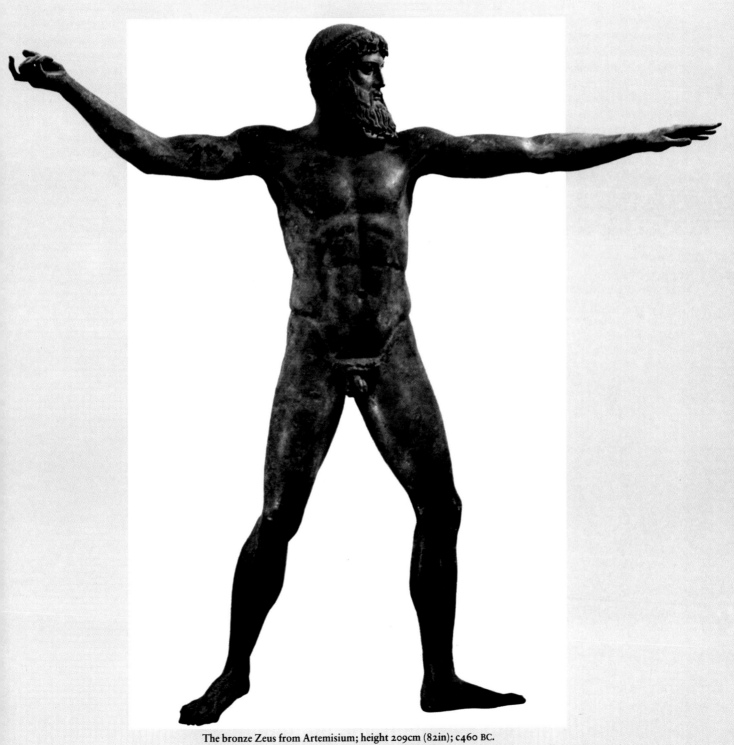

The bronze Zeus from Artemisium; height 209cm (82in); c460 BC.
National Museum, Athens (see page 133)

CLASSICAL Greek art spans the period from the defeat of the invading Persian armies (480–479 BC) to the ascendancy of Alexander the Great (336 BC). It is traditionally more familiar than Archaic, but the problems presented by the survival of the evidence are much the same: virtually no organic material remains, little bronze, and not much original marble sculpture. Most public and many private buildings were now of stone, while because of the Roman passion for things classical, more sculpture survives in the form of Roman copies. With the decline of vase-painting as a major art after the 5th century we lose close contact with developments in Greek painting, for little survives except through the adaptations of the vase-painters and the Roman artists.

There is, however, a "complete change in spirit between archaic and classical art..., in part a change from interest in doing to interest in being" (C.M. Robertson), for which the evacuation and sack of Athens in the Persian War of 480 was surely the catalyst. Because of the Greeks' oath not to rebuild the temples destroyed by the Persians, and Athens' slow recovery, the first postwar temple was that of Zeus at Olympia

(c470–456 BC). When the Athenian program of rebuilding began under Pericles and Pheidias after 450 BC it was a deliberate political step towards turning the old voluntary Delian League into the Athenian Empire.

The serene confidence of High Classical art of the mid-century turned to flamboyance and prettiness as the Peloponnesian War (432/1–405/4 BC) became more wearing and demoralizing, turning again to a brooding introspectiveness after Athens' final defeat by Sparta. The 4th century saw further political and social change, with the decline of the city-state, the resurgence of Persia, and finally the Panhellenic vision of Alexander the Great (336–323 BC). Partly under the influence of such poets as Euripides and such philosophers as Socrates, his enemies the Sophists, and Plato and Aristotle, the individual became more important, which led to a softening and humanizing of form, style, and subject in the arts. The use of myths became much rarer, and domestic scenes gained ground, though frequently given a mythological label.

"Classical art" usually refers to Athenian art, except perhaps in sculpture; but the Greco-Persian gems of the 4th century BC are one example of how the tide of artistic in-

The Classical Greek world: sites mentioned in the text

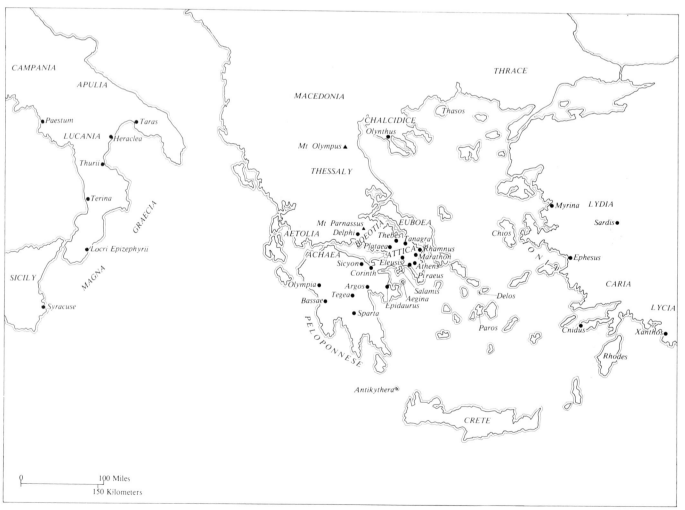

fluence began to turn from Athens. Most provincial styles declined, but with the rise in the 5th century of the powerful tyrants of the colonies in Sicily and southern Italy this area became artistically important, particularly for architecture. Because of the lack of good marble there, little sculpture was made, but vase-painting so flourished that by the 4th century South Italian vase-painting schools (notably the Apulian and Lucanian), originally inspired by the Panhellenic colony of Thurii on the Gulf of Taranto, founded in 443 BC by, among others, Athenians, had completely overtaken the Athenian workshops.

Sculpture. The sculptors of the early Classical period (*c*480–450 BC) made full use of the knowledge of the human body attained by the late Archaic artists. The result was well summarized by the carvings on the temple of Zeus at Olympia (constructed *c*470–456 BC). On the west pediment, the fight between the Centaurs and Lapiths was shown: frenzied, often savage action, but broken down by the designer into comprehensible groups. On the east end, where the worshiper entered the temple, the moment before the chariot-race of Pelops was depicted. Here the figures stand still, but the emotion is much tenser. Feeling and individuality are, characteristically for the period, conveyed through pose and gesture rather than facial expression—compare the bronze charioteer from Delphi (Delphi Museum). The calm, commanding figure of Apollo in the center of the west pediment typifies this aspect, and demonstrates the new, easy stance with the weight on one leg. The triangular shape of the pediment was now used to advantage, to draw attention to the central figures and to show the effect of the main action on those others who sit or crouch in the corners. Only the six metopes at either end were decorated at Olympia, with the 12 labors of Herakles. These too are confidently and sensitively composed within the square frame, even though little of the fine detail would have been seen from the ground.

The only other major architectural sculptures from this quarter-century are the metopes from Selinus (Temple E) in Sicily (Museo Nazionale, Palermo; *c*470–460 BC)—significantly also away from the area affected by the Persian invasion —but there are numerous smaller reliefs. From Athens there are only votive and record reliefs at this time (for example the so-called *Mourning Athena* from the Acropolis, *c*460 BC; Acropolis Museum, Athens), but in the Islands and the Greek colonies the series of tall grave-stelae surmounted by a palmette continued. Like the Archaic ones, they normally showed the dead person standing quietly, and it is interesting to see how fashion has changed again and the women now wear only the plain woolen *peplos* (dress). To this period also belong the problematical three-sided reliefs from southern Italy known as the Boston and Ludovisi "thrones" (Museum of Fine Arts, Boston, and Terme Museum, Rome).

For the 5th and 4th centuries our knowledge of sculpture in the round suffers particularly from the lack of original evidence, because so few examples survive. However, the descriptions of such ancient authors as Pausanias, Pliny, and Lucian can now be supplemented by Roman copies, though often carved in different materials. We know the names of several major sculptors, such as Kritios and Nesiotes, Pythagoras, Calamis and Myron, and it is clear that all were experimenting with the new anatomical and technical achievements. The *Omphalos Apollo* (a copy of a work of *c*460–450 BC, now in the National Museum, Athens), a study of the way slight asymmetry of pose goes with perfect balance, has been attributed both to Calamis and to Pythagoras—an example of the problem of attribution, for ancient descriptions are usually too imprecise to link these Roman copies with named originals.

With Kritios and Nesiotes we are on slightly surer ground. They made the statues of the *Tyrannicides Harmodius and Aristogeiton*, erected in 477/6, which have been identified in several copies that show a vigorous composition of two striding, threatening figures with powerfully modeled musculature. The famous bronze Zeus, poised to throw his thunderbolt, found in the sea off Artemisium (National Museum, Athens), is an original of the same type, some 15 years younger. All are shown at that self-contained moment of balance, just before an action, in which the sculptors of the Transitional period were particularly interested, and which was developed to its limits *c*460–450 BC by Myron of Eleutherae with his *Discobolus* and his *Athena and Marsyas* (copies in Museo Nazionale, Rome; Städtische Galerie, Frankfurt am Main; and Lateran Museum, Rome, respectively).

These Transitional compositions followed logically from the Archaic, but they manifest an inherent and unsatisfying restlessness which is the rider to the experimental approach of the artists. Their successors after 450 BC overcame this. Several names are known to us, like those of Strongylion, who followed the traditions of Myron, and Cresilas (*fl.* 450–425 BC), a rather severe sculptor whose portrait of Pericles is typical of the idealizing portrait figures now becoming popular. But it is the name of Pheidias that stands out.

We get a good idea of his style through the sculptures of the Parthenon at Athens (constructed 449–432 BC), over whose design he had general control. At least here we can examine original 5th-century work, whereas most of his other statues are only known to us from copies, often on a small scale. Although there is plenty of life and movement about his compositions on the Parthenon, his style is a quiet, idealizing one, and the figures are self-contained and inward-looking.

The Parthenon contained many sculptural innovations, such as the presence of the frieze on an otherwise Doric building, and the fact that the themes of pediments, frieze, and metopes were all linked with Athena and Athens. The design of the pediments now showed complete confidence: foreshortening is fully understood, and even the shallow frieze is conceived with a proper sense of depth. Two drapery styles are evident on the building, demonstrating how many hands were involved: a plainer one, where the heavy cloth only hints at the body underneath, and an ornate style, emphasizing the

The Pediments of the Temple of Zeus at Olympia

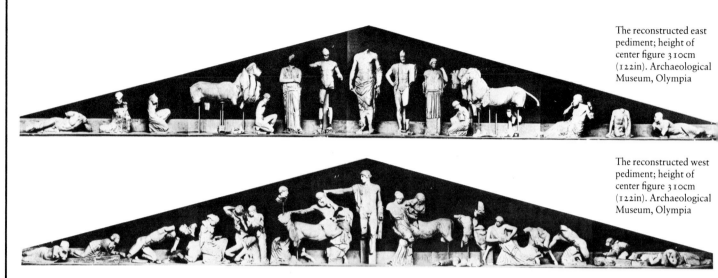

The reconstructed east pediment; height of center figure 310cm (122in). Archaeological Museum, Olympia

The reconstructed west pediment; height of center figure 310cm (122in). Archaeological Museum, Olympia

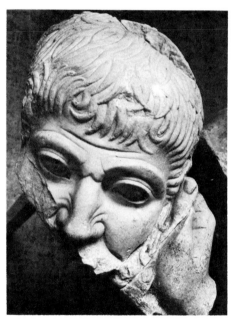

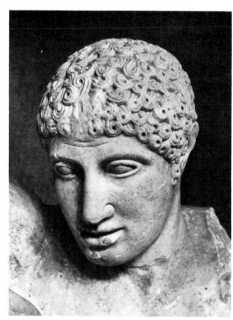

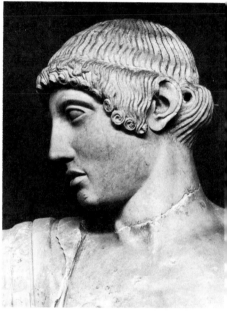

The Temple of Zeus suffered several accidents and repairs from as early as the 4th century BC and the corner figure of the west pediment had to be replaced in Antiquity. In AD 426 it was burnt and in the 6th century overwhelmed by an earthquake and subsequently covered with up to 16 ft (5 m) of alluvial sand. This accounts for the good preservation of the sculptures, some of which had also been built into the walls of a Byzantine village.

The subject matter of the architectural sculpture of a Greek temple is not always readily related to the deity and cult. In the east pediment, over the temple entrance, we see the god of the temple, Zeus, presiding over the ceremonies before the chariot race between King Oinomaos of Pisa (who stands at one side with his wife Sterope) and the younger Pelops (who stands at the other with

the king's daughter Hippodameia, whom he will win). Their chariots, attendants, and seers wait. It was said in Antiquity that Pelops' success was achieved by bribing the kings charioteer, but an alternative version simply gave Pelops divine horses. The subject reflected on both the importance of chariot races at Olympia and on Pisa's recent removal from control of the Games by the Eleans. The west pediment shows the young god Apollo, Zeus' son, as arbiter in the drunken brawl between centaurs and the Lapiths, whose king Pirithoos' wedding feast had been broken up by their animal behavior. The theme was popular in Greek art and, in the 5th century, might be taken symbolically as a demonstration of Greek superiority over the uncivilized and barbarian—a reflection on the role of the northern Greeks (the home of the centaurs) in the recent invasions of the

Above On the west pediment: *left* a Centaur, *center* a Lapith boy

▲ On the west pediment: the head of Apollo

Persians in Greece which had been repelled. For a different deity to the occupant of the temple to be honored in the secondary pediment is not without parallel.

The composition of the east pediment is static and strictly symmetrical, dominated by the figure of Zeus, who is slightly taller than the protagonists in the race. The effect is dignified and has an architectonic quality well suited to the decoration of the principal gable of the temple and impressive even from a distance—remember that the floor of the pediment was 52 ft (16 m) above the ground level before the temple. By contrast, the west

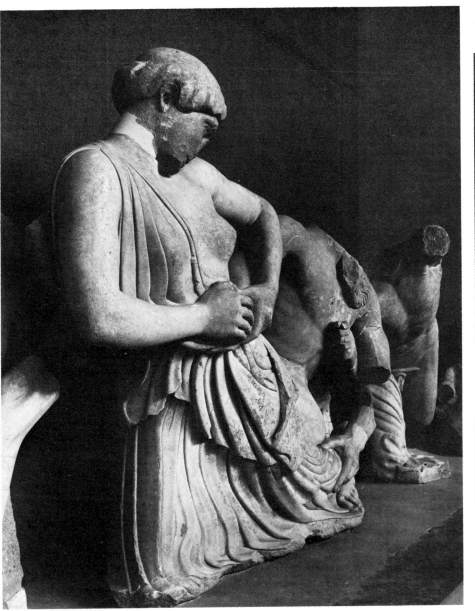

◀ A Lapith girl on the west pediment

▲ The seated boy on the east pediment

▼ The old seer on the east pediment

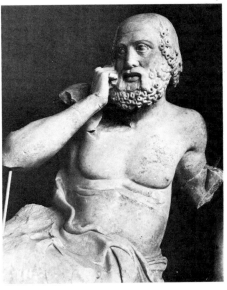

pediment presents groups of two and three struggling figures, some half animal. Although the groups are distinct and the general composition symmetrical, the overall impression is one of restless movement; the designer must have been more concerned to demonstrate the confusion of the fight and its narrative detail.

There is an overall unity of style which indicates the hand of a master designer who provided models for his studio to execute. The figures offer our best examples of the early Classical or Severe style. The standing males adopt the new, relaxed pose with the weight of the body shifted on to one leg and the resultant effect on posture properly observed. The women wear the heavy *peplos* (dress) whose austere lines contrast so strongly with the fuss of pattern and pleats favored by the sculptors of Archaic Greece. Command of anatomy is advanced but not as

yet complete, and the pattern of the composition determines pose as much as considerations of naturalism. The dress too is still conceived as pattern and can in places be shown falling illogically over the limbs of figures which, though executed in the round, were designed to be seen from the front only. There are, however, surprisingly advanced examples of accurate observation of both expression and anatomy in a period of Greek art in which such naturalism had been barely tried. The head of the old seer clearly shows his dismay and foreknowledge of his patron's doom, and his body is a masterly study of slack senility. Contrast the slight modeling of the boy and his unaffected posture, playing with his toes while he waits for the action. There is contrast too in the physique of the mother and daughter in the east pediment, and in the soft form, almost puppy fat, of one of the Lapith girls. Stronger emotions are

variously portrayed in the grimacing centaurs, stubborn resistance in a Lapith, Olympian dignity in the Apollo. This new freedom of sculptural expression is barely caught again in the succeeding idealizing styles which we judge best in Classical Athens on the Parthenon, but the genius of the Olympia Master reawakens to inform the development of later classical sculpture in the 4th century.

JOHN BOARDMAN

Further reading. Ashmole B. and Yalouris N. *Olympia*, London (1967).

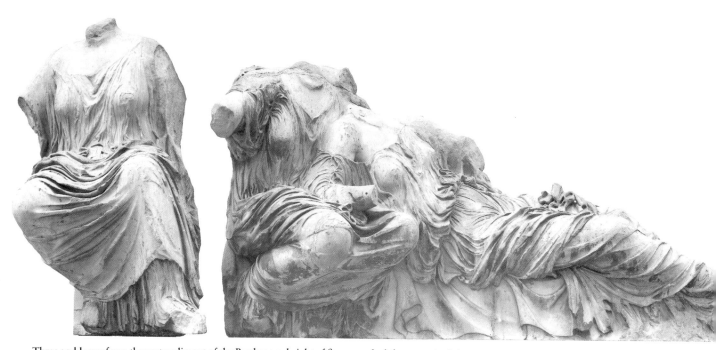

Three goddesses from the east pediment of the Parthenon; height of figure on the left 134cm (53in); c449–432 BC. British Museum, London

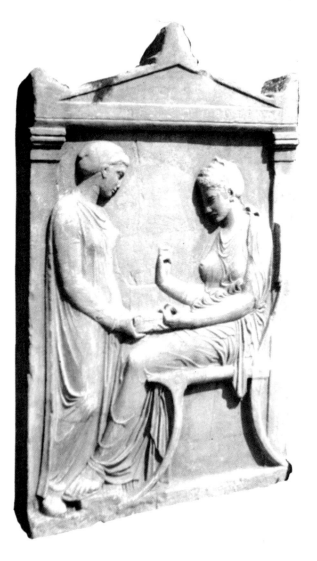

contrasts between the folds of fine material and the flesh that is allowed to show through. The fine style became very popular in the late 5th century: for example, the frieze of the Temple of Apollo at Bassae (c425–420 BC; British Museum, London), the Nike by Paeonius in Olympia (c420–410 BC), and the parapets of the Temple of Athena Nike at Athens (c410 BC). By then technical confidence was such that even in the plain style folds were carved very deep, allowing a double contrast with smooth material and with the flesh: for example, the curious Caryatids from the Erechtheum on the Athenian Acropolis (c420–413 BC; Acropolis Museum, Athens, and British Museum, London).

Other buildings with sculptural decoration were erected in Athens during this half-century, mostly as part of the Periclean program (for example the Hephaisteion, c450–440), and elsewhere in Greece (for example the Temple of Nemesis at Rhamnus in Attica, c436–421 BC, and the new Heraion near Argos, started in 423 BC) and the Greek world (for example the Heroön at Gjolbaschi, c420–410 BC, and the Nereid Monument at Xanthos, c400 BC, both in Asia Minor).

Sculptured gravestones reappeared in Attica—people could now afford them again, and after the enormous building program sculptors were available. The artistic standard was often exceptionally high, and many reflect the style of the Parthenon very closely. The slabs are squatter than those of the Archaic period, admitting more figures, but except where the inscription remains, as on the stela of Hegeso from the Dipylon cemetery (c400 BC; National Museum, Athens) it is often difficult to distinguish the dead person.

The development of votive and record reliefs ran parallel

Left: The Stela of Hegeso; height 149cm (59in); c400 BC.
National Museum, Athens

with the gravestones (like, for example, the one showing Demeter, Persephone, and Triptolemos from Eleusis, *c*440 BC, National Museum, Athens), and provides important dating evidence for stylistic changes. These traditions of relief-carving also continued in other parts of the Greek world, not only the Islands, Ionia, and Magna Graecia but regions like northern Greece and Boeotia that had no major sculptural traditions of their own. However, Athens now became the chief center, having herself apparently relied heavily on Island carvers at the time of Pericles' revival after 450 BC.

However, the Peloponnese, particularly Argos, maintained its own tradition, with broader, rather heavier figures. Its best-known exponent was Phidias' contemporary Polycleitos. His style is best deduced from copies of his *Diadoumenos* (*c*440–430 BC) and the *Doryphoros* (*c*450–440 BC) which illustrated his lost book on ideal human proportion, the *Canon*. In place of the surface patterns of archaic sculpture he apparently aimed at a full depth and full naturalism of both individual parts and the whole body. Thanks partly to his interest in *chiasmus* (the tension and corresponding relaxation of limbs and muscles on opposite parts of the body) he achieved a harmonious design which, unlike the single-aspect compositions of the Transitional sculptors, was satisfying when seen from any angle.

Polycleitos' statues have, like Pheidias', a certain austerity that recalls the previous generation. We know Polycleitos had followers, but only their names survive, such as Patrocles, Naucydes, Daedalus, and the younger Polycleitos. However, just as the Phidian tradition relaxed with the developing drapery styles and more sensual forms, so these men evidently softened the square, heavy-muscled Polycleitan types into more slender and flowing figures like the bronze *Idolino* (Museo Archeologico, Florence), a Roman copy of a late-5th-century original which for once copies the material in which most Polycleitan statues were made (though like most Greek sculptors he worked in stone, wood and fine metal and ivory too).

Among Pheidias' pupils a few names stand out: Alcamenes, who seems to have inherited the majesty of his teacher's style; Agoracritus from Paros, a fragment of whose *Nemesis* made for the Rhamnus temple survives in the British Museum, London; and Callimachus, whose reputation for too finicky attention to detail accords well with the final stages of the transparent drapery style at the very end of the 5th century.

The sculptors of the early 4th century continued the traditions of the later 5th, with balanced poses, transparent or heavy drapery, and serene, rather remote expressions—for instance, the sculptures from the temple of Asclepius at Epidaurus, ascribed to Hectoridas, Timotheos, and Thrasymedes (*c*400–380 BC; now National Museum, Athens) are younger brothers of those on the parapet of the Athena Nike temple.

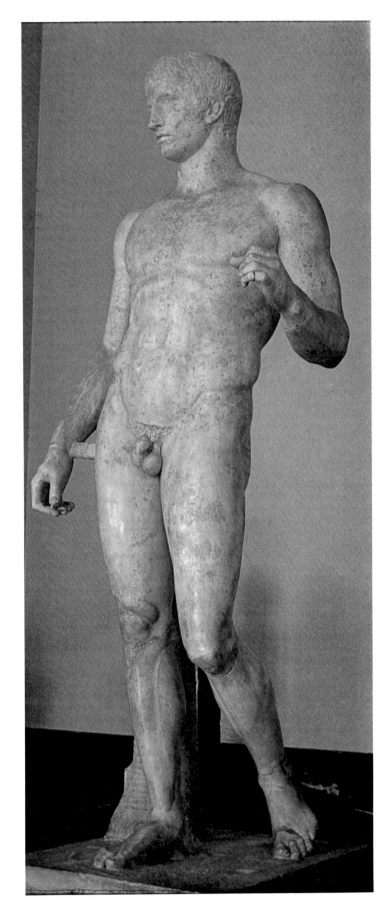

A Roman marble copy of Polycleitos' bronze spear-carrier (Doryphoros); height 199cm (78in). Museo Archeologico Nazionale, Naples

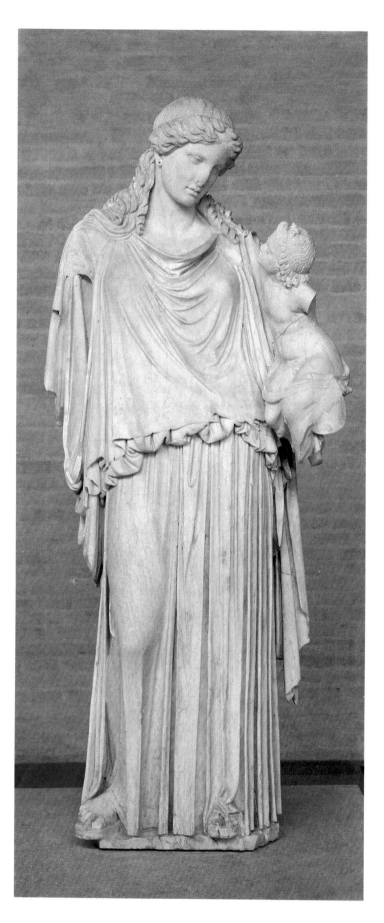

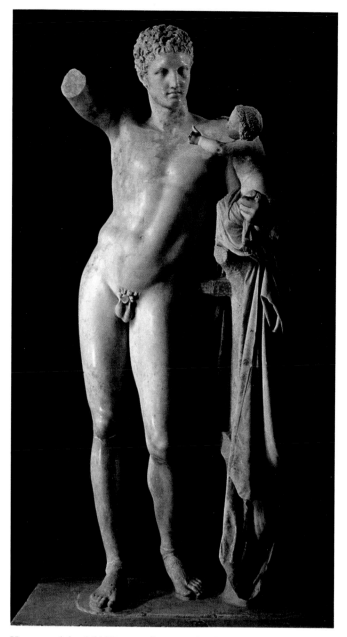

Hermes and the child Dionysos, by Praxiteles; height 215cm (85in). Archaeological Museum, Olympia

Within 20 years a humanizing, more personal element appeared. Poses became more flowing, faces softer and more emotional; technical dexterity was less flamboyantly and more subtly expressed. Cephisodotus' *Peace holding the infant Wealth* illustrates this well (best copy in the Glyptothek, Munich). Though at first sight its design resembles Phidian statues, its spirit is utterly different. There is a tenderness and an intimacy between mother and child that is alien to the 5th century; the spectator is now excluded because they are absorbed in each other, no longer because of any remote serenity. It is a statue that points the way sculpture would go. The massive drapery with its deep-cut folds recalls the Erechtheum Caryatids, but there is a new feeling for texture, for the intervening layers of cloth as well as for the flesh under them.

The first half of the 4th century was another period of

Left: A copy of Peace holding the infant Wealth, by Cephisodotus; height 199cm (78in). Glyptothek, Munich

restless transition, between the confident, introspective High Classical and the baroque freedom of the Hellenistic. The next step is seen in the work of men like Praxiteles (*fl. c370–330 BC*), Cephisodotus' son (?) and artistic heir. He was a prolific and influential sculptor, and many Roman copies have been linked with him. The descent of his *Hermes* at Olympia from the *Peace* is clear, but the pose is more sinuous and relaxed, the relationship between the two figures less remote and more subtly shown, and the features more limpidly modeled. At last the sculptor seems aware of the flesh and bones beneath the skin. Praxiteles' most influential statue, the *Aphrodite of Cnidus* (known only in copies), was shown naked (a 4th-century innovation). She was set up to be visible from all sides—much attention was now being devoted to the third dimension, and compositions encouraged the spectator to move round the statue, giving a feeling of restlessness, particularly in scenes of violent emotion.

The trend towards greater depth is also evident in the Athenian gravestones, whose volume of production now reached its height. The basic design remained the same, but everything was underlined, as it were: figures were carved almost in the round, domestic scenes were virtually heroized, and a Hellenistic emotionalism began to appear. It was achieved by the disposition of the figures, and by such traits as making their eyes deep-set and thoughtful.

This particular mannerism first appeared on the sculptures of the Temple of Athena Alea at Tegea (*c370–350 BC*; National Museum, Athens), where it has been attributed (on slender evidence) to Praxiteles' contemporary Scopas of Paros. It became fairly general, even on otherwise placid figures like the seated Demeter of Cnidus (*c350 BC*; British Museum, London). The tendency towards depicting emotion encouraged individual portraiture in the 4th century, though the figures, often great men of the past, were still idealized conceptions.

Many of the trends of the earlier 4th century were only fully realized in the Hellenistic period: the Praxitelean soft modeling bore fruit in the "Alexandrian" style; Praxiteles' figures were made to a new set of proportions which were fully worked out by his slightly younger contemporary Lysippos; the emotionalism linked with Scopas found full expression in the gravestones, portraits, and action scenes of the late 4th and following centuries.

Terracottas. The term 'minor art' is perhaps applied more aptly to terracotta figures than to any other Greek art form, for here sculpture is often brought down to a domestic level. Large figures in clay became rare after the early 5th century, though they had a longer life—especially as acroteria (on the corners of temple roofs) and in similar architectural contexts—in places like Cyprus, Sicily, and Italy, where good marble was uncommon. One of the most imposing is the half-life-size Zeus and Ganymede at Olympia, which still has many late Archaic features, such as the smile and general exuberance, but which as a composition fits better with the

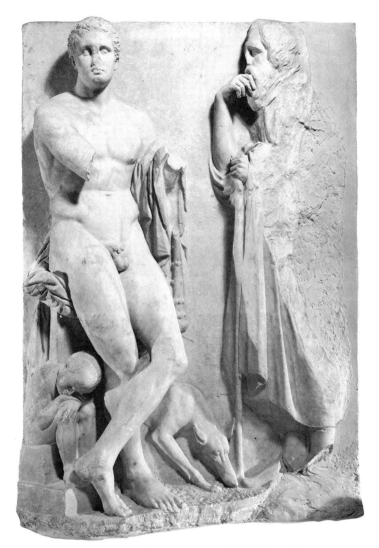

An Athenian marble grave-stela: a young man with his father, a dog, and a child; height 168cm (66in). National Museum, Athens

Transitional marbles and bronzes.

This time-lag was even more marked in figurines. The years *c480–475* were much less revolutionary for coroplasts (modelers) than sculptors. The first quarter-century had seen a general improvement in terracotta manufacture in mainland Greece, apparently after the East Greek supply dried up following the Ionian Revolt (499 BC). Most terracottas were now mold-made and hollow, with handmade backs, though some solid handmade types persisted, for instance at Corinth. The change to early Classical came gradually, but by 450 BC it was most noticeable in the simplification of drapery styles. For example, the "standing woman" figures from Attica can be divided into a "first type" (*c475–450 BC*), where the pose and the stylized folds are typically late Archaic, but otherwise the strong horizontal-vertical accent of the *peplos* (not the late Archaic *chiton*) is a concession to Classical austerity, and a "second type" (from *c450* to at least 400 BC), which carries this to its logical conclusion—the hands at her sides emphasize the horizontal-vertical accent, and the whole recalls

the style of the Olympia sculptures.

By the later 5th century the influence of the Parthenon could be seen in showy drapery effects. The large number of figurines from the earlier 4th century tend to reflect Praxitelean forms, reusing traditional types while generally raising standards, especially in Attica. Despite these overall trends and the obvious commercial intercourse of the Classical Greek world, local peculiarities and styles persisted in terracottas as in virtually no other form of Greek art. Athens was an important center, but so were Boeotia and Corinth, Rhodes and Halicarnassus, and in the West, Sicily, Locri, Taras (Taranto)—almost every city seems to have harbored some production of its own.

The general conservatism is to be explained by the rather domestic purposes for which terracottas were made: as votive offerings, as decorations for the home, and as toys. The votives represented the deity or the worshiper, and much the most common type in the 5th century was still the standing or seated female figure, frequently holding an offering or attribute. Hollow masks and busts have also been found, especially from Locri and Taranto. In vase-paintings they are shown hanging on walls, presumably to seek divine protection. Those classified as toys include animals and jointed dolls, but it can be difficult to draw the line: many figurines may simply have been household ornaments. Alongside these, more original studies from mythology and daily life began to appear, and by the late 5th and the 4th centuries the range include many subjects which, paradoxically, large-scale sculpture ignored until the Hellenistic period, such as actors (especially comic actors), and genre figures of dancers and women gossiping or about their business—types that look forward to the Tanagra and Myrina figures of the Hellenistic period.

A distinctive type of votive terracotta are the relief plaques made at Locri in southern Italy between c480 and 450 BC. Nearly all illustrate scenes from the story of Persephone, Queen of the Underworld, and were presumably intended as offerings to her. As is to be expected, there is still an Archaic flavor though Classical elements appear. A much duller 4th-century series from Taranto is mainly concerned with the heroized dead. The relief tradition of Melos (c465–435 BC) is more interesting, including scenes of mythology and daily life: these reliefs were high-fired to resist wear, and were presumably intended to decorate chests and other furniture, or to be hung up in houses. Later, terracotta—often gilded as well as painted—was used for other forms of appliqué work for furniture too, as well as for buttons and medallions.

In the 5th and 4th centuries coroplasts occasionally worked for Athenian and South Italian vase-painters to make "plastic", that is, modeled vases, generally cups or *rhyta* in the form of animal or human heads recalling a metal prototype, but sometimes also more complicated groups. Terrracotta was often used as a substitute for more precious substances, particularly metal, and thus provides important archaeological source-material for the life-style of less wealthy Greeks. But

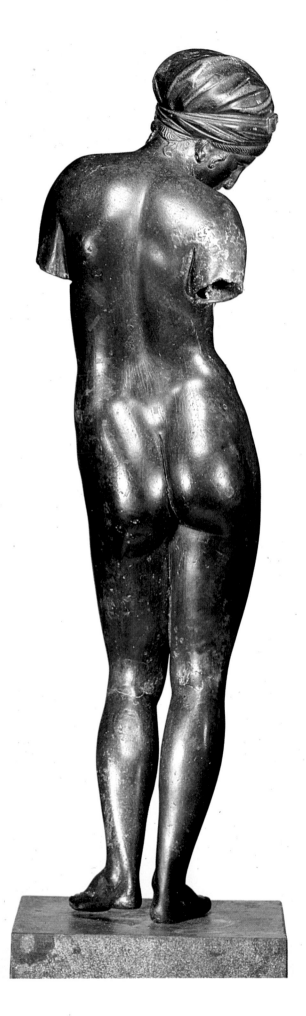

here again the very bright colors—reds and pinks, blues, yellows, whites, and gold—which survive on many clay figures remind us of how they were intended to look.

Bronzes. Bronze statues were made throughout the Classical period. Larger works were hollow-cast by the *cire perdue* process, their eyes added in glass and eyelashes in silver. The Delphi Charioteer is an outstanding example from the beginning of the period (Delphi Museum), while the Athena excavated in the Piraeus in 1959, and the two youths from the sea off Anticythera and Marathon show the softening that was typical by the third quarter of the 4th century (National Museum, Athens). More expensive small-scale work was made of ivory (now mostly lost) or bronze, generally solid-cast but following the conventions of major sculpture. Such works often give the impression of being large statues reproduced at domestic scale simply to provide human pleasure.

Figurines were also used as accessories on the rims and handles of bronze vessels, particularly *kraters*, *hydriae*, and *oinochoae* (mixing-bowls and jugs), and large basins. The tradition had continued from the late Archaic period, but the range of subjects was now more limited. In the 4th century genre scenes became more popular. For decorating belts, helmets, cuirasses, and similar items cast reliefs were used, often depicting mythological figures; details were incised, and sometimes inlays of precious metals added. When new these bronzes had a warm golden tone against which incision would stand out darkly—quite unlike the patinated or over-restored articles in many museums.

Among the most common decorated bronzes were mirrors, of several distinct types. The late Archaic model continued until *c*450 BC. Here the handle was formed by a figure (generally female) cast in the round and usually standing on a support. Their rather elaborate and fussy details contrast with modern notions of "Classical simplicity", and are perhaps survivals of late Archaic mannerism. Around 450 BC a new type appeared, without a handle but with a hinged cover, normally ornamented in repoussé relief with a female head, mythological scene, or palmette. The underside of the cover was often incised with a similar scene, of the kind thought appropriate for women's rooms; an important class has only this incised decoration. The simplest type had a plain handle and simple palmette decoration.

Gold and silver plate and jewelry. After the Persian Wars the production of gold- and silverware increased considerably, though these metals were not used for mirrors or small toilet-vases. Until *c*450 BC the most popular shapes were the traditional ritual vessels, such as the *phiale mesomphalos*, a shallow libation-dish with a boss let into the center of the base for the fingers. Before the end of the 5th century almost all plate in Greece was dedicated in sanctuaries and temple

Left: A hollow-cast bronze statuette of a naked girl; height 25cm (10in); c430–400 BC. Glyptothek, Munich

treasuries, where it has not survived, either because it was regarded as bullion or else because it disappeared with pagan religion. Thus most of what remains comes from the graves of barbarian chieftains in the surrounding lands, most notably the Thracians in Bulgaria and the Scythians in south Russia and the Crimea. It is clear that these people appreciated Greek silver and gold from the quantities that have been found there; in the late 5th and 4th centuries Greco-Scythian metalwork was produced for their benefit, and imitated locally.

From *c*450 BC the repertoire of shapes expanded under Achaemenid influence to include, for instance, the animal-head *rhyton*, though the *phiale* always retained its popularity. Also *c*450 engraved silver vessels came into vogue, the expensive counterparts of red-figure vases. Towards the end of the century gold- and silverware became more common in private houses, and the simpler shapes are often reflected on a humbler scale in the plain black-glazed pottery of Athens. The great revival of repoussé work around this time apparently killed the engraving technique, and the 4th century saw some superbly elaborate designs incorporating vegetable and floral patterns, and the repeated figures or heads of animals, humans, and monsters.

The jeweler's art was developed fully during the Classical period, and the techniques of filigree and granulation were mastered. Our chief sources are again on the fringes of the Greek world. Among the most popular items were earrings in great variety, wreaths, necklaces—many with pendants—and bracelets, small embossed plaques to be attached to drapery, and rings.

Gems and finger-rings. Plain rings existed at all times, but the Classical period was marked by the growing popularity of rings with metal or inset stone bezels, similar to the modern signet ring. Some fine examples are known, particularly from the 4th century: for example, Cassandra on a gold ring (Metropolitan Museum, New York). They served the same function as the Archaic type with a carved gem set on a swivel, which continued to be the most common form, even though relatively speaking fewer have survived. They were still the preserve of the rich but during the 5th and 4th centuries the wearing and using of seals spread to the whole Greek world. The find-spots range from Italy and Sicily to the Persian Empire and south Russia. More Classical than Archaic gems have been found in controlled excavations, but because of their long life as heirlooms this helps little in dating, and although gem-engraving spread to new centers (probably including southern Italy) their styles hardly differed, with the exception of the Greco-Persian stones and those carved by the Etruscans for their own use. Artists' signatures were fewer, but more significant, for example Sosias (*fl.* 450–420), Onatas (*fl.* 1st half of 4th century), and Athenades (*fl.* 425–400), but the outstanding figure is Dexamenos of Chios, who signed four scaraboids datable to the third quarter of the 5th century—a fine sensitive "portrait", elegant water-birds, and a woman at her toilet.

Engraved Gems and Classical Coins

▲ A lion and a stag. Rock crystal scaraboid; height 2cm (⅘in); *c*450 BC. British Museum, London

▼ A satyr toiling under the weight of a wineskin. Carnelian scaraboid; height 1.7cm (⅔in); *c*480 BC. British Museum, London

A characteristic of Classical Greek art is its unity of style regardless of scale and material. In the miniaturist arts of the engraving of gems and of coin dies, the monumental quality of the major works of sculpture is somehow miraculously caught. The two genres are related. Coin-dies are of metal, the device cut in intaglio to strike the coins which, in their varying states of wear or preservation, are our only evidence for the original work. The gems were cut like the dies, intaglio in the stone, but in this case we have the originals, not the impressions. Both arts were relatively new to Greece since, before the 6th century BC, the Greek world had known no coins, and its artists had forgotten the arts of cutting hard stones for gems since the Bronze Age.

Gemstones were not, in the Classical period, prized for their intrinsic value or even, so far as we can judge, for their color, but as a medium for intaglio engraving which enabled them to be used for sealing, identification, sometimes simply for decoration. The stones are generally quartzes—carnelian, chalcedony, jaspers—semiprecious to us but rarer in Antiquity. The earlier engraved gems had been small and usually of the scarab shape, about 6/10th in (15 mm) long, but in the 5th and 4th centuries BC they are larger, about 1 in (25 mm) long, and simpler in shape (scaraboid), designed to be set in pendants rather than on finger-rings. With the 4th century similar stones are more often set immobile in rings in the manner familiar to us today. The cutting was done without the aid of a magnifying lens, probably on a fixed lathe worked by a bow drill, and despite the difficulty of the technique extreme finesse of detail was achieved. We know that major artists and sculptors also cut gems (compare the achievements of Cellini much later) and in some of these miniature masterpieces we surely have originals from masters whose larger works we can know only from copies of later periods.

The range of subjects for the stones is restricted only by their size and, naturally, multi-figure myth scenes are usually avoided. Head studies are less common than we might expect, though more frequent towards the end of the Classical period when portraiture begins to be developed. One carnelian scaraboid has the old, Archaic subject of a satyr toiling under the weight of a full wineskin, and an agate "sliced barrel" shows an unusual study of the statue of a boy boxer almost certainly the work of the master Dexamenos (unfortunately there are few signatures on gems). The animal studies are among the most ambitious and successful in Greek art and, from the later 5th century, there are more studies of women and Aphrodites. The half-naked Victory (Nike) building a trophy is among the finest of all ancient gems; it must be from the hand of a great artist whose name survives among the many recorded by later writers but is unretrievable because his signed and identifiable work eludes us.

▼ A Victory erecting a trophy. Chalcedony scaraboid; height 3.5cm (1⅜in); *c*350 BC. British Museum, London

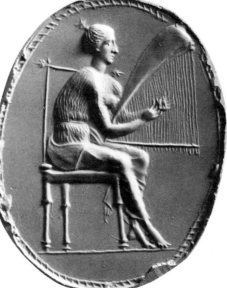

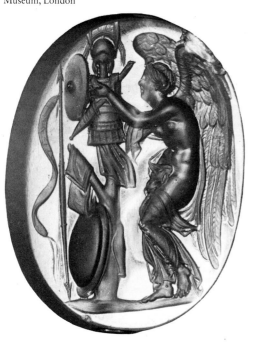

Above left A woman playing a harp. Rock crystal scaraboid; height 3.5cm (1⅖in); *c*420 BC. British Museum, London

◀ A boy boxer. Agate sliced barrel; height 2.5cm (1in); *c*450 BC. British Museum, London

▼ A head of Helios (the Sun) on a coin from Camirus (Rhodes); diameter 2.5cm (1in); c375–350 BC

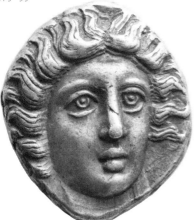

◄ Eagles with a hare and a locust from Acragas, Sicily; diameter 4cm (1½in); c412 BC

▼ Herakles and the lion, from Heraclea in southern Italy; diameter 2.5cm (1in); c350–330 BC

◄ A satyr on a coin from Naxos, Sicily; diameter 2.5cm (1in); c460 BC.

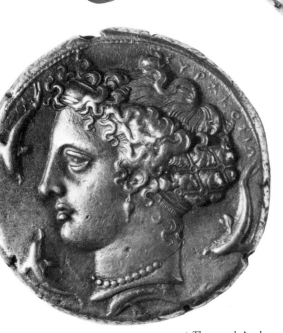

▲ The nymph Arethusa on a coin from Syracuse, Sicily; diameter 3.5cm (1⅗in); c405 BC

Most Classical Greek coins were struck in silver: gold or electrum coins are rare and confined to special mints or occasions, and bronze coins were only beginning to be used for smaller denominations. Coins at first served only local needs but were soon carried further, virtually as bullion, for interstate trade (a bewildering variety of weight standards was employed). They are thicker than modern coins, the devices often rendered in high relief—often too high to ensure the survival of higher areas of the design after handling, which is why frontal heads or similar ambitious subjects were rarely attempted. There was a natural tendency for the larger mints to be conservative in their choice of devices and it was often the less prominent states that issued the greater variety of devices and even with artistically superior designs. But a traditional device can be reinterpreted in successive issues, and at Syracuse, where the coins carry the head of the nymph Arethusa, first-rate artists designed a series of masterly dies, some of which they signed (and signatures are as rare on coins as on gems). One of them is by Kimon. The Greek colonies of south Italy and Sicily produced some of the finest Classical coins. One coin of c460 BC still retains something of the Archaic in its bold anatomical study of the squatting satyr. Animal subjects are as common as they are on gems and there are rather more mythological figures or even action scenes since the need may have been felt to allude to local cults. Although the coins were mass-produced it is only the accidents of wear and burial that stand between us and a full appreciation of the quality of the original die. The cutting on the metal die is generally less meticulous than in the stone gem-intaglio but comparable considerations of design apply for the oval and the circular fields, and probably the same artists were employed.

JOHN BOARDMAN

Further reading. Boardman, J. Greek Gems and Finger Rings, London (1970). Kraay, C.M. and Hirmer, M. Greek Coins, London (1966).

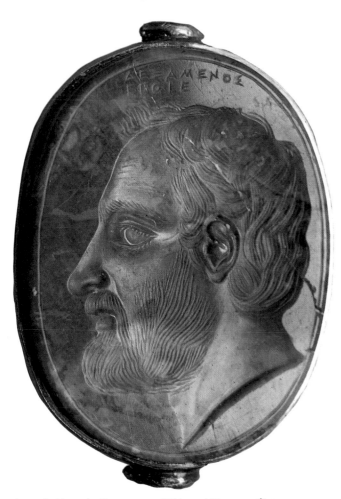

A scaraboid gem by Dexamenos of Chios; width 1.7cm (⅗in).
Museum of Fine Arts, Boston

most noticeably, in technique, because where the Greeks concealed their technique these engravers even exploited the marks of cutting and drilling. Eastern shapes like the prismatic and conoid stamp seals survived, but high-domed Ionian scaraboids, especially of blue chalcedony, became the most popular form.

In the Archaic period, artistic influence had passed from east to west: Greco-Persian gems show a reversal of direction. An interesting instance is the animal fight, an old eastern motif now reintroduced in the Greek manner; while the fact that a number of Greco-Persian stones have apparently been found in Sparta tallies with the historical picture of close Spartan contact with Persia in the late 5th and 4th centuries.

Coins. It is not surprising that the same artists sometimes carved both coin-dies and gems. Stylistic links between them are often difficult to deduce, but occasionally artists signed both forms, as in the case of Phrygillos (one gem, and coin-dies for Syracuse, Thurii, and Terina) which also demonstrates how widely engravers traveled. The broad stylistic divisions of Ionia, mainland Greece, and the West persisted, but while the major commercial states like Athens and Corinth only changed their coin-types slowly because familiar coins encouraged confidence in trade, the cities of north and east Greece and in particular southern Italy and Sicily issued series of different and often flamboyant devices. Most cities identified their coins with inscriptions as well as their own deity and symbol: for example the beautiful dekadrachm of Syracuse, 405 BC, signed by Cimon, which carries the Syracusan dolphin and nymph Arethusa, and on the reverse a

The scarab shape lost ground to the simplified and generally larger scaraboid. Other shapes included lions, sliced cylinders and barrels, and tabloids. The most popular stone was chalcedony, followed by carnelian; jasper, agate, rock crystal, and glass were also used. Subjects were more limited than in the Archaic period: myths were rarer, but domestic scenes and naturalistic studies of animals and even insects were in demand. The old encircling border lost favor, sometimes being replaced by a groundline, but the tendency was towards spaciousness, particularly among the Ionians.

The one "regional" style that is readily distinguishable is the Greco-Persian, made in the Persian Empire for about 200 years from the late Archaic period. The exact circumstances in which this very large and widespread group of pieces were carved are still debated, but it seems highly probable that at first and in the western empire Ionian Greek engravers were involved. The formal Persian style was broken down by a new and un-Oriental intimacy and informality, as typically Greek animals and domestic scenes were introduced and groups reduced to single figures without extraneous ornament. However, Greco-Persian gems differed from purely Greek ones in subject matter (showing, for example, Persians, such animals as the antelope and bear, and animals at "flying gallop") and,

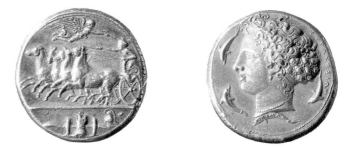

The dekadrachm of Syracuse by Cimon. British Museum, London

chariot. The Arethusa series illustrates changes of hair and jewelry styles throughout the 5th century, and demonstrates, in the three-quarter view of the chariot and in the sensuous profile head, how well coin-engravers kept pace with contemporary developments in painting and sculpture. This issue is now connected with the Syracusan victory over Carthage, but such historical cross-references are rare.

Architecture. The architectural traditions of the Archaic period were continued in the Classical, with a general trend towards greater elegance and refinement of details, such as the

curve of the stylobate and of the columns (entasis). The Greek temple plan allowed great scope for variety of dimension and spatial organization, as study of any of the numerous temples erected during the 5th and 4th centuries shows, from large complex Doric buildings like the Parthenon (447–438 BC) to small, elegant Ionic structures such as the Temple of Athena Nike (427–424 BC), both on the Athenian Acropolis. The Doric order reached its climax in the Parthenon, while some grandiose Ionic temples were erected in Asia Minor in the later 4th century, such as those of Artemis at Ephesus (c355–330 BC) and Sardis (c350–300 BC). The ornate Corinthian capital of acanthus leaves first appeared on the Temple of Apollo at Bassae (after 430 BC), and was occasionally used thereafter (for example at Tegea, c370–350 BC). It only became popular in Hellenistic and Roman times.

Marble was the normal material in mainland and east Greece, but in Italy, Sicily, and occasionally on the mainland, limestone covered with stucco was used. Details such as capitals were colored, and temples were generally decorated with sculptures, as in the Archaic period.

Similar decoration could be applied to other public buildings, such as monumental altars, treasuries, and *tholoi* (circular buildings), while on the fringes of the Greek world there were elaborate tomb structures. Theaters were now built of stone for the first time. Other monumental buildings included *odeia* (music-halls), *stoai* (colonnades), council buildings, fountains, and even hotels. Private houses remained simple, but from an early date the Greeks (especially the Ionian colonists) had been interested in town-planning—Aristotle credits Hippodamus of Miletus, planner of the Piraeus c450 BC, with the invention of the grid-plan.

Painting and mosaics. With the exception of a few painted tombstones, often now reduced to mere sketch-lines, virtually no free painting from before 350 BC survives, but it is clear from its influence on vase-painting (especially white-ground vases) and mosaics, and on copies made for Roman taste (and thus unreliable as sources), and from the enthusiasm of writers of the Roman period such as Pausanias, Lucian, and the elder Pliny, that the importance of free painting in the Classical period was out of all proportion to the meager archaeological record: most paintings were murals, done on wooden panels or sometimes plaster, and have been lost with the buildings they adorned.

Like the sculptors (but unlike, for instance, vase-painters) free painters were held in high esteem, and the names of influential artists survive. Polygnotus of Thasos (*fl.* c475–447 BC) was regarded as the "inventor" of painting. He decorated several buildings at Athens, sometimes collaborating with the Athenian Mikon, but his most famous works were *Troy Taken* and *The Underworld* in the *lesche* (clubhouse) of the Cnidians at Delphi. His characters were noble, showing emotion on their faces, in their pose and in their gesture. He was also a skillful delineator of character. This implies a great change from the action scenes of the Archaic period, set on the surface of the picture and not needing this third dimension to make them interesting. Not surprisingly, portraiture in sculpture now emerged, at a time when vases also briefly displayed an interest in the old, ugly, or alien personage.

The preoccupation of early Classical painters with spatial construction apparently led Agatharchos of Samos to attempt perspective representation in the second half of the 5th century. Vitruvius' account of this is confused, and vase-paintings shed little light on contemporary developments since vase-painters were always more concerned with the surface of the pots. Agatharchos probably established the principle of the vanishing point, but rather than organizing the whole picture around a single one, he allowed different vanishing points for each object or area.

In the late 5th century painters returned to the problem of shading. The Athenian Apollodorus (*fl.* c430–400 BC) was nicknamed "the shadow painter" because he "mimicked form through shading and color" (Hesychius). He was probably the first to use mixed colors—Polygnotus' palette had consisted only of black, white, red, and brown—and so gave his figures "the appearance of reality". Of his younger contemporaries Zeuxis of Heraclea (*fl.* c430–395 BC) took these discoveries further, while Parrhasios of Ephesus (*fl.* late 5th century) produced his effects of volume by subtlety of line; his figures were praised for their inner life and passive suffering, in the tradition of Polygnotus.

The 4th-century artists, men like Pausias of Sicyon (who invented the encaustic technique; *fl.* mid 4th century) and Nikias of Athens (*fl.* c340–300 BC) continued this pursuit of realism into the Hellenistic period. The *trompe l'oeil* effects they desired are known to us only from anecdotes and Roman derivatives like the "unswept floor" at Pompeii. It was achieved by bold foreshortening and partial perspective, but though the figures were shaded to stand out from the background, it was not until the Renaissance that they were shown as lit from a single source. Classical paintings had no spatial unity.

Mosaics of the late 5th and the 4th centuries are found in considerable numbers in houses at Olynthus and in places like Olympia and Alexandria, and in Macedonia. They were made with natural pebbles, black, white, and multicolored. The cube technique (and with it shading) was only introduced after Alexander's conquests, and thus Classical mosaics have a stark linear effect akin to vase-painting. The subjects are those of the other arts.

Vase-painting. The evacuation and Persian sack of Athens in 480 BC had remarkably little effect on potters and vase-painters, and early Classical vases show an unbroken continuation of the trends of the late Archaic, having undoubtedly been produced by the same artists.

The black-figure technique, used by hack workshops until c450 BC, was employed for the Panathenaic prize-*amphorae* into the 2nd century, surviving all other painted wares. For a time in the 4th century these vases carried the archon's (magis-

trate's) names and so provide important absolute dating evidence.

In the red-figure technique there were technical advances; for example, the profile eye was now shown correctly, and the fussy, precise zigzag pleats and hems of Archaic drapery yielded to a freer rendering of interrupted lines and hooks. The Archaic continuity of line was breaking up; under the influence of free painting the use of dilute glaze for details increased and in the 4th century the relief line was abandoned.

Red-figure was essentially an Archaic technique in which the figures stood out as surface designs against an unmodulated background. The new interests demanded the sort of spatial concepts being evolved by Polygnotus and Mikon. Some vase-painters reacted with a spirit of experimentation, exemplified by daring foreshortening and ambitious composition, but after c450 BC they could no longer compete, and vase-painting declined to the position of a minor art. The great painters made their advances in free painting, to which the vase-painters approached most closely with the white-ground technique.

In the early Free style (c475–450 BC) several new trends can be distinguished. The Mannerists harked back to the preceding decades, combining Archaic conventions with new freer renderings. Their leader, the Pan Painter, "is that rare thing, a backward-looking genius", but his followers lacked his inspiration. In contrast stood the large vases with spacious compositions on several levels that reflected Polygnotan murals, with statuesque figures and contorted poses recalling contemporary Transitional sculpture. Prominent artists were the Altamura Painter and the Niobid Painter. Another group preferred quieter, more delicate designs that looked forward to the classicism that followed, men like the Villa Giulia Painter and his pupil the Chicago Painter, the Penthesilea Painter (a more ambitious man who could overreach himself under free painting influence, as on his namepiece in Munich (Antikensammlung) and the Pistoxenos Painter, whose cup in London (British Museum) showing Aphrodite riding on a goose perhaps embodies this quiet ideal. This was painted in the white-ground technique, used in late black-figure but exploited more fully in the 5th century. It recalls closely the white plaster of wall-paintings. At first dilute glaze was used for outlines, and the use of color masses—reds, browns, greens, and blues—restricted. But this attempt to emulate free painting was unsuccessful—even though after 450 the best vase-painting was in the white-ground technique—partly because the vase-painters were too deeply entrenched in the "silhouette" principle, and partly because the result was not durable. White-ground therefore remained a sideline of red-figure, and in the second half of the 5th century was restricted to *lekythoi* (oil-flasks) intended as grave offerings.

The outstanding artist of the Free style (c450–420 BC) was the Achilles Painter, notable especially for his white *lekythoi*, on which more color and mat-painted outlines were now used. His style has a quiet Periclean grandeur, into which his pupil the Phiale Painter introduced a domestic liveliness. The

Aphrodite on her goose: a cup by the Pistoxenos Painter; diameter 24cm (9in); c470 BC. British Museum, London

A white-ground lekythos of Group R; height 48cm (19in).

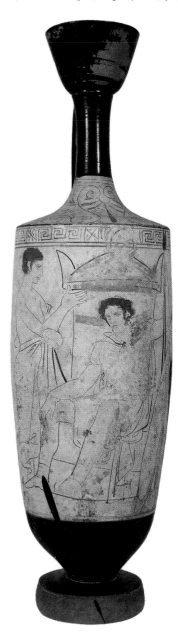

Eretria Painter exemplifies a tradition of fine draftsmanship, continued by the Meidias Painter whose clinging draperies recall later 5th-century sculptures. The Kleophon Painter and his less solemn pupil, the Dinos Painter, illustrate the later Polygnotan tradition on vases: round fleshy forms, loose draperies, and a good spatial and emotional sense. The end of the century saw the latest white-ground *lekythos* workshops (the Woman Painter, Group R, the Reed Painter, etc): solemn, brooding figures, reflecting the bitter disillusion of the final humiliating years of the Peloponnesian War.

Two distinct trends can be detected in the 4th-century red-figure: the Ornate style, growing from the florid traditions of artists like the Meidias Painter, which favored thick lines and heavily patterned drapery (presumably reflecting current dress fashions) with copious added white and yellow. Three-quarter views were much used and tiered compositions were again

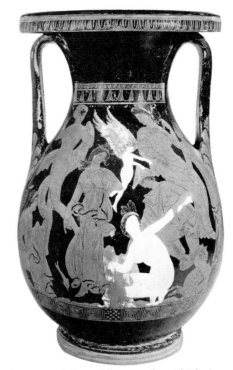

Pelike by the Marsyas Painter: Peleus wrestles with Thetis; height 42cm (17in). British Museum, London

A detail from the name-vase of the Darius Painter; c340–330 BC. Museo Archeologico Nazionale, Naples

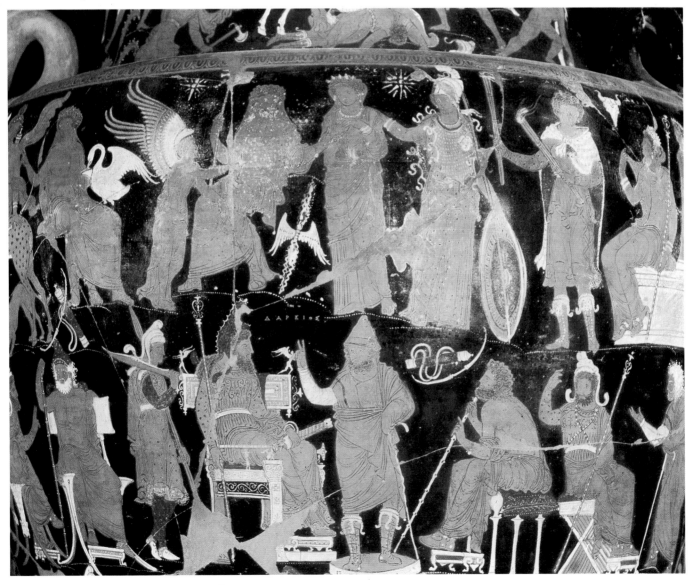

popular with men like the Talos, Pronomos, and Suessula Painters. During the century more added color, gilding, and even relief details were used, until finally whole figures and scenes were applied to the surface in relief, sometimes completely in the round. In opposition to this last attempt to compete with free-painting stood the Jena Painter and other exponents of the Plain style, following in the Dinos Painter's tradition. At their best they were skilled and restrained draftsmen who used little accessory color, and reverted to profile figures emphasizing the surface of the pot.

From *c*350 BC a few artists managed to combine the best of both traditions in the "Kerch" style. The *pelike* by the Marsyas Painter (British Museum, London), illustrates this well: restrained but rather sketchy drawing of details and folds; deliberate use of white to emphasize prominent figures; a tiered, rather emotional composition, but one where the turning figures (especially the nymph on the right) subtly underline the form of the vase without competing against it. None of these outlived the decade 330–320 BC, leaving the field in Athens open to plain "black-glazed" ware and to "West Slope" vases. Presumably the best painters were working elsewhere, and tastes in tableware had changed.

Outside Athens there was little painted pottery, though the Corinthians and Boeotians imitated Attic wares. The latter possessed a strong black-figure tradition which continued into the 4th century, to culminate in a lively, crude series of parody vases from the Cabirion sanctuary near Thebes.

The only fabric to rival Attic was South Italian, produced from *c*440 BC onwards and throughout the 4th century to satisfy the needs of the Greek colonists in the West. South Italian glaze tended to be less lustrous than Attic and the vase shapes more varied, if less precise. Particular interest lies in their depiction of rare myths and scenes from lost plays.

Two styles springing from Attic traditions can be distinguished by 430–420 BC, one based on Taras (Taranto) which developed into Apulian, the other, leading to Lucanian, which is known by the recent discoveries of pottery-kilns to have been centered on Heraclea (Policoro). Apulian was the more monumental, with a fondness for large *kraters* (mixing-bowls) with elaborate compositions, often in several registers. But although individual groups and figures could show drama and emotion, the composition as a whole was often static and uninspired. Apulian did not lose contact with Attic, and never became provincial or barbarous like most other late Italiote. In the 5th century BC the leading artist was the Sisyphus Painter, who stood behind the two 4th-century traditions: the Plain style, typified by the Tarporley Painter and his school, which lasted until the end of the century, its quality declining as quantity increased; and the Ornate, whose apogee was in the school of the Darius Painter (*c*350–325 BC) who produced huge, elaborate vases with much added color, especially white, yellow, and red. Out of this the Gnathian style evolved

at Taranto from *c*360 onwards, using only added colors and no longer any reserved red-figure. Perhaps of all the vase-painting styles this one most reflected free painting developments.

Lucanian, the product of the prolific workshops of the Pisticci and Amykos Painters (*fl. c*440–410 BC), was generally monotonous. In the 4th century Lucanian was influenced by both Apulian trends, but because of its isolation even better artists like the "ornate" Primato Painter could lapse into provincialism, and late-century vases were so bad that it may be asked if Greeks painted them at all.

The three far-western styles only began in the 4th century. Paestan (at Paestum, Greek Posidonia) grew out of Lucanian from 375 onwards, and was dominated by Asteas' and Python's workshops, whose best pieces are the *phlyax* vases, in the middle and later century, showing burlesque stage scenes. Campanian and Sicilian were always closely related, though the former showed more variety. There were several Campanian workshops, of which the Cumae Group was the most important, using much added yellow and white, as well as green, red, and blue. Sicilian, descended from this, more original in choice of subject and, particularly late in the century, more lavish in its use of color on a pale clay, was very different from the restrained, stylish work of early Classical Athens.

Conclusion. The convenient date for the "end of Classical art" is the accession of Alexander of Macedon in 336 BC, but art did not actually come to an end then, as the ancients liked to think. Rather, it had reached that point of complete technical confidence which opened the way for the experiments in human proportion of sculptors like Lysippos, and the corresponding baroque fancies of Hellenistic sculpture and architecture. With the decline of the city-state, the individual became more important, as is reflected in the rise of real portraiture and the corollary, grotesques and caricatures, in a more "humanized" artistic context. In painting this is shown in the decline of vase-painting in the face of free painting which could render emotion and characterization, and on the other hand of the silver and gold vases, and jewelry, demanded by the ostentatious and wealthy, which the potters could only imitate on a more humble level in plain black-glazed wares. Typically, Greek art was ready to adapt and use the new concepts brought by Alexander's conquests.

A.J.N.W. PRAG

Bibliography. Arias, P.E., Hirmer, M., and Shefton, B.B. *A History of Greek Vase-Painting*, London (1968). Boardman, J. *Greek Art*, London (1973). Cook, R.M. *Greek Painted Pottery*, London (1972). Richter, G.M.A. *A Handbook of Greek Art*, Oxford (1974). Richter, G.M.A. *The Sculpture and Sculptors of the Greeks*, New Haven (1970). Robertson, C.M. *A History of Greek Art*, Cambridge (1975).

9

HELLENISTIC ART

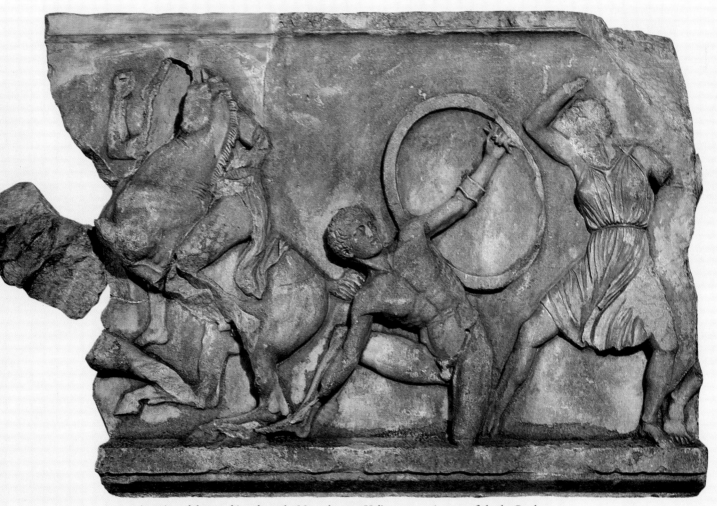

A section of the east frieze from the Mausoleum at Halicarnassus: Amazons fight the Greeks
height 39cm (15in); c350 BC. British Museum, London (see page 150)

ELLENISTIC is a chronological term applied to art produced in the Greek world from the second half of the 4th century BC until probably the 1st century BC. To define it more precisely is extremely difficult, though the historical events that mark its beginning and end are plain enough.

In 336 BC Alexander the Great became King of Macedonia. In his brief, brilliant career, Greek influence was extended far beyond its previous limits, as far east as the Indus and from the Crimea to Egypt. Over this wide area trade and cultural interchange thrived, stimulating fresh artistic inspiration. When Alexander died in 323 BC he left no strong successor, so his Empire was torn apart by jealous rivalries. From c306 BC separate kingdoms grew up under new dynasties: the four main ones were Macedonia itself, under the Antigonids; Syria under the Seleucids; Egypt under the Ptolemies; and Pergamum under the Attalids. These new rulers had both resources and inclination to support the arts, and especially in the 3rd and 2nd centuries BC their courts commissioned craftsmen from far and wide.

Southern Italy was the other major center of Greek art during the period. Most Greek colonies in this area enjoyed some prosperity, especially Syracuse and Tarentum, despite the struggle with Carthage and the growing threat of Rome. Rome was the force that finally put an end to Hellenistic art, as Roman dominion extended to southern Italy in the late 3rd century and then to Greece and beyond. By 146 BC Greece was a Roman province. In 133 BC Attalus III, the last King of Pergamum, died, leaving his kingdom to Rome. Syria was

taken over in the 1st century, and Egypt annexed after the death of Cleopatra VII in 31 BC. So perhaps 27 BC, the year in which the entire Greek world first became subject to the rule of imperial government centered on Rome, is the neatest date with which to conclude the period.

The Romans played a vitally important part in the dissemination and preservation of Hellenistic art. Their tastes developed from the stimulus of enormous quantities of booty, brought to Italy from the 3rd century BC onwards. They became great patrons and collectors of art, wealthy men building up extensive collections of Greek masterpieces—several temples in Rome even became art galleries. If original works were not available, copies were quite acceptable, as they had been earlier especially to the kings of Pergamum. Such copies—most mere hackwork, lacking subtlety and indeed accuracy—together with coins, scraps of comparative evidence, and a few inadequate descriptions in ancient authors, are often the only evidence we have for the work of major artists of the Hellenistic period. Most originals are in the minor arts, and are often hard to date.

Sculpture. As early as 350 BC distinctively new ideas can be detected in the tomb built for Mausolus, ruler of Caria, at Halicarnassus, the original Mausoleum. This flamboyant building, a great pyramid-like structure, was lavishly adorned with freestanding and relief sculpture, the work of four sculptors, Scopas, Timotheos, Leochares, and Bryaxis, and two architects, Pythios and Satyros. Though there is much dispute about delegation of responsibility and details of reconstruc-

The Greek world, late 4th–1st century BC

tion, Scopas was probably the dominant artist. Trained in the Peloponnese before 360 BC in the tradition of Polycleitos, his enthusiasm was channeled into dramatic, emotional figures with intense facial expressions, as in the east frieze of the Mausoleum (British Museum, London). This depicts the battle between Greeks and Amazons, with strong diagonal lines to emphasize motion and effort, and deeply drilled, swirling drapery.

One of the freestanding pieces from the Mausoleum a tall, well-dressed man, possibly a member of Mausolus' family (British Museum, London), was a forerunner of another major development of the Hellenistic period—portraiture. Here is a careful likeness of an individual with a heavy face, somewhat arrogant since his full lips curve disdainfully. At about the same time realistic portraits were being produced elsewhere, of which the most famous is perhaps a bronze showing the grim face of a victorious boxer at Olympia (c335 BC; National Museum, Athens), often attributed to Silanion. From Alexander's lifetime onwards portraiture became very popular, his fame stimulating the demand for likenesses of living people. The foremost artist in this development was Lysippos, who had been entrusted with the official portrait sculptures of Alexander. Unfortunately none of his original works survive, so it is impossible to assess accurately the quality of the idealism with which he may have endowed his work. Coming from Sicyon in the Peloponnese, he claimed to be self-taught, though he acknowledged the influence of Polycleitos, and enjoyed a long career of about 50 years beginning c360 BC, profoundly influencing later artists. He is credited with many inventions, though surviving copies do not illuminate these. He appears to have favored the tall, slender, narrow-hipped figure, with the head smaller in proportion to the body than before. More important was the new three-dimensional quality he added to his works. In his *Apoxyomenos* (copy in the Vatican Museums, Rome) we see an athlete scraping himself with a strigil. The pose is momentary, with arms raised in a direction different from that of the body, the left arm obscuring the chest. The figure is intended to be seen from any angle, a feature of Lysippos' other works.

The works of two of Lysippos' pupils demonstrate clearly how sculpture was used for propaganda purposes. Eutychides of Sicyon made a statue of Tyche, Good Fortune, commissioned c300 BC by Seleucus I to symbolize Antioch as the capital of the new kingdom of Syria. The surviving miniature replicas (Louvre, Paris; Vatican Museum, Rome) enable us to assess the lively symbolism. The regal goddess, wearing a turreted crown, sits on a rock, her foot on the shoulder of a swimming personification of the Orontes, the river of Antioch. Particularly noticeable is the three-dimensional composition, emphasized by the strong diagonal drapery and contrasting positions of the figures. About the same time Chares of Lindos, Lysippos' favorite pupil, designed for Rhodes its

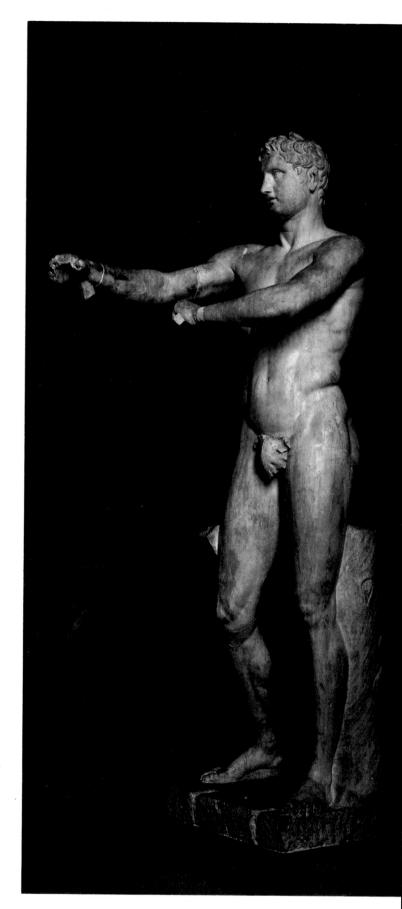

A copy of Lysippos' Apoxyomenos; marble; height 205cm (81in); original c320 BC. Vatican Museums, Rome

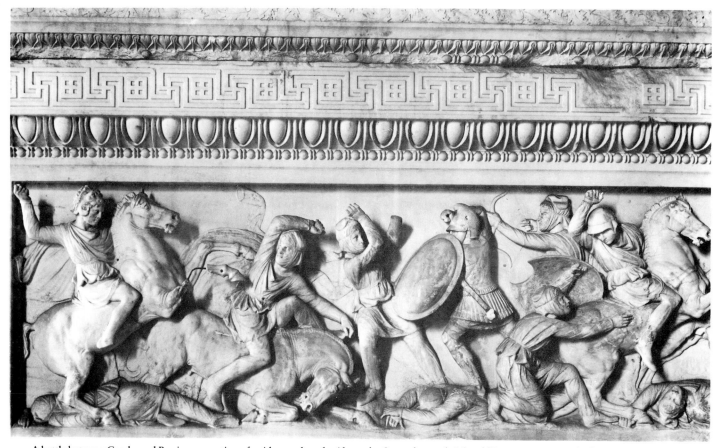

A battle between Greeks and Persians: a section of a side-panel on the Alexander Sarcophagus; height of frieze 59cm (23in); the figure on the extreme left in a lion-skin helmet may be Alexander. Istanbul Archaeological Museum

Colossus—an enormous bronze effigy of the Sun, a symbol of the city's pride in its freedom.

An interesting original sculpture of the last third of the 4th century BC, also made with political purpose, is the so-called Alexander Sarcophagus, a rectangular chest with relief sculpture on all four sides (Archaeological Museum, Istanbul). Perhaps commissioned by Abdalonymus whom Alexander installed as King of Sidon, it commemorates Alexander's military victory over Persia and the reconciliation between conqueror and conquered. On one long and one short side spirited battle scenes are carved, including perhaps Alexander himself conspicuous in a lion-skin, on a rearing horse, hurling his spear at a Persian. On the other sides are hunting scenes in which Macedonians come to the aid of a Persian whose horse is being attacked by a lion.

In the 3rd century portraiture continued its development towards realism, though our knowledge is distorted because Roman taste has chiefly preserved philosophers and literary celebrities. A climax was reached c210 BC in the eloquent portrait of Chrysippos by Euboulides (Louvre, Paris); the simple cloak of the philosopher hangs over his bent, emaciated form, his face hollow, his beard ill-trimmed. For portraits of kings, coins are the best source. A fine example is the forceful portrait on the obverse of the rare silver octadrachms of Ptolemy I, King of Alexandria 305–282 BC (Museum of Fine Arts, Boston). Studies of anonymous individuals and children became popular too. The life-size *Antium Girl* (c250–225 BC; Terme Museum, Rome) shows a young woman in a momentary pause while walking, turning to her left, her attention concentrated on the religious objects she is carrying. A study of a different type is the so-called *Barberini Faun* (Glyptothek, Munich), a sleeping satyr, a remarkable rendering of the total relaxation of sleep. Such realism was based on a more exact knowledge of anatomy, sustained by a growing interest in science. At the beginning of the 3rd century Lysistrates, brother of Lysippos, started taking casts from the human face, while a little later doctors in Alexandria were conducting dissections.

From 250 BC one city emerged as the chief and most influential center for sculpture: Pergamum. The court attracted artists of many different origins and traditions, and it stimulated them to produce dynastic propaganda in a remarkably homogeneous style. After 228 BC Antigonos from Greece and Epigonos of Pergamum were requested to celebrate the victory of Attalus I (reigned 241–197 BC) over an invasion of Gauls, or Galatians as they came to be called. The resulting monument was a large round base on which a Galatian who had killed his wife was about to kill himself to avoid capture (Terme Museum, Rome). Round it were four dying Galatians, their slanting bodies leading the eye to the central group. In this dramatic, three-dimensional composition the artist's object was realism. The limp dejection of the dead woman, the blood spurting from wounds, bulging muscles, shaggy hair, deep, savage eyes, even ethnic characteristics such as moustache, torque, and trumpet, combine to convey the splendor of victory through the pride and courage of the foe.

Eumenes II (reigned 197–160 BC) enthusiastically continued his predecessor's policy of making Pergamum a great

cultural center. To preside over Attalus' new library a copy of Pheidias' Athena Parthenos, smaller than half size, was commissioned in Athenian marble. In the same room stood statues of the great traditional figures of Greek literature to link the new firmly with the old. Athens had its Parthenon, so Pergamum should have an equivalent—the Great Altar of Zeus and Athena (Pergamon Museum, Berlin), probably but not certainly built by artists of several nationalities for Eumenes between 180 and 160. The Altar recalls the temple not only in the use of sculpture to illustrate national events but also in details. The figure of Athena on the east frieze of the Altar, for example, is similar to the one that was on the west pediment of the Parthenon.

The Altar itself stood on a high platform approached by steps from the west and surrounded on three sides by a wall and a colonnade which projected in spurs on either side of the steps. There were two friezes, the main one on the outer faces of the platform and flanking the steps, the other on the inner side of the wall round the Altar. The Great Frieze on the outside shows the battle between gods and giants, a mythological parallel for the conflict between Pergamum and the Galatians. On the longest east side we have Zeus and Athena towards the northern end where they would be immediately visible to visitors entering the Altar precinct by the main gate from the city, together with other gods, each fighting one or more giants. On the south side there are deities of light and sky, on the north chiefly those of night, and on the west the sea gods and Dionysos. Everywhere there is movement—in the repeated rhythms of individual combats, the changing diagonals, sweeping gestures, and swirling drapery—and constant variety in a wide range of poses. Beside the entrance the figures leave the frame and support themselves on the steps. There is no less variety in the picturesque details, which pay meticulous attention to traditional mythology—a giant with a lion's head, with wings of leaves, or serpent-footed; or the gods with their accompanying beasts; or triple-bodied Hecate or Poseidon's chariot drawn by sea-horses.

The inner frieze, which survives in a very fragmentary condition (Pergamon Museum, Berlin), was smaller. It told the story of the life of Telephos (Herakles' son, whose mother, Auge, was believed to have brought the cult of Athena to Pergamum and from whom the Attalids claimed descent) by means of a novel episodic narrative in which scenes were separated by trees, columns, or back-to-back figures. The arrangement of the figures was also an original feature—they were placed arbitrarily on two or three levels, none using more than two-thirds of the vertical height of the frieze.

A little earlier than the Great Altar is a fine dramatic piece, the *Winged Victory* (Louvre, Paris), now sadly incomplete but probably of Pergamene origin, originally set up on the island of Samothrace c190 BC to commemorate a naval victory. The over-life-sized female figure alights on a ship's prow, her feet firmly planted against the rushing wind. Movement is emphasized by the curving wings and the drapery blown back against the body to reveal its shape, an elaborate, careful

treatment of clothing which became fashionable. A portrait statue of Cleopatra, for instance, still in her house on Delos (138–137 BC) shows her wearing a light shawl of fine material over her dress.

Other sculptures are narrative. The group showing the death of Laocoön and his sons, the work of three Rhodian sculptors, Hagesandros, Polydoros, and Athanodoros, probably dates from c100 BC (Vatican Museums, Rome). The terrifying situation as the three figures wrestle with the monstrous snakes sent by Apollo to destroy them is emphasized by their twisted, agonized bodies. The group clearly owes much to the Great Altar and, like a piece of relief sculpture, is designed to be viewed from one point only. Comparable with it is a tremendously powerful, pyramidal group, known only from a florid copy of the early 3rd century AD (Museo Nazionale, Naples) which shows Dirke being tied to a bull and about to be torn to pieces. According to literary sources the group was set up on Rhodes but the artists were Apollonius and Tauriskus of Tralles in Asia Minor, the adopted sons of Menekrates of Rhodes, a sculptor who was probably the designer of the Great Altar at Pergamum. Such interchange of ideas and personnel makes it hard for us to trace and identify regional schools or individual styles with any precision.

From the 2nd century onwards an especially popular class of sculpture was the female nude or seminude, presumably Aphrodite with slim, sloping shoulders, small breasts, and broad hips. The Aphrodite from Melos (Louvre, Paris) is one of the most famous examples, a standing figure over 6½ ft (2 m) high. Her body has a complicated twist as the upper part turns to the left and the hips to the right, which is emphasized by the cloak round her legs. Other completely naked figures crouch, as does a Rhodian statuette (100 BC; Archaeological Museum, Rhodes) based on a type perhaps originated by Doidalsas of Bithynia (fl. c250). The goddess's plump, sensuous body has a three-dimensional twist as she kneels on an ointment box, lifting up her hair with both hands.

Studies of individuals continue. A fine example is the bronze boxer (c50 BC; Terme Museum, Rome). A stocky, muscle-bound figure, he turns his dull, ill-humored face to the right, as he rests wearily, forearms on knees, hands stiff and awkward in their protective strapping. His right shoulder and elbow are gashed; his nose broken; his ears cut and swollen. Physical abnormalities and monsters (especially centaurs in the 1st century BC) became popular subjects with sculptors, presumably because of their customers' tastes. There were also excellent portraits, the bronze head of a man from Delos (c100 BC; National Museum, Athens), for example, or the head of Homer (Museum of Fine Arts, Boston), probably slightly earlier, with its realistic rendering of blindness—wasted eye sockets, thin lids, and wrinkled brows.

In the 2nd century, however, there were signs of a reaction against exaggerated realism. The statue usually identified as Demetrius I of Syria (reigned 162–150 BC; Terme Museum, Rome) with its godlike nudity shows an idealized picture of statesmanship and intellect. His body is massive and haughty,

The Great Altar at Pergamum

The reconstruction of the west facade shows part of the Great Frieze, which has been rescued from Byzantine fortifications and 19th-century limekilns. To aid comprehension of the uniquely extended battle the figures were named, giants usually below the frieze and gods above.

The figures of the Great Frieze, taller than life size (height 7 ft 5 in, 2.3 m), are carved in extremely high relief, casting strong, dramatic shadows. In the chief group mighty Zeus lunges, his aegis round his left arm, and originally a thunderbolt in his right hand. Serpent-footed Porphyrion struggles, his muscular back contrasting with the frontal view of the young giant next to Zeus, who sinks, clutching his wounded right shoulder, the veins of his arm cording in agony.

To Zeus' right another giant has fallen, his thigh pierced by a thunderbolt. The anguish of his profile face is echoed in the full countenance of winged Alcyoneus, with its deep-set eyes, furrowed brow, and open mouth. Athena, crowned by hovering Victory, lifts him by his hair to drag him away from his mother Ge, Earth, who rises pleading pitiably, entreaty in her every line.

Attention to detail contributes greatly to the sculpture's narrative force. Artemis in the short tunic of a huntress strides forward, one of her beautifully booted feet on a dead giant. Her dog bites a snaky-tailed giant, well-endowed with body hair, who retaliates by gouging out the animal's eye. To exaggerate the power and strength of the bite, the dog's muzzle is elongated and the giant's hair mingles with its mane. Even the interiors of shields are carefully decorated, while the moon goddess, Selene, rides on a shaggy saddle cloth, interestingly different from the smooth hide of her mount.

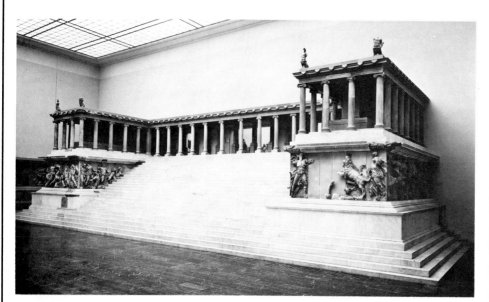

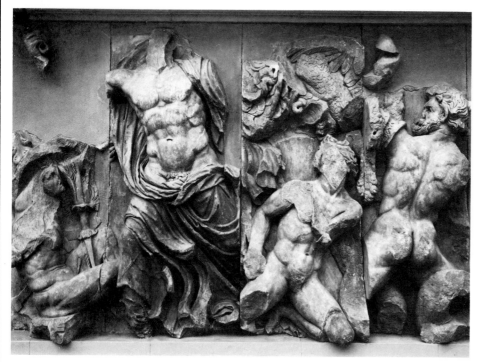

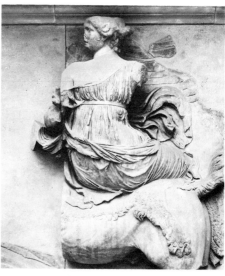

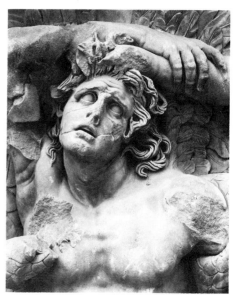

Above The Great Altar at Pergamum as reconstructed in the Pergamon Museum, East Berlin

▲ Detail of the east frieze: *from left to right* a wounded giant, Zeus, a young giant, and Porphyrion

Above right On the south frieze: the moon goddess Selene

▶ Detail of the east frieze: the winged Alcyoneus is lifted by his hair

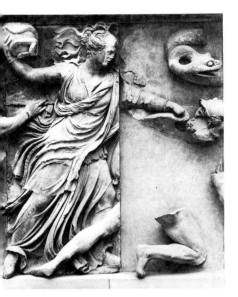

◄ On the north frieze: Nyx, the goddess of the night

▼ On the east frieze: Otus and Artemis

Below A scene on the inner frieze: building the boat for Auge

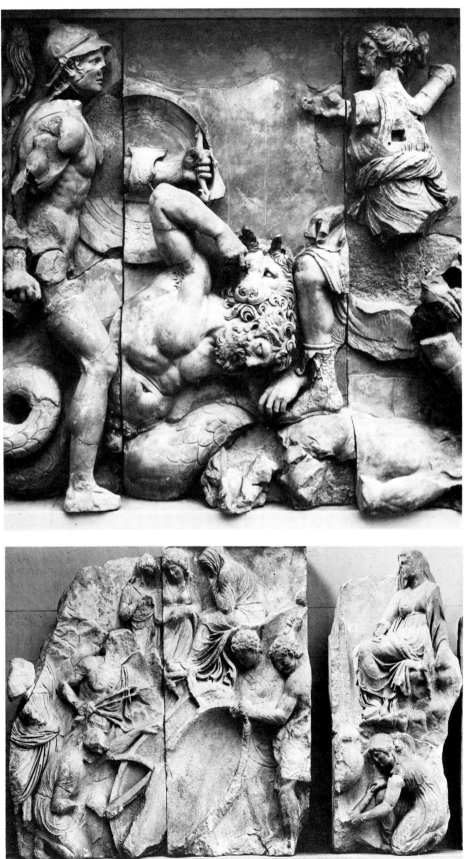

The treatment of drapery clearly illustrates stylistic differences among the sculptors of the frieze. Clothes billow and surge to emphasize the movement of Zeus and Athena, or in a more traditional manner complement the tall figure of Apollo as he towers over his fallen opponent. Selene wears a soft dress, its delicate folds highlighting the fine skin of her back and contrasting with the heavier cloak round her legs. As Nyx, the goddess of the night, strides forward hurling a serpent-wreathed vessel at a giant, her heavy robes sweep back, the thin veil fluttering behind. Her dress shows a new fashion in drapery: double lines of creases, or perhaps embroidery, which run across the main folds.

The later inner frieze, only 5 ft (1.5 m) high, placed at eye level, is of a different genre, analogous to painting, though probably never painted in its unfinished state. In the scene showing the construction of the boat in which Auge, daughter of the king of Arcadia, is to be set adrift, disgraced by the birth of Telephos, four carpenters work diligently, presumably supervised by the male figure on the left. The grief-stricken Auge with two servants is above, smaller in scale because further away. On the right, at the foot of a rocky knoll on which a nymph is sitting, a girl tends a fire under a caldron of pitch for caulking the boat. Meanwhile Herakles finds his son being suckled by a lioness in a rocky landscape. He watches, club and lion skin by his side, his back to the plane tree that marks the beginning of this episode.

K.B. THOMPKINS

Further reading. Bieber, M. *The Sculpture of the Hellenistic Age*, New York (1961). Hansen, E.V. *The Attalids of Pergamon*, New York and London (1971). Robertson, M. *A History of Greek Art*, Cambridge (1975). Schmidt, E. *The Great Altar of Pergamon*, Leipzig (1962).

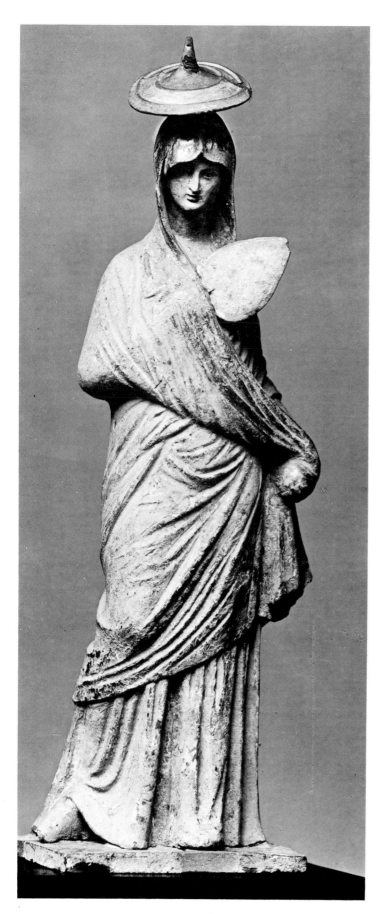

his brow deeply furrowed, his expression contemptuous—all to emphasize his kingly aloofness. Other works too show a return to the less realistic treatment of earlier centuries, sometimes even imitating the style of the Archaic period. An exponent of this kind of work was Damophon (*fl.* mid 2nd century) who made several cult-statues for sanctuaries in Greece, and was much influenced by Pheidias whose statue of Zeus at Olympia he restored. In the 1st century Arkesilaos was a versatile imitator. He carved a Venus for the temple in Rome dedicated by Julius Caesar in 46 BC, in the manner of a 5th-century statue.

Terracotta figurines. The manufacturers of terracotta figurines benefited greatly from increased personal wealth and enthusiasm for decorative pieces in the Hellenistic period. Their products were small, sharing many characteristics of large-scale sculpture.

The first type, Tanagra figurines, taking their name from the cemeteries in Boeotia where they were found in enormous numbers, were favorite offerings to the dead. Made in Athens and in many other centers in Italy, Asia Minor, and elsewhere, they were extremely popular throughout the Greek world from *c*340 until 200 BC. Tanagra figurines were chiefly female, fully clad, and represented scenes of daily life, though occasionally one may be interpreted as a goddess, a Muse (perhaps with a musical instrument), or Aphrodite half-naked. Women and girls stand, dance, or sit, sometimes playing knucklebones. Occasionally young men and boys—seated or standing—are the subjects, or chubby, babyish Erotes, usually in flight. There are also a few grotesque figures, probably in part influenced by contemporary comedies—ugly old nurses, for example, or enormously fat women. Naturalism was the aim, with relaxed poses and familiar dress to give the figures a human quality which helps to explain their popular appeal.

The manufacturing technique was an advance on previous practice, using molds of several pieces to achieve a greater variety of shapes. Often the body and arms were made from one mold, and the head from another, while attributes such as hats, fans, or wreaths were added, enabling an enormous variety of figures to be produced from a small set of molds. The figurines were colored in the traditional manner. White slip was first applied and then, after firing, bright colors, including a large range of reds, blues, and yellows.

After 200 BC the terracotta industry fragmented, different centers concentrating on certain subjects. One particularly important group is called Myrina, after the small town near Pergamum whose cemeteries yielded large numbers of figurines. Tanagra types, in bigger, more varied, and more elaborate forms, continued until *c*130 BC as production and repertoire gradually increased. Mythological subjects featured frequently and comic actors too, many of whom are very fine, though the style in general finally degenerated into grotesque coarseness.

Left: A terracotta figurine of a young woman from Tanagra; height 33cm (13in). Staatliche Museen, East Berlin

Bronze statuettes. Bronze statuettes were very popular, whether copies of major sculptures simply for decoration, or portraits of poets and philosophers for their admirers or of rulers as neat compliments. The old schools of mainland Greece were halfhearted and lost their reputation to new centers, Pergamum, Alexandria, or Delos. Although much was cheap and vulgar, made in large quantities for an undiscerning public, a few pieces were really fine. As in major sculpture vitality was all important with new, sensational dramatic poses. The *Loeb Poseidon* (Staatliche Antikensammlungen, Munich), for example, shows the god in a restless, rather theatrical pose, the proportions of the figure very much recalling the work of Lysippos. The *Baker Dancer* (Walter Baker Collection, New York) too, an Alexandrian piece of *c*230 BC, with its composition of triangles in different planes, owes much to Lysippos and his pupils, while its treatment of clothes, rolled and stretched tight, typifies the new attitudes.

Realism was especially characteristic of some bronzes made in Alexandria where the cosmopolitan population provided a rich source of subject matter. Negroes were common, as were native Egyptians such as priests with shaved heads and enveloping mantles. Hard-featured peasants were shown, so too were children, and characterizations of the sick; an extremely emaciated, seated man (1st century BC; Dunbarton Oaks Foundation, Washington), for example, or a humpbacked beggar with a humble, yet resentful expression (Staatliche Museen, Berlin). Dwarfs were also popular, as were hunchbacks, though many of these pieces are poor quality and hard to date.

A bronze statuette of a dancing dwarf from Mahdia, Tunisia; height 30cm (12in). Musée National du Bardo, Tunis

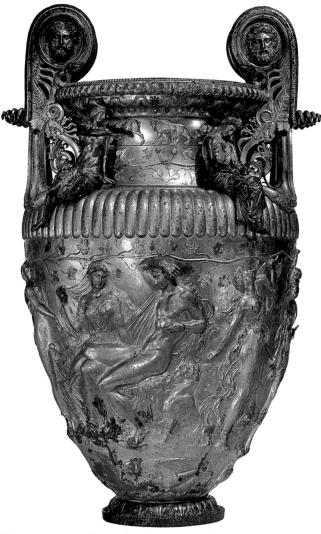

The Derveni krater; bronze; height 91cm (36in); late 4th century BC. Archaeological Museum, Thessalonica

Metalwork. Utilitarian bronze objects also reveal the high living standard of the Hellenistic period. Furniture which had highly ornamented parts made of bronze, was popular, as were bronze vessels, pails, mirrors, and other utensils—especially *kraters* for mixing wine and water. The only manufacturing center known for certain was southern Italy, especially Tarentum, which exported very widely though articles must also have been made elsewhere. One of the finest examples of all is the *krater* used as an ash container in a grave at Derveni in Macedonia (probably late 4th century BC; Archaeological Museum, Thessalonica). The handles and the figures on the shoulders are cast, a technique much favored in southern Italy at the time; the rest is repoussé, with some added silver detail. The subject matter is Dionysos who sits with his leg in the lap of his bride, Ariadne, surrounded by whirling maenads and satyrs. He reappears in solid bronze on the shoulder with two maenads and a sad satyr mourning the dead.

Much more gold and silver plate was manufactured during the Hellenistic period, not only for the proverbially rich rulers, but also for wealthy private individuals who found it a useful investment. More metal became available as the resources revealed by Alexander's conquests were exploited. The repertoire of gold- and silversmiths increased as they produced

many more objects for domestic use, with varying decoration—sometimes floral patterns, sometimes human or animal heads, sometimes mythological scenes—though once again the freedom with which artists traveled makes it difficult to isolate the products of any particular place from the limited surviving material.

Jewelry. Jewelry also flourished in the prosperity of the period, encouraged by the increased availability of raw materials. Most of our examples come from tombs where the custom of burying whole sets of jewelry with the dead bears witness to the wealth of the time. As with other metalwork, jewelry was made in many places and though we cannot isolate individual styles two centers seem to have been important: Alexandria and Antioch.

Many of the basic designs—diadems, naturalistic wreaths of leaves, some of extreme delicacy, ear- and finger-rings, or bracelets—continued virtually unchanged, as did the old techniques of filigree, enameling, and granulation. Egyptian motifs became popular, however, especially an old protective device, the Knot of Herakles, favored as a centerpiece for diadems and bracelets for 200 years after 300 BC. The crescent from western Asia was also much used as a pendant on necklaces. Of the traditional Greek designs Eros was most popular, though other mythological characters appeared, while a new animal- or human-headed hoop earring was fashionable from c330 BC, an innovation probably from northern Greece. Most important of all was the exploitation of a previously rare technique: the attachment of stones and colored glass to give a bright, polychrome effect. At first chalcedony, carnelian, and especially garnet were popular; later a wider range of stones and also pearls were used.

Gem-cutting for rings became an important art, and oval garnets and amethysts were particularly popular. Portraits were quite common and more ambitious scenes show the influence of contemporary sculpture for mythological themes or more everyday topics. The cameo in layered stones, especially sardonyx, was invented and used extensively, not only for jewelry but also for larger toilet articles, cups, and bowls. A rare survival from Alexandria is the Farnese Cup (probably 2nd century BC; Museo Nazionale, Naples), clearly a piece of visual propaganda, extolling the benefits obtained from the Nile floods, though its precise interpretation is a matter of great controversy.

Architecture. The eclecticism that informed Hellenistic jewelry was equally characteristic of architecture. The old orders disintegrated, their parts being treated as interchangeable, while Ionic and Corinthian developed at the expense of the less decorative Doric. Flamboyance was the fashion, and nowhere more so than in the Ionic temple of Apollo, Didyma (from 300 BC) with its deliberate diversity of column bases and capitals, richly decorated with mythological, abstract, animal, and plant designs. The Corinthian capital also readily lent itself to magnificent display, with many leaves in two high crowns, and luscious volutes and flowers, as the temple of Zeus in Athens (after 175 BC) clearly shows.

Major architectural work naturally focused on the centers of prosperity. The long years of civil war in the 4th century had left Greece too poor to initiate much, though gifts of buildings were gratefully received by cities and sanctuaries. The wealthy courts and rich mercantile classes of the Hellenistic kingdoms stimulated not only religious and civic architecture but also the building of palaces and opulent private houses set in streets made fine by colonnades and fountains. Evidence for palaces is scanty, but adequate to convey an impression of great magnificence. Pella, Alexander's capital, and Delos contain fine examples of private houses, with floors and walls richly decorated and an abundance of sculpture.

No less indicative of the individualism and opulence of the age were the monumental tombs. The historian Diodorus (fl. 60–30 BC) describes the tomb set up for Alexander's favorite, Hephaistion, an enormous stepped pyramid lavishly decorated with statues; and there are many parallels for such mausoleums, notably at Halicarnassus. They were particularly popular in Asia Minor, and perhaps owed their origin to the tombs of native kings. Another type, more popular in Macedonia, was the elaborate chambered tomb, mostly below ground, comprising a room and an antechamber with a decorative facade, approached by a passage. The most lavish tombs of all, like houses but wholly underground and heavily decorated, were in the necropolis at Alexandria.

Wall-painting. Surviving examples of Hellenistic wall-paint-

Hellenistic jewelry: a necklace and crescent, part of a diadem, and a hoop earring. British Museum, London

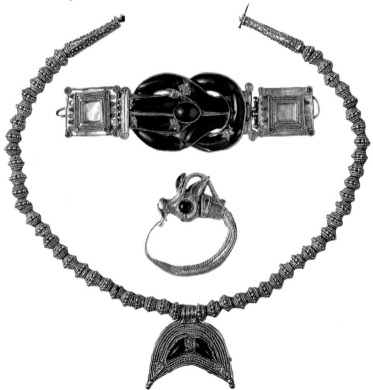

ing are provincial and inferior. For first-rate works we are dependent on Roman copies and adaptations, chiefly from Pompeii and Herculaneum, where much of the work is mediocre, probably produced, under contract, from rough copy books. Sometimes there are several versions of one theme, suggesting derivation from some earlier work, or a distinctively Hellenistic topic, such as the recurring story of Telephos. Dionysos and Ariadne in the famous paintings from the Villa of the Mysteries, Pompeii (*in situ*), are remarkably similar to a terracotta group from Myrina (Louvre, Paris); perhaps both are based on Pergamene paintings.

Hellenistic tombs and private houses had stuccoed, painted walls. At first the effect was simple; a wall was divided into three major zones, the lowest painted white, the main field red, and the cornice yellow. Later the plaster was sometimes modeled to imitate wall courses and a projecting cornice, and the paint mottled like colored marbles. As the decoration became more elaborate, the architectural effects were heightened by illusionist painting, the first example being on Delos *c*100 BC (House of Dionysos; Delos Museum) where modeled pilasters and entablature frame a painting of a foreshortened coffered ceiling, to give an impression of space between the columns.

Such house walls were a natural setting for compositions with figures, probably painted mainly on wooden panels. Of the specialist artists who made these paintings we know only a little more than their names, chiefly from the Roman writer Pliny the Elder (AD 23/4–79). For the third quarter of the 4th century BC we hear of Pausias of Sicyon who specialized in flowers, the widespread influence of which can be traced in mosaics and metalwork as far apart as Thessaly or Italy. Or there was Nikias of Athens with his large, solemn, cleverly shaded figures (a new technique) gazing at the spectator, or Apelles, Alexander's official portrait painter whose style may be reflected in some Roman paintings.

From a careful study of the copies some development can be traced, especially an increasing ability to depict three-dimensional scenes by means of highlighting, shading, and foreshortening. Valuable confirmation comes from original Hellenistic tomb paintings, occasionally very elaborate such as the facade of a tomb at Lefkadia in Macedonia with its painted imitations of sculpture (*in situ*), usually simpler with a decoration of domestic objects and wreaths. At Kazanlik in Bulgaria is an elaborate tomb (*c*300 BC; *in situ*), with particularly fine paintings on walls and ceiling, including a frieze centering on the dead man and his wife, who are receiving offerings.

As composition techniques in painting gradually improved, the physical setting of the figures, interior or exterior, became more important. Gravestones, especially from Thessaly, provide a little contemporary evidence for the styles of the mid 3rd century BC, though because the encaustic technique was used, much of the quality of the color has disappeared. The dead person is often shown seated with a servant and appropriate furniture; a particularly ambitious example shows

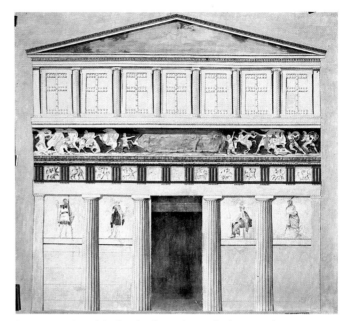

A reconstruction of the facade of a tomb at Lefkadia, Macedonia

Hediste who died in childbirth, with an open door behind her revealing more of the house (Archaeological Museum, Volos).

For the final phase of Hellenistic painting there is only one good example and a little literary evidence, supported by copies, which names Timomachos of Byzantium as the last great easel painter—his works were bought by Julius Caesar at enormous cost. In a house on the Esquiline Hill in Rome (*c*50 BC) a damaged series of scenes closely based on Homer's *Odyssey* has been found (Vatican Museums, Rome). Odysseus' wanderings are given an elaborate and realistically accurate setting of landscape, sea, and architecture, though the figures remain of paramount importance.

Mosaics. The art of the mosaicist thrived and became more ambitious. For evidence of the work of the late 4th and 3rd centuries the houses at Pella in Macedonia, with their well-preserved pebble mosaics, are our chief source, the best dating from the 3rd century. Big pebbles were used in simple geometric designs that covered large areas of floor, mainly in white, gray, and green, similar to the simple patterned floors in some Macedonian tombs. Smaller pebbles were used at Pella in figured scenes for which hunting was a popular subject. The *Stag Hunt* (*in situ*) is signed by Gnosis, apparently an artist of considerable ability, versatile in his modeling of the hunters and their cloaks, and skillful in his composition not only of the main scene but also of the fine floral border. His success was the more remarkable because he used natural colored pebbles and lead strips to outline the figures.

After *c*250 BC pebble mosaics were no longer made. Their place was taken by tessellated work which in its most developed form used tiny squarish pieces of naturally colored stones and later glass, set in a bed of cement and ground smooth. The origins of the technique are uncertain but by the 2nd century Pergamum seems to have become a center for the

The Tomb of Philip

The partially excavated east front of this tomb (*in situ* at Vergina; 350–325 BC) has a finely painted frieze above its brightly colored Doric facade. Hunters armed with spears, some on horseback, pursue wild animals through a winter landscape suggested by leafless trees, recalling the work of Philoxenos of Eretria (*see* Hellenistic Art, p163). The main room of the vaulted tomb is entered from the spacious antechamber by a marble door. Perhaps because Philip's assassination in 336 BC cut short the work, the walls of the inner chamber are unfinished, though the antechamber has high quality plaster, and a nearby tomb has three fine murals, additional evidence of unprecedented value for 4th-century BC painting.

Near the center of the back wall of the inner chamber stood a marble sarcophagus, containing a gold casket whose weight including contents was almost 24 lb (11 kg). Delicate leaf and flower patterns enhanced by applied rosettes, some inlaid with blue glass paste, decorate the casket's front and sides. Its legs are shaped like lion's paws and on the lid is a multi-rayed star: the emblem of the Macedonian royal family. Inside were the cremated bones of a man in his forties, covered with a gold oak wreath. Philip II, father of Alexander the Great, was 46 when he was killed.

A similar but smaller, more simply decorated casket, the only other one known, stood in a marble sarcophagus in the antechamber.

▲ The east front of the tomb

▲ The ivory portrait head; possibly of Alexander (actual size)

▲ The ivory portrait head identified as Philip (actual size)

It contained bones wrapped in a sumptuous gold and purple cloth, covered with an exquisitely delicate gold wreath of twigs and flowers.

Offerings to the dead were found in the southwest corner of the main chamber. A perforated bronze lantern decorated with a fine gold head, and other vessels, chiefly of bronze, together with a still pliable sponge, surrounded the large circular cover of a now disintegrated leather ceremonial shield—ornamented with ivory, colored glass, gold and silver—on a wooden frame. Beside it were two pairs of greaves and between them the first Macedonian iron helmet ever found. To the right was a circular, adjustable diadem of gold-plated silver, often seen on portraits of kings of Macedon.

In the antechamber was a pair of gilded bronze greaves whose uneven length and different modeling should perhaps be associated with Philip's lameness. The relief decoration on the gilded silver quiver shows the sack of a town with scenes of furious attack and desperate defence. The elegantly simple jug, found with other silver vessels of comparable workmanship by the north wall of the main chamber, is excellently executed,

especially the small repoussé head added at the base of its handle.

In the main room were fragments of ivory, including heads, hands and feet from five figures, perhaps originally decorations of now decomposed wooden furniture. One portrait head identified as Philip (who was partially blinded in battle) shows a mature, bearded man with a deep scar over his right eye. Another, a youthful face with upward gaze is sometimes identified as the only extant contemporary portrait of Alexander. A third could be his mother, Olympias. Perhaps the others are Philip's parents, and the whole series a miniature copy of the ivory and gold statues of the royal family commissioned from Leochares in 338 BC for dedication at Olympia.

K.B. THOMPKINS

Further reading. Andronicos, M. "The Royal Tomb of Philip II, an Unlooted Macedonian Grave at Vergina", *Archaeology* (Archaeological Institute of America) Vol. 31, Sept/Oct 1978. Hammond, N.G.L. and Griffith, G.T. *A History of Macedonia, Vol. II, 550–336 BC*, Oxford (1979). Kurtz, D.C. and Boardman, J. *Greek Burial Customs*, London (1971). Ninos, K. (ed.) *Treasures of Ancient Macedonia*, Athens (1978).

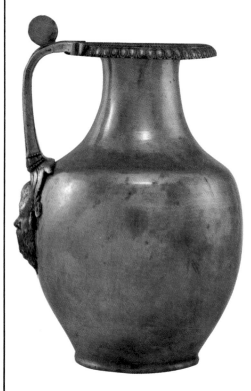

◀ A silver jug; height 25cm (10in)

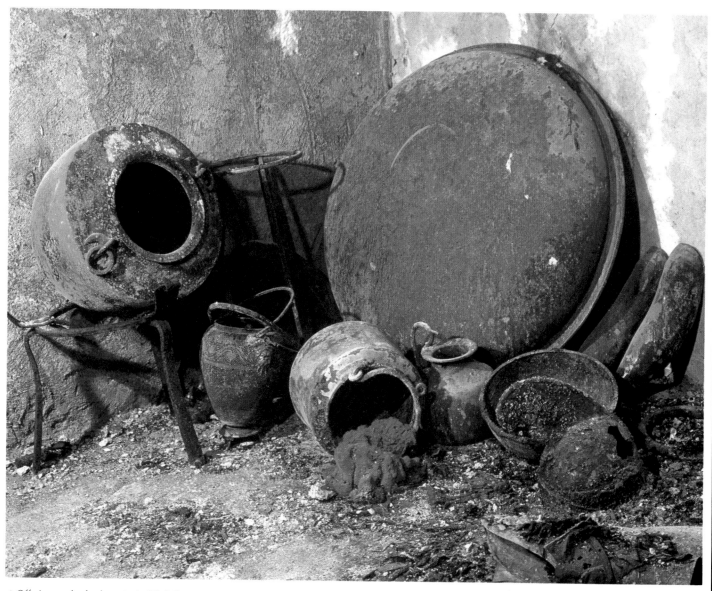

▲ Offerings to the dead found in the southwest corner of the main chamber

▼ The gold casket; height without legs 17cm (7in), length 40cm (16in)

▶ A gilded silver quiver, and gilded bronze greaves of uneven length found by the door of the antechamber. Length: *left* 38cm (15in) *right* 41cm (16in)

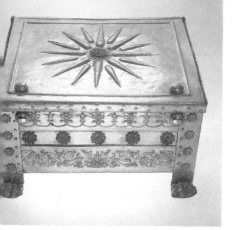

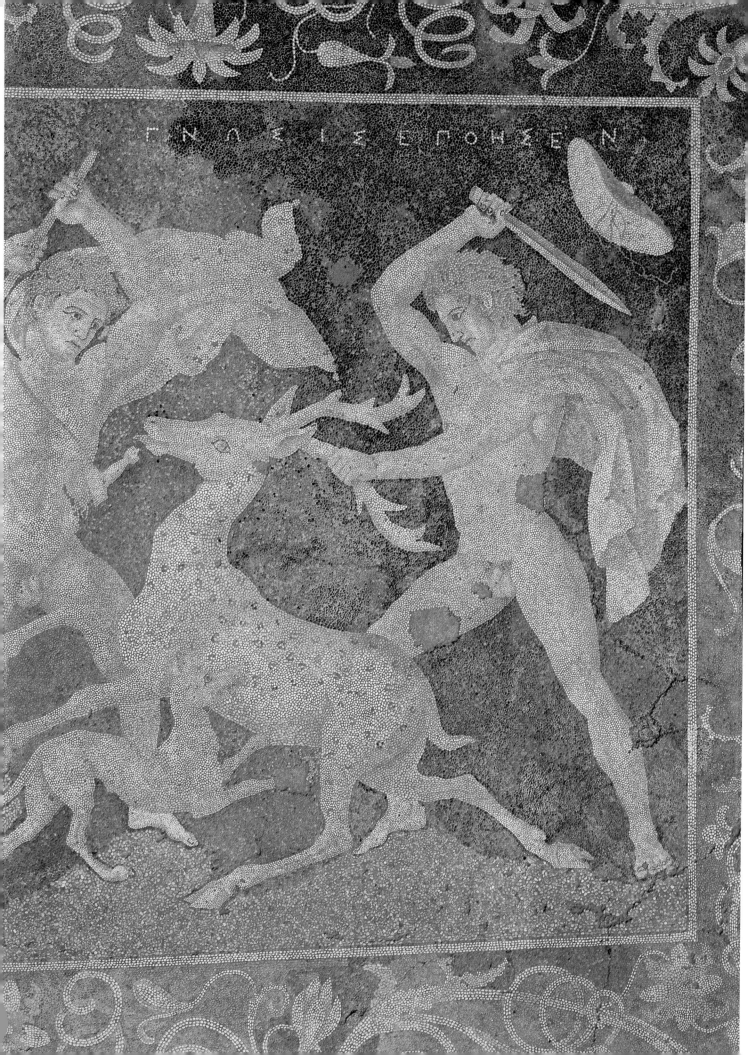
ΓΝΩΣΙΣ ΕΠΟΗΣΕΝ

production of mosaics, which rapidly increased in finesse. Sosos of Pergamum (*fl. c*170 BC) was ranked as an old master by the Romans chiefly for two works known from Roman copies: his *Doves Drinking* (Museo Capitolino, Rome) with its mastery of light and shade on the metal vessel and the reflection of the birds in the water, and his *Unswept Floor*, with its minute attention to details and skillful shading (Lateran Museum, Rome).

The subjects of mosaics were essentially decorative, not pictorial. Their backgrounds were normally plain, a dark greenish-blue, for example, for the solidly modeled *Dionysos Riding a Panther*, from Delos (*c*150 BC; *in situ* in the House of the Masks, Delos). Occasionally, however, the mosaicist copied an important picture. The Alexander Mosaic from Pompeii (*c*150 BC; Museo Nazionale, Naples) may be a fairly careful copy of a work by Philoxenos of Eretria (*fl.* 319–297 BC), slightly coarsened by the change of technique which used almost 1½ million tiny cubes of stone and glass to reproduce Alexander's victory over the king of Persia at the Battle of Issus (333 BC). The strong lighting and bold foreshortening of the dramatic scene as the young, bareheaded Alexander pursues the elaborately robed, fleeing Darius is enhanced by one stark tree and a mass of diagonal spears.

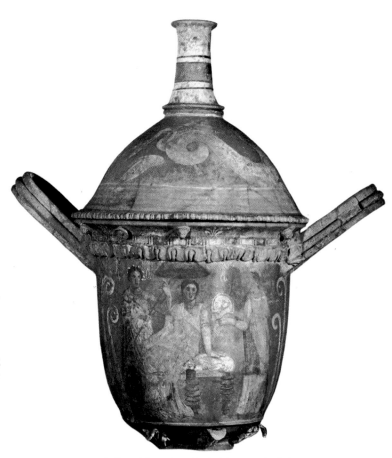

Left: The Stag Hunt, by Gnosis, at Pella in Greece (in situ)

The Alexander Mosaic from Pompeii; c150 BC. Museo Archeologico Nazionale, Naples

A 3rd-century lidded bowl from Catania; height 56cm (22in). Institute of Classical Archaeology, Catania University

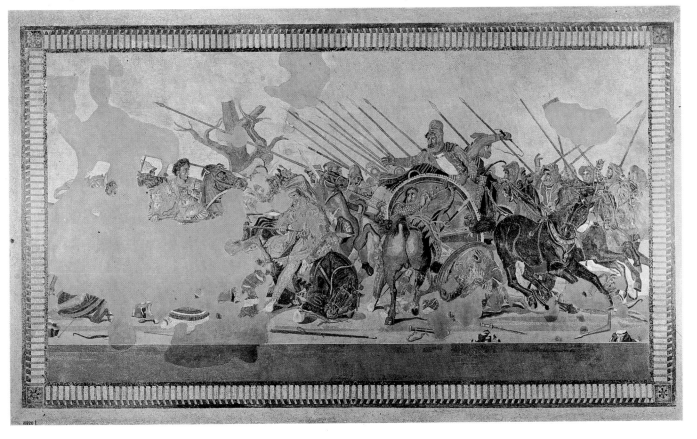

Pottery. Because artists had so much scope for other activities, traditional styles of Greek pottery-painting survived into the Hellenistic period only for special objects, for funeral rites, perhaps, or for athletic prizes. Only in southern Italy did red-figure continue for local markets until a little after 300 BC, benefiting from the reduced competition of Athenian imports. There were several regional schools, modifying traditional red-figure and experimenting with new techniques, all influenced by developments in easel painting. Apulian, based probably on Tarentum, was the major style, specializing in large, often excessively decorated funeral vases, frequently with scenes taken from mythology or tragic drama. The pots were much more colorful than Athenian red-figure with considerable use of white, yellow, and deep red. The other schools, Lucanian, Campanian, and Paestan were provincial by comparison, though Lucanian specialized in caricature and they all produced a lively class of vases showing scenes from rustic farces with actors in padded costumes.

The best work of Sicilian potters in the last quarter of the 4th century was executed in a bright polychrome technique which continued after 300 BC when more traditional styles had gone out of production. There was a flourishing industry based on Centuripe, near Catania (280–150 BC), making large, ornamental pots, often bowls or dishes with lids. Women sacrificing or in a religious procession were frequent subjects, set against a rose-pink background, enlivened by careful attention to facial expressions, skillful treatment of near-transparent robes, and subtle coloring and shading.

Another south Italian product, Gnathia Ware, was made for almost 100 years after 350 BC, probably in the same workshops as Apulian. The pots were smaller, made in imitation of metal shapes, painted black with white, red, purple, or yellow designs on top. The decoration was confined to a limited range of leaf patterns with occasional figure scenes. In Greece itself West Slope Ware was similar with a small repertoire of naturalistic and abstract patterns. It lasted probably into the 1st century BC over a wide area of the eastern Mediterranean, being manufactured perhaps in Pergamum and Alexandria, as well as in the cities of mainland Greece.

Hadra Ware, mainly used as ash urns in the cemeteries of Alexandria and probably made in that city in the second half of the 3rd century, demonstrates a different effect: decoration in color on the white or pale surface of the pot. Stylized foliage, wreaths, fantastic animals, and abstract patterns are most common, arranged sparingly in bands chiefly on the neck, shoulder, or upper belly.

Another method of decorating pottery gained some popularity as a cheap imitation of metalwork: the addition of molded ornament. Sometimes it was simple (a laurel wreath round the neck of a pot, for example) but occasionally it was used for an entire figure scene. In the 3rd and 2nd centuries Megarian bowls were important, made, despite their name, in many places. They were black or brown, with decoration in relief, either molded with the pot or stamped out and separately attached. In addition to plant motifs and patterns there were elaborate figure compositions, including an interesting series in the 2nd century illustrating stories from literature.

Conclusion. Over a wide area the Hellenistic period was a time of change. Artists and craftsmen lived and worked in a world of new political organizations, new cultural contacts, and new economic opportunities, a world that inevitably conditioned their products from the most elaborate and costly to the smallest and most humble. The individual was now all-important; monarchs required material manifestations of their power, while all classes strove to improve their living standards, not least wealthy merchants who wished to live with every luxury their money could buy. Everywhere people displayed a fresh, enthusiastic interest in human life, particularly in its more picturesque aspects; even traditional religious ideas and mythological themes were reinterpreted in personal terms. Such an approach far outlasted the chronological limits of the Hellenistic period; its influence on subsequent art, especially Roman was both extensive and profound.

K.B. THOMPKINS

Bibliography. Charbonneaux, J. *Hellenistic Art*, London (1973). Havelock, C.M. *Hellenistic Art*, London (1971). Tarn, W. and Griffith, G.T. *Hellenistic Civilisation*, London (1966). Webster, T.B.L. *Hellenistic Art*, London (1967).

10

ETRUSCAN ART

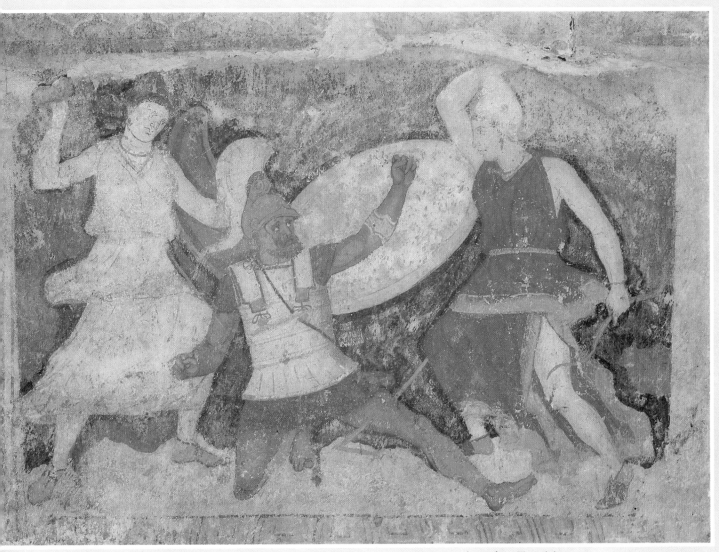

Amazons fight a Greek warrior: a painted scene on an Etruscan stone sarcophagus from Tarquinia
Museo Archeologico, Florence (see page 175)

THE Etruscans inhabited the region of Italy bounded to the north by the valley of the Arno, to the east and south by the Tiber, and on the west by the Tyrrhenian Sea. In Antiquity it was called Etruria and contained great forests and rich potential for agriculture and mining. The ethnic and linguistic affinities of the Etruscans are not clear. According to a tradition well known in Antiquity they migrated from western Asia Minor around the 12th century BC. To date no firm archaeological evidence supports this story but Etruscan is similar to a dialect once spoken on the Aegean island of Lemnos. Both languages may be survivals of an ancient Mediterranean tongue, or the Etruscans may have brought their language to Italy at an early date.

Archaeologists call the Iron Age culture of ancient Etruria "Villanovan", reserving the name "Etruscan" for the period after c700 BC. This nomenclature stresses a theory, still upheld by some scholars, that the Etruscans only arrived in Italy at this time. But a strong continuity links the 8th and 7th centuries in the region and the Villanovan culture is now generally regarded as the true precursor of Etruscan civilization, though a profound change did occur in Etruria during this time.

Distribution of sites mentioned in the text

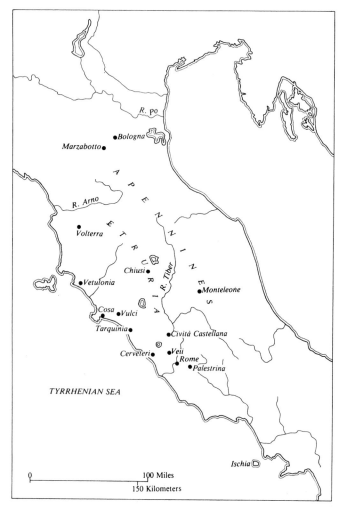

Phoenician and Greek merchants and colonists became active in the western Mediterranean in the Geometric period (see Archaic Greek Art) and had made contact with Villanovan villagers by c800 BC. Thereafter the Villanovans and their successors, the Etruscans, were gradually drawn into the mainstream of Mediterranean culture. The Greeks founded their first colony in Italy on the island of Ischia before 750 BC, and by 600 BC a chain of Greek colonies ran along the shore of southern Italy from Naples to Taranto and round the eastern coasts of Sicily. The Phoenicians held the western tip of the island, opposite Carthage in Africa, and had colonies on Sardinia.

Greek and Roman authors mention some early events in central Italy but the Etruscans only emerge into history during the 6th century BC. By then, the political system of city-states, with a social and religious structure familiar in later centuries, had crystallized. Etruscan kings ruled Rome; the Etruscans had established colonies in Campania, the lower Po Valley, and Corsica. It was the period of their greatest power, but during the late 6th and early 5th centuries they were expelled from Rome and defeated at sea and on land by their Greek neighbors.

During the 5th and 4th centuries BC Greek fleets occasionally plundered Etruscan coastal sites. To the south of Etruria the young Roman Republic was growing in strength, while to the north the Gauls had settled in the Po Valley and periodically raided south of the Apennines. Surrounded by these dangers, the Etruscan city-states failed to unite effectively. Veii and other cities fought intermittent but fierce wars with Rome and by 280 BC they were probably all subject-allies of the Republic.

Afterwards, the Etruscans continued to enjoy some local self-government but gradually they were assimilated into the Roman world. In 89 BC they were granted Roman citizenship. By the end of the 1st century BC their language was obsolete and their culture had merged with that of Imperial Rome.

Traditionally 12 in number, the Etruscan city-states were autonomous. They formed a loose confederation, united by their common language and religion (always a profound influence in Etruria) but often following their own interests. In early times the cities were ruled by kings but by the 5th century BC power had passed to the wealthy and exclusive class of nobles.

This political and social structure had a deep effect upon the development of art in Etruria and upon the type of surviving evidence. The individuality of the city-states generated a fascinating divergence of local art forms. The nobles were gifted patrons of the arts and custom dictated that men and women of great families should be placed in fine tombs, surrounded by prized possessions, some of which have come down to us.

Etruscan artistic styles. The Villanovans were capable craftsmen, decorating their pottery and bronzes with geometric designs and occasionally with primitive representational scenes. During the 8th century BC they began to copy goods

obtained from Phoenician and Greek merchants, but traditional Italic forms remained dominant until c700 BC.

In the next 100 years the Etruscans achieved a new prosperity, based upon the export of metal ore. Since Greek art was under the influence of the high cultures of the eastern Mediterranean, Greek goods in the Orientalizing style reached Etruria together with exotic objects from Asia Minor, the Phoenician cities, Cyprus, and Egypt. These imports were imitated in Etruria, the craftsmen excelling in the production of decorative objects in the Orientalizing style (c700–600 BC) for their princely patrons.

Greek inspiration prevailed in Etruria during the period of the Archaic style (c600–475 BC); Corinthian, Ionian, and Attic styles in turn dominated the taste of the Etruscan city-states, where local artistic styles were now very individual. Town-planning was introduced, monumental architecture and large-scale sculpture and painting became firmly established as major art forms. The exuberance of the Archaic style reflects the self-confidence felt by the Etruscans, now at the height of their power.

As the Greeks emerged victorious from the Persian War, the Classical style appeared in Greece. By this time, Etruscan civilization had already begun to decline; there was a recession of trade with Greece and the Etruscans were slow to accept the Classical style (c475–300 BC). Archaic forms survived and Etruscan artists were reserved in adopting the severe, idealizing style of Greek early Classical art. The Etruscans responded more fully to the less austere manner of the late Classical style and there was a sporadic revival in Etruria during the 4th century BC.

After the death of Alexander (323 BC) the Greek world ex-

An Etruscan gateway: the Porta all'Arco, Volterra

panded around the eastern Mediterranean and developed the elegant Hellenistic style (c300–1st century BC), which strove to express emotion and emphasized dramatic moment. Rome became the capital of the Mediterranean world and increasingly contributed to Hellenistic culture. The Etruscans, no longer politically independent, adopted the style but maintained some regional characteristics.

Throughout the seven centuries of their individual artistic expression the Etruscans were dependent upon foreign inspiration, principally that of the Greeks. Thus the major styles of Etruria are called by the same names as those of Greece. But whereas the Greek styles grew organically, reflecting their historical, social, and intellectual background, the Etruscans accepted outward forms without always assimilating inner content. It is hard to find a parallel in the history of art for the Etruscans' consistent borrowing of Greek styles, yet they were not shallow imitators. They were sensitive to the beauty of Greek visual arts and proved themselves most able craftsmen. They used Greek art forms, styles, themes, and even details, but were always selective, adapting them to Etruscan conventions to express Etruscan taste, often in the idiom of a single city-state.

Architecture. The Etruscans adopted the grid street-plan used at Greek colonial sites in Italy, but ideal town-planning was difficult to impose on the older cities of Etruria, which had grown from Villanovan villages. An example of an ideal plan is the colonial site of Marzabotto, near Bologna, founded towards the end of the 6th century BC. A main street ran due north and south and was crossed at right angles by three streets of similar width, all flanked by drains. A grid of smaller streets divided the rest of the town. Buildings for religious observance crowned the nearby hilltop and cemeteries lay outside the habitation area, an Etruscan custom.

Throughout their history the Etruscans were deeply concerned with the afterlife. Many of their cemeteries were veritable cities of the dead—their sites remain evocative. The tombs differ from place to place and from century to century, much depending on whether inhumation or cremation prevailed as the local funerary rite. Some tombs are rock-cut chambers, approached by steps from ground level or entered by a doorway with an architectural facade carved in the cliff face. Others were constructed of stone blocks, either standing above ground or partially buried, like the great *tumuli* whose molded drums were cut from the rock and had masonry additions. Masonry was used in early times for false vaults, false arches, and false domes, while true barrel vaults were built in the Hellenistic period.

Earlier masonry city walls had squared blocks which were set in regular courses; later walls were constructed in the polygonal manner. Hellenistic reliefs show city walls with turrets, castellations, and arched gateways. Such gateways, which are occasionally decorated with human heads carved in relief, and stretches of great city walls are very often the most imposing monuments at Etruscan sites.

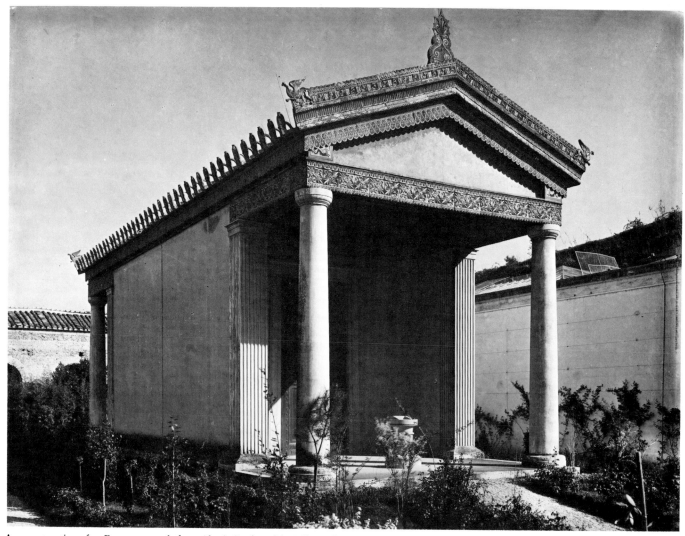

A reconstruction of an Etruscan temple from Alatri. Garden of the Villa Giulia, Rome

Little is known about the external elevations of houses, though tomb facades and representations, especially on cinerary chests, presumably reflect their appearances. Examples show facades each with a porch and columns, and indicate an upper story. A cinerary chest in the Museo Archeologico, Florence, represents a stone house with fine masonry and arched doorways, flanked by pilasters.

More is known of the ground plans of Etruscan houses. The Villanovans had lived in huts, often oval in layout. At Marzabotto houses were arranged on a rectilinear pattern but had no uniform plan, though several had rooms grouped around a central courtyard with a passage leading in from the street. Contemporary 6th-century tombs echo a more complex house plan with an entrance corridor flanked by a chamber on either side, and a central hall which opened into three back rooms. Later tombs sometimes have rooms on either side of the hall, an arrangement similar to houses at Pompeii. There is also evidence that the hall or *atrium* on occasion had an opening to the sky, a development known in the Hellenistic period and associated with the Etruscans in Antiquity.

Many internal domestic features are represented in the tombs, which are often painted in gay colors. Beams are supported by columns with capitals in Doric or sometimes Aeolic style, and some ceilings are coffered. Doorways have heavy lintels and inclining jambs, some doors have strong frames with metal studs and handles, and windows are rectangular or arched.

Etruscan temple architecture was allied to Greek forms, which the Etruscans modified, principally in their use of materials and the ground plan, to suit their own religious needs. The Etruscans characteristically only used stone for the base or *podium* of a temple. The walls were of unfired brick, covered with plaster, and the columns and beams of timber—plentiful in Etruria. The exposed wooden elements of the superstructure were protected by terracotta plaques. Together with the stone substructure, the temple terracottas often survive as our best evidence for the original appearance of Etruscan buildings.

Unlike Greek forms the *podium* of an ideal Etruscan temple was almost square and approached by a flight of steps from the front alone. The front half of the temple was a deep porch with two lines of four columns. At the back, there were three rooms or *cellae*, their doors opening onto the spaces between the columns. An alternative arrangement had one *cella* between two wings, open at the front. The columns were traditionally made of wood, without flutes; the capitals had round cushions and square abaci, resembling the Doric order.

The great wooden beams and overhanging eaves gave Tuscan temples a top-heavy appearance. This was emphasized by their brightly painted terracotta decorations. The horizontal

beams were covered in terracotta slabs, often with repeating patterns in bas-relief, while the ends of the ridgepole and roof beams were capped by plaques, sometimes decorated in high relief. The roof was tiled and where the tiles overlapped at the eaves the joints were masked by decorated antefixes. Statues or acroteria might be set upon the gable or along the ridgepole but unlike the Greeks the Etruscans left the pediment open, not filling it with sculpture until Hellenistic times.

The Etruscans also built temples with one *cella* and two columns; models and tomb facades demonstrate that fluted columns and Ionic capitals were used. Little is yet known of other public buildings in Etruria, though there are extant examples of stone platforms with fine moldings, probably for taking the auspices, and models of arcades and freestanding towers. Early bridges were constructed of wood, set upon stone foundations, while arched stone bridges were built in Hellenistic times.

Sculpture.
The Villanovans made models of familiar objects and primitive statuettes from clay and bronze. Their human figures have large heads with ill-defined features and thin, straddling limbs, while their lively animals sometimes recall Greek Geometric types.

During the Orientalizing period objects of faience, ivory, precious metals, bronze, and pottery from the eastern Mediterranean and Greece reached Etruria. Some of these imports were carved or modeled in the round, others were decorated in bas-relief. Etruscan craftsmen enthusiastically imitated them, making lavishly embellished objects for personal and household use. They portrayed monsters, strange men, and draped female figures, usually presented in compact volume and often with carefully noted details. Foreign repertoires were mingled and Italic themes occasionally added to produce an eclectic Etruscan Orientalizing style.

At Chiusi, a contemporary sculptural form probably had local inspiration. The ashes of the dead were often placed in vessels with lids fashioned as schematic human heads, though some examples seek to convey individuality.

Towards the end of the period, large-scale sculpture appears. Seated figures from Cerveteri, delicately modeled in terracotta, are some 20 in (50 cm) in height (Palazzo dei Conservatori, Museo Capitolino, Rome; British Museum, London). Stone statues from Vetulonia, crudely carved in the round, reach life-size (Museo Archeologico, Florence). Stone funerary stelae have figures in bas-relief or incised, one accompanied by an inscription in Greek letters, adapted for the Etruscan language.

It is important to note the conventional Etruscan choice of materials for sculpture. In contrast to Greek tradition, they usually reserved stone for funerary monuments, mainly using the local stone. Bronze was appreciated and employed for offerings dedicated to the gods, for household goods and personal possessions, which often attain a high artistic standard. Terracotta served for architectural decorations, for sarcophagi, cinerary urns, and votive offerings.

New sculptural forms reached Etruria during the Archaic period and the ability of sculptors developed rapidly. They followed Hellenic styles but local idioms occur. At Tarquinia stone slabs were carved in bas-relief, sometimes illustrating narrative themes. At Vulci and other centers, stone statues of monsters, animals, and humans were set up outside tombs as guardians. A fine example represents a centaur (Villa Giulia, Rome). The nude male form, derived from the early Archaic style of Greece, has a large head, staring eyes and sturdy limbs, held in motionless frontal pose.

At first Archaic bronze figures were somewhat rigid, with stress on vertical lines but they soon acquired new characterization and vitality. Cast statuettes of recognizable gods appear, and to decorate the increasing number of household bronzes warriors, athletes, dancers, and other types are often shown in vigorous action. The emphasis on expressive detail, such as the head or hands, is characteristic of the Etruscans,

A stone statue of a centaur from Vulci; volcanic stone; height 76cm (30in); early 6th century BC. Villa Giulia, Rome

while the flowing lines, long heads, and plump bodies indicate Ionian taste.

Sheet bronze was worked in repoussé to decorate furniture and wooden objects, for example the magnificent chariot found at Monteleone (Metropolitan Museum, New York). Large works were fired in terracotta—outstanding examples are the sarcophagi from Cerveteri, shaped like couches with smiling married couples reclining upon the lids (Villa Giulia, Rome; Louvre, Paris).

Simple temple decorations in terracotta occur about the middle of the Archaic period. Subsequently antefixes of various designs were made in molds; some have heads surrounded by a shell motif, others depict complete figures. The bas-relief friezes repeat groups of gods or men and some lively horsemen. Most celebrated, however, are the compositions in high relief and statues, modeled in the round, which were set upon the roof. The sculptors, inspired by the achievements of the Greek late Archaic style, created naturalistic figures capable of expressing both movement and emotion. Energy is implicit in fighting warriors, their details picked out in color, from Città Castellana, and there is latent menace in the striding Apollo from Veii (both in the Villa Giulia, Rome). The sculpture of Veii was famous in Antiquity and the Romans recalled that Vulca of Veii, the only Etruscan artist known by name, decorated a temple in Rome towards the end of the 6th century BC.

Works in the Archaic manner were produced at some Etruscan centers well into the 5th century BC. This is apparent in bas-reliefs on sarcophagi, cinerary chests, and other monuments from the region of Chiusi, or from the stelae of Bologna (Museo Archeologico, Chiusi; Museo Archeologico, Bologna). Their style is lively, their design simple, and they often depict aspects of ordinary life.

The severe style of early Greek Classical sculpture was not so fully assimilated by the Etruscans, though they became more interested in representing human anatomy and accepted a trend towards idealization. A head, which forms the lid of a cinerary urn, demonstrates such impersonal presentation, an example of the association of Greek style with a local art form (Museo Archeologico, Florence). The development of the Classical style in Etruria is shown in a series of votive statuettes in terracotta and bronze. The men are either nude or when clothed they sometimes wear an Etruscan cloak or military equipment, while the dignified women are finely dressed. The Mars of Todi, one of the few surviving large-scale bronze statues, illustrates the later Classical style of Etruria. It is a graceful study of a pensive young soldier, standing in a well-balanced pose with the weight upon one leg (Vatican Museums, Rome). Many contemporary household bronzes are of outstanding quality with their cast components, for example the handles or feet, formed of well-composed groups of figures.

In Hellenistic times there was a revival of temple decoration. The most important feature now was the sculpture filling the pediment. Moments of high tension were illustrated and supple figures shown dramatically posed. The bronzes include strange, elongated statuettes, often of priests, muscular males, and elegant women. Some wear fashionable clothes and jewelry but others are nude, their small heads with elaborately dressed hair set upon slender bodies.

Stone sarcophagi were still carved in the region around Tarquinia; the production of cinerary chests was maintained at Chiusi; and at Volterra the local alabaster was used for fine cinerary chests (now in the Museo "Guarnacci", Volterra). On many are reliefs showing episodes, often violent, from Greek mythology, or scenes of farewell—the dead setting out on their journey to the underworld. Figures reclining upon lids were sometimes shown with exaggerated features, in the spirit of caricature. Frequently, however, they are genuine portraits, with inscriptions recording the name, family, age, and offices held by Etruscan nobles.

Painting. Almost all large-scale Greek paintings have perished but we can trace the development of their drawing from painted pottery styles. Greek graphic art had a profound influence upon Etruscan polychrome wall-paintings, which form the most numerous group of murals to survive from the pre-Roman Classical world. The Etruscan wall-paintings have come down to us because underground tombs at some Etruscan centers were decorated in fresco. This art form probably had a religious purpose: to perpetuate the efficacy of funerary rites and to recreate the familiar surroundings of life in the dwellings of the dead.

The oldest known painted tomb in Etruria is the Tomb of

A terracotta fighting group from Città Castellana. Villa Giulia, Rome

The bronze Mars of Todi; height 142cm (56in); c400–350 BC.
Vatican Museums, Rome

Of mid-6th-century date, the five Boccanera slabs show the influence of Corinthian vase-painting. They depict seated sphinxes and figures, standing stiffly, linked only by their gestures (British Museum, London). The more flowing lines of the Campana plaques (Louvre, Paris) suggest Ionian taste. Movement is introduced and figures carefully interrelated. Whether the figures represent gods or men, details of dress and symbolism are Etruscan.

From mid Archaic to Hellenistic times Tarquinia was the greatest center of tomb-painting. The fresco technique was generally used—walls of rock-cut tombs were thinly covered in plaster, the outlines of the picture sketched or incised, and the painting filled in while the plaster remained damp. Some of the paintings can be seen in the tombs; others are in the Museo Nazionale, Tarquinia.

The Archaic paintings have a two-dimensional plane, their designs based upon the relationship of figures and colors employed. Heads are drawn in profile, shoulders are frequently full-view, and legs are again in profile. Artists filled in these outlines with a uniform wash, adding some internal details. Blue and green were added to the palette and differing shades of color were used.

The Etruscans' paintings abound with exuberant life, fully reflecting their confidence at this time. Funerary themes, such as banquets and athletic games, are repeated but other aspects of life appear. Only the back wall of the Tomb of the Bulls, dated 540–530 BC, is fully decorated. Its principal scene illustrates a Greek epic story but erotic subjects are also shown. On all four walls of the Tomb of the Augurs are themes of funerary ritual and sports, some figures recalling the contemporary style of black-figure vase painting. The Tomb of Hunting and Fishing has carefree outdoor scenes whilst the main person in the Tomb of the Jugglers watches a display in his honor. The Tomb of the Baron illustrates a tranquil moment of worship or greeting.

Some late Archaic and early Classical tombs have banqueting scenes on the end wall, while on the sidewalls accompanying musicians and dancers are shown, representing the performing arts for which the Etruscans were famous in Antiquity. In the Tomb of the Leopards, two figures recline on each of the three couches and naked boys serve wine. The sidewalls of the beautiful Tomb of the Triclinium, c470 BC, have fine compositions with a lyre-player, flautist, and energetic dancers, their draperies emphasizing movement. The drawing displays a new competence, familiar from Attic red-figure pottery at the beginning of the Classical period.

At this time the custom of tomb-painting had spread inland to Chiusi and other centers. At Tarquinia there are fewer tombs painted in the Classical period but, by the 4th century BC decisive developments had taken place in the graphic arts. The drawing style of the painted pottery and engraved bronzes evokes three-dimensional space, in which overlapping figures are presented in integral groups, their heads and bodies sometimes shown in three-quarter poses and with foreshortening. These techniques were also used in large-scale paint-

the Ducks at Veii. On the walls are plain red and yellow zones, divided by horizontal bands of red, yellow, and black, upon which struts a row of birds. The colors and drawing recall 7th-century pottery in the Subgeometric style. Painted scenes flank an inner doorway of the Campana Tomb, also at Veii; here natural colors and proportions are disregarded and every available space filled with animal or floral motifs.

There were early painted tombs at Cerveteri and painted terracotta plaques have been found in both the necropolis and the living area, demonstrating that buildings, like tombs, had wall-paintings. Two series are outstanding, both painted in black, white, brown, and red/purple on a light background.

The Tomb of the Augurs

Near the ancient city of Tarquinia lies the Colle dei Monterozzi, the site of a great Etruscan cemetery. An occasional mound or tumulus, surrounded by cut-stone walling, might still be seen in the 19th century and some earthen mounds survive today. These tumuli crowned Etruscan tombs; the tombs were entered by a rock-cut stairway, leading from the open air down into the dark, cool chambers below. A few of the tombs were decorated with wall-paintings.

The Tomb of the Augurs is a small, rectangular chamber, cut from the soft rock, with the ceiling shaped to resemble a gabled room. The walls and ceiling were smoothed, plastered, and painted in fresco and the surviving paintings retain a fresh coloring with bright reds predominating. The architectural features of the ceiling are emphasized by color, the central beam in red and the sloping sides in white; the pediment space of the back wall (opposite the entrance) was filled with two feline animals attacking a deer, a scene now much damaged. Below this there is a horizontal band composed of black, red, white, and green stripes, and then the principal figurative frieze which has a white background. A red stripe forms the ground upon which the figures stand; below is a white stripe and a black dado reaching down to the floor. These elements continue around the whole chamber and serve to unite the figurative scenes of the frieze.

As in other Archaic wall-paintings, the artist first incised or outlined the forms in black, also sometimes dividing the areas of differing colors, and then filled them in with a uniform wash, adding some internal details. The figures and objects are drawn with little realization of three-dimensional space but the artist has striven to present a material realism and to note significant details. The delightful effect is achieved by the confident drawing of the lines, the interrelation of the figures together with a desire to fill the adjacent spaces, the bright colors, and the vitality of the scenes.

A fine doorway is shown at the center of the back wall—the lintel, jambs, and door frame are in contrasting reds, with the nailheads picked out in white—and may symbolize an entrance into the afterlife: on either side stand men in attitudes of mourning and farewell. They wear white tunics and short black and red cloaks and boots. The adjacent spaces are filled with growing plants and a bird.

▶ Section and plan of the Tomb of the Augurs

▼ The final figure on the left wall: a masked man in precipitous flight

Below right On the right wall: a boy carries a folding stool towards a man. A small mourning figure crouches between them

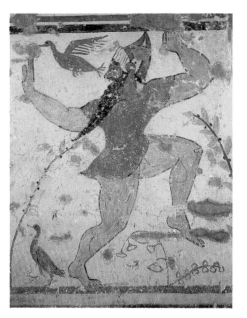

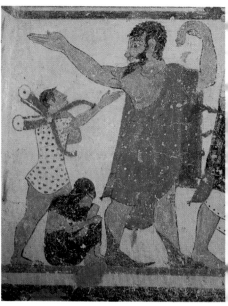

Three groups of figures, each forming a separate scene but all taking part in funerary games or ritual, appear on the right wall. On the left is a boy, dressed in a white tunic covered with black dots, carrying a folding stool towards a bearded man wearing a loosely draped, red cloak and boots, who gazes back over his shoulder. These figures are related by their gestures; between their feet, a small figure is crouched in an attitude of deep dejection, a black garment pulled over the head. To the right of this group stands a bearded man, bare-footed and wearing a black and red cloak over his tunic, who holds a curved stick or *lituus* in his right hand. Once he was considered to be an augur, or soothsayer, a theory that gave rise to the accepted name of the tomb, but this figure represents an umpire: he faces and gestures towards two burly wrestlers, the central figures of this wall. The wrestlers' attitude is tense and vigorous; they lean towards each other, their heads almost touching, their wrists clasped, as if to test each other's strength. The prizes, a pile of bronze bowls, are set between them; flowers

and flying birds fill the adjacent spaces. A second pair of combatants is shown on the right; a masked man, the word *Phersu* written beside his head and dressed in a short black tunic and red loincloth, holds a vicious dog on a leash; the dog is attacking a man who is blindfold and armed with a huge club. This scene, together with much of those painted on the entrance wall and the left wall, is sadly destroyed but the final figure on the left wall survives and shows a masked man in precipitous flight. Here, the artist has achieved a fine feeling of movement and filled the spaces between the limbs with plants and birds.

The Tomb of the Augurs is dated *c* 530 BC, when the custom of decorating some tombs with wall-paintings was becoming well established at Tarquinia and the artists were capable of responding in a mature Archaic style, reflecting Greek black-figure vase-painting and closely allied to contemporary Etruscan ceramic art. At this time, Etruscan art was especially influenced by East Greek or Ionian taste and it is known that Ionian artists settled and worked in Etruria. A

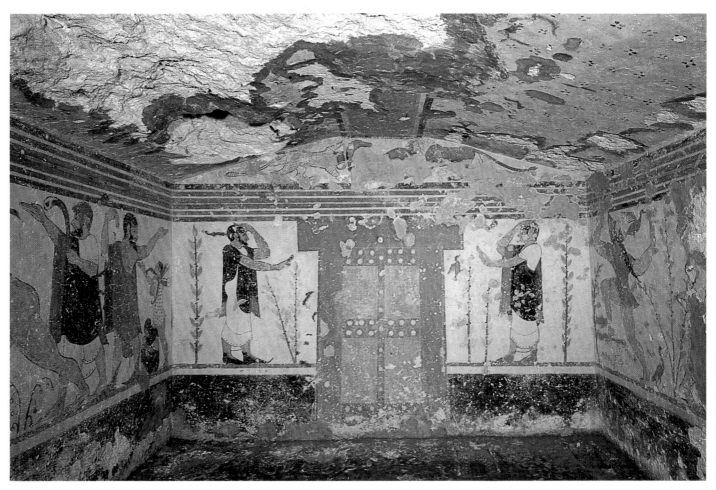

▲ The back wall of the Tomb of the Augurs: the doorway with mourning men on either side

▼ On the right wall: an umpire, two burly wrestlers, and a masked man

familiarity and delight in Ionian style is shown in the flowing lines and corpulent figures of the paintings of the Tomb of the Augurs; the artist might have been of Ionian origin. These Ionian elements are mingled, however, both with subject matter and details often of purely local significance: the

figures wear Etruscan clothes; folding stools with ivory appliqué were much used in Etruria; and the *lituus* was an Etruscan symbol of authority. The games, held in honor of the dead, include wrestling, a sport adopted from the Greeks by the Archaic period, but also a more bloodthirsty ritual, described above. Though analogies are rare in Etruscan art, this must represent an Etruscan form of ritual or enactment of a myth. The words, written beside some figures, are descriptions in the Etruscan language; the

word *Phersu*, set beside a masked man, is found in Latin as *persona* meaning a mask, actor, or the part he played and hence has passed into several European languages, including English.

It is never simple to rationalize either religious beliefs concerning the afterlife or the manner in which they may have affected the construction or decoration of tombs. We do not know why some wealthy Etruscan families decided to decorate their tombs with wall-paintings, yet some idea that the dwellings of the dead should resemble the familiar homes of the living is inherent in the custom of carving a room from the living rock and of emphasizing its architectural features. The themes selected for presentation in the tomb paintings include scenes of earthly pleasures, perhaps in some sense expressing a hope of continued enjoyment after death. But often they also record the funerary games and rites held in remembrance of the dead and sometimes scenes of mourning, as do those of the Tomb of the Augurs.

ELLEN MACNAMARA

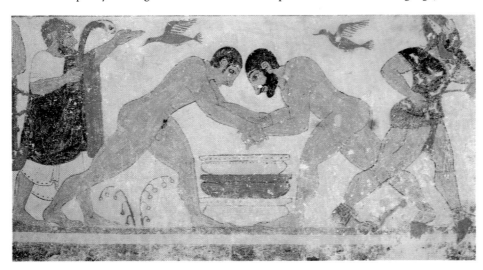

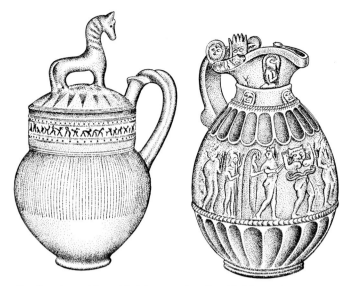

Bucchero jugs with modeled, impressed, and molded decoration

ings in polychrome, in which shading and highlights were added to express volume: the artists were also concerned to contrast light and dark areas. The scene of a Greek fighting Amazons, on a sarcophagus from Tarquinia (Museo Archeologico, Florence), illustrates late Classical handling of perspective and color tones. It may have been painted by a Greek artist working in Etruria.

As in other Etruscan art forms, a mood of despondency and a preoccupation with death are shown in Hellenistic tomb-paintings. Dreadful demons appear, often escorting the dead to the underworld and an idea of judgment is evident. Strong family feeling prevails, however, in paintings like those in the Tomb of the Shields at Tarquinia, in which successive generations are shown banqueting. The artist has attempted to express individuality and names are written beside the portraits. Occasionally civic pride appears, as in the illustration of the rescue of some famous Etruscan prisoners and the murder of

their captors, or a full-length portrait of a nobleman in ceremonial robes from the François Tomb at Vulci (Museo Torlonia, Rome). Such scenes remind us of the Etruscans' own recollections of their glorious past and of their contribution to Roman ritual.

Minor arts. In the absence of fine objects of wood, leather, textiles, or other perishable materials, the minor arts of the Etruscans must be judged mainly from their pottery and metalwork. Since both personal possessions and household objects were placed in tombs, they survive in some quantity and provide an eloquent commentary on the major arts.

Traditional Villanovan pottery had forms characteristic of the Italic Iron Age—fired, brown/black, with incised decoration. During the 8th century BC they also began to copy the shapes, light-colored fabric, and designs painted in red/brown, of Greek Geometric imports. By 700 BC, local potters were imitating yellow/buff Corinthian ware, decorating it in dark paint, sometimes depicting monsters, animals, or men from the Orientalizing repertoire.

The principal ceramic contribution of the Etruscans is a black, glossy ware called *bucchero*, which appears before the middle of the 7th century BC. Sometimes Villanovan forms with incised decoration were followed, but Greek pottery shapes became increasingly copied. Modeled embellishments were added, especially on vases imitating metalwork or carved ivory, and repeating patterns were impressed with a roller stamp. In the Archaic period, *bucchero* became heavy and over-decorated and, during the 5th century BC, production ceased.

Until *c*550 BC, Corinthian black-figure imports continued

Gold clasp from the Barberini Tomb, Palestrina; 7th-century BC. Villa Giulia, Rome

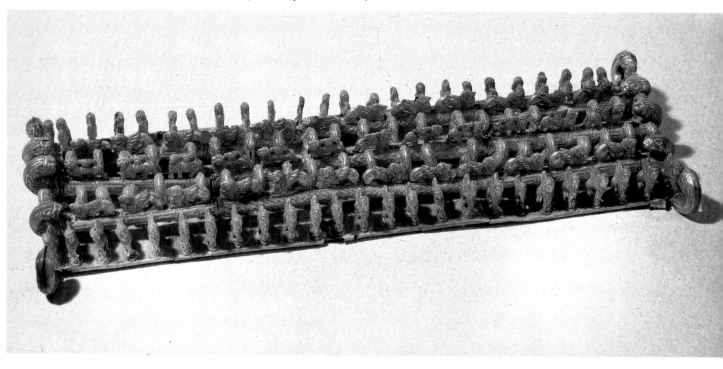

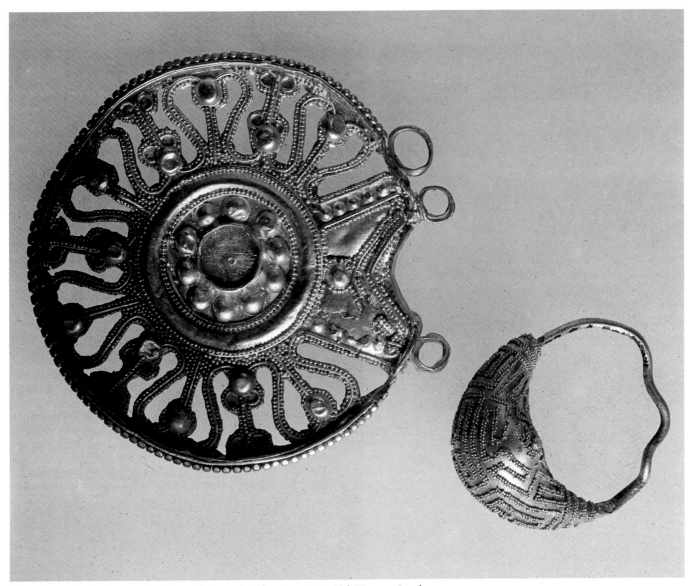

An earring and a ring decorated with granulation; 7th–6th century BC. British Museum, London

to dominate the Etruscan markets. Subsequently Ionian influence is evident and Ionian craftsmen even worked in Etruria. Their most outstanding products are the Caeretan *hydriae*, a series of water-jars made at Cerveteri. Athenian potters manufactured special exports for Etruria and, as their superb black-figure and red-figure pottery increased in popularity, they monopolized the trade. Meanwhile Etruscan potters produced black-figure vases with Greek forms. The painting is seldom elegant, but is usually bold, with lively figures.

The Etruscans were slow to adopt the true red-figure technique. At first they painted figures in red over a black ground, though they were aware of the development in drawing technique in the early Classical period. By the end of the 5th century BC fine red-figure vases, closely following Attic style, were being made, mainly at Vulci and at Città Castellana. The south Italian schools also influenced Etruscan pottery of the 4th century BC, when northern cities, including Volterra, were producing red-figure ware. Black-glaze pottery became popular and, during the Hellenistic period sophisticated vase forms, silvered to imitate metal, were manufactured in central Etruria.

The Greeks praised Etruscan metalwork, particularly their goldwork and bronzes. Bronze was used for a very wide variety of goods, from jewelry to armor, from horse-gear to household furniture. Bronze was hammered, worked in repoussé, cast and engraved, the craftsmen following contemporary technical developments and artistic styles.

Pottery forms, especially those used for serving wine, were reproduced in bronze. Ladles, strainers, candelabra, incense-burners, braziers with their equipment, and other types of household goods were made of bronze and often finely decorated. Personal possessions include men's helmets, shields, armor, and beautiful toilet articles for women. Among these are caskets, in which combs, carved powder boxes, delicate perfume bottles, and the accompanying perfume pins and oil flasks were kept, and the wonderful series of hand mirrors with mythological and genre scenes engraved upon the backs.

Among luxury goods, amber and ivory were carved, the former used mainly for jewelry and the latter for chalices, combs, and boxes. Multicolored glass served for beads, brooches, and perfume-bottles. Semiprecious stones were cut and employed in rings and other jewelry. Gold and silver were

used for cups and jugs and, above all, for jewelry.

Etruscan jewelry is celebrated for its craftsmanship, particularly for goldwork using the technique of granulation. In the 7th century BC Italic forms and Orientalizing designs were mingled in Etruscan jewelry but later Hellenic taste was followed. Brooches, pins, finger-rings, bracelets, earrings, hairbands, buckles, and other pieces were exquisitely worked in the contemporary artistic style, a reminder of both the good taste and the ostentation of Etruscan nobles in the centuries of their prosperity.

Conclusion. Modern art historians have reached different conclusions about the achievements of the Etruscans in the visual arts. Some have considered them mere plagiarists, adopting Greek forms with little originality and indifferent ability. Others, noting how the Etruscans educated their Italic neighbors, have credited them with exceptional sensibility and craftsmanship.

Some truth lies at both extremes. Without a substantial Italic tradition in the visual arts, the Etruscans were inspired by Hellenic styles in all seven centuries of their independent artistic development. Yet lacking the historic and intellectual background of Greek art, Etruscan artists sometimes failed to respond to Greek ideals and were capable of producing poor-quality work unacceptable in the Greek world. Etruscan art cannot claim to rank with that of Greece but its merit distinguishes it from contemporary Italic cultures and requires that it be judged by Greek standards. The Etruscans were always selective in their choice of Greek artistic precedents but, when their artists carefully followed them, they came close to the Hellenic models. When they took Greek forms and styles but adapted them to Etruscan conventions and taste, they subtly transformed them into their own, and even contributed new art forms.

The Etruscans must also take their place in the history of the visual arts as vital intermediaries between the Greeks and Romans. Profiting from the rich resources of their homeland, the Etruscans welcomed the civilization of their Greek contemporaries. During Rome's early development the neighboring Etruscans were an acknowledged source of culture, and introduced many Hellenic forms to Rome.

ELLEN MACNAMARA

Bibliography. Boëthius, A. *Etruscan and Early Roman Architecture*, Harmondsworth (1979). Coarelli, F. (ed.) *Etruscan Cities*, London (1975). Haynes, S. *Etruscan Sculpture*, London (1971). Heurgon, J. *Daily Life of the Etruscans*, London (1964). Moretti, M. and Maetzke, G. *The Art of the Etruscans*, London (1970). Pallottino, M. *Etruscan Painting*, New York (1952). Pallottino, M. *The Art of the Etruscans*, London (1955). Pallottino, M. *The Etruscans*, London (1975). Richardson, E. *Etruscan Sculptures*, London (1966). Richardson, E. *The Etruscans, their Art and Civilization*, Chicago (1964). Sprenger, M. and Bartoloni, G. *Die Etrusker: Kunst und Geschichte*, Munich (1977).